Digital Currents

Digital Currents: Art in the Electronic Age surveys the major impact of video and digital technologies on visual culture and artistic practice and examines the revolutionary changes taking place in the role of the artist as social communicator. It recounts the involvement of those artists who pioneered early use of electronic mediums in the arts, describing the development of entirely new forms of representation and practice such as those associated with video and digital installations, net art, viewer participation, and virtual, augmented reality.

Digital media have catalyzed new perspectives on art, affecting the way artists see, think, and work and the ways in which their productions are distributed and communicated. Lovejoy discusses key works and the new issues they raise in the context of today's major cultural shifts. This third expanded, updated edition has a new chapter on the Internet and new sections on sound, narrative, and on science, and art, making it an ideal new media and visual culture source book.

Margot Lovejoy, Professor of Visual Arts at the State University of New York at Purchase, has received, amongst many other honors, an Arts International Grant and a Guggenheim Fellowship for her multimedia work. She has exhibited internationally and was recently featured in New York's important Whitney Museum of American Art Biennial and ZKM (Center for Art and Media), Karlsruhe, Germany. She has lectured widely on art and technology issues.

This book has a vital companion website at **www.digitalcurrents.com**

A note about the Digital Currents website

The concept driving the creation of www.digitalcurrents.com is to develop a functioning companion to the book in a form that can be continuously updated in line with the rapid changes going on around us both culturally and technologically. Most of the information content on site cannot be found in the book itself and there are surprises. When clicked on, the many yellow dots in the dynamic overall homepage area will bring up special floating quotes about art and technology. The sites's primary circular modular interface construction allows readers immediate access to artist and media information with online addresses to artists' homepage URLs and significant projects. The Context section of this module provides historical timelines showing relationships between art movements, dates, important technological invention, and world events. The Issues segment raises questions discussed in the book about the relationship between art and technology. The navigation bar located at the bottom of the site contains further information arranged by topics: ABOUT; REVIEWS; RESOURCES; ACCESS&LINKS; GLOSSARY. The Resources, Access and Links areas provide significant information about relevant conferences, centers, magazines. There are articles about on-line library and museum issues and discussion about copyright and the digital frontier and more. . .

Digital Currents

Art in the Electronic Age

Margot Lovejoy

Routledge
Taylor & Francis Group

NEW YORK AND LONDON

www.digitalcurrents.com

First published as *Postmodern Currents: Art and Artists in the Age of
Electronic Media* 1989 by UMI Press
Subsequently re-published 1992 by Prentice Hall (now part of Pearson Education)
Fully revised second edition published 1997 by Prentice Hall
This third expanded edition first published 2004 by Routledge
29 West 35th Street, New York, NY 10001

Simultaneously published in the UK
by Routledge
11 New Fetter Lane, London, EC4P 4EE

Routledge is an imprint of the Taylor & Francis Group

Digital Currents website created by Margot Lovejoy and Jacques Tege through
the auspices of Pratt Institute as an independent study under the direction
of Miroslaw Rogala, Chair of CGIM/Department of Computer Graphics and
Interactive Media, 2003–04

Index compiled by Lisa Kenwright, Indexing Specialists (UK) Ltd

Designed and typeset in Franklin Gothic by Keystroke, Jacaranda Lodge, Wolverhampton
Printed and bound in Great Britain by TJ International Ltd, Padstow, Cornwall

Library of Congress Cataloging in Publication Data
Lovejoy, Margot.
 Digital currents: art in the electronic age / Margot Lovejoy.– 3rd ed.
 p. cm.
 Rev. ed. of: Postmodern currents. 2nd ed. 1997.
 1. Postmodernism–United States. 2. Technology and the arts.
 3. Computer art–United States. 4. Video art–United States. I. Lovejoy,
 Margot. Postmodern currents. II. Title.
 NX180.M3L68 2004
 700′.1′05–dc22 2003025226

British Library Cataloguing in Publication Data
A catalogue record for this book is available from the British Library

ISBN 0–415–30780–5 (hbk)
ISBN 0–415–30781–3 (pbk)

Contents

List of illustrations

Color plates between pages 172 and 173

Figures

Foreword

Because innovation is continuous, it is difficult to establish precise boundaries between historical periods. Which painting or building signals the beginning of the Renaissance? Which work of the imagination or of scientific discovery signals its end? Answers to such questions are bound to seem arbitrary. Surely a historical period is not just the temporal site of certain artifacts and discrete intellectual events. We give names such as "medieval" and "Renaissance" and "modern" to stretches of time that appear to be unified by characteristic beliefs and procedures – or, what is more to the point of Margot Lovejoy's *Digital Currents: Art in the Electronic Age*, periods disrupted by characteristic conflicts.

No society can prevent discord in the relations between individuals and institutions. We know from our own experience and historical memory that those relations have often been difficult, even violent, in modern times. Politics attained modernity in the American and French revolutions. The burst of scientific and technological development in the late eighteenth century is called the Industrial Revolution, a phrase that evokes riot and new poverty, as well as abundant goods and new wealth. Nonetheless, we are sometimes tempted to assume that modern conflict differs from earlier varieties only in degree, not in kind. This assumption leads to the comforting reflection that certain other periods may have been even more violent than ours. Perhaps they were. But the relations between selves and institutions during the past two centuries have inflicted on ordinary life a new kind, not simply a new degree, of harshness.

The modern period began when technological change speeded up to the point where succeeding generations could no longer feel certain that they lived in the same world. As Lovejoy's *Digital Currents: Art in the Electronic Age* documents in vivid detail, modern technology disrupts the history of experience; it changes not only the landscape but the way that landscape is seen. It shapes perception and induces a new kind of uneasiness, the distrust we feel toward tools and convenience that we would be reluctant to do without – devices that have, after all, done much to define what we are. But why should the familiar things of our world – automobiles, television sets, computers – be such frequent targets of

our distrust? Lovejoy suggests an answer in her discussion of artists' access to high-level computer and video technologies.

Access is difficult when innovations sponsored by large corporate and governmental institutions remain under their control, as they so often do. No television network is likely to offer itself as an artist's medium, so video artists must work at a smaller scale. Yet, no matter how intimate and productive one's interaction with technology, there is always the sense that it remains the instrument of institutional authority that by its nature stands in opposition to the self. And the still increasing rate of technological development makes that opposition particularly effective. Often bureaucracies and marketplaces can maintain an ascendancy over individuals (including their own personnel) simply by sustaining change at a destabilizing pace. During the past two centuries, to be a self is to be under relentless pressure to catch up. This pressure has no precedent in earlier times. Individuals were not prepared for it two centuries ago, nor have we adapted to it yet. Artists try to relieve the pressure of change by extricating technology from institutional agendas – that is, some artists engage in that struggle.

Lovejoy draws a distinction between artists who flee technology and those who try to engage it on terms other than the ones dictated by institutional purposes. The contrast is between art as nostalgia for a premodern, premechanical pastoral and art as a means of grappling with a quick-moving present. From this distinction follows another: between the artists who engaged their art with mechanical and photomechanical technology and those who grapple with the electronic technology that has appeared in the last few decades. Among the first group are Marcel Duchamp, the Dadaists and Surrealists, and the Pop artists – most notably Andy Warhol, who, as Lovejoy recalls, went so far in embracing the machine as to wish that he could become one himself. The second group is not so well known. *Digital Currents* is an indispensable guide to an area of culture that is treated as marginal but has already become more central as the electronic media more powerfully define us and our world. Lovejoy singles out for close examination the artists who carry on with the task that has occupied the most courageous sensibilities since the time of the Industrial Revolution: to experiment with advanced technology not for some definable gain but for the sake of making it a more helpful mediator between individuals and institutions. Shaped by aesthetic motives, technology will be better at shaping us.

Carter Ratcliff

Preface

I have written this book out of a mixture of puzzlement, fascination, curiosity, and, finally, commitment to share what I have learned over the many years it has taken to complete my investigation. It grows out of the concerns artists themselves have about the development of art. Because artists' work is necessarily in the vanguard relative to later interpretation of it by art historians or critics, this book is meant as a frame-of-reference for the future. It is a survey designed to make connections – to penetrate the morass of issues and historical detail, to find pathways which cross over fields to reveal a structure which, like a Mayan monument covered by jungle growth and long hidden by neglect, is suddenly revealed for what it is. The function of this cross-disciplinary book is simply to uncover these connections. In extending Benjamin's theories about how technology changes the way art is produced, disseminated, and valued, and how new art forms grow from new tools for representation and new conditions for communication, I examined the conditions of our postmodern electronic age to find the roots of the present crisis in art.

Because this book is a survey, a major regret on my part is that I cannot include more of the important art works and artists. I've been able only to touch the tip of the proverbial iceberg. Difficult choices had to be made in order to complete my task without too much digression from the points that needed to be covered. Because each area of electronic media is now so large and has so many practitioners, I had to decide whether to present more historical illustrations or more current work. I tended toward the latter. A Glossary of technical terms appears at the end of the book. As in any survey, much of the material has had to be greatly condensed. Although some technological information presented here will inevitably be superseded by new developments even before *Digital Currents* appears in print, I believe reporting on the current status of technology will help to create a flavor for the issues under discussion. Changes are occurring at an ever-increasing tempo. It is my hope that the reader will find this book to be an important signal along the path. A website, digitalcurrents.com, accompanies this text as an ancillary source of information and insight. It contains major resources about media, artists, issues, and contextual information in the form of time lines. Its links to artists' homepages and other important resource materials will be updated on a regular basis.

Acknowledgments

Apart from the many artists, galleries, and colleagues who helped make this book a reality, I owe special thanks for the contributions of Kristin Lovejoy, Ruth Danon, and Andrew Levy, as well as to my husband Derek for his invaluable editorial help and his enduring support. To each, my profound thanks.

Mark Kostabi, *Electric Family*, 1998, ink on paper.

(*Mark Kostabi*)

Introduction

Our fine arts were developed, their types and uses were established, in times very different from the present, by men whose power of action upon things was insignificant in comparison with ours. But the amazing growth of our techniques, the adaptability and precision they have attained, the ideas and habits they are creating, make it a certainty that profound changes are impending in the ancient craft of the Beautiful. In all the arts there is a physical component which can no longer be considered or treated as it used to be, which cannot remain unaffected by our modern knowledge and power . . . We must expect great innovations to transform the entire technique of the arts, thereby affecting artistic invention itself and perhaps even bringing about an amazing change in our very notion of art.

Paul Valéry [1]

Living at the beginning of the twenty-first century in new conditions produced by the electronic era, artists confront a revised cultural and technological context. The purpose of this book is to examine the relationship between technological development and aesthetic change. It views the cultural crisis of the present postindustrial age by seeing it as parallel to the wrenching cultural, aesthetic, and social crisis brought about by the Industrial Revolution.

Fundamental to the understanding of the impact of technological media on society as a whole, as well as on perception and the fine arts, is the work of Walter Benjamin.[2] He brought into a key position in critical discourse awareness of the relationship between art and technology. He argued that widespread integrated changes in technological conditions can affect the collective consciousness and trigger important changes in cultural development. His essay "The Work of Art in the Age of Mechanical Reproduction" (1936) is a significant assessment of the pivotal role played by photographic technologies (first as catalyst, then as instrument for change) in twentieth-century art.

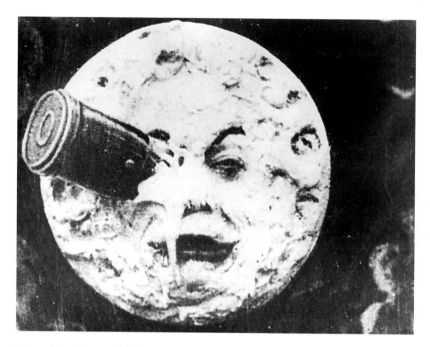

Figure I.1. Georges Méliès,
Le Voyage dans la Lune, 1902, film still.

(Museum of Modern Art/Film Stills Archive, New York)

Benjamin was the first to study mass culture seriously as a focus of philosophic analysis. In "Author as Producer" Benjamin anticipated the crisis of identity, and the loss of moral authority of the author/artist. His interdisciplinary thinking anticipated the interwoven, layered structuring of associations and observations that has come to be understood as the postmodern. It is clear from his writing, particularly "The Arcades Project," that, while Benjamin understood the potentially positive influence of technology on art and on culture, he was also aware of the major losses created by what he called the loss of "aura," that sense of uniqueness and primal consciousness that attaches to a singular work of art and that is lost in reproduction. Whether consciously or subconsciously, the independence and the deep integrity of his thinking led him to move philosophy beyond what Adorno called the "frozen wasteland of abstraction" to a concrete engagement with historical concerns and images.[3] This entailed endless examination of the forces which formulate culture. His work is still alive for us today as a medium for "fertilizing the present."[4]

Benjamin's work has influenced contemporary cultural critics and theorists including Roland Barthes, Jean-François Lyotard, Jean Baudrillard, Michel Foucault, and Jacques Derrida. In addition, aspects of his thought have deeply affected a generation of writers such as John Berger, Raymond Williams, Geoffrey Hartman, Celeste Olalquiaga, and Brian Wallis. His writings are included in important collections of postmodern essays such as *Art After Modernism: Rethinking Representation* (edited by Brian Wallis) and *Video Culture* (edited by John Hanhardt), among many others. Several of his essays serve as benchmarks for today's generation of students of the social sciences and the arts.

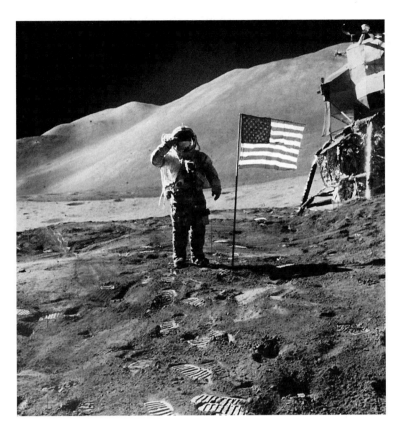

Figure I.2.
*National
Aeronautics and
Space
Administration
(NASA),*
Astronaut David
Scott Plants
American Flag on
the Moon, July
26, 1971.

This and the Méliès image reflect powerful changes in our awareness. Méliès's 1902 fantasy film about the moon landing evokes "man on the moon" mythologies – green cheese and all the clichés still embedded in our vocabularies about the moon. The 1971 reality of the moon landing, as seen internationally on living-room television screens, created a major generation gap between adults, who saw it as proof of the impossible come true, and their young children, who saw it as just an everyday event on television. For the children, it was the basis of the expectations of their age. Today's generation witnessed the 1988 scaling of Mount Everest via a miniaturized television camera so small it could be placed in the headgear of one of the climbers.

Cultural studies, which have gone beyond Benjamin to provide the most illuminating commentary on current representation issues vis-à-vis mass media and technological conditions, come from several sources: Baudrillard on simulacra, simulation, and the hyperreal; Barthes and Foucault on intertextuality and interactivity; Derrida and the feminist movement on deconstruction. These theoretical understandings, which further those of Benjamin, are useful tools for probing and exploring art in its relationship to technology. This is so especially now that it can be demonstrated that some of these theoretical concepts closely correspond to the structure and functioning of electronic media tools themselves.

I have written this book out of a need to explore the impact of electronic media on representation and on our culture as a whole, and, in the process, to extend the theories of

Benjamin. Photography and cinematography created what Benjamin called "a shattering of tradition," a crisis in representation without fundamentally shifting the Western paradigm of art. However, digital simulation has finally shattered the paradigm of representation we have been operating under since the Renaissance. We are now, in many ways, living in a new world.

In this book I am using a definition of representation which refers to a system of iconography containing both the perceptual and the aesthetic when related to art and having conventions of both tool and medium inscribed in it. At different moments of history, it changes relative to a paradigm which contains within it the unified framing of agreed-upon assumptions that shape the understanding of what art is in a particular period. Images or objects that artists construct are not just simple responses to individual experience. They are always ordered, coded, and styled according to conventions which develop out of the practice of each medium with its tools and process, whether the medium is a traditional one such as painting, sculpture, printmaking, photography, or an electronic one such as video or computer. Artists' vision and artists' responses to the world are dominated by the conditions and consciousness of a particular period.

The invention of the camera (Chapter 1) changed the nature of representation in drastic ways. Photographic images depend on the variable gaze of the camera eye. Photographs are inseparable from time passing and from the specific placement of visual reality. Cinematography provides the possibility of multiple viewpoints. The camera moves, rises, falls, distances objects, moves in close to them – coordinating all angles of view in a complex juxtaposition of images moving in time. Film (and video) offer a deepening of perception, for they permit analysis of different points of view and they extend comprehension beyond our immediate understanding by revealing entirely new structures of a subject beyond those available to the naked eye alone.

The modern period, most often described as the period between the end of the Enlightenment (corresponding to the end of the eighteenth century) and the middle of the twentieth century, has been described from a variety of positions. In the use Walter Benjamin made of the term, "modernism" referred to a diverse historical period which evolved in the conditions and context of the Machine Age. New forms of representation such as photography and cinematography contributed to a new consciousness and to more modern ways of seeing which reflected the idealism of a faith in progress through technological progress.

Benjamin pointed out, however, that the discovery of photographic technologies from 1850 onward essentially undermined the existing function of art, not only because photography and photomechanical reproduction could provide visual reportage but because it threatened the "aura" and value of the original, the handmade object that relied on the specialized skills of the artist. He understood that once a camera records images or events unique to a particular place and time, a disruption of privacy takes place. Its uniqueness is destroyed. A loss of its original magic, spirit, authenticity or "aura" takes place. John Berger comments that in our present culture the unique is evaluated and defined as an object whose value depends upon its rarity and status as gauged by the price it fetches on the market. But because the value of a work of art is thought to have a value greater than a commercial one, it can be explained only in terms of "holy objects": objects which are first and foremost evidence of their own survival.[5] The past in which they originated is studied in order to validate them. Once the work is seen in many different contexts, e.g., reproduced in different forms such as on a postage stamp or a billboard, its meaning changes. It begins to mean something else and fragments into new sets of fresh associations.

Photography is not simply a visual medium but is also a photomechanical tool, a means of reproducing endless copies from a single original, an aspect that Benjamin acknowledged as the major factor affecting art in its relation to the age of mechanical reproduction. The copying processes of photography undermined the aura of the original and its value in the marketplace. Thus it threatened the existing foundations of the art establishment which were based on the hand skills, implying the genius of the artist. Photographic reproduction and the cinema raised social questions about the artist's role, about the audience for art, about art as communication rather than art as object, and thus brought into focus the social function of art. Because of its threat to the art object and the issues it raised in its association with Machine-Age copying processes, as well as its challenge to established canons and institutions of art, photography's full development as a medium for art and its acceptance as a viable fine art form were suppressed until the beginning of the postmodern period.

Rather than using photography directly as a medium for their work, painters were moved from a preoccupation with forms of illusion and realism toward attitudes which led to abstraction and formalism. Many artists used photography indirectly as a tool of reference or aid in their drawing and painting activities only in the privacy of their studios. However, many were influenced by the aesthetic aspects of the new form of representation. The works of Manet and Degas reflect the influence of photographic imaging in the flatness of the pictorial space and in the unexpected and informal composition associated with photographic instantaneity.

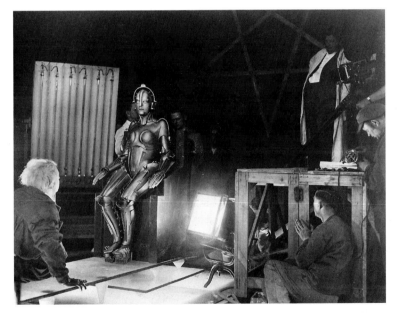

Figure I.3. Fritz Lang, *Metropolis*, 1926, film still.

Lang constructs a terrifying image of a twenty-first-century totalitarian society dominated by technology. Here, he is shown on set shooting a scene from *Metropolis*, his last major silent film, where the mad scientist Rotwang reveals "The False Maria" robot he has created – the personification of technology used for evil persuasive purposes.

(Museum of Modern Art/Film Stills Archive, New York)

A number of avant-garde strains developed in reaction to the Machine Age (see Chapter 2). Two of these movements used photography and technology directly, but they took different routes. On the one hand, the Dadaists and Surrealists developed strategies to use machine parts and photomontage as a means of commenting on the alienating influence of rampant industrialization and the commercialization of mainstream art. On the other hand, the Constructivists and Futurists extolled the aesthetics of photographic reproduction, seeing hope in the Machine Age for a new kind of culture . They used photomechanical technology to extend and distribute their work. Paradoxically, the Cubists, whose painting aesthetic was deeply influenced by the visual experiments of Marey's chronophotography, did not use photography directly. Similarly, although the Bauhaus artists used machines to manufacture their work, they created an aesthetic of pure form.

By the 1930s the term "modernism" came to refer to a special institutionalized movement, an aesthetic understanding of art shaped by the systematic critical writings of Clement Greenberg in essays he published between the 1930s and 1960s. Greenberg argued that art practice conformed to immaculate, linear laws of progression that were verifiable and objective. He favored a reductive understanding of art as pure form, a stance that excluded any literary or theatrical references or descriptions and shut out the real world as subject matter.

Mainstream Abstract Expressionist painting and sculpture were countered by an avant-garde that centered on the ideas of Marcel Duchamp and the Pop movement. While the European avant-garde was more political in its opposition to the status quo and to technological conditions, the American Pop movement was avant-garde in its adoption of industrial technologies for making its work. When Andy Warhol began silk-screening photo images directly onto his canvases, Pop artists began the appropriation of mass culture, photomechanically reproducing images directly into the field of painting. In so doing, they bypassed dealing with the social implications of photography raised by Benjamin. Although many photographers such as Steiglitz and Steichen asserted photography as a fine art medium, it was not until after its reproductive technology was brought directly into the field of painting by Pop artists, more than one hundred years after its invention, that it was accepted into the canon as a fine art medium like any other.

Postmodernism (see Chapter 3) is a shift to an essentially far broader territory in which the suppression of social and cultural influence is no longer possible. The defining moment in the visual arts, when the shift to postmodernism began, was the late 1950s, when architectural forms of representation began to be radically revised away from pure formalist tendencies toward a more "vernacular" style. The aloofness of the steel curtain walls with their purity and rationality seemed at odds with the times. New technological conditions, including electronic communication networks such as television had deeply invaded private space, creating a new kind of cultural infrastructure. Postindustrial capitalism based on electronic technologies under development from the 1950s and 1960s ushered in a new kind of "information society," a "society of the spectacle."

Avant-garde movements in the 1960s and 1970s moved, in opposition to the still-dominant modernist aesthetic, toward an expanded dematerialized view of art – for example, Earth art; Fluxus; Performance; Conceptual art – and work that incorporated the new electronic media tools, especially video and the computer. The incorporation of mass culture and photography into the fine arts by the Pop movement, in tandem with the use in the arts of new forms of electronic representation, marks the moment of a major crisis for representation.

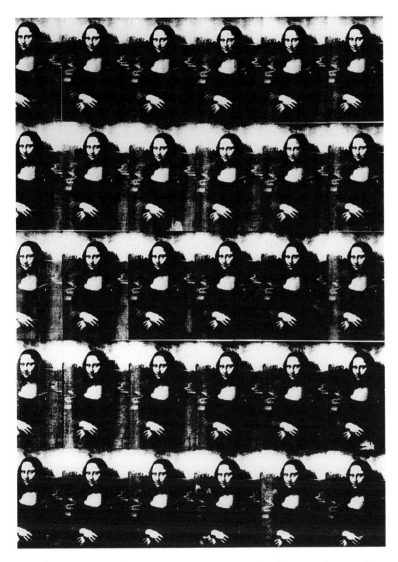

Figure I.4. Andy
Warhol, *Thirty
Are Better than
One*, 1963,
silkscreen on
canvas, 110¼in.
× 82¼in.

Warhol creates an "original" constructed of thirty copies of the original. His appropriation of the most famous cultural icon of all time is a comment on the power of reproductive media to promote celebrity.

(Photo: Nathan Rabin)

Ironically, once photography was accepted into the fine arts canon, all the issues denied for so long under the rubric of modernism became the very focus, the very means of deconstructing modernism. The deconstruction of the fine arts canon began through widespread use of the tools of critical theory, whose influence emerged in the 1970s. Of particular importance were the issues brought out earlier by Walter Benjamin (about aura, identity, the copy and the original, death of the author, originality and genius); along with poststructuralism, psychoanalysis, and feminist theory. This process of deconstruction, particularly by feminists, raised consciousness regarding the marginalization of certain artists not only because of

gender but because of race or class. Artists began to use theoretical issues themselves as the very subject matter of their work.

In the arts, electronic media such as video and the computer challenge older modes of representation. New media have created postmodern conditions and have changed the way art itself is viewed. Culturally, it is characterized by major change: From the concept of a single Eurocentric cultural stream dominated by white male privilege to one which recognizes diverse identities and voices interacting in a complex web of ideological and behaviorist associations. It is further characterized by the impact of mediated images on perception; by deconstruction of the major canons and narratives that have up to now formed Western thought; and by the development of a visual culture, transmitted by electronic technologies which have consciousness-transforming capacity, superseding one that relied mainly on the word.

Video was welcomed as a powerful new form of representation – a time/space medium capable of broadcast and transmission of images and sound over long distances. It was welcomed by a diverse range of artists from many fields (see Chapter 4). At first, it was rooted in formal modernist concerns. As its technology evolved, it began to converge with television and film. Although different from them, it also became a consciousness-transforming form of representation. It has now become part of an expanded multimedia territory where it is combined with the interactive capabilities of the computer, as in CD and DVD production, and in virtual reality and interactive installation works. It is also used as a means for capturing moving images to connect to the Internet.

The digital simulation capabilities of the computer create a break with the paradigm of representation we have followed since the Renaissance. The computer has the capability of combining sound, text, and image within a single database. Images no longer reside in the visual field but in the database of the computer (see Chapter 5). To see an image, information about the image's structure of lights and darks must be called up for display. The image is thus an information structure which has no physical presence in the real world. Not only is it a dematerialized image, but it is also one which can be destabilized and constantly invaded, changed, and manipulated by a viewer interactively through software commands. This possibility for intervention and interaction challenges notions of a discrete work of art, one that is authored by the artist alone. An interactive work is one which uses branching systems and networks for creating connective links and nodes. The artist who decides to work with technology now assumes a different role in relationship to creating work, one similar to a systems designer, and the work takes on a different route in relationship to the viewer who participates in the work's ultimate unfolding and meaning.

George Landow, in his *Hypertext: The Convergence of Contemporary Critical Theory and Technology*,[6] demonstrates that, in the computer, we have an actual, functional convergence of technology with critical theory. The computer's very technological structure illustrates the theories of Benjamin, Foucault, and Barthes, all of whom pointed to what Barthes would name "the death of the author." This happens immaterially and interactively, via the computer's operating system.

By the 1980s, the growing crisis in representation brought about deep changes in both theory and practice. The pervasiveness of media technologies in modern society creates a new set of questions which call for new theories of the relation between language, behavior, and belief, and between material reality and its cultural representation. Baudrillard speaks about the veritable bombardment of images and signs as causing an inward collapse of meaning where "reality is entirely constructed through forms of mass-media feedback where

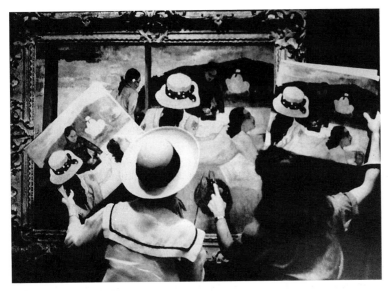

Figure I.5. Paul Hosefros, *Gauguin and His Flatterers*, June 25, 1988, photograph, *The New York Times*.

This Gauguin painting destined for sale to the public has its value increased by being shown on the front page of *The New York Times*. Copies of the original newspaper (sold for a few cents) show how copies of the original painting (sold for a few dollars) are here being compared to the original (sold for a few million). The right to reproduce this photographic copy (of the copies and the original) was purchased by the author of this book, for $100, to reproduce an agreed-upon number of copies of the original.

values are determined by consumer demand." Is there any absolute knowledge when there is no longer an authentic message; when there is only the absolute dominion of information as digitized memory storage banks? The constant melting down of forms causes a kind of "hyperreality," a loss of meaning as a result of the neutralization of difference and of opposition, which dissolves all claims to universal truth.

Inasmuch as any survey inevitably suffers from exclusions and from serious compression of the major critical and historical issues, this book is meant to function as a framework for discussion about the relationship between technology, representation, and perceptual and aesthetic change. I have written it out of my concerns as a contemporary artist aware of the gap in understanding in the relationship between art and technology. Since writing the book fifteen years ago, much has become clearer and much has shifted in my perception of technological change due to the rapidity of unfolding developments and their significance for the visual arts, particularly in the area of interactivity, and of virtual reality, and in the field of interactive telecommunications and the World Wide Web. In revising and updating it as a result of these major changes, I am addressing these new areas. Most of all, I wish to deepen the debate. Like many artists, I was excited by the promise of the new media. I still engage with them, but I cannot say that I do so without a great awareness of their dangerous social and cultural implications. I am also aware that the book is dealing with current issues and with technologies which rapidly become obsolete. My concern in writing it is to create the ground for future discussion about the relationship between art and technology.

Notes

1 Paul Valéry (1871–1945) is regarded as one of the greatest poets of the twentieth century.
2 Walter Benjamin (1896–1940) committed suicide as he was about to be captured by the Nazis at Port Bou in France.
3 Theodor Adorno, Introduction to Benjamin's *Schriften*, p. 7. Quoted in Gary Smith, ed., *Benjamin: Philosophy, Aesthetics, History* (Chicago University Press, 1989).
4 Terry Eagleton, *Walter Benjamin* (London: Verso Books, 1992), p. 179.
5 This discussion of Walter Benjamin's thought owes a debt to John Berger's *Ways of Seeing* (London: BBC and Penguin Books, 1981).
6 George P. Landow, *Hypertext: The Convergence of Contemporary Critical Theory and Technology* (Baltimore and London: Johns Hopkins University Press, 1992).

part one

SOURCES

Vision, Representation, and Invention

> The history of every art form shows critical epochs in which a certain art form
> aspires to effects which could be fully obtained only with a changed technical
> standard, that is to say, in a new art form.
>
> Walter Benjamin

Seeing is changing

The mind of any age is the eye of that age. Consciousness of the way the world is understood changes at different moments in history relative to the available knowledge of that period. A major shift in consciousness can change the premises about how we should seek to understand the world; what is important to look at and how we should represent it. Technological advances inform powerfully our knowledge base and affect all the premises of life, altering the way we see and think. They affect the content, philosophy, and style of art works. Technological development and artistic endeavor have always been closely related in one way or another, whether in a linear sense or a paradoxical one. Invention of technological tools for representation affects the way the world is seen, how events are interpreted, and the way culture is formed.

Today's avalanche of powerful new representational electronic tools has created a dramatic change in the premises for art, calling into question the way we see, the way we acquire knowledge, and the way we understand it. Contemporary artists face a dilemma unimaginable even at the beginning of the twentieth century when photography and cinematography created a crisis in existing traditions of representation. Electronic tools and media have shattered the very paradigm of cognition and representation we have been operating under since the Renaissance.

CONTEXT for further information refer to website

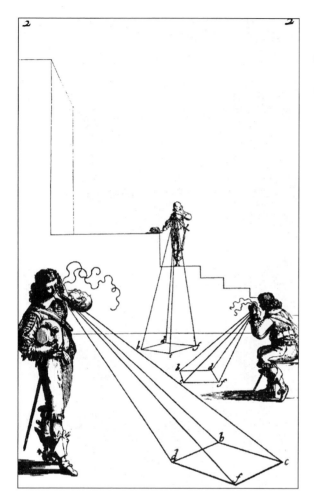

Figure 1.1. Abraham Bosse
(1602–76), *Perspective Drawing.*

Sighting 2-D illusion in 3-D space
using the mathematical structure of
perspective.

Dick Higgins, poet, composer, publisher, and performance artist, sums up the current paradigm shift by formulating a myth as illustration and by raising questions.

> Long ago, back when the world was young – that is, sometime around the year
> 1958 – a lot of artists and composers and other people who wanted to do
> beautiful things began to look at the world around them in a new way (for them).
> *The Cognitive Questions* (asked by most artists of the twentieth century,
> Platonic or Aristotelian till around 1958): "How can I interpret this world of which
> I am a part? And what am I in it?"
> *The Post-cognitive Questions* (asked by most artists since then): "Which world
> is this? What is to be done in it? Which of my selves is to do it?"[1]

What does it mean when the image is no longer located in the visual field but is located only as information in a database? What is the role of the artist in an interactive art work in which the public becomes an active participant? Can art go beyond objecthood to be an

immaterial form of communication located on the Internet for downloading through a localized printer? What is the function of art as a result of this major change? New technological media have transformed the nature of art, the way it communicates, the way it is distributed or transmitted. With the change of consciousness that accompanies the postmodern electronic era with its new technological tools for representation, the questions challenging artists today deepen and raise new ones: "How did we reach this point? What is the function of art? Is art disembodied communication? To whom am I speaking? How will I act?"

These questions force a confrontation with the legacy of artistic practices and myths rooted in the traditions of contemporary culture. This book is committed to seeking answers to these questions. To find a basis for answers to them and to create a new set of guiding assumptions, we must understand the relationship between technological development and artistic endeavor and how that relationship has profoundly influenced the evolution of culture since the Renaissance.

Vision and art

Vision is one of the most powerful of the senses. Seeing is related to art through a system we call *representation*, a complex term which allows us to examine significant aspects of art practice. Images are not just simple imitations of the world, but are always reordered, refashioned, styled, and coded according to the different conventions which develop out of each medium and its tools – sculpture, painting, printmaking, photography, video, and computer amongst others. However, the way we see is shaped by our worldview, which governs our understanding of what representation is. Thus we can say that representation is a form of ideology because it has inscribed within it all the attitudes we have about our response to images and their assimilation; and about art-making in general, with all its hierarchies of meaning and intentionality.

A useful construct for examining the distinction between vision and representation is provided in an interesting current book by contemporary art historian Svetlana Alpers, *The Art of Describing: Dutch Art in the 17th Century*.[2] Here she compares the differences in attitudes between Dutch and Italian Renaissance artists toward representation. Italian forms of representation were based in the humanistic textual worldview of the Renaissance with its conceptual notions of perfect beauty and poesis. Artists' selections from nature were chosen with an eye to heightened beauty and mathematical harmony – an ordering of what was seen according to the informed choices and judgment of the artist based on particular issues and concepts rather than as a form of representation where the single most important reference is the natural appearance of things. It reflected the views of Plato as articulated in texts such as the *Republic* (Books VI, VII, and X). Plato regarded imagination and vision as inferior capacities, a product of the lowest level of consciousness. He believed that reason allows us to contemplate truth, while the products of vision and imagination can present only false imitations, part of the irrational world of illusion and belief inferior to philosophy and mathematics which he designated as higher forms of knowledge. He illustrated his ideas using the example of a bed, postulating that there are three kinds of beds: one the essential concept of the bed, created by God; then that of a real bed made by a carpenter trying to make ultimate reality; finally, the artist's representation of it which stands removed from its reality. For Plato, human vision and imagination are based in imitation, and thus never able to claim access to divine truth. Plato mistrusted and opposed visuality and imagination through his fear that

various forms of mythology, where life was defined as a series of relationships between human beings and various deities, could become dominant ones. He held that the basis for under-standing human existence was through reason and the mind. Imagination and the images produced by it could be trusted only if, first, they were deemed to be imitations, never original; second, they were subordinate to reason; and third, they served the Good and the True. His need to create boundaries around the cultural legitimacy of products of the imagination was meant only as a means of protection for the "greater good." Reflecting Platonic ideals, in its rejection of a visual culture, Italian culture was based in a textual one – a search for truth, meaning, and knowledge.

By contrast, according to Alpers, Dutch seventeenth-century Renaissance painting reflected an acceptance of technologically assisted seeing. Over several epochs in Holland, experiments had been carried on to perfect the accuracy of mechanically assisted means of seeing such as the optical lens. Confidence in technology and cultural acceptance of this form of research into technological visualization in confirming and extending sight through microscopic close-ups, reflections, and distant enhanced views was understood as the way to new and potent forms of knowledge. Such commitment became the basis for a more visually oriented culture based in objective, material reality. Dutch paintings of this period focus on a world seen, a straightforward rendering of everyday life, based on observation, sometimes with the aid of the camera obscura lens, with all the spatial complexity and social detail of real interior views. Meaning in them is not "read" as in Italian painting, but rather the paintings are energized by a system of values in which knowledge of the contemporary external material world is "seen" as a means for understanding.

In this sense, Dutch painting can be said to reflect the views of Aristotle,[3] who was confident about the value and importance of vision and the direct observation of nature and taught that theory must follow fact. In his view, form and matter constitute individual realities (whereas Platonic thought posits that a concrete reality partakes of a form – the ideal – but does not embody it). Aristotle taught that knowledge of a thing beyond its description and classification requires an explanation of "why it is" and posited four principles of explanation: its function; its maker or builder; its design; the substance of which it is made. Also, he characterized imagination as a precondition for reason, describing it as a "mediating sensory experience

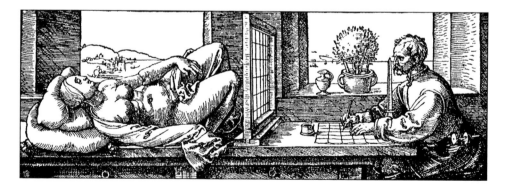

Figure 1.2. Albrecht Dürer, *Untitled*, 1538, woodcut.

Artists have always designed their own tools for creating the two-dimensional illusion on paper or canvas of what they see, such as this early grid with a sighting eyepiece.

rather than the experience which Plato thought would lead only toward dangerous illusions."[4] For Aristotle, imagining is based in the visual. Imagination lies between perception and thinking because it is impossible to think without imagining. Picturing in the mind, such as abstract forms or flashes of reality, accompanies abstract ideas, and thinking cannot proceed without such imaginings. Believing that imagination is not only a mediator between sensation and reason, Aristotle understood that it could also rearrange sense perception to form new ideas. It is essential in understanding abstract conceptions that go beyond human experiences of space and time to imagine the future.

Between these two poles of thought, many different positions exist. Even though some Italian artists used optical devices in the production of their work, what they saw was informed by their philosophical attitudes. Reality can be an abstraction depending on the mindset of the artist despite the mechanical device one may be observing through. The distinction we must draw between Dutch and Italian painting lies in the differences between their outlooks and methods inscribed within their worldviews which define their approach to representation. We can draw a comparison between Vermeer's use of the camera obscura and Italian artists such as Bellotto, Guardi, Crespi, Zucarelli, and Canaletto, all of whom used it as an aid in preparing their drawings and paintings.

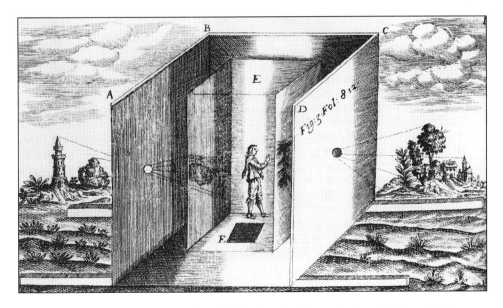

Figure 1.3. Early camera obscura, from A. Kircher, *Ars Magna Lucis et Umbrae*, 1645.

The camera obscura was recorded by Aristotle (384–322 BC) and was well known to Arabs in medieval times. Leonardo described it in his *Codex Atlanticus*: "When the images of illuminated objects pass through a small round hole into a very dark room, if you receive them on a piece of white paper placed vertically in the room at some distance from the aperture, you will see on the paper all those objects in their natural shapes and colors. They will be reduced in size and upside down, owing to the intersection of the rays at the aperture. If these images come from a place which is illuminated by the sun, they will seem as if painted on the paper."

(Collection Boston Athenaeum)

Art historian Charles Seymour has shown that the optical effects in Vermeer's paintings are the direct result of aided viewing and recording of phenomena that could be seen only in conjunction with a camera obscura. Seymour describes Vermeer's *View of Delft*:

> The highlights spread into small circles, and in such images the solidity of the form of a barge for example, is disintegrated in a way that is very close to the well-known effect of circles (or disks) of confusion in optical or photographic terms. This effect results when a pencil of light reflected as a point from an object in nature passes through a lens and is not resolved, or "brought into focus" on a plane set up on the image side of the lens. In order to paint this optical phenomenon, Vermeer must have seen it with direct vision (through the camera obscura) for this is a phenomenon of refracted light.[5]

The aforementioned Italian painters, although known for their use of the camera obscura, simply used the device as a reference tool for placement accuracy without incorporating any of its effects directly into their landscape painting. Considerably more information on the use of mechanical aids in Renaissance painting is now available as a result of the research of British artist David Hockney in his recently published *Secret Knowledge: Rediscovering the Lost Techniques of the Old Masters*.

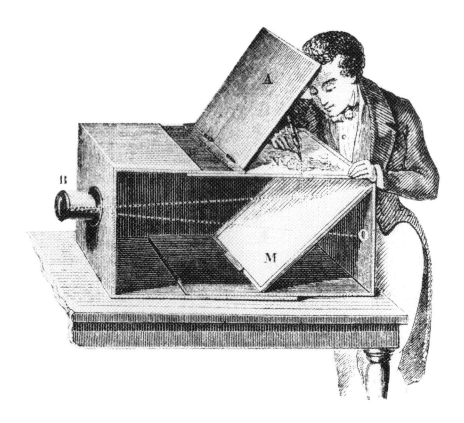

Figure 1.5. Camera lucida, circa eighteenth century.

The camera lucida consisted of a lens arrangement that enabled the artist to view subject and drawing paper in the same "frame," and thus the image that seemed projected on the paper could be simply outlined.

(International Museum of Photography, George Eastman House)

Figure 1.4. (opposite) Camera obscura, circa seventeenth century.

By 1685, a portable camera obscura (in appearance, much like the first cameras) had been invented by Johann Zahn, a German monk. Described as a machine for drawing, this version concentrated and focused the light rays gathered by the lens onto a mirror which then reflected the image upwards where transparent paper was fixed in place for tracing the image. Count Francesco Algarotti confirms the use of the camera obscura as a tool in his 1764 essay on painting: "The best modern painters amongst the Italians have availed themselves greatly of this contrivance; nor is it possible they should have otherwise represented things so much to life. Everyone knows of what service it has been to Spanoletto of Bologna, some of whose pictures have a grand and most wonderful effect." Canaletto, Guardi, Bellotto, Crespi, Zucarelli, and Canale used it as an aid in preparing their drawings and paintings.

(International Museum of Photography, George Eastman House)

These two distinctly different attitudes toward representation have characteristics similar to those distinctions between vision and technological seeing, which today are still important aspects of the discourse about representation.

Science and art converge in the Renaissance in different ways

The incomparable development of the Renaissance art of both the south and the north rested to a large extent on the integration of several new sciences in anatomy, perspective, mathematics, meteorology, and chromatology. Supporting the use southern European Renaissance artists made of theses important scientific discoveries lay Platonic convictions about the harmonious structure of the universe, emphasizing the rational relationship between the soul, the state, and the cosmos. Their goal was to reach heightened beauty and harmony as an embodiment of universal meaning and of supreme inner truth. The particular and detailed iconography of northern Renaissance (i.e. Dutch) art reflected their intense interest in the tools of knowledge, those lenses that made it possible for them to observe nature accurately.

Seeking rational solutions for organizing visual information to create the illusion of three-dimensional space on a two-dimensional surface, artists adopted the mathematical principles of vanishing-point perspective discovered by the Florentine architect Brunelleschi in 1420. Through perspective, line, form, and color, the visible experience of nature could be stabilized. As a consequence of the conventions of perspective, images are constructed so that the convergence of mathematically structured vanishing points addresses the central vantage point of the single spectator as being the ideal in the creation of illusion. God's will was connected with the mathematical regularity of optical phenomena. However, as Berger suggests, "the inherent contradiction in perspective was that it structured all images of reality to address a single spectator who, unlike God, could only be in one place at a time."[6]

Another important mathematical consideration influencing artists in capturing the desired harmony and order to be found in the proportions of nature was the golden mean. Derived from the Golden Section, a Platonic strategy used in seeking the ideal of beauty in the designing of the Parthenon, it was confirmed by the Fibonacci series of numbers in the sixteenth century. This harmonious, abstract mathematical proportioning of space continues to be a strong influence in contemporary art, architecture, and the design of everyday objects. In some sense, these mathematical underpinnings toward abstraction in art can be seen as direct antecedents to the mathematical algorithms of the computer.

For Leonardo da Vinci (1452–1519), painting was a humanistic demonstration of universal knowledge. The depth and precision of his theoretical analysis of nature (botanical obser-vations, notes on the turbulence of water and clouds), the drawings of his inventions (submarines, flying machines, engineering schemas), and his drawings of perspective and human anatomy are still stunning to us today. His notebooks are proof of the versatility and universality of his thinking as he attempted to fathom the riddles of human personality and the mysteries of natural phenomena. His painting was an expression for us of the search for the ultimate truth inherent in the human condition. For him, art-making was held in relationship to the concept of man as the measure of the universe. Although he has been called the "the father of technology" and was fully aware of scientific invention, and engineering principles (and understood the relationship of tools to seeing), Leonardo was driven more by philosophic

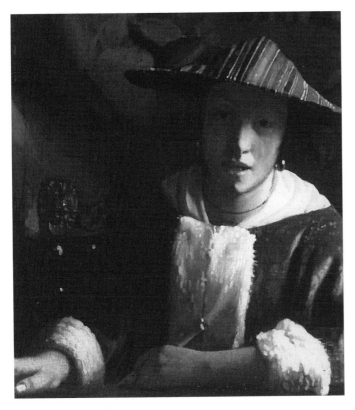

Figure 1.6. Jan Vermeer, *Young Girl with a Flute*, 1665, 7⁷/₈in. × 7in.

Vermeer's image with its many "circles of confusion" or shimmering unfocused highlights as observed through the camera obscura is part of camera vision, quite different in style and intention from those painted by Italian Renaissance artists. While Vermeer developed a distinctive style by allowing the effects of viewing through the lens to become an active medium in what he painted, Italian Renaissance painters were mainly interested in using the camera obscura as a tool for solving problems of placement and accuracy although they despaired of its foreshortened compressed perspective and limited sense of depth.

(Widener Collection, National Gallery of Art, Washington)

and aesthetic questions in creating his paintings and drawings and did not make direct use of technological devices for his art. In this sense, Leonardo's embrace of knowledge and of the ideal, rather than the direct use of technological tools for his art, anticipate in him, as we shall see, the later contradictions of modernism.

The camera as artificial eye: a new form of representation

During the three hundred years of the use of the camera obscura as an optical mechanical aid before the chemistry of photography was developed, many artists used it to help them in their observation of nature. In the Low Countries, Italy, and France, the camera obscura

enjoyed widespread continuous use throughout the seventeenth, eighteenth, and nineteenth centuries as a convenient tool for artists. The natural phenomenon of the camera obscura, in which light, passing through a lens (in the simplest case, through a pinhole) onto transparent paper can reflect, upside down, the image of nature captured and focused by the lens. Many different styles of "cameras" and optical lenses were designed to address the popular needs of artists to help them in their observations of nature. Other mechanical drawing devices (such as those depicted in Dürer's fifteenth-century set of woodcut illustrations), for converting a view of three-dimensional objects into two-dimensional drawings, include sighting devices for foreshortening; an eyepiece and framed grid on transparent glass for portrait sketching; and stringed movable grids for mounting on drawing tables.

By the 1830s, the only missing link for permanently fixing the camera's images on paper was the light-sensitive chemistry of photography. Although scientists and inventors such as Schultze and Wedgwood made contributions to the study of photosensitivity, it was an artist/printer, Joseph Nicéphore Niépce, who made the first real breakthrough in the link-up between the optical principles of the camera obscura and light-sensitive chemistry. In 1826 he successfully made an eight-hour exposure on a sensitized pewter plate in a camera – thereby capturing the world's first faint photograph of a scene from his window. However, the follow-up invention of the silver daguerrotype, in 1839, received far more attention.

But it was the British artist/inventor Henry Fox Talbot who succeeded in producing (in 1840) the first truly viable photographic process – the negative/positive system. His method is still in use today because from a single negative an unlimited number of photographic prints can be produced, leaving the negative intact. Talbot called his discovery "photogenic drawing" and later published a book entitled *The Pencil of Nature*.

Because the camera obscura was so related to its use over hundreds of years as an imaging tool for artists, the invention of the fixed images of the photographic process seemed at first an astonishing boon to the art community of the time. In its fullest sense as a revolutionary means of representation as well as a means of reproduction, duplication, and reportage, the camera created a crisis in the art world which became fully evident only a century later.

Invention of photography: reaction and counter-reaction

The invention of photography produced intense international excitement in artistic and scientific circles and general recognition of its rich potential for society as a whole. In the arts, there were widely differing views. At first, there was initial acceptance. Delacroix wrote an essay on art instruction (1850) in which he advised the study of the photograph.[7] Courbet and Ingres joined the host of artists who now began to commission photographs as references for their large formal paintings.

However, in conservative circles, there was swift negative reaction. When the invention of the daguerreotype was announced in 1839, the critic Paul Delaroche declared, "From today, painting is dead." With the prime emphasis in art based on aesthetic principles established since Renaissance times, the invention of photography collided head-on with the vision and attitudes of artists and intellectuals who were at odds with the realities of the Industrial Revolution. This crisis parallels that of our own era now that electronic technologies have changed the conditions of life and the consciousness of our own generation.

In England, social theorist/critic John Ruskin and poet/craftsman William Morris reacted strongly to forms and values of the Industrial Age and were able to articulate widespread negative feeling about the new social conditions. Photography came to be identified with

the shift to the Machine Age with its alienating loss of human connectedness. It was seen as a threat to human intervention and to feeling itself. They proclaimed that artist and machine were essentially incompatible and that fragmentation of the work process robs the worker of pride and purpose in what he produces – in short, that "production by machinery is evil." They emphasized hand skills as a positive value over tools of industrial production – a prejudice which has persisted into modern times.

In the twentieth century, the critical social effects the photographic technologies were having on the formation of culture were analyzed by Walter Benjamin. He was the first to state that the work of art had been liberated by the processes of photography from its ritual *cult* seclusion (for example, in tombs, temples, or churches) to reside now without benefit of its *aura* of place on the pages of art books and magazines or on the pages of newspapers mixed with texts or advertisements. Once a camera records images or events unique to a particular place and time, a disruption of privacy takes place. If the image is a work of art, its uniqueness is destroyed. A loss of its original magic, spirit, authenticity, or aura takes place once it is seen in many different contexts, for example, when reproduced in different forms such as on a postage stamp or a billboard it begins to mean something else and fragments into new sets of fresh associations.

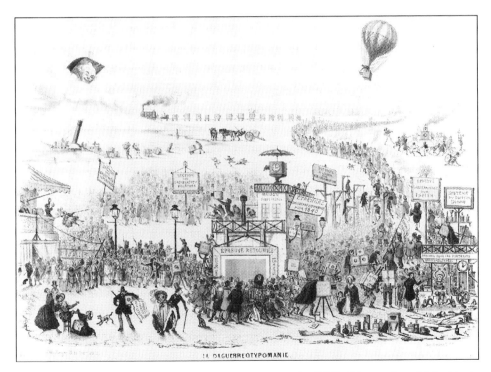

Figure 1.7. Théodore Maurisset, *La Daguerreotypomanie*, 1839, lithograph, published in *La Caricature*.

This first caricature of photography lampoons the social, economic, and cultural upheaval brought about by the invention of photography. There are cameras everywhere – on wheelbarrows, railway cars, steamboats, packed on heads, shoulders, backs, underarm, set on tripods, roofs, even hanging from a balloon. Cheering sections are marked off for daguerreotype Lovers and Haters.

(International Museum of Photography, George Eastman House)

Technological reproduction collapses what Walter Benjamin termed the "aura," the ritual aspect of the original, the one and only. He stated:

> Mechanical reproduction emancipates the work of art from its parasitical dependence on ritual, To an ever greater degree, the work of art becomes the work of art designed for reproducibility. From a photographic negative, for example, one can make any number of prints; to ask for the "authentic" print makes no sense. But the instant the criterion of authenticity ceases to be applicable to artistic production, the total function of art is reversed. Instead of being based on ritual, it begins to be based on another practice – politics.

Through reproduction, however, art is seen in contexts different from its original periods and settings; as a result, artworks acquire meanings that diverge from those inherent at the point of production. John Berger, in his *Ways of Seeing,*[8] simplified Benjamin's text. Let us analyze, for example, Leonardo's *Mona Lisa* to illustrate the issues in the way that Berger would go about it. Torn from its original ritual "time and place" in a Medici palace, the most famous and valuable painting in the world now resides in a bullet-proof, glass-encased, climate-controlled setting at the Musée du Louvre in Paris. How can we separate the *Mona Lisa* from its baggage of fame and its much-touted financial value in order to see it only for its aesthetic value? Copies of this famous painting have been used countless times in contexts as wrenchingly different as a small art-book illustration or blown up as part of a giant commercial billboard advertisement. Through inexpensive multiple reproduction, the image has become transformed as an icon of the past, familiar as a cultural reference point and internalized as part of mass culture. As such, it has acquired new social meaning, value, and use.

This issue continues to be fundamental to understanding the schism between the fine arts and the direct use of more recent technologies for art-making. Today's electronic technologies, including video, copiers, and computers are also, like photography, essentially copying devices. For the most part, reproductions of images from all of them can be produced in infinite numbers from the master matrix, software, or negative without wear or damage.

The social function of art as opposed to its commodity value is brought into focus as soon as reproduction or copying of originals becomes possible. Oil painting, which had dominated the European cultural outlook for four centuries, is indissolubly linked with the system of private property as an original object that can be bought and sold. The value of the painting is tied to its material uniqueness – to its value as a precious object – rather than to its value as a form of communication, whereas a photomechanical reproduction, even of the highest quality, has much less market value. Paradoxically, the copying and wide distribution of an art work not only increases its currency in the public consciousness but also generates commercial worth because of its celebrity. In our present culture, the value of a unique object depends on its rarity and status gauged by the price it fetches on the market. But because the value of a work of art is thought to be greater than that of a commercial work, the work of art can be explained only in terms of holy objects: objects which are first and foremost evidence of their own survival. The past in which they originated is studied in order to validate them. Art that is enlarged, reduced, printed as postcards or posters, and widely disseminated for enjoyment of the public at large, reaches a broader audience, an expanded one beyond the confines of art institutions and the gallery system. As a consequence, the cultural sphere is broadened, enriched, and democratized.

The emphasis was now absolutely on the exhibition value of the work. Once a work of art could be reproduced, or was designed to be reproduced through photographic intervention, a crisis of authenticity arose:

> With the different methods of technical reproduction of a work of art, its fitness for exhibition increased to such an extent that the quantitative shift between its two poles turned into a qualitative transformation of its nature. This is comparable to the situation of the work of art in prehistoric times when by the absolute emphasis on its cult value, it was, first and foremost, an instrument of magic. Only later did it come to be recognized as a work of art. In the same way today, by the absolute emphasis on its exhibition value, the work of art becomes a creation with entirely new functions, among which the one we are conscious of, the artistic function, later may be recognized as incidental. This much is certain: today photography and the film are the most serviceable exemplifications of their new function.[9]

Myths from Renaissance times declared the divinity of masterful creativity and of genius. This outlook valorized art made by "hand of the artist." This sense of "pure" art was an attempt to extend the magical, ritualized meaning, the "aura" of a work which up to then related to its original value as a social production.

It became clear that photography was not simply a visual medium but a tool, a means of reproduction for making endless copies from a single original, an aspect that Benjamin acknowledged as the major factor affecting art in its relation to the age of mechanical reproduction. Photographic reproduction raised questions about audience and communication which brought into focus the issue of art as object in relation to the social value of art as well as to its function in society.

Portraiture is perhaps the last aspect of the photographic image which still has cult value in the sense that remembrance of loved ones, those absent or dead, is invested with a cult value. An aura emanates from the fleeting expression of a human face. In 1849, more than a hundred thousand daguerreotype portraits were taken in Paris alone. However, those painters who relied on portraiture as a livelihood were now threatened by the low-cost, eminently superior photographic method for capturing moments in time. They were affected by the same technological unemployment which affected scores of illustrators and graphic artists. A mood of panic developed. Faced with the inevitability of change, nineteenth-century art workers began to embrace the medium of photography for their everyday livelihood, similar to the massive changes faced by today's contemporary designers and graphic artists who have switched from photographic to computer skills to avoid technological unemployment.

Scientific discoveries and camera vision influence development of a new aesthetic

The new photographic technologies spawned scientific research into many areas of interest to artists, such as color theory and the nature of light and vision. This research is paralleled today by developments in computer imaging, where a vast amount has now been discovered about the specifics of perception, optical functions, color theory, and artificial intelligence – all this being an attempt to understand the functions of how we see and how we think. Manet

was the first to defy the five-hundred-year-old conventions of pictorial space dictated by single vanishing-point perspective that had been in control of the picture plane since its discovery during the Renaissance. His new way of seeing, influenced by photography, was at odds with the prevailing concepts of realism at the time.

The goal of the naturalists and the realists was also to define actuality or realism, but their vision was seen through the prism of classical Renaissance conventions. For example, the goal of the naturalists, based on the ideas of the painter Théodore Rousseau, principal figure of the Barbizon school (circa 1830–70), was to recreate reality so as to establish a direct, metaphysically satisfying relationship with nature as a force concealing a purposeful order – a profound pantheism. Every bump on every tree bore testimony to the full scope of divine presence. On the other hand, Courbet's realist manifesto (1861) was a commitment to concentrate only on scenes from contemporary life, "To prove that everyday life contains as much nobility and poetry as any subject from history or myth." It was a powerful reaction at the time to the frivolous eclecticism of the New Empire's Academy represented by Bouguereau, Gérôme, Meissonier, Cabanel, and Winterhalter. However, Courbet's realist pictures were self-conscious idealist allegories of everyday life, full of Platonic overtones.

Besides his rejection of the conventions of foreground, middle ground, and background and the modeling of space in diminishing tones to create the illusion of distant space, Manet interjected the immediate vision suggested by the momentary time frame of photography to create paintings which would "capture the immediacy of instant vision." In doing so, he rejected the entire tradition of academic painting's pictorial translation, with its dividing lines and modeling between picture planes, and substituted a flattened space where shapes disappear into each other and level out, much like the high-contrast effects so characteristic of the photograph. Manet's rejection of classical tradition in an effort to create a new kind of visual presence is synthesized in the work of Monet, who thought of the object "not in terms of the form he knew the object to have, but in terms of the image which the light from the object reflected into the retina of the eye."[10]

Eadweard Muybridge's stop-motion photographs captured images of rapid movement through time which, up to then, had not been available for detailed analysis and study by artists. Internationally distributed by 1887, his richly illustrated book became a fundamental source of information in the art community. His multiple exposure photographic investigations of human and animal locomotion revealed clearly all the errors made up to then by painters and sculptors in their representations, for example, of the running stances of horses in battle scenes (e.g., Géricault, Delacroix, Velázquez). Degas's racing scenes painted after 1880 depict their natural gait made evident by the time-stopped photograph.

The momentary effect, the instantaneous and unexpected angle of view intrinsic to camera vision, also strongly affected artists' outlook. Degas's work reflects a fresh change of view as he incorporated the apparently "artless" compositional accidents of the serial camera "snapshot" as part of his style. For although the photograph had been criticized for its lack of style, literalness, and non-selective qualities, it had produced a fresh way of seeing which Degas transformed into a new kind of pictorial logic.

Influenced and stimulated by the work of Muybridge and others who were experimenting with the serial effects of motion and photography, Jules-Étienne Marey in 1882 invented a "photo-graphic gun" which could capture linear trajectories of moving objects in a single image which he called *chronophotography*. Artificially lighted oscillations of movement were photographed against a dark ground by means of activating intermittently the shutter of the "gun" during a long exposure. The chronophotographs served as inspiration for the Cubists and

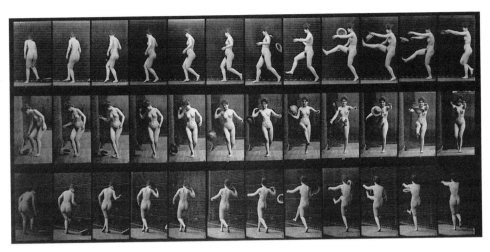

Figure 1.8. Eadweard Muybridge, *Woman Kicking*, 1887, collotype, plate 367 from *Animal Locomotion*, 7in. × 20in. Muybridge's books of stop-motion photographs of human and animal locomotion expanded the possibilities of perception by capturing time and movement frame-by-frame. Generations of artists have used these works, which are still current today.

(Collection The Museum of Modern Art, New York. Gift of the Philadelphia Commercial Museum Fund)

Futurists, who were directly influenced by the broken, serialized abstract linear patterns of movement.

These influences led to a new way of conceiving pictures, explained Maurice Denis in the 1880s: "A picture before being a horse, a nude or an anecdote is essentially a flat surface covered with colors assembled in a certain order." A radically different aesthetic was developing – one which would eventually lead toward abstraction and away from traditionally held attitudes toward figuration and external influence. Paradoxically, the influence of photographic experiments led to abstraction rather than to an acceptance of the camera as a medium.

Photography declared an art form

By the 1880s "art" photography, featuring still-life and draped models, had become commonplace. These works reveal clearly that a relationship had developed between painting and photography. A number of painters abandoned their trade and took up the new medium of photography, bringing to it not only their knowledge of composition and sensitivity to tonal qualities but also their sense of style and interest in experimentation. Others made use of photographic projections on their canvases as a way of initiating work on a painting.

Photographers soon opened themselves to criticism through gallery exhibitions of their own works in 1855 and in 1859. However, criticism focused on whether photographs could contain "the soul and expression to be found in true art." The poet/critic Baudelaire regarded the presumptions of the new art form as corrupting (much as electronic media are seen today): "It must return to its real task which is to be the servant of the sciences and of the arts but the very humble servant, like printing and shorthand, which have neither created nor supplanted literature."

Figure 1.9. Raoul Hausmann, *Tatlin at Home*, 1920, collage of pasted photo-engravings, gouache, pen and ink, 16in. × 11in.

Hausmann was one of the first to use the new form of collaging photographic images and illustrations from many sources – including magazines, letters, and newspapers. After World War I, Berlin Dadaists such as Hausmann, who had always taken a critical, ironic stance toward the machine, now began to dream of a future in which supermachines would be placed in the hands of those who would build a new and better society rather than in the hands of the old warmongers. To Hausmann, the Russian Constructivist artist Tatlin was the living incarnation of these aspirations.

(Moderna Museet, The National Swedish Art Museums)

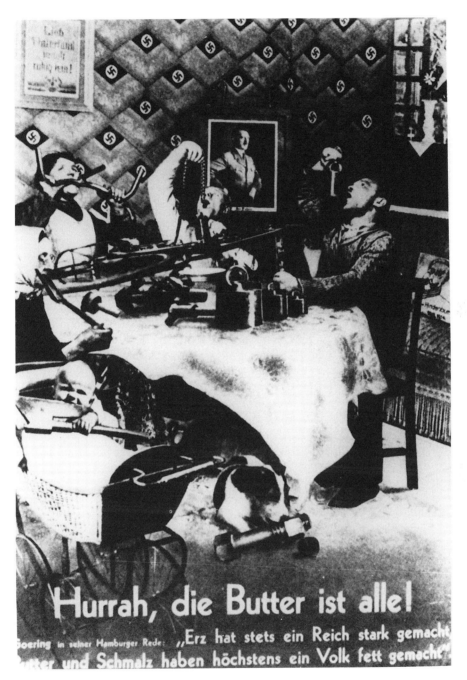

Figure 1.10. John Heartfield, *Hurrah, die Butter ist Alle! (Hurrah, the Butter Is Gone!)*, 1935, photomontage, produced for the magazine *A-I-Z* (December 19, 1935).

Heartfield chose photomontage as an art form that was powerfully evocative, with expanded possibilities for the communication of his ideas. The text recounts Hermann Goering's Hamburg speech: "Iron has always made a country strong; butter and lard have at most made the people fat."

Since existing French copyright laws applied only to the arts, photography had first legally to be declared as an art form before it could come under their protection. In a test case in 1862, arguments cleverly turned around the questions: Is the painter any less a painter when he reproduces exactly? Does not the photographer first compose in his mind before transmitting his perceptions via the camera? The court decision granted full copyright protection to photography as an art form (although engravers were not equally served by this law). These questions about photography as a viable art form obscured the primary question. Photography, both as a tool for mechanical reproduction and as a medium for representation, had challenged the existing tradition for art.

Photographic technologies spawn new art forms

Photomechanical reproduction of artists' line drawings (and, later, photographs) through the use of photo engraving, photo gravure, and photolithography revolutionized the commercial printing trades. Reproductive photography allowed for the study of art itself and made a powerful contribution to the development of communication through the proliferation of newspapers and popular illustrated magazines. Photographic reproductions of the art of the past could now be reprinted much more effectively than through the use of drawings or engravings. Artists could now contemplate and study the works of their international contemporaries at close range, in the comfort of their studios.

The profusion of photomechanically produced imagery available at the turn of the century gave rise also to a striking new art form. Outside of the mainstream, the Dadaists exploited publication techniques to develop an extraordinary new kind of found image – collaged images culled directly from printed newspaper and magazine materials. The Dadaists chose authentic fragments from everyday life because they believed these could speak more loudly than any painting. For them, photomontage was essentially a way of outraging the public and destroying the aura or market value of their work by revealing it as appropriated reproductions. For the first time, artists were using collaged photoimagery and photomechanical techniques as part of conscious artistic style. In photomontage, awkward joints and seams where the image sections were collaged together in the original could be hidden when the image was printed photomechanically, thus imbuing the reproduced collage image with a logic of its own. Its powerful possibilities were brought into focus by artists such as Raoul Hausmann, John Heartfield, and George Grosz as a tool for expressing forcefully and directly a point of view about the social chaos of their era.

Independent of the Dadaists, the Russian Constructivists Rodchenko and El Lissitsky used photomontage methods to produce large posters and powerful graphic works because they could be reproduced and distributed at the same speed as a daily newspaper. The Surrealist Max Ernst developed his own poetic approach to photocollage in his small volume *Une Semaine de Bonté*. By reassembling and recontextualizing appropriated elements of Victorian engravings and changing the relationships between their parts, he created disturbing, sometimes nightmarish effects.

The influence of tools

Tool types have a bearing on the nature and structure of artistic production and conceptualization. Each type of tool offers its own possibilities, its own strengths and weaknesses. Each is characteristic of a particular epoch, and its marks are a reflection of that period. Each is implicitly related to questions of time and space. Although the coherence of the artist's conceptualization process is the most fundamental aspect of art-making, the influence of tools and of technological conditions transforms the production and dissemination of art.

For example, a meticulously detailed oil painting may require months of manual labor and planning and, in its final form, represent the focusing of both a mental and physical act. It is a unique production, a single cultural object imbued with the mark of the hand. By contrast, a photolithograph can be produced as a multiple image in a different time ratio using manual, mechanical, and photographic tools. These means of production will reflect characteristics of the mechanical era both as aspects of a photographic mechanism and as the gear of a press. "With mechanical aids, elements of time and space can be manipulated with new speed . . . application of energy by mechanical means alters our physical environment."[11] The multiple print form makes the art work more available to a wider public.

When Delacroix wrote about the new medium of photography (see note 8), he expressed both amazement, delight, and fear of the new.

> A daguerreotype is more than a tracing, it is the mirror of the object, certain details almost always neglected in drawings from nature . . . which characteristically take on a great importance, and thus bring the artist into a full understanding of the construction. There, passages of light and shade show their true qualities, that is to say they appear with the precise degree of solidity or softness – a very delicate distinction without which there can be no suggestion of relief. However, one should not lose sight of the fact that the daguerreotype should be seen as a translator commissioned to initiate us further into the secrets of nature; because in spite of its astonishing reality in certain aspects, it is still only a reflection of the real, only a copy, in some ways false just because it is so exact.

Electronic tools have a "hidden point of view, far more complex than that which is built into a brush, a printing press or a camera."[12] Silently and instantaneously, they store, collect, transmit, and multiply visual and digital information according to the programmed instructions situated within their electronic system boxes, removing many routine manual and mental functions. "Think it – Have it."[13]

The electronic peripheral devices of computers (keyboard, digital drawing pad – manual; printer, plotter – mechanical; copier, film recorder, or video – electronic/photographic) combine and subsume all levels of art production tool types. The art works produced by these systems inherently reflect the characteristic marks of their electronic production origins and are disseminated as multiples (photographic prints, copier prints) or transmitted as video. "The invasion of the very fabric of the art object by technology and what one may loosely call the technological imagination can best be grasped in artistic practices such as collage, assemblage, montage, and photomontage; it finds its ultimate fulfillment in photography and film (video), art forms which can not only be reproduced, but are in fact designed for mechanical (and electronic) reproducibility."[14]

A shattering of visual tradition

Walter Benjamin identified cinematography as an entirely new aspect of visual representation, one which shattered all existing traditions. The movie camera created an entirely new aspect of representation by adding movement, edited views, and large-scale projections of imagery with sound. (Cinematography was invented by the Lumière brothers in 1895 following on the photographic experiments of Marey and Muybridge to capture movement.) Through slow motion, rapid panning, gliding close-ups, and zooming to distant views, space, time, illusion, and reality were fused in a new way. The camera moves, rises, falls, distances objects, moves in close to them, coordinating all angles of view in a complex juxtaposition of images moving in time. The flow of moving images permits an analysis from different points of view. They represent a deepening of perception, for they permit analysis of different points of view and extend comprehension beyond our immediate understanding by revealing entirely new structures of a subject than is available to the naked eye. New structural formations of subject and image become possible. Cinema appeals to our conscious impulses, as well as our unconscious, in the dramatic ways it can represent and record our environment. In film, montage became part of the essential element of the grammar of the moving image. Through editing, juxtaposition could easily create new meanings through interruptions, isolations, extensions, enlargements, and reductions.

> By close-ups of the things around us, by focusing on hidden details of familiar objects, by exploring commonplace milieus under the ingenious guidance of the camera, the film on the one hand extends our comprehension of the necessities which rule our lives, and on the other hand, it manages to assure us of an immense and unexpected field of action.[15]

The experience of seeing a film is very different from seeing a painting before which the spectator, as a single individual, can stand in contemplation of the work, concentrating his or her attention for as long as desired. With film, the individual usually becomes part of a collective audience whose attention is controlled by the moving image which cannot be arrested. The audience is in effect controlled by the constant sequenced changes of images moving in time, images which are designed to affect emotions and dominate the thinking process. Film, moving first from a silent phase and later to one of sound, led to an intense experience of the visual with greater collective participation. Some critics chose to call it merely a "pastime," a "diversion for the uneducated," a "spectacle which requires no concentration and presupposes no intelligence." However, from the beginning, film touched the core of an immense public need for creating new myths and legends which help in the adjustment to new times. The great silent filmmakers Eisenstein, Griffiths, Gance, and Chaplin brought the form to a high level. The form's arrival marks the beginning of a shift from a culture reliant on text to one with a greater reliance on image. This shift has become even more significant with the development of television. As time has gone on, it has become possible to argue that film has begun to replace, or rival, the novel as the most important narrative form.

Rise of a modernist aesthetic by the end of the nineteenth century

As Western culture began to take on the greater complexity of modern times, old premises about representation, dating from the Renaissance times, were challenged. Influences from the mid-century scientific study of optics, and the physiological principles of visual perception and color, had their effect in shifting the consciousness of the Impressionists to a modern system of seeing. However, rather than accepting photography as a way of seeing, and as a means of gathering knowledge, the Impressionists embraced a system of restrictions which included their decision to work outdoors rather than in the studio. This was part of their working manifesto that they should deal solely with the truth and actuality of natural light and of everyday life as the only acceptable basis of their practice as painters. This tendency bred a modernist formality and distance which led to abstraction rather than figuration and can be thought of as the final stage of realism and the rise of a modern aesthetic based on observation which, paradoxically, rejected technology.

Picasso commented on this shift of focus to his friend the photographer Brassaï: "Photography has arrived at a point where it is capable of liberating painting from all literature, from the anecdote, and even from the subject. In any case, a certain aspect of the subject now belongs in the domain of photography. So, shouldn't painters profit from their newly acquired liberty . . . to do other things?"[16] This attitude reflects a shift of focus away from pictorial realism to a new point of departure, a viable position from which to begin constructing a fresh modernist aesthetic. Even the naturalists and realists with their idealist attitudes were challenged by the new technological and intellectual climate to move toward abstraction.

The goal of the Postimpressionists, Fauves, Cubists, Symbolists, and Expressionists was to create images consonant with the integrated relationship between "what one sees and

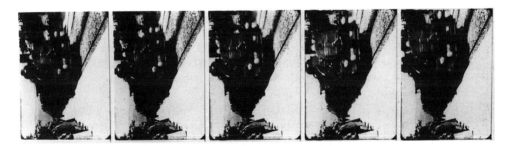

Figure 1.11. Lumière Brothers, frames from *Un Train Arrive en Gare*, 1896.

Georges Méliès captured the flavor of incredulity at the newness of perception provided by cinematography in this account of the very first public presentation of the Lumière Brothers' demonstration of the new Cinematograph in December, 1895: "I just had time to say to my neighbor: 'They've put us to all this bother for nothing but a magic-lantern show. I've been doing those for years.' Scarcely were the words out of my mouth, when a horse dragging a truck began to walk toward us, followed by other wagons, then by pedestrians – in a word, the whole life of the street. At this spectacle we remained open-mouthed, stupefied, and surprised beyond words. Then came in succession The Wall, crumbling in a cloud of dust, *The Arrival of a Train*, *Baby Eating His Soup*, trees bending in the wind, then *Closing Time at the Lumière Factory*, finally the famous *Sprinkler Sprinkled*. At the end of the performance, delirium broke out, and everyone asked himself how it was possible to obtain such an effect."

what one feels about what one sees." All experience, dreams, fantasies, poetry, music, and emotion itself became viable subject matter. They began to see that individual realities are only interpretations of the mind. Art, then, is illusion, interpretation, conception – not objective reality.

Underlying the new drive to movement and abstraction lay the fundamental contribution to perception that photography provided: camera vision as part of the vocabulary of the eye and as part of representation. It provided the impetus toward abstraction; alternation from positive to negative planes and forms, and microcosmic and cosmic views of the universe; and also gave substance to arbitrary thought in the context of time/space through the moving image. A vast new arena of visual and intellectual communication was brought into play by photography, photomechanical reproduction, and the rise of cinematography, a restatement of the Aristotelian view of the value of material representation that we explored earlier through the example of the northern Renaissance tradition.

Despite the important aesthetic development of photomontage and cinema in the 1920s and 1930s within radical avant-garde circles, the direct issues raised by photography were deflected – for the traditional mainstream art establishment saw photographs and photo-mechanical reproduction as a challenge to the "uniqueness" of art objects destined to be sold in the art market. Under the new theology of a "pure" high art, questions about the social value of art remained unanswered. The transformation of social consciousness by new forms of photographic communication created further confusion.

Photomechanical reproduction raised questions about the "uniqueness" of copies as works of art, thus undermining the existing function for art not only because it could provide visual reportage but because it threatened the aura of the handmade object which relied on the specialized skills of the artist. Because of these threats – its association with the copying processes of the Machine Age, its potential to challenge established canons and institutions of art – photography's full development as a medium and its acceptance as a viable fine art form was suppressed until the beginning of the postmodern period. Works executed by the "hand of the artist" were deemed doubly precious in an age dominated by the machine, a prejudice termed by Walter Benjamin as "a fetishistic, fundamentally anti-technological notion of art." Acceptance of these attitudes in the art world represents a break in the openness of artists toward use of mechanical tools and drawing devices and hardened artists' negative opinions about the overt use of photography in their work, although many continued to use photographs as a reference.

Parallel attitudes for today

Most artists were able at first to avoid facing the fundamental issued forced on them by the radical intervention of photography and cinematography. These issues had to do with creating a new social function for their work, a new subject matter, a new way of seeing and experimenting with new art forms and of dealing with the question of the copy as opposed to the value of the original. Instead of facing these issues, they developed a doctrine of *l'art pour l'art*, that is, a theology-based idea of a "pure" art, one which canonized it as a spiritual entity which lay beyond categorization.

Photography and cinematography served to shatter further the nineteenth-century traditional outlook on representation. A new paradigm for art was needed which would better reflect the consciousness and conditions of the times. As we have seen, the moving image,

with its ability to reveal entirely new structures of a subject, its coordination of all angles of view in a complex juxtaposition of edited images moving together in time, brought into the field of representation a powerful new consciousness – transforming medium and tool. Because it could be projected for vast audiences, it created social questions about audience and the function of art as immaterial communication. However, issues raised by cinematography have been kept apart from the visual arts canon until its recent convergence with video, television, and digital forms.

The immediate cooptation of photomontage techniques by the commercial world further tainted their use. The very intrusion of the influence of photographic technologies into every aspect of life had the effect of prejudicing its direct use for art, except as an anti-aesthetic statement by the avant-garde movements. Primarily, photography acted as a powerful catalyst invading every aspect of the cultural climate and the very fabric of society, creating the underlying conditions for a new kind of technological imagination and the impetus for invention of new forms of representation.

Notes

1 Dick Higgins, questioning changes in art, quoted in Brian McHale, *Constructing Postmodernism* (London and New York: Routledge, 1992), pp. 32–3.
2 Svetlana Alpers, *The Art of Describing: Dutch Art in the 17th Century* (Chicago: University of Chicago Press, 1983).
3 For the Greeks, the word *techne* meant both art and technology. The oldest engineering text, the *Mechanica*, was written by the philosopher Aristotle (384–322 BC).
4 Deborah Haynes, *The Vocation of the Artist* (Cambridge University Press, 1996).
5 Charles Seymour Jr, "Dark Chamber and Light-Filled Room: Vermeer and the Camera Obscura," *Art Bulletin* 46 (September 1964): 325.
6 John Berger, *Ways of Seeing* (London: BBC and Penguin Books, 1981).
7 In England, Sir Charles Eastlake, president of the Royal Academy, accepted the presidency of the Photographic Society of Great Britain; and in France, the well-known painter Baron Gros became the first president of the Société Héliographique whose other founding members included Eugène Delacroix and many prominent artists.
8 John Berger, *Ways of Seeing*.
9 Walter Benjamin, "The Work of Art in the Age of Mechanical Reproduction," in *Illuminations* (New York: Schocken Books, 1978), p. 236.
10 F. Lanier Graham, *Three Centuries of French Art* (Los Angeles: Norton Simon Inc., Museum of Art, 1973), p. 41.
11 Sonia Sheridan, *Electra* catalogue, Musée de l'Art Moderne de la Ville de Paris, France, 1983, p. 396.
12 Ibid.
13 Ibid.
14 Andreas Huyssen, "The Hidden Dialectic: The Avant-Garde – Technology – Mass Culture," essays on *The Myths of Information: Technology and Post-Industrial Culture*, ed. Kathleen Woodward (Madison, Wisconsin: Coda Press, Inc., 1980), p. 158.
15 Benjamin, "The Work of Art."
16 Quoted in Van Deren Coke, *The Painter and the Photograph* (Albuquerque: University of New Mexico Press, 1974), p. 299.

2

The Machine Age and modernism

> Photography had overturned the judgment seat of art – a fact which the
> discourse of modernism found it necessary to repress.
>
> <div align="right">Walter Benjamin</div>

At the beginning of the twentieth century major technological change raised fundamental questions which fostered expanded consciousness in the arts, literature, music, and science, creating the radical innovation which, even today, underpins cultural development. The theories that were, however, to have the most profound effect in the shattering of tradition in the new century were those of Sigmund Freud and Karl Marx. Freud's theories emphasized the importance of the instinctual subconscious side of human behavior and asserted that emotions and urges are more important than rational thought. Marxist economic and political models of thinking gave rise to new criteria of value which promoted criticism of the most basic social forms, including the influence of technology in relation to the formation of culture.

Two tendencies evolved between, on the one hand, those artists who still embraced traditional materials, practices, and forms, even though their consciousness had been changed by the deep technological shifts brought about by the Machine Age, and, on the other hand, those who, as a result of it, developed an anti-aesthetic. The former, the Cubists, Fauves, and Postimpressionists, repressed the influence of the machine by moving into the new territory of abstraction with its formal concerns. However, the Constructivists and Futurists gave themselves up radically to the spirit of the new age, glorifying the machine as a tool and the machine aesthetic as part of style. Another wing of the avant-garde, the Dadaists, were ready to question the very structure of art itself and its relationship to the art world and society as a whole. They used the machine as an icon to comment on socio-political realities.

Both wings of the avant-garde used photographic technologies as tools in their work. For example, the Constructivists used photomechanical methods as a rapid way of reproducing

political posters while the Dadaists used "readymade" photomontage as a way of attacking the values of the commercial gallery system. "Constructivists and Dadaists stand as the positive and negative sides of a total and a utopian critique in terms of order and chance, of art within social modernity."[1]

All artists had to come to terms with the machine. Whatever they did, they could not ignore its enormous influence. As part of a variety of responses to the machine that were taking place in the fields of painting and sculpture, Picasso and Braque led the way, in their Cubist works, by deliberately jettisoning the single viewpoint of perspectival space and the conventional structures of visual signification.[2] In a single image, they included the front, back, top, and sides of a subject. Part of their Cubist point of departure toward dynamic abstraction was influenced by the fractured, broken-up, serialized images suggested by Marey, Muybridge, and cinematography. Cubism mirrored the edited, fragmentary aspects of reality presented by film without using the apparatus itself. While their interests in formal issues, such as space, structure, rhythm, and composition were a response, in part, to developments in photography, they were also both a reaction to the irrevocable possibilities for representation opened by photography and a repression of it. Their attitude toward technological seeing – both being stimulated by it, yet not embracing it for their work – again

Figure 2.1. Etienne-Jules Marey, *Chronophotographe Géométrique*, 1884, chronophotograph.

This multiple exposure in a single frame of a figure jumping over an obstacle was produced with the aid of the photographic gun that Marey invented in 1882. The gun permitted twelve exposures per second. A scientist and inventor, Marey devoted himself to the study of movement in all its forms. His fascination led him to invent a series of tools for observing and recording movement too fast for the eye to perceive. His multiple exposures created a means for visualizing concretely the abstract fluid aspects of motion that had such an impact on the imagery of the Cubists and Futurists.

illustrates the distinction we have been discussing about ways of seeing which represent two potential ways of thinking about representation. These two approaches are not just characteristic of the Renaissance.

Although the Industrial Revolution had been in progress for over a hundred years, the turn of the century saw its flowering. The Russian Constructivists welcomed the Machine Age positively – believing that the future of society lay in the liberating, beneficial forces of science, technology, and industry. They sought to fuse art and life through an expanded approach to mass culture, performance, and production. In proclaiming that "art must align itself with the magnificent radiance of the future," the Italian Futurists also embraced advances of the Machine Age. For Boccioni, Balla, and Severini, the machine provided heady iconography for their art. These artists broke up the static surface forms of cars, trains, and figures seeking "lines of force" – repeating shapes over and over to create swirling, spiraling movement suggestive of unrestrained energy.[3] For them, the beauty of technological apparatus and of mechanical reproduction was the effects associated with power, destruction, and war. This idealization of the machine was an aesthetic perfectly in tune with the nascent fascistic tendencies of those times.[4]

In a political break with tradition, the Dadaists confronted conventional art practices with anti-art tactics. From avant-garde outposts in Zurich, Berlin, Paris, and New York, Dada periodicals insulted the bourgeoisie, the police, and the art establishment. They designed their ironic, irrational, contrived assemblages of machine parts and photocollage works to be the center of scandal. They used the formal public atmosphere of commercial galleries to raise fundamental questions about the "purity" of art; its commodity value as compared to its social value; and the uniqueness of handmade objects in relation to the value of machine-made copies.

Art going out into technology: fusing art and life

Beginning in 1917, the Constructivists began using a combination of technology and art in the hope of building a new social order in revolutionary Russia. Their art was based not only on their political ideals but on respect for new technologies, materials, techniques, and the logical structure which arises from these. Tatlin called it "art going out into technology." Rodchenko called for a public art and declared the new era "A time for art to flow into the organization of life." By 1920 visual artists began to involve themselves in an industrial design movement to bring culture to the public as located in everyday living – textiles and clothing design, books, furniture, and interiors. At the same time they also designed and distributed political posters, created public monuments, and involved themselves in agit-prop street theater. They designed a train which carried an agit-prop exhibition cross-country and produced work in the form of "spoken newspapers" and "telegraphed posters" which were intended to inform a largely illiterate public. The poet Mayakovsky summed up the prevailing spirit of artistic involvement in creating mass public cultural awareness when he declared: "Let us make the streets our brushes, the squares our palette." Prominent amongst the Constructivists at that time were Tatlin, Rodchenko, El Lissitsky, Gabo, Pevsner, Malevitch, and the film director Vertov.

Their enthusiasm for an experimental fusion of the arts expressive of the Russian Revolution led to explorations of the connections between theater, architecture, film, and poetry. El Lissitsky and Malevitch (like the Cubists and Futurists) were deeply interested in

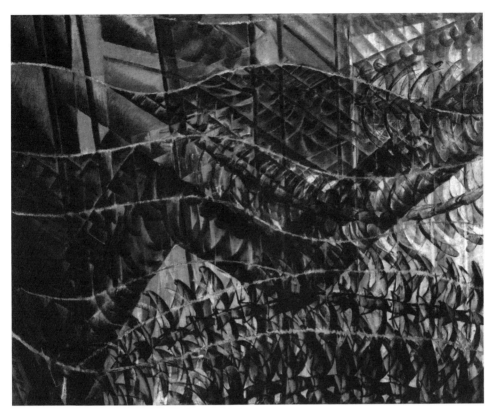

Figure 2.2. Giacomo Balla, *Swifts: Paths of Movement + Dynamic Sequences*, 1913, oil on canvas, 38$\frac{1}{8}$in. × 47in. Balla's dynamic Futurist painting shows the direct influence of Marey's experimental motion chronophotographs which made the flowing aspects of sequenced movement visible for the first time.

(Collection The Museum of Modern Art, New York)

theater costumes and lighting, and designed public spectacles and performance works which were the precursors of today's multimedia works. By the 1920s the momentum of change had brought "just about every possible technique and style of painting, theater, circus and film into play. As such the limits of performance were endless; nowhere was there an attempt to classify or restrict the different disciplines. Constructivist artists committed to production art worked continuously on developing their notions of art in real space, announcing the death of painting."[5]

The Constructivists maintained a separation between their public art with its social use value and their private work in which they continued their pre-revolutionary explorations of abstraction. The formal aesthetic inquiries in their paintings and sculptures first developed through their involvement with the Suprematist movement. By the 1920s Rodchenko, El Lissitsky, Malevitch, and Popova, in their private works, took the lead in radicalizing abstraction by moving to an extremely reductivist analysis of their painting aesthetic. Malevitch's white square and Rodchenko's black painting were far in advance of their time. Neo-Constructivists of the mid-century were to repeat these experiments in aesthetics. For example, Rauschenberg

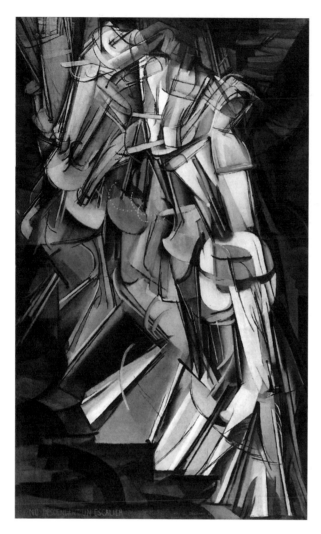

Figure 2.3. Marcel Duchamp, *Nude Descending a Staircase, No. 2*, 1912, oil on canvas, 58in. × 35in. Duchamp admitted that the influence of Marey's multiple exposures led to this radically different painting which created such a controversy at the famous New York Armory show in 1912.

(Louise and Walter Arensberg Collection, Philadelphia Museum of Art)

created the "white paintings" in 1951, and Rodchenko's 1921 *Last Painting* comprised three canvases, each painted with one of the primary colors (red, yellow, and blue), a strategy also used later by Yves Klein. These critical studies brought many artists of the time to the crucial point of decision at which painting as a private special activity was rejected in favor of art as a "speculative activity to social development" – where creativity and daily work were merged. Artists such as Naum Gabo, Nicholas Pevsner, and El Lissitsky did not share this level of social commitment and eventually migrated to Germany, feeling threatened by accusations that their art was connected to metaphysics and mysticism. By 1925, Stalin's rise to power brought rapid closure to this period of intense experimentation in the arts.

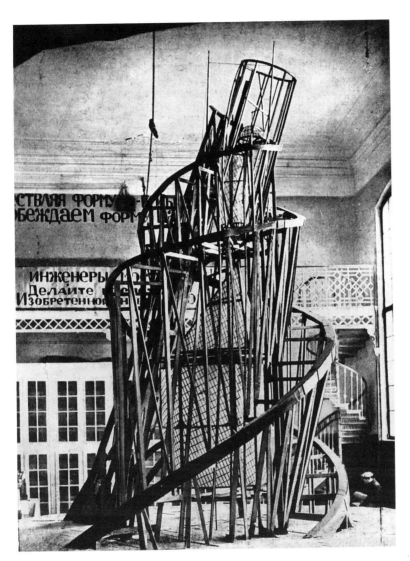

Figure 2.4. Vladimir Tatlin, *Monument for the Third International*, 1920, reconstruction of finished model, height 15ft 5in.

Tatlin was one of the first to proclaim a new way of using materials; that material – wood, iron, glass, and concrete – itself is the message, and that the expressive importance of materials lay in their substance, not their form. His point of view was that form should follow function. His work embodied a long-desired integration of sculpture and architecture. Although *Monument* was never realized, it was originally designed to be 300 feet higher than the Eiffel Tower. Its spiral framework was to enclose four glass-walled rotating chambers (turning at different speeds) to house different functions. The lowest level, which was to revolve once a year, would be used for conferences. The next level, a slanting pyramid, would rotate once a month and be used for executive activities. The third level, with a hemisphere on top, would contain an information center, and rotate once a day. He left spaces for gears and machinery and girded his tower with functional stairways.

(Moderna Museet, The National Swedish Art Museum)

The Bauhaus: a modernist industrial design movement

Constructivist ideas for a fusion of the arts found fertile ground at the Bauhaus school (founded in Germany, in 1919), where one of the most remarkable faculties in history was assembled: Vasily Kandinsky, Paul Klee, Johannes Itten, Oskar Schlemmer, Marcel Breuer, Herbert Bayer, Josef Albers, and László Moholy-Nagy. The philosophy of the Bauhaus represents an aspect of modernism writ large: an abstract aesthetic of pure form connected to the function of the object. Like the Cubist response to technological representation, the objects and images produced by Bauhaus artists were tied to a pure art – a notion of beauty of form – an outlook which did not run counter to using the machine to create it, for modern machine manufacture was embraced as a means capable of producing for the public beautiful commodities to provide an experience of quality in everyday life.

The school's founder, Walter Gropius, was convinced of the need to create an art practice where unity between architect, artist, and craftsperson could be achieved by training artists, engineers, designers, architects, and theater people to believe in a synthesis of the arts. Gropius insisted on a program revolutionary for its times, designed to liberate the students from past influences and prejudices. His idea of learning by doing, of developing an aesthetic based on sound craftsmanship, helped to create a unity between the fine arts and the crafts. The Bauhaus spread its ideas through publication of documents by its faculty and became the center for the propagation and development of new international experimentation in the arts.

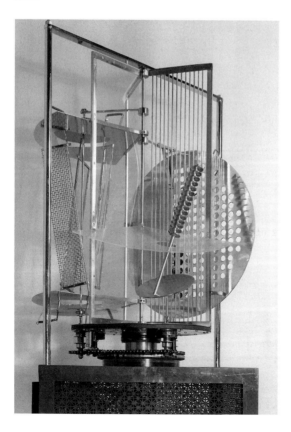

Figure 2.5. László Moholy-Nagy, *Light Space Modulator*, 1923–30, kinetic steel sculpture, 59$\frac{1}{2}$in. × 27.5in.

Moholy-Nagy's work, also known as *Light Prop*, an electrically driven, mechanically complex machine crafted over a period of several years at the Bauhaus, is a monument to the Bauhaus Constructivist enthusiasm for the machine aesthetic. The powerful play of light and shadow patterns captured an extraordinary dimension of space-time, achieved through superimpositions, mirroring, and prismlike effects of moving light. Moholy-Nagy predicted that light would be an entirely new medium.

(The Busch Reisinger Museum, Harvard University Art Museums)

Moholy-Nagy, one of the most influential and innovative faculty members of the Bauhaus, not only schooled his students in the use of photography and photomontage but focused their attention on optical experiments and the time/motion aspects of film and light as means for making art. In his books *The New Vision* and *Vision and Motion*, he developed new theories of perception and vision as they apply to the technological world. For example, Moholy-Nagy engaged in studies for projected light and motorized movement for his new type of kinetic sculpture series of "time/space modulators" which explored optical illusion.

He embraced photography and film as the foundation for a "new vision," as a new way of reshaping individual consciousness and thereby as a way of seeing society from a different perspective. His "new vision" reflected his commitment to social change. For him, the camera was a tool for educating the eye, to extend and supplement natural vision and traditional perceptual habits. With his students, he used examples of his explorations into the play of light and shadow, unusual perspectives, multiple exposures, photograms, and photomontages to create a new "optical culture" born of a changed visual awareness. For him, photography was a medium that suggested experiment in art, that posed specific formal questions which (if explored freshly) could lead to new understanding. He saw its relationship conceptually to space, drawing, and text which led to a unique approach to graphic art. Along with Stieglitz, Moholy-Nagy is credited with raising photography to the level of an art form in its own right.

Moholy-Nagy was a tireless technical innovator[6] as well as a painter, thinker, and writer. His powerful influence extended far beyond the Bauhaus when he founded the Chicago School of Design in 1939 after fleeing from Germany. Moholy-Nagy saw light as essential to the production of art and the expression of form. In his kinetic sculpture series of *Light Space Modulators*, his aim was to produce a work which lay between the movement of film and the light and dark of photograms, while concerning himself primarily with optical illusion, light, shadow, space, and movement.

In direct contradiction to prevailing prejudices of the European art establishment of the 1920s, where emphasis was still on traditional materials and hand skills for art-making, Moholy-Nagy used industrial plastics to make sculpture. To demonstrate that other possibilities existed in art-making apart from hand skills, Moholy-Nagy ordered the fabrication of a work of art by telephone. He asserted that the skills of hand-making fundamentally limited the artist, not only from taking full advantage of technological means of representation but also in placing such emphasis on the genius of the skill of making that it limited the possible idea or concept behind the work. Just as photography freed the hand of the artistic functions of delineating reality, where the eye perceives more quickly than the hand can draw, the process of pictorial reproduction could keep pace with the trained mind's functioning.

The pioneering influence of Steiglitz (1862–1946) is inestimable. Steiglitz made a contribution to the birth of a modern spirit through the activities of his 291 Gallery. Established in New York by 1905, it became an important meeting place for both American and European artists. Besides photography exhibits, he was also able to introduce to an American audience the two major strains of the European avant-garde and to create a meeting ground in America for them. They included most of the foremost French painters of the time – Matisse, Picasso, Cézanne, and Braque – as well as the anti-art group Duchamp, Picabia, and Man Ray. His gallery, in effect, became a clearing house of ideas where American experimentalists could enter into a discourse with their European counterparts. This resulted in a lively trans-Atlantic exchange.

Steiglitz's own work, grounded in documentary subject matter, was influenced by painterly style. His important work in photography and the publication of the influential journal *Camera*

Work, laid the groundwork for the later "official" art-world acceptance of photography to the fine-art canon in the 1960s.

However, of all the arts, the moving image made the greatest impact on public consciousness. Film emerged as the art form most expressive of the fusing of art and life in the new technological age, one which naturally led to a fusion of all the arts – theater, music, poetry, and literature. In 1923, the constructivist filmmaker Dziga Vertov identified with the movie camera:

> I am an eye. A mechanical eye. I, the machine, show you a world the way only I can see it. I free myself for today and forever from human immobility. I am in constant movement. I approach and pull away from objects. I creep under them, I move alongside a running horse's mouth. I fall and rise with the falling and rising bodies. This is I, the machine, maneuvering in the chaotic movements, recording one movement after another in the most complex combinations. Freed from the boundaries of time and space, I coordinate any and all points of the universe, wherever I want them to be. My way leads towards the creation of a fresh perception of the world. Thus I explain in a new way the world unknown to you.

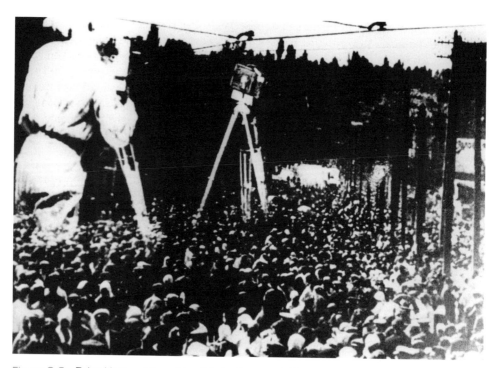

Figure 2.6. Dziga Vertov, *Man with a Movie Camera*, 1929, film still.

Vertov's passion for the movie camera's potential to create a fresh perception of the world by freeing time and space – "coordinating all points of the universe" – is captured in this montage of the cameraman towering over crowded streets.

In film, the spectator's thoughts are captured and forcibly propelled through a timed, edited, sequenced version of reality. Unnatural juxtapositions of a variety of moving images create a radically new synthesis of them. Film's form and process were avant-garde because of their technical and physical shock value. Film, like Dada, played an important role in undermining nineteenth-century cultural assumptions and institutions.

Vertov's sense of the "kino-eye" and Sergei Eisenstein's theories of montage especially influenced "independents," those filmmakers who existed outside of the growing international commercial film industry. By the 1940s, these "independent" filmmakers were producing poetic and non-narrative work. From then on, the underground cinema movement grew rapidly. By the 1950s, it had created its own traditions, film cooperatives, distribution system, and film journals, and had attracted many painters, sculptors, and photographers such as Léger, Dalí, and Balla, all of whom made short experimental films over the years. Though film as a genre has been largely excluded from the art history canon, the growth of interest on the part of artists led to their intense interest in the 1960s in the new time-art medium of video as a way of expressing their social and perceptual interests.

Duchamp raises fundamental questions about the function of art

Although Marcel Duchamp (1887–1968) began as a Cubist and was claimed by both the Dadaists and the Surrealists, he developed concepts which were beyond the confines of any movement and created a philosophic domain of his own which questioned "every assumption ever made about the function of art."[7] He felt that the machine had formed modern consciousness. More in keeping with the spirit of the Machine Age than with painting, Duchamp experimented with new manufactured materials and with the iconography of the machine itself. He introduced and experimented with almost every concept or technique of major importance to avant-garde artists for the next fifty years. His controversial *Nude Descending a Staircase* (which was influenced by Marey's photography) was exhibited in the 1913 Armory Show in New York. Its *succès de scandale* made him an immediate celebrity.

In 1915, he began a large work constructed of metal and glass, a project which occupied him for the next eight years. Often referred to as his masterpiece, *The Bride Stripped Bare by Her Bachelors, Even* (also known as the *Large Glass*) playfully suggests the idea of a "love machine." The transparent *Large Glass*[8] (richly overlaid with puns and references to science, philosophy, and the art of the past) bears within it a totally new approach both with respect to the thinking process in art and with respect to the materials and the making. His use of machine parts with references to popular culture overlaid with their allusions to Freudian thought were the basis of aesthetic ideas and attitudes which continue to be a profound influence.

In 1913, Duchamp exhibited a standard manufactured object, a bicycle wheel mounted on a stool, as a "readymade" – an object elevated in the iconoclastic Dadaist tradition to the realm of art. Duchamp's readymade asked questions about the status of an art object extracted from its functional context. Is it a commodity produced and distributed within an institutional framework that is very much like any other marketplace? Is it an object made by an artist's own hand? Is it denying the very possibility of defining art? By appropriating an ordinary copy – a mass-produced machine-made object – and placing it in the context of a gallery, Duchamp also created the opportunity for altering its significance: a new thought about the object aimed to "reduce the aesthetic consideration to the choice of the mind, not to the

Figure 2.7. Marcel Duchamp, *The Large Glass* or *The Bride Stripped Bare by Her Bachelors, Even* (original: 1915–23), replica: 1961, oil, lead, foil, and varnish, 109¼in. × 69⅛in.

This construction presents an ironic attitude toward machines and human beings. Duchamp is said to have been influenced by Raymond Roussel's play in which the functions and forms of machines are related to the sex drive. *The Large Glass* was made of unconventional materials and contains many innovative elements. Because it is on glass, its relation to the viewer and the space it inhabits is dynamic and constantly changing.

(Louise and Walter Arensberg Collection, Philadelphia Museum of Art)

ability or cleverness of the hand."[9] Later, he chose other manufactured objects – a bottle rack, a urinal, a coat rack – as readymades.

Duchamp was also deeply interested in science. In her catalog essay to a 2001 exhibition, *Unnatural Science*,[10] curator Laura Heon points to the playfulness of modernist artists who, at the turn of the twentieth century, were fascinated by public lectures interpreting new developments in science. For example, some of Duchamp's "playful physics" concepts are reflected in *The Large Glass*. In another work, he challenged forms of Euclidean geometry by creating a system of measurement based on ideas of randomness and chance. He seemed to revel in "slightly extending" the laws of physics and chemistry.

Intrigued with the work of Tesla, Kelvin, and others in the fields of electricity, radioactivity, and magnetism, many other well-informed but non-science intellectuals began to fantasize about natural immaterial non-visible dynamic forces that were beginning to be understood and applied at the turn of the twentieth century. Under those conditions, visual artists including Duchamp, Picabia, and Man Ray, poets and thinkers such as Guillaume Apollinaire, and the playwright Raymond Roussel began to create a science of imagining solutions very much influenced by Alfred Jarry's literary character Dr Faustroll. Faustroll declared: "Pataphysics

is the science of imaginary solutions [which] will examine the laws governing exceptions."[11] Faustroll as the main character of Jarry's book has many adventures (influenced by the popular science papers of Lord Kelvin)[12] including the one where he examined aspects of travel in eternity. Another narrative explored elements of clothing which could store up luminous vibrations in wavelengths that related to the costume's wearability. Invisible infrared rays could decipher writing in invisible ink because other colors of the spectrum were locked in an opaque box. These playful, sometimes philosophic interventions were sparked to a major extent by scientific research and conjecture under way at the time.

As Duchamp said years later: "I came to feel an artist might use anything – a dot, a line, the most conventional or unconventional symbol – to say what he wanted to say. This proposition can be demonstrated by choosing – it is the act of choice that is decisive."[13] Duchamp was widening the question posed originally by photography about the reproducibility versus the uniqueness of a work and the necessity of hand skills. He shifted the possibilities for art-making to place the most important emphasis on the conceptual process, thus introducing the possibility of using the techniques of industrial manufacture as another aspect of choice. Questions he raised concerning the commodification of the art object, the appropriation of readymade materials as part of art-making, and the contextualization of a given work within the gallery system as a way of questioning its value directly influenced the Pop artists of the 1960s. For them, Duchamp became a cult figure whose ideas helped to coalesce groups of artists who were simultaneously influenced by his ideas in the late 1950s. They became the new avant-garde, in both England and the United States.

The new kinetics use light and movement and machine parts

Curiosity about natural phenomena, scientific and mathematical puzzles, and their relationship to aesthetic problems led many visual artists to experiment with machine parts and materials, to probe new phenomenological mysteries for their aesthetic potential. These perceptual experiments in both real and illusory movement and time were of special interest to sculptors such as the Constructivist Naum Gabo, who produced, in 1920, the first motorized kinetic sculpture called *Standing Wave*. Moholy-Nagy also worked with motorized movement and light in his *Light Prop*, begun in 1922. Kinetic sculpture relies on the physical use of light and movement and makes use of simple motor-driven devices, motorized light boxes, and various static fluorescent and incandescent light sources.

While working on the *Large Glass* and the readymade, Duchamp had experimented with ideas about the fourth dimension and with movement of various kinds. By 1920, he had built a machine which he called *Rotary Glass Plate*, consisting of narrow, motorized panels revolving around each other. When seen from the front, the moving blades appear as one undulating spiral creating the illusion that a three-dimensional object is two-dimensional, an ironic denial of reality. A few years later, he again played with optical illusion in his *Rotary Demisphere Machine*, which made spinning convex surfaces seemingly become concave. "Underlying Duchamp's optical machines is the concept of a gliding system of dimensions and realities."[14] He also invented a kind of playful measurement system in which he substituted chance as an alternative to the rational approach of science.

These beginnings of a kinetic sculpture movement led to work by Alexander Calder, and a host of other artists, particularly in the years following World War II, and eventually to the Zero

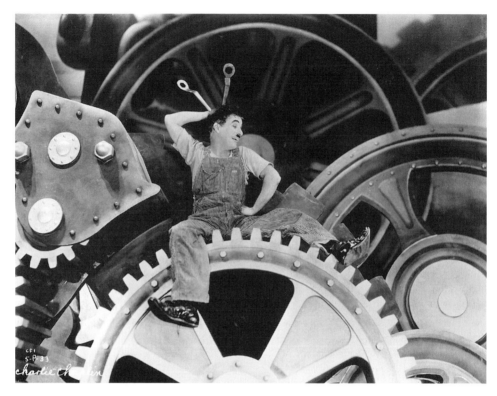

Figure 2.8. Charlie Chaplin, *Modern Times*, 1936, film still. Although *Modern Times* is a powerful manifestation of the pessimism of the 1930s toward technology and the way that life was being standardized and channeled, Chaplin demonstrates engagingly how to outwit machines as a way of drawing attention to the deep problems presented by technology.

(Museum of Modern Art/Film Stills Archive, New York)

and Grav movements in Europe and the American Art and Technology movement which expanded the concepts of kinetic art into the realm of collaboration between artists and engineers and the use of new technologies.

End of era – who owns and controls the machines?

If the 1920s were a period of hope for change, through advances in technology and machine culture, the Depression of the 1930s brought fear and despair, a mood which dominated the art of the Surrealists. For them, the machine represented an intrusion, a menace. Their program was a retreat "to the inner depths of man's mind," and for that there was no need of machines. Confidence in rational technological progress gave way to disillusionment because of rising unemployment, rampant commercialism, and the rise of fascism – all of which raised deep political questions about the market economy and about the ownership and control of machines. Chaplin's brilliant film *Modern Times* characterizes this period by demonstrating that machines ironically create abundance but leave want – materially and spiritually – when they are utilized only for the benefit of property interests. The swift

takeover by German, Italian, and Japanese fascist forces at the outset of World War II led to a frighteningly devastating struggle through the use of technologically advanced air power and weaponry, which destroyed the infrastructure of most of Europe and parts of Asia. It led to the deaths of millions, including the systematic killing of the Jewish people in a form of "holocaust." Following the atomic bomb blast and destruction of Hiroshima, fear and horror further sapped faith in technology and confidence in rational behavior.

Two directions in early twentieth-century art, both aspects of modernism, had found their first North American meeting ground at Steiglitz's Gallery 291. One tendency we have associated with the anti-art of the Dadaists, the Constructivists, and the Futurists, who were reacting to the increasingly technologized conditions of modern life either through a positive embrace of technological advance and a use of it for representation or through a use of technological seeing and materials to comment on its alienating influence. The second tendency was toward abstract formalism and the growing focus on the solution of formal aesthetic problems amongst the foremost painters of the time. These two comprise what we broadly refer to as modernism in art.

In an important sense, the war shattered the radical impetus and political commitment of the European avant-garde with its historical, cultural, and philosophic modus operandi. In America, it was as though the avant-garde belief in the power of art either to transform society or to challenge it lost its political thrust, was defused, and became pragmatically transposed by a utopian American belief in progress through technological development and the marketplace. Endemic to American culture is a direct pragmatism which is in contrast to the more philosophic tradition of the European. Many European artists (among them Duchamp and the Surrealist Max Ernst) had stayed on in New York after the war. Untouched by the devastation of the war in Europe, the American economy's postwar boom conditions produced a group of wealthy American collectors eager to invest in art. The pendulum of the art world began to shift from Paris to New York, although in Europe new critical thinking that resulted in structuralism, poststructuralism and deconstruction was emerging. This would have a direct effect on understanding the evolution of postmodern issues and aesthetics.

Modernism becomes an aesthetic style

Up to now, modernism has been discussed not only as a way of identifying a radical break with the past in terms of social and cultural history but also as a major aesthetic development brought about by changes in perception and new attitudes toward representation. However, another institutional version of modernism came into focus after the war shaped by Clement Greenberg's persuasive essays published during the period 1930 to 1960. This view is one that even today governs our concept of art. It encompasses modernism, as a self-consciously experimental movement which came to mean that a work of art should be rendered "pure" by being confined to the effects specific to its own medium, that is to the aesthetics of the object itself. This meant the identification of art with the tradition of painting and sculpture and thus to the aesthetic of the object. It is this famously succinct "Less is More" version of modernism to which we refer in the ensuing discussion.

From the early 1950s, the new modernist ethos now oriented itself fully toward solving formal problems of form, color, and texture. A group of American artists – Jackson Pollock, Willem de Kooning, Philip Guston, Arshile Gorky, Robert Motherwell, Adolph Gottlieb, Mark Rothko, and others who loosely came to be known as the Abstract Expressionists – produced

work that was heroic, apolitical, and introverted, based on inner sensation and experience, with an emphasis on the medium of painting itself. They made use of traditional materials and painterly gesture. Their work was aesthetic expression as an exalted virtue, as a vehicle for metaphor and symbol. It was the idealist modernist abstract ethic at its most "pure."

This kind of modernism, a neo-Platonic form of representation, became a movement based on denial of issues outside of the art system, whether historical issues, social issues, or issues of artistic cultural production. Any characteristic considered to be extrinsic subject matter – particularly narrative, description, or literary reference – was excluded as impure. It was a reductive system – an art of expression and form exemplified by abstract painting or sculpture. Stylistic change was based wholly on innovative conceptual or technical advances which could increase the aesthetic purity and pleasure of a work. Modernism, with its progression of "great ideas" and "great masters" evolving from Abstract Impressionism through to Minimalism as a critical and aesthetic stance, became the dominant mainstream movement.

An alienated counter-culture called the *beat generation* arose in the 1950s, influenced by writers Jack Kerouac, Allen Ginsberg, and William Burroughs. It raged against the double standards of 1950s purveyors of mass culture. Marshall McLuhan wrote in 1951 about the power of commercial interests to control the public mind. He also suggested that "the very considerable currents and pressures set up around us today by mechanical agencies of the press, radio, movies, and advertising . . . [are] full, not only of destructiveness, but also of promises of rich new developments."[15]

Younger artists felt oppressed by the official mainstream acceptance of the heroic stance of Abstract Expressionism. To them it seemed dated, mannered, and bankrupt. It was in direct opposition to the more open radical approach to the arts which had been developing at Black Mountain College since 1933.[16] There, the spirit of debate and openness to innovate led to the founding of a different American avant-garde. Poetry, music, film, and theater were lively adjuncts to the painting and sculpture program. Josef Albers, Merce Cunningham, Buckminster Fuller, Willem de Kooning, Clement Greenberg, David Tudor, and countless other major influential figures were all associated with the program at Black Mountain. Amongst their students were Jasper Johns, Robert Rauschenberg, and Dorothea Rockburne, who were challenged by the new ideas being generated. The musician John Cage (influenced by Eastern aesthetics as well as by Surrealism, the work of Duchamp and Abstract Expressionism) performed theater events which combined his ideas about chance in music with aspects of painting and sculpture. Cage was an especially important influence, for he also taught at New York's New School for Social Research, where his course in experimental composition became a major revelation for a broad spectrum of artists from diverse disciplines. These included Allan Kaprow, George Brecht, George Segal, Yvonne Rainer, Al Hansen, and other close contemporaries. Cage's classes led to daredevil willingness to break new ground by "trying anything." New forms evolved – Assemblage; Happenings; Environments; Performance art – reflecting the exhilaration of the early 1960s.

Influenced by Antonin Artaud's *The Theater and Its Double* (translated by M. C. Richards, a Black Mountain faculty member), John Cage began to think of theater as beyond narrative, as a territory of time and space inhabited by unrelated but coexisting events. While Artaud's "theater of cruelty" encouraged a powerful ritualistic dialogue with the audience, Cage's *Theater Piece #1* was emotionally distanced, but at the same time equally enigmatic. It was performed at Black Mountain College in 1952, and became legendary as the first "Happening" and the beginning of chance operations in music and dance works. Providing context for the performance, Rauschenberg's 'White Paintings' were hung overhead. Merce Cunningham

danced throughout the audience and the performance space followed by a barking dog. Coffee was served by four boys in white. David Tudor performed on the piano in competition with Edith Piaf recordings played on an old phonograph by Rauschenberg. Cage sat for two hours on a step-ladder sometimes reading a lecture on the relationship of music to Zen and sometimes simply silent, listening.[17]

Cage created and organized the event around chance operations where everyone did whatever they chose to during certain assigned intervals or blocks of time. The experience was a near sensory overload. Each observer's experience of the event was completely different, an aspect central to Cage's performance goals. "The event," as it came to be known, established Cage's unmistakable imprimatur of a kind of intertextuality which we can say was the precursor of a nonlinear, inclusive postmodern aesthetic.

Like Duchamp, Cage insisted that the true source of art lay "not in subjective feeling and the creative process but in the everyday presence of events happening in an environment." He felt the purpose of art was, above all else, "the blurring of distinctions between art and life." Cage encouraged the use of accident and chance as nature's own principle: "one that required the artist to avoid rational creation of hierarchies, and points of climax, in favor of repetition and a kind of all-relatedness."[18] Unlike Duchamp's subversive and ironic stance

Figure 2.9. *James Rosenquist Working in Times Square,* 1958, photograph.

Taking on the occupation of a billboard sign painter for a time, Rosenquist painted images so large that he remarked, "I could hardly tell what they looked like except for their textures but I had to be accurate and make them look like the things they were supposed to be." Swaying on planks twenty-two storeys above the street, Rosenquist mixed paints and created super-colossal figures. He had to walk three blocks away to be able to scale the size relationships in the images he was painting. This experience had a profound effect on his work.

(Leo Castelli Gallery, New York)

toward art, Cage was more in tune with the joyousness of Zen. In his nearly pantheistic thought, he influenced various developments occurring toward Minimalist art, toward the Happenings movement of Allan Kaprow, toward the Judson Theater Movement, and toward the paradoxical punning games of Conceptual art. He even influenced the use of found images from popular culture by the Pop artists and the Fluxus movement. The shared, ultimate purpose of these groups was, to quote Allan Kaprow, "[the] release [of] an artist from conventional notions of a detached closed arrangement of time-space. A picture, a piece of music, a poem, a drama, each confined within its respective frame, fixed number of stanzas, and stages, however great they may be in their own right, simply will not allow for breaking the barrier between art and life. And this is what the objective is."

A neo-Dada collective, Fluxus was a loosely knit nonconformist group that evolved in the early 1960s inspired by both Duchamp and Cage. Group members came from the field of music, performance, film, and visual art. Like the Dadaists they used technological methods, tools, and materials as a means to extend their work as part of its shock value, They were noted for the creation of Happenings, mixed-media events, publications, concerts, and mail-art activities. Dick Higgins presided over the Something Else Press which energetically spewed out books and pamphlets fueling the movement. Allan Kaprow labeled Korean Performance artist (later video guru) Nam June Paik a "cultural terrorist" for arranging for the tipping over of a piano as a "Happening" at a Dada-like concert. Chris Burden undertook a series of death-defying acts. As a performance piece, Yoko Ono allowed audience participation in snipping off her clothing. Fluxus strategy was to democratize the art-making process by destabilizing the status of the art object and dematerializing it. Their events were repeatable by anyone, involving a battery of props made up of everyday found objects. The ironic, witty, Fluxus style was anarchically irreverent and subversive in its commentary and, compared to more conventional work, placed the artist in a different position with regard to the audience.

The Pop movement – transition to the electronic era and postmodernism

In the seven-year period 1957–64, the arts in America went through a dramatic upheaval as the formal strategies of Abstract Expressionism, and of the formalist international-style modernist edifice as a whole, began to seem irrelevant in the light of popular consumer culture and in the context of a complex economy which was becoming based more and more on mass electronic communications. A younger group of artists began to demonstrate the direct connections between art and an increasingly technologized society; they declared their independence from modernism and Formalism and began the unprecedented use, as the subject matter of their work, of images appropriated from the mass media. They used directly in their work everyday pulp images to reflect the cultural style of the consumer society that spawned them. The work of these Pop movement artists marks the transition into the postmodern period.

The Pop aesthetic was anti-art in the Duchampian sense, anti-American in its ironic commentary on the cultural effects of rampant commercialism, and yet profoundly American in its appropriation of the same technology developed and designed for propagating consumer culture. Pop artists borrowed specific photographic images from magazines and billboards, television, and newspapers, and created a new context for them by adding photographs or drawn elements of their own. Some artists, such as Andy Warhol, actually earned their living

as commercial artists. James Rosenquist, for example, painted huge billboards above Times Square and spoke about his experience of painting gigantic images of spaghetti. It was natural for Pop artists such as Rosenquist to begin the direct use of photographic imagery in their paintings and prints, using photomechanical processing for printed effects as part of both style and of the total rhythm of their creative process.

In England the Pop movement arose simultaneously. There Richard Hamilton and Eduardo Paolozzi were its leading exponents. In the United States, some of the best-known artists included Andy Warhol, James Rosenquist, Roy Lichtenstein, Tom Wesselman, Robert Rauschenberg, Jasper Johns, Jim Dine, and Claes Oldenburg. Members of both groups, deeply influenced by the theories and example of Duchamp (who had become a cult figure for them), met each other at the Duchamp retrospective held in California at the Pasadena Museum in 1963.

The familiarity and commercial popularization of photographic images (which at the end of the nineteenth century had prejudiced artists against the direct use of photography in their work) now attracted the most progressive painters and sculptors. In opposition to the formal abstract tendencies of modernism, figuration – a more public stance in art – began to return, a shift which has become fully established in the postmodern period. Pop artists renewed questions also about the potential of industrial manufacturing techniques, not only as part of a work's execution but as part of its total aesthetic, its look, its style, its

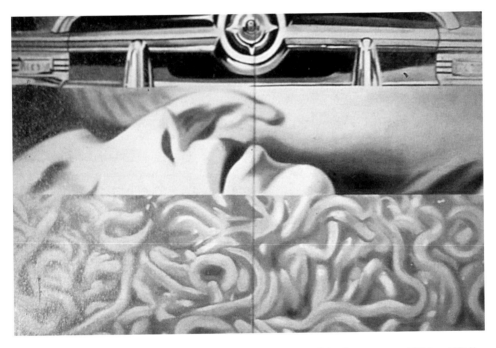

Figure 2.10. James Rosenquist, *I Love You with My Ford*, 1961, oil on canvas, 59½ × 27½in.

Rosenquist juxtaposes realistically painted mass products such as cars in out-of-scale relationships to other pictorial elements to make us see more clearly, while at the same time proposing a deeper mystery. His work is typical of how Pop artists made use of consumer society images to produce iconic statements.

(Moderna Museet, The National Swedish Art Museums and ARS)

meaning. The fusion of technical process with aesthetic concern became a fundamental and characteristic aspect of Pop art. Although the subject matter of their work was popular culture, Pop artists distanced the subject from its social relations without assigning a political spin to it – a strategy which served to reify it, and place it within the realm of high art emblems as part of style, thus blocking the social commentary on the means of reproduction as discussed by Walter Benjamin.

By 1962, Andy Warhol had began to screenprint high-contrast photoimages onto his canvases. More than any of the other Pop artists, Warhol fused the method and style of industrial production. That photographic images and screenprinting were despised, commercially tainted media considered inappropriate for art-making only increased their allure for the avant-garde. They were in fact ideal for translating the style and scale of the serial sequenced images that Warhol devised. Photoimagery and photomechanical reproduction methods became a vitally important aspect of his aesthetic. Once silk-screened photographic images were printed onto canvas, old prejudices about photography could be sustained only with the greatest difficulty.

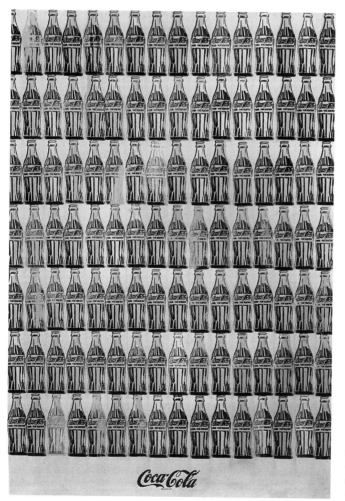

Figure 2.11. Andy Warhol, *Green Coca-Cola Bottles*, 1962, silk-screen on canvas, 82¼in. width × 57in. depth.

Warhol chose for his work advertising promotion images that were designed to tap into the consumer's inner system of desire. Fascinated by consumer culture, its economics, and its profound effect on the psyche, Warhol came closest in his "Factory" studio to producing machinelike effects in these sequences of bottles that suggest mass-production patterns.

(Whitney Museum of American Art, New York, and ARS; Photo: Geoffrey Clements)

Explaining how Warhol produced his "printed" paintings, John Coplans wrote: "Since a major part of the decisions in the silkscreen process are made outside of the printing itself (even the screens for color can be mechanically prepared in advance) making the painting is then a question of screening the image or varying the color. These decisions can be communicated to an assistant . . . What obviously interests Warhol is the decisions, not the act of making."[19] Warhol deliberately appropriated existing popular mass-media photographic images and embraced industrial assembly line procedures for the production of his serial images as part of his overall style. He dubbed his studio the factory and declared, "If I paint this way, it's because I want to be a machine."

Warhol understood the dynamics of popular culture and the way images functioned to create desire and fascination within consumerist, celebrity-crazed society. Damned as a charlatan for being inarticulate, he ironically and paradoxically caught the tone of the times again and again with images such as *Electric Chair*, *Campbell Soup Cans*, and *Brillo Boxes*, and with portraits of stars all the way from Marilyn Monroe to Mao-Tse Tung. Like the Dadaists, Warhol wanted to create scandal, to shock, to raise questions. Like Duchamp, he became an infamous figure lionized by part of the art world for his extreme ideas. He also became the ironic subject of media attention. His line "In the future, everyone will be famous for fifteen minutes" is equally famous. For the mass public, Warhol's lifestyle and art as promoted by the media created a new phenomena – the artist as celebrity.

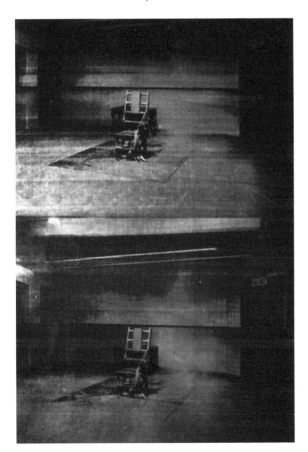

Figure 2.12. Andy Warhol, *Electric Chair*, 1965, silk-screen on canvas, 22in. × 28in.

Warhol's choice of the electric chair as an emblem of contemporary America has a chilling effect. The artist's photographic rendering of the official execution machine as an icon prompts reflection on the judicial system.

(Leo Castelli Gallery, New York, and ARS; Photo: Rudolph Burckhardt)

Warhol began making experimental films in his studio and created a new *vérité* style where there was no editing of the final product. He simply placed the camera in a corner of the room and let it run, an attitude later taken up by video artists. Later, his films became sensationalistic, tackling sex, psychology, and power, based on the personal lifestyles of his group following.

Daniel Wheeler writes of Warhol's unequivocal acknowledgment of the impact of media to register decisively and coolly the terrifying emptiness and terrible loss this entailed. Warhol's cooptation of appropriated mechanical reproductions for his work reflects "the loss of faith in the kind of visionary subjectivity that had moved the Abstract Expressionists to reach for, and sometimes even attain, the sublime. The consequence may be felt not only in the riveting hollowness of Warhol's art – particularly in the Brillo boxes, those leading indicators of postmodern simulacra – but also in the cold, deadpan stare of the late self-portraits with their look of insatiable, inarticulate yearning for the unrecoverable."[20]

Collaboration and research lead to a new range of work

Beginning in the late 1950s, new collaborative printmaking workshops began to spring up around the United States. An unparalleled spirit of investigation and invention spurred research into new materials and methods. The earliest of these workshops – Tamarind, Universal Limited Art Editions, and Gemini G.E.L. – invited rising avant-garde Pop artists Rauschenberg, Johns, Dine, Oldenburg, Lichtenstein, Rosenquist, and others to experiment, applying the full range of known commercial technology to their art works. This system of collaborative studios offering technical innovation in-the-service-of-the-arts provided the springboard for a new kind of work which called on unorthodox use of processes and materials. Available to them were light-sensitive resists for metals, large positive aluminum lithographic plates (for use with the precise registration of offset presses), new synthetic meshes and special inks for silk-screen, photomechanical production aids such as a range of large-format high-contrast film types, contact screens, process cameras, and plastic molding techniques – a veritable feast of technical and industrial processes that up to then had not been explored in the fine arts.

Attitudes gained from these experiences, using photography, industrial photomechanical reproduction methods, and industrial technology in making fine-art prints, had spin-offs particularly in kinetic sculpture and large Minimalist works, which emphasized industrial fabrication as part of their meaning and style. A new range of work – the hard-edge and "Op" works of the 1960s, with poured paintings and molded canvas surfaces, as well as the pristine, smooth-surfaced Minimalist, and the huge formal Super-Realist works of the early 1970s – were made possible through research and technological development of new artists' materials such as acrylic paints, mediums, and pigments (synthetic color); adhesives and tapes; plastics (such as styrofoam casting materials); airbrushes; and projecting equipment.[21]

Painters begin to ask questions about photography

Because the Greenbergian "dogma of modernism" had become so thoroughly entrenched as the new orthodoxy, and because the official establishment was so intolerant of any difference or digression from its formalist program, painting or sculpting models from life now became

an act of rebellion. The return of mimesis in art came along several routes – especially through the use of photographic references projected by the Super-Realist painters; photomechanical methods by the Pop, Fluxus, and neo-Dada artists; and the use of actual photographs by the Conceptualists.

Conceptual art is known as an anti-form movement in which the gradual dematerialization of the art object takes place. Puritanically stern in their denial of pleasure in materials in order to distance themselves from the materiality and nonillusionistic character of Minimalism, conceptual artists began to use text and photography as a means of calling into question modernist notions of individualism and originality. In their use of photography, they also found a means for documenting their immaterial performances and environmental works. Without photography, Christo and Smithson, for example, would have had little record of their huge land works in real environments.

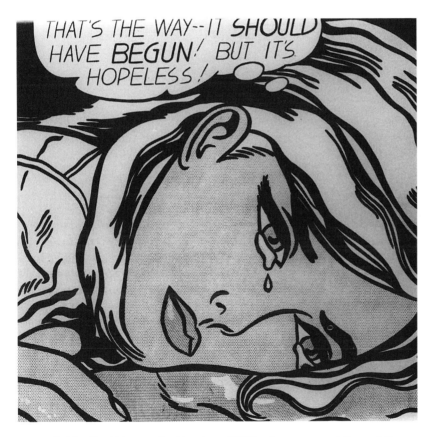

Figure 2.13. Roy Lichtenstein, *Hopeless*, 1963, oil on canvas, 44in. × 44in.

The Dada spirit for recycled images (inserted into the discourse of the 1960s by Duchamp) influenced painters such as Lichtenstein, who began to use mass-media images as subject matter. However, he maintained that his use of comic strips was for their "look," for purely formal reasons – not for the same kind of ironic reaction to social conditions that had earlier motivated the Dadaists and Surrealists.

(© Roy Lichtenstein, Leo Castelli Gallery, New York)

Conceptualism, the last of the truly international art movements, was in opposition to Minimalism in the sense that it ran counter to the Greenbergian version of modernism as being posited only in painting and sculpture (an identification which led naturally to the value of the object). The Conceptualists opposed the commodity state of the object and promoted the idea that art as idea could become common property. Because of its reliance on language and text, conceptual works could be disseminated beyond the context of the gallery, and took on many forms, for example, in public projects which were then recorded in magazines or books. Too extreme for the public to follow, too removed from the material object to be viewable or saleable in traditional contexts, too scandalous also, in that it arose in opposition to the Greenberg formulation of modernism, it began to suffer when those theories lost credence.

The strategies of Conceptualism and its discourse laid the foundations for the deconstruction period which followed. During this period new lines of inquiry and engagement opened out. Conceptualist influence has carried over and is an extremely important aspect of new work by both American and European artists still influenced by it.

Figure 2.14. Eduardo Paolozzi, *Artificial Sun*, 1965, silk-screen print, plate 1 from *As Is When: Interpretations of Ludwig Wittgenstein*, 28in. × 22in.

When Paolozzi presented his collection of found materials from Pop culture magazines, newspapers, and advertisement posters to a group of artists at the Institute for Contemporary Art in London, he influenced a whole group of British artists to begin thinking about their work in a different cultural context. In this series of silk-screen prints based on Wittgenstein's writings, Paolozzi used photo-silk-screen to create completely new relationships between the disparate elements.

(Donated by Dr and Mrs Paul Todd Makler, Philadelphia Museum of Art)

Photorealism or Super-Realism was an outgrowth of the extreme purism and formalism of Minimalist art. It brought *trompe l'oeuil* naturalistic imagery into the field of painting (created on a giant scale). The work was patterned on two-dimensional photographs and represented a new attitude after such renunciation. This style accentuated the abstract qualities of extreme spatial foreshortening, variable focus, smooth emulsionlike surfaces and sparkling luminosity found in photographs. Photorealist paintings create a double deception, for in their referencing the real from a photograph, and painting a reproduction of the photograph, rather than the real, they were producing what Jean Baudrillard called a *simulacrum* – a copy of a copy. Paradoxically, photographers, institutionally marginalized for generations by the art establishment, had been seeking high-art institutional acceptance and validation for their work by mimicking painting, and forcing their medium to deal only with formalist issues. However, photography now became an accepted and widespread part of art-making itself.

Figure 2.15. Richard Hamilton, *Kent State*, 1970, silkscreen, printed in color, composition, 26⁷/₁₆in. × 34³/₈in.

When Richard Hamilton photographed his television monitor during an international news broadcast of the shooting of Kent State University students demonstrating against the US invasion of Cambodia, he captured a historic moment. His translation of the scene into a screenprint still bears the blurry striated quality of an early overseas transmission. He intended the print as a commemoration of a moment in time not to be forgotten.

(Collection The Museum of Modern Art, New York: John R. Jakobson Foundation Fund)

By 1964, two clearly opposing directions in art had become evident. The first was a neo-Dada avant-garde with their interest in popular culture, an assemblage approach to art-making, and openness to technological media and cultural influence. The second, Minimalism, represented an extension of the formalist ideals of modernism. Paradoxically Minimalism was subverted by the Conceptualist and Photorealist movements which began to make use of photography for art-making.

Notes

1 Michael Newman, *Postmodernism*, ICA Document 4 (London: Institute of Contemporary Arts 1987), p. 33.
2 Later, they began to collage ordinary "found" elements (such as newspaper fragments, postage stamps, nails, string) as a kind of effluvia of the Machine Age – both as a reflection of the times and as a challenge to the conventional "preciousness" of standardized art materials used in the production of art projects as commodity items for the art market.
3 Their radicalism included using noise as music, shock and nonsense in theater, and the destruction of all traditional forms and institutions (including museums) in order to create an anarchistic living culture "made in the present for the present" before people could progress "beyond painting" which was seen as a symbol of the old order and thereby represented a tyranny of "good taste and harmony."
4 Walter Benjamin writes in his essay "The Work of Art in the Age of Mechanical Reproduction": "'Fiat ars – pereat mundus', says Fascism, and, as Marinetti admits, expects war to supply the artistic gratification of a sense perception that has been changed by technology. This is evidently the consummation of 'l'art pour l'art'. Mankind, which in Homer's time was an object of contemplation for the Olympian gods, now is one for itself. Its self-alienation has reached such a degree that it can experience its own destruction as an aesthetic pleasure of the first order. This is the situation of politics which Fascism is rendering aesthetic."
 Benjamin also wrote in the same essay that photographic reproduction, mixed with sound, saw mass movements, such as demonstrations, more clearly through a camera lens than through the naked eye. In newsreels (as in television) such mass movements, including war, lead to a form of human behavior which particularly favors mechanical equipment.
5 Rose Lee Goldberg, *Performance Art: From Futurism to the Present* (New York: Harry N. Abrams, 1988), p. 44.
6 He is credited with discovering the photogram in 1922.
7 Calvin Tomkins, *Off the Wall* (New York: Penguin Books, 1983), p. 126.
8 Duchamp designed a book to accompany the work called *The Green Box*. It contained his notes and sketches about the work and was ironically presented in the spirit of an industrial equipment manual.
9 Quoted in *Ideas and Image in Recent Art*, exhibition catalog, Art Institute of Chicago, 1974, p. 10.
10 Laura Heon, *Unnatural Science* catalog essay, *Unnatural Science, an Exhibition*, Mass MOCA, North Adams, Mass., spring 2000 to spring 2001.
11 Ibid., p. 9.
12 Ibid., p. 10.
13 Quoted in Pontus Hultén, *The Machine*, catalog, New York: Museum of Modern Art, 1968, p. 102.
14 Quoted in ibid., p. 103.
15 Marshall McLuhan, *The Mechanical Bride: Folklore of the Industrial Man* (New York: Vanguard Press, 1951).
16 These were combined with the authoritarian teachings of Josef Albers, who transmitted the Bauhaus maxim of design and use, form and function, art and life. (Albers believed in the training of perception and consciousness, a process that also involved learning to understand the true nature of materials and the relationship between them.)
17 These notes are from Martin Duberman's *Black Mountain: An Exploration in Community* (New York: E. P. Dutton, 1972), p. 277.

18 Daniel Wheeler, *Art Since Mid-Century: 1945 to the Present* (Englewood Cliffs, NJ: Prentice Hall/Vendome Press, 1991), p. 125.
19 Riva Castleman, *Printed Art*, catalog, New York: Museum of Modern Art, 1980, p. 11.
20 Wheeler, *Art Since Mid-Century*, p. 312.
21 By 1959, the Artists' Technical Research Institute had been founded.

3

The electronic era and postmodernism

We are in the midst of a vast process in which (literary) forms are being melted down, a process in which many of the contrasts in terms of which we have been accustomed to think may lose their relevance.

<div align="right">Walter Benjamin</div>

Works of art are repositories for ideas that reverberate in the larger context of culture.

<div align="right">Marcia Tucker</div>

The postmodern shift

The transitional moment between the end of an entire epoch and the arrival of a new age was encapsulated in a 1968 exhibition, *The Machine as Seen at the End of the Mechanical Age*. Curated by Pontus Hultén at the Museum of Modern Art, New York, it was a cultural response to the demise of a modern manufacturing society based on manufacturing machines as the "muscle" of industry and the rise of a postindustrial, postmodern information society culture based on instant communication services. Besides showing artworks which either commented on technology or were a demonstration of the machine aesthetic as part of style, it previewed computer and video electronic media works as new aspects of representation. A major feature of these powerful media is their ability to transmit sound, image, and information over long distances, invading every aspect of contemporary life, deeply affecting the public consciousness, forcing an end to a modernist visual-arts culture based on suppression of the outside world. The new media became the threshold to a new territory of postmodern conditions and issues.

In the 1960s, architecture, a cultural form always a direct barometer of change because of its direct ties to economic, technological, industrial, and social development, began to revise

Figure 3.1. Robert Rauschenberg, *Signs*, 1970, silk-screen print, 43in. × 34in.

Rauschenberg stated that this print was "conceived" to remind us of the love, terror, and violence of the previous ten years. Danger lies in forgetting. His photographic juxtaposition of Martin Luther King's death, the Moon landing, the Kennedy brothers, Janis Joplin (later to die of a drug overdose), soldiers, and protesters against the Vietnam War was a restatement of the old issue of photomontage.

(Castelli Graphics, New York; Photo: Pollitzer, Strong, & Meyer; © Robert Rauschenberg, VAGA, New York 1994)

radically its formalist tendencies. "International style" buildings seemed suddenly irrelevant and out of place in turbulent times. Everywhere images of war, environmental pollution, and political upheaval seemed to challenge the purity of polished glass and steel curtain walls.

Architects Robert Venturi and Denise Brown reacted against the utopian, austere international style's rationally determined steel and glass boxes and concrete bunkers,

criticizing their failure to reflect the times. The dispiriting effects and aloofness of modernist buildings which fell short of acknowledging cultural memory, context, living patterns, and individual needs led them to write in the 1970s their now famous essay "Complexity and Contradiction in Architecture: Learning from Las Vegas." They called for a return to the vernacular, to the "complexity of Main Street", and for reform of architecture's elitist language. This essay has been said to announce the arrival of the postmodern condition. Mies Van der Rohe's 1920 statement "Less is more" now became "less is a bore".

At the same time, television[1] projected the world of the 1960s directly into the public's consciousness, transmitting dramatic, disturbing images of the Vietnam War mixed with scaled-up images of consumer objects which attempted to hook the viewer into believing that both kinds of images were of equal importance. With the "delirious circularity of the channel dial," all assumptions of coherence vanished in the new cultural infrastructure. The disorganization and nonlinearity of the networks defined television as a site of multiple intensities. This chaotic form in which information and theatrical effects were mixed with the totally banal, and where art, culture, politics, science, and so forth were all brought together outside of their usual contexts and connections began to create a vast meltdown of forms within the public consciousness. Television became the arena of a confusion, a melting pot of forms, concepts, and banalities which acted as the crucible for a postmodern consciousness (see Chapter 4).

It was Venturi's interrogation and condemnation of modernism's purist international style which inspired the very term "postmodern." He rejected the rational utopian ideology inscribed in architectural forms of representation. Because architecture must be lived with, Venturi

Figure 3.2. Keith Haring, *Untitled*, 1983, sumi ink on paper, 72in. × 134in.

Part of the neo-Pop phenomenon, which grew out of street culture, Haring has the ability to synthesize and capture contemporary ideas in a powerful vernacular. One part doodle-graffiti, one part Paul Klee, one part design, he sets out to influence public opinion about such things as drugs and nuclear war. In both of the images shown here, he comments on the control of the public by television. Haring's popular success made him into an art star with important clout for disseminating his ideas.

(The Estate of Keith Haring, New York; Photo: Ivan Dalla Tana)

saw that modernist aloofness and cool distance was out of touch with the chaotic contra-dictions, complexity, and diversity of everyday life. Formal glass and concrete slab buildings could not satisfy a populace who wanted and needed a more accessible architecture, one less monumental, more human in scale, one which was more messily vital, multivalent and layered – "like life" – rather than one with a dominantly formal structure. His more "vernacular architecture" accepted the needs of the public to be factored into the architectural equation, along with the chaos, instability, and many-layered complexity of commercial mass culture. He called for a return to "the difficult whole" where various parts, styles, or subsystems are used to create a new synthesis. Postmodern architecture began to embrace pastiche as a strategy, an aesthetic of quotation, appropriation, and incorporation of traditional styles to provide recollection of the past.

The postmodern presumes the modern, and includes both an academic, or "high," aspect and a "low," or vernacular, one. Postmodernism views texts and images as radically polyvalent, rather than linear, permitting a reconfiguring of one's experience of the world. Around 1960, French structuralist and poststructuralist theorists such as Foucault, Barthes, and Lyotard attacked the very concept of objectivity and of fixed meaning – especially in language. Making use of linguistic theory, these writers argued how much our interpretation of the world is shaped by the language we use to describe our experiences. While modernist beliefs are based on a linear view of progress, a defining feature of postmodernity is the impossibility of that kind of evolution. The world began to be seen as an experience of continually changing sequences, juxtapositions, and layerings, as part of a decentered structure of associations.

Using the tools provided by structuralism and deconstruction, feminist theory began to deconstruct modernist assumptions and to assert the value of feminist art. Issues of gender, identity, and race, long suppressed, were foregrounded. Feminist influence encouraged recognition of the interaction of many diverse voices. The feminists and the cultural critics began to deconstruct the major canons and narratives that had formed Western thought. They influenced the development of a visual culture transmitted by electronic technologies which have consciousness transforming capacity, superseding one that relied mainly on the word.

"Post-machine" electronic art and technology exhibitions

Several exhibitions with art and technology as a theme celebrated the arrival of the electronic era. Although they focused on electronic media, the work was still based on modernist premises in its aesthetic attitudes. These early works can act as a useful measure for us of the extent to which technologically based art works have been reflected in aesthetic change from the 1970s to the present.

Cybernetic Serendipity, curated by Jasia Reichard, a large-scale exhibition which included computer printouts of musical analysis, computer-designed choreography, and computer-generated texts and poems, opened at the Institute of Contemporary Art in London and later traveled to Washington. Other exhibitions with art and technology as a theme were in preparation. *Software* at the Jewish Museum, New York, opened in 1970. At the Smithsonian Institute, Washington, DC, *Explorations* opened in the same year. This exhibition was curated by Gyorgy Kepes, director of MIT's important new Center for Advanced Visual Studies, which was established in 1968.

The guiding principle of MOMA's 1970 exhibition *Information* was that all art exists only conceptually and as such is "pure information." The computer was a natural metaphor for

Figure 3.3. John Baldessari, *I Will Not Make Any More Boring Art*, 1971, lithograph, 22in. × 30in.

Exasperated by modernist dogma with its distance from social issues and its formalist agenda, John Baldessari destroyed in 1970 all thirteen years of his art work and publicly cremated their ruins as a dramatic protest against the constraints of modernist hegemony. Like a boy forced to stay after school to atone for breaking the rules, he scrawled the reiteration of his protest: "I will not make any more boring art.'

(John Baldessari and the Marion Goodman Gallery, New York)

this exhibition. Many of the works demonstrated the concept of systems analysis and its implications for art. "Information" explored groups or networks of interacting structures and channels as a functionally interrelated means of communication. These exhibitions were part of the avant-garde movement of the 1960s and 1970s which moved toward a dematerialized view of art that refused the object.

They were also a tribute to the new spirit of openness toward use of industrial techniques in art-making which had an especially dramatic impact on the art of the 1960s and 1970s. By the time of the 1961 *International Exhibition of Art and Motion* at the Stedelijk Museum in Amsterdam (also curated by Pontus Hultén) and the 1964 Documenta exhibition in Kassel, Germany, interest in kinetics had grown in Europe toward an escalation of technical means. The Zero and Grav groups (neo-Dadaist and neo-Constructivist kinetic sculptors) began serious work using industrial machine technologies. In the United States, sculptors especially began to harness new electronic tools which were rapidly being developed: electronic communication systems and information technologies; computers and lasers with their scanning possibilities,

Figure 3.4. Mark Tansey, *Secret of the Sphinx*, 1984, oil on canvas, 60in. × 65in.

Tansey's paintings amass a wealth of information and combine with imaginative inventiveness to create mysterious commentaries on history and meaning in contemporary life. Making obvious use of photographic style, Tansey subverts it to make his stories seem more real and to raise questions about technology, history, and contemporary life.

(Private collection, Marian Goodman Gallery, New York)

along with innovation in television and video; environments controlled by light- and audio-sensors; programmable strobe and projected light environments with sophisticated consoles.

Although computer graphics research was, by the late 1960s, being conducted internationally in the highly industrialized countries of Europe and North America and in Japan, few artists had access to equipment or were trained in the specialized programming needed at that time to gain control over the machine for their work. Those artists, primarily from the 1950s neo-Constructivist tradition, whose main interests lay in the formal modernist study of perception and the careful analysis of geometrically oriented abstract arrangements of line, form, and color, rather than descriptive or elaborated painting, were especially drawn to finding a means of researching their visual ideas on the computer (see Chapter 5). They sought the collaboration of computer scientists and engineers as programmers. By 1965, advances in television technology had spawned the new electronic medium of video and the first video camera/recorder, Portapak, was released in New York by the Sony Corporation. This relatively portable equipment drew widespread interest among artists[2] because of its

Figure 3.5. Jean Dupuy (*left*), Jean Tinguely (*center*), and Alexander Calder (*right*) with *Heart Beats Dust* at the exhibition *The Machine as Seen at the End of the Mechanical Age*, Museum of Modern Art, New York, 1969.

EAT (Experiments in Art and Technology) arranged a competition for collaborations between engineers and artists. *Heart Beats Dust* was the winning entry. The jurors issued this statement: "In each of the winning entries a spectrum of technology was used with great impact on the art forms. Evident is the realization that neither the artist nor the engineer alone could have achieved the results. Interaction must have preceded innovation . . . The unexpected and extraordinary, which one experiences on viewing these pieces, result from inventiveness and imagination, stimulated not by the brute force of technical complexity but by probing into the workings of natural laws."

(Photo: Harry Shunk)

Figure 3.6. Jean Dupuy, artist, and Ralph Martel, engineer, *Heart Beats Dust*, 1968, dust, plywood, glass, light, electronic machine.

The essential material of this sculpture is dust enclosed in a glass-faced cube and made visible by a high-intensity infrared-light beam. Alexander Calder activates the dust by placing the scope to his heart, triggering acoustic vibrations by the rhythm of his heart beats. The work manifests a form of collaboration with nature where natural forces within and outside the human body are brought into play.

(Photo: Harry Shunk)

transmission-receiving aspects and its implications for low-cost immediate feedback in comparison with film. The medium was ideal as the starting point for informal, studio closed-circuit experiments with concepts of time and motion – as a continuation of the formalist tradition of kinetic sculpture. The first video artists (see Chapter 4) conceived their works as modernist sculptural installations and performance.

Experiments in art and technology: collaborations in two kinds of thinking – art and science

Convinced there was a need for an information clearing house to make technical information and advice available, and a service for arranging individual artist–engineer collaborations in the United States, artists felt the need to seek collaborations with engineers and scientists to help in producing innovative work using new technologies. The artist Robert Rauschenberg and scientist Billy Klüver formed a new organization called Experiments in Art and Technology (EAT), which published its first bulletin in January 1967. Because of its governmental and corporate contacts, EAT was in an ideal position to act as a liaison between artists,[3] engineers, and corporations and to provide a meeting place where seminars, lectures, and demonstrations could be presented.

Bell Laboratory physicist Billy Klüver's friendship with members of the progressive Swedish avant-garde, such as poet and painter Oyvind Fählstrom and Moderna Museet Director Pontus Hultén, had brought him into contact both with European artists (as an advisor for Hultén's 1961 Stedelijk Museum kinetic exhibition) and with the New York art world. "Klüver saw many parallels between contemporary art and science, both of which were concerned basically with the investigation of life . . . [he had] a vision of American technological genius humanized and made wiser by the imaginative perception of artists . . . Klüver seemed to speak two languages, contemporary art and contemporary science."[4]

In 1965, when an invitation came to American artists from a Swedish experimental music society to contribute to a festival of art and technology, Klüver became the logical liaison between artists and engineers. Although the project fell through, it helped to establish a relationship between a group of choreographers associated with the Judson Memorial Church and musicians John Cage and David Tudor, multimedia artist Robert Whitman, and Oyvind Fählstrom. They began to combine technology with performance events known as Happenings named after the interactive participatory performance-based work of John Cage and Alan Kaprow (see Chapter 2). The excitement and energy of the emergent avant-garde were characterized in the efforts of Rauschenberg and Klüver, who in 1966 brought together thirty Bell Laboratory engineers to work with visual artists, dancers, and musicians. They raised funds for an ambitious project called Nine Evenings: Theater and Engineering by contacting individual corporations, foundations, art dealers, and collectors. However, from the start, the artist–engineer collaboration system encountered difficulties, for the engineers were not used to working against theatrical deadlines and frustrated artists were unable to rehearse properly without finalized technical support.

Aesthetically and technically, Nine Evenings was less than anticipated, but it proved that collaborations between artists and engineers were possible. In many ways, its most important function lay in defining the nature and basis of the problems (not the solutions) inherent in artist–engineer collaborations. Both artists and engineers had to learn new ways of thinking where the practical and the creative could interact. The experience they gained illustrated

clearly not only the high financial costs of such ventures but also the enormous amount of time and effort needed in planning and coordinating such complexity of activity and thought.

For example, the most ambitious (and ill-fated) project undertaken by EAT came in 1967, in the design and construction of an art and technology pavilion for the Pepsi-Cola Company at Expo '70 in Osaka, Japan. Following months of discussion and consultation, a construction and maintenance budget was decided upon and a preliminary concept for a mirror-surfaced domed interior was approved. Sculptures inside and outside, some using laser light and motion, would create a setting for the interactive and performance pieces to be presented inside the dome. The accent was on experimental programming which would involve the public and alter the functional relations between art and the public in a popular setting. Fog jets would shroud the exterior of the pavilion in a perpetual cloud of mist. No one could have predicted the enormous effort and difficulty of realizing such a project, which overshot its budget so alarmingly that, in the end, Pepsi's tolerance was exhausted and EAT was asked to leave even though work on the pavilion had been completed successfully and (miraculously) on time. The pullout represented a serious setback for EAT in its role as corporate mediator. Many of its six thousand members began to grumble that they were being bypassed and merely used as statistical fodder for EAT's grant proposals. Questions began to be raised about the cultural value of such expensive experimentation.

Artists and industry

The most costly and ambitious exhibition of collaborations between artists and engineers was *Art and Technology*, an exhibition curated by Maurice Tuchman, which opened at the Los Angeles County Museum in 1971. Five years in preparation, the show featured the work of twenty-two artists who had been paired to work with specific corporations under an elaborate contract system that covered costs of technical assistance, production, and maintenance of the work for the three-month duration of the exhibition. The contracts represent probably the most consciously thorough practical attempt of all the art and technology exhibitions to ensure there would be no pullouts or inadequate provisions for technical assistance in case of malfunctions. There were three categories of artists using new technologies: first, those whose formalist work was primarily concerned with the direct use of machines to explore the

Figure 3.7. (opposite top) Pepsi-Cola Pavilion, Osaka, 1970, environment designed by EAT.

The pavilion was designed as an interactive environment inside and out to be responsive to sound and light through strategically located systems, most of them triggered by the behavior and movement of the spectators. The outside of the dome was enveloped in a fog produced by mist jets.

(Photo: Harry Shunk)

Figure 3.8. (opposite bottom) Remy Charlip, *Homage to Loie Fuller*, March 8, 1970, performance inside the EAT Osaka Pavilion.

The spherical mirror at the top of the dome, the largest one made at the time, not only reflected the viewers but intensified the color and movement of the many performances that took place inside. The mylar walls created illusionistic reflected effects that produced a sense of participation and interactivity.

(Photo: Harry Shunk)

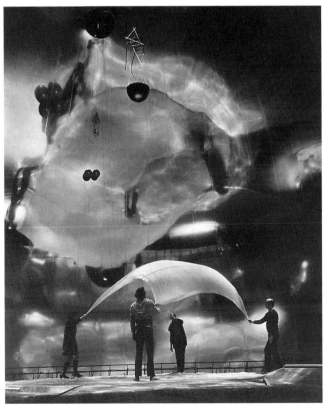

aesthetics of light and kinetic movement. These included Robert Whitman, Rockne Krebs, Newton Harrison, and Boyd Mefferd. The second category comprised well-known New York artists whose experimental work made use of fabrication technology (i.e., using the machine as a tool to produce their work), such as Claes Oldenburg, Roy Lichtenstein, Richard Serra, Tony Smith, Andy Warhol, and Robert Rauschenberg. The final group – James Lee, Ron Kitaj, and Oyvind Fählstrom – provided poetic and humorous relief in their serendipitous works by using the machine as an icon.

Although the tumultuous five-year period (1966–71) from the exhibition's original inception to its final presentation was marked by unforgettable socio-political malaise, none of the artists in the exhibition used technology to comment on the technological violence of the Vietnam War, which millions of Americans were watching on television. The war engaged a profound problem in the American ethos, for it challenged the belief in the American dream – man and machine creating a new democratic utopia through technological efficiency and progress. The 1960s mood of hope and optimism was replaced in the early 1970s by rage and frustration in a sea of events that seemed out of control. There began to be a growing awareness of the fatal environmental effects of some technologies. That technology could be poeticized

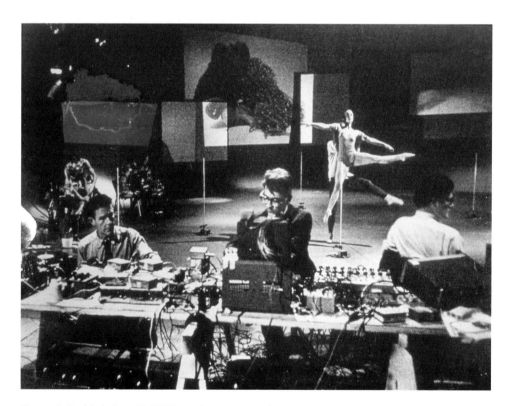

Figure 3.9. *Variations V*, 1965, performance work.

Foreground, left to right: John Cage, David Tudor, Gordon Mumma. *Rear, left to right:* Carolyn Brown, Merce Cunningham, Barbara Dilley. Choreography: Merce Cunningham; music: John Cage; Film: Stan Van Der Beek.

(Elelectronic Arts Intermix; Photo: Herve Gloaguen)

and humanized by art suddenly seemed irrelevant when its use had been unleashed for such destructive ends.

The critics attacked – insinuating that the exhibition represented a nefarious marriage between advanced technology, the museums, and big business. They coined new terms – "corporate art" and the "culture of economics."[5] A serious economic depression followed the ten-year war. It signaled a significant cutback in government and corporate support for the arts, a serious threat to costly technological collaborations. A crisis was also brewing in the art world.

In the early 1970s, the costly formal experiments (especially those kinetics employing computer technologies) that had taken place in the realm of high technology in the service of the arts, confined mostly within a conceptual framework, had led to an art not easily displayed in conventional museums and galleries. The work presented physical problems related to technological maintenance, obsolescence and sheer size, problems related to both the preserving and marketing functions of art institutions. There were few curators and critics who had the institutional training or interest to go beyond the usual parameters of art to explore the new aesthetics presented by the various technological thresholds of the new work. A consensus, between museum curators and critics, arose from these realizations. It resulted in a major change in their attitudes toward the validation and inclusion in the fine art canon of those art works which relied directly on technological means, excepting, however, the new electronic medium of video (see Chapter 4).

Art as pure information

"In Conceptual Art", wrote Sol LeWitt, "the idea or concept is the most important aspect of the work . . . all planning and decisions are made beforehand and the execution is a perfunctory affair. The idea becomes the machine that makes the art." When art's importance lies beyond what can be seen or touched, it thus becomes "dematerialized." The movement against art as material form was launched in various ways and took various forms. Rauschenberg's 1961 portrait of a Paris art dealer consisted of a Dadaesque telegram: "This is a portrait of Iris Clert if I say so." Yves Klein delivered a lecture at the Sorbonne in 1959 entitled "The Evolution of Art Towards the Immaterial." For Klein, the void of immateriality meant freedom, boundless open space, and levitation. This tendency toward dematerialization of the art object which began when photographic technologies were developed became even more of an issue with the evolution of digital imaging.

By the mid-1970s, important advances in technology opened possibilities for the computer also to become a truly personal tool for artists (see Chapter 5). The invention of the microprocessor and more powerful miniaturized transistor chips (integrated circuits) changed the size, price, and accessibility of computers dramatically. Commercial applications in design, television advertising, and special image processing effects in film and photography became an overnight billion-dollar industry, providing the impetus for increasingly powerful image-generating systems. The need for such intimate collaboration between scientists and engineers with artists now seemed no longer so urgent, for custom "paint system software" and "image synthesizers" began to appear on the market. Artists began to challenge the computer to go beyond the formal tasks it had up to then performed and found it could be used as both a tool and a medium. Imagery becomes dematerialized information in the computer's database. When digitized, this information affects a completely new outlook on

the visual field. Digital modeling began to create a crisis in representation. Because any kind of imagery can be digitized and reformulated, the computer, by the 1990s, had subsumed photography, video, and film.

Photography becomes a tool for deconstructing modernism

As we have seen, in line with refusal or violation of the formal purist aesthetic of modernism, the photographically represented world (with all its media, genres, and materials) was not drawn fully into the arena of mainstream expression. Ironically, once photography was accepted into the fine art canon, issues denied for so long under the rubric of modernism became the very focus and the means for its deconstruction. Strategies used were appropriation or quotation of pre-existing historical images, texts, forms, and styles. Mass-media influences originating in ironic "Pop" imagery were brought into a new, more political forum.

The formal, modernist aesthetic of fine art photography – handmade prints with their own claims of an acknowledged particular object presence or "aura" – has essentially separated photography from the more expanded postmodern view of it, as expressed by Walter Benjamin. He had seen photography as a powerful form of mass communication, with a social function which dominates the culture of everyday life. However, in forms such as photomechanical reproduction, cinema, and television, "fine art" photography had become trapped in the meshes of a confining system. Abigail Solomon-Godeau, in an essay entitled "Photography After Photography," writes about the nexus of postmodern attitudes with photography.

> Virtually every critical and theoretical issue with which postmodernist art may be said to engage, in one sense or another, can be located within photography. Issues having to do with authorship, subjectivity, and uniqueness are built into the very nature of the photographic process itself. Issues devolving on the simulacrum (authenticity versus artificiality), the stereotype, and the social and sexual positioning of the viewing subject are central to the production and functioning of advertising and other mass-media forms of photography. Postmodernist photographic activity may deal with any or all of these elements and it is worth noting, too that even work constructed by the hand . . . is frequently predicated on the photographic image.[6]

Barbara Kruger's work offers a good example of these major tendencies in art and its relationship to technology because she raises ironic questions about representation relative to social constructs. She uses the copy and appropriation as the major site for her conceptually based work. She reproduced found images from mechanically produced sources and adds texts to them so that they function effectively as active commentary. Her pieces, as she says, "attempt to ruin certain representations, to displace the subject and to welcome a female spectator into the audience of men." Kruger's media-conscious work is at the intersection of mass media, mass culture and high art. Her work is confrontational, agitational, and is aimed at destroying a certain order of representation: the domination of the "original," which up to now has largely been male-identified.

In another example of deconstruction, Sherrie Levine created a radical critique of originality (the hand of the artist) by rephotographing and thus "appropriating" in their entirety the

Figure 3.10. Barbara Kruger, *Untitled*, 1982, unique photostat, 71³/₄in. × 45⁵/₈in.

Kruger reproduces a (patriarchal) cultural myth to comment on different levels of value – for example, the value placed on hype about "genius" and "originality" in relation to art-market value as opposed to the communication value of the art work. Through creating her own work from found, appropriated images, she confronts the art-market method of assessing the artist as part of the "cult of genius" and the original as related to the hand of the artist by discarding both concepts.

(Collection The Museum of Modern Art, New York. Acquired through an Anonymous Fund)

works of other well-known artists (such as Walker Evans, Rodchenko, or Mondrian) and by signing the fabricated copy. Her neo-Dada work created a sensation and forcibly brought the issue of the copy into strong focus. Her work comments on the uncertain subjective basis for validation and justification of art. Paradoxically (both because her work aroused so much controversy and because of its special postmodern relevance) it has been reproduced countless times, thus raising its market value.

Mike Bidlo (another artist who, like Levine, appropriates other artists' work in order to critique the originality, authorship, and market system) has created an entire exhibition of Bidlo Picassos including *Guernica*, the Gertrude Stein portrait, and *Les Demoiselles d'Avignon*, which he showed at the Castelli gallery. His work poses the questions: When is a copy an original? And what is its market value in relation to the original? Bidlo and Levine challenge concepts such as the authenticity of the original, the primacy of the creative act, and the mastery or genius of the artist. Walter Benjamin provides an apt context for their efforts: "The criterion of authenticity ceased to be applicable to artistic production. Here the total function of art is reversed. Instead of being based on ritual, it begins to be based on another practice – politics." Copying processes are a threat to the value system of the gallery world. Copy artists

also reveal in their work the tension between the high value the arts have placed on "the real" and on commodity value in relation to the postmodern emphasis on the immateriality of mediated signs and referents.

Neo-Pop works which have dazzled gallery viewers with their punk sensibility since the early 1980s have used photography, and have appropriated commercial images from comics and media along with collage and an effluvia of found materials. However, the new Pop differed in its implicit critique of commercial culture by unmasking the "manipulative nature of the message-bearing images fed . . . through various media and designed to keep us consuming goods, goods produced solely to be consumed. The result is not only an appropriation of that imagery but also an appropriation of the power of that imagery."[7] The methods used by artists such as Keith Haring, Kenny Scharf, Rodney Alan Greenblatt, and Jeff Koons to convey their messages make use of the same mannerism, exaggeration, and sense of easy fun mixed with wrenching disjuncture that characterizes television itself. While 1960s Pop established an equation between aesthetic appreciation and commodity consumption of images, and, as a result, made their works more accessible to the public, the work had a "disinterested" non-political subjectivity to it which in effect refashioned the images, abstracted them, and effectively detached them from the context of their social relations. The reincarnation of Pop, however, is socially aware and uses incongruous, out-of-context imagery of all kinds to make its point. This new work aped the energy and the glitzy unabashed directness of commercial advertising style, of television and magazine style, but with its own political agenda.

Levine's use of other artists' work to question "the copy" and "the original" recalls the issues raised by Duchamp when he exhibited in a gallery his readymades – objects not only made by machines, but produced industrially as multiples of an object. Duchamp had pointed out that the meaning and value of art is a constructed product of the mind, and that changing the context of an object could create a new meaning for it and enable it to be seen differently through a different perspective. This act of appropriation and repetition indicates a kind of cultural exhaustion which has important shock value because it dramatically brings into focus major issues which normally lie below the surface, issues which need to be questioned. Seen in today's context, Duchamp's ideas, building on those of Walter Benjamin about appropriation, have gained fresh impetus by bringing up issues of the copy and the original, and the privileging of the object. Duchamp's readymades set an important precedent because they recontextualized and re-oriented art away from its own identity as a form (as in Minimalism or Abstract Expressionism) toward the kind of instability, and undecidablity, of postmodernism.

Deconstruction strategies open alternatives in the field of representation

Feminism, which evolved in its last incarnation as a result of the dramatic social change of the 1960s, contested the modernist canon. Feminist artists questioned the male-dominated litany of aesthetic values, of artistic criteria, and of art-historical practices. Suppressed and marginalized for so long by the dominant power structure, they began to profoundly interrogate and alter the subject matter for art, and the way art is practiced and positioned. By introducing feminist content into their work through the use of innovative new materials and techniques, they brought into the field of representation new views of gender and identity; of the body as subject matter; and dismantled, as we have seen, traditional notions of originality and

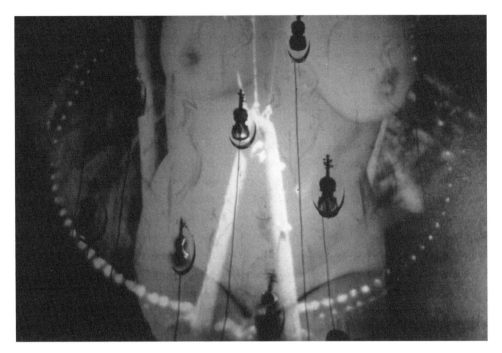

Figure 3.11. Carolee Schneemann, *Cycladic Imprints*, 1993, four slide projectors, dissolve units, stereo sound collage.

Schneemann's work through the past three decades has focused on the body as a site for shifting identities and political struggle. In *Cycladic Imprints*, her use of technology is both a conceptual and a sensual interface where specific forms of mechanization introduce randomizing configurations: seventeen motorized violin bodies are continuously in motion superimposed on a wall 18 by 30 feet long, painted with patterns of an archaic double curve. Projections from programmed slide projectors dissolve hundreds of images further animating the piece. "Schneemann has time and time again invented kinetic machinery and projection systems to dissolve the boundary between painting and film, working on the edges of dissolution where static elements are overcome, overtaken into motion."

(Carolee Schneemann)

authorship. With their fresh outlook they created new forms of mixed-media exploration such as the body-art of Hannah Wilke, the performance work of Carolee Schneemann, and the installations of Adrian Piper.

In "Death of the Author,"[8] Barthes asserted that the author (or artist) is never the source and the site of meaning but rather that meaning is never invented, nor is it locked in. A work exists in a "multidimensional space in which a variety of works, none of them original, blend and clash. The work is a tissue of quotations drawn from the innumerable centers of culture;" The artist or author is no longer the only container for feelings, impressions, passions, but is rather "this immense dictionary from which he draws a writing (image) that can know no halt: life never does more than imitate the book, and the book itself is only a tissue of signs, an imitation that is lost, infinitely deferred." This position of refusal to find fixed meanings or originality in authors, artists or their work is a fundamental refusal of what he regarded as an ossified and essentially backward-looking humanism.

The debate about these ideas and the aesthetic attitudes that grew out of the discourse led to appropriation, parody, and pastiche as critical imaging methods. As we have seen, the unmediated appropriation exemplified by Levine and Bidlo's works has a transgressional political edge. Appropriation may be seen pessimistically as merely looking backward. Alternatively, appropriation may be seen as renewal. It adds the context of history to current affairs. As pastiche, it can be a hybrid of imitations of dead styles, recalling the past, memory, and history with satirical intention. It can be referred to as a kind of radical eclecticism in which various styles or subsystems are used to create a new synthesis. Similarly, parody can be employed in different ways. The work of the neo-Expressionist artists could be seen as a satirical quotation of older work but it could also be seen as an effort on the part of contemporary German artists after the war to find new ground.

Deconstructive strategies opened the way to alternative representations involving social and cultural contexts for ideas. Eurocentric thought assumed a centered, authoritative voice based on a single worldview, structured through domination and transformation of subjected cultures. This attitude now seems outdated in the face of a globalized transnational, information economy. Even the process of analysis itself is suspect.

In the wake of cultural deconstruction and the shifting consciousness of the times, resistance to technology as an integral aspect of art-making and cultural development began to erode. Not only had new media invaded and changed the very fabric of public life by the mid-1970s (see Chapters 4 and 5), but they also began to play an integral part in altering perceptions and attitudes about the structure of art and its production and dissemination. The wider dispersal and dissemination of artistic practices could no longer be contained within the old framework. "The shift from art that could only refer to itself, to an art that could refer to everything, took place almost overnight."[9]

The new consciousness

After half a century, television has contributed strongly to a new cultural condition, a shift of assumptions and attitudes. A chaotic condition in which information and theatrical effects are mixed with the totally banal, and where art, culture, politics, science, and so on are all brought together electronically outside of their usual contexts and connections, has created a vast meltdown of forms within the public consciousness. Use of compressed, intensified images and messages, with their edited forced sequences and shock value, has now become part of everyday visual vernacular, by now, an absorbed aspect of Western aesthetic tradition and mass culture. Television's image flow has created a visual cultural phenomenon surpassing, and subsuming, the influence of the printed word, radio, and cinema. Television has the power to communicate, intensely mediate, and transform the public mind set.

Television itself is now undergoing a major change. In today's home entertainment center, television is only one of many options which vie for the public's attention. With the rise of computer technologies, the public may surf the Internet rather than the television airwaves. Computer games, CD-ROMs and DVDs are beginning to make inroads in the public consciousness. Watching rental videos of films on the home video player, and home box-office channel television rentals, is causing changes in the public cinema where "cineplex" projection facilities are becoming smaller and smaller, offering as much variety as possible for the viewers, rather like choosing another "channel." Interactive shopping channels are replacing the trip to the department store. The affordable small hand-held analogue or digital

camcorder is creating a whole new arena where the public are becoming videomakers, showing their works on their own television monitors. The public is thus brought face to face with itself. The creative use of media tools has become accessible to a far wider public than ever before.

MTV (music television) is a popular entertainment form involving popular music accompanied by performers, now widely available by satellite around the world. Its visual effects, borrowed from earlier independent artists' films and video, have been coopted, producing a mass public with a far more sophisticated visual sense than ever before. One spin-off of global television is the large number of films being produced with startlingly innovative visual effects. Films are becoming more visual, designed to avoid language problems in the culture of the global market.

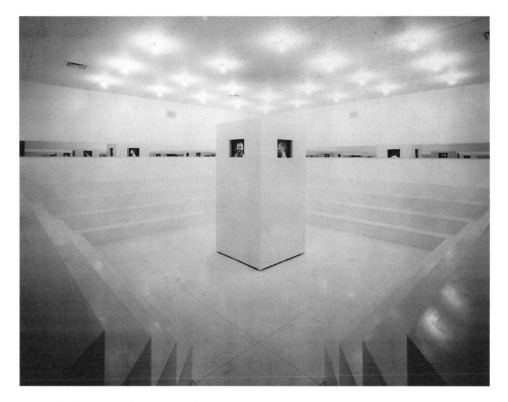

Figure 3.12. Adrian Piper, *What It's Like, What It Is*, #3, installation, *Dislocations* exhibition, Museum of Modern Art, New York, 1994.

Piper believes that artists have an unusual social responsibility "to crystallize and convey important information and ideas about the culture." She designs many of her works to situate the viewer directly into the drama of first-hand experiences of racism: e.g., to be the only black person in a white social community; to feel as though one has to be on guard at all times – back, front, sides – as the only person targeted by racially denigrating terms. She wants the viewer to identify with someone suffering racism. This work isolates her black subject in an all-white panopticon-like space, forced to identify with What it's like and What it is.

(Photo: Scott Frances/Esto)

For the body: a new kind of time and space

The contemporary body as it now exists inhabits a new kind of simulated environment in which time and space have become obsolete. Celeste Olalquiaga, in her poetic book *Megalopolis: Contemporary Cultural Sensibilities*, describes the postmodern experience.[10] The contemporary body now exists in a new kind of simulated environment where our conception of the corporeal self has been altered. Connected by mobile phone and the ubiquitous, all-pervasive plastic card, confused by a video landscape that has made a simulacra of reality in one's image, stripped of identity by controlled government and corporate information processing and surveillance to the point of total exposure, the postmodern individual is experiencing a major transformation of perception and consciousness.

The skewing of time by the constancy of artificial compressed viewing of television, its distortion by time/distance factors of jet lag, faxing, e-mailing, communicating on the Internet – our hours jammed with sensory overload – results in a strange kind of distracted state of exhaustion. As Olalquiaga says, "Spatial and temporal coordinates end up collapsing: space is no longer defined by depth and volume, but rather by a cinematic (temporal) repetition, while the sequence of time is frozen in an instant of (spatial) immobility." As a result, the body yearns for concrete intense experiences of reality, saturating itself with food, consumer goods, and an unhealthy fixation on sex.

Postindustrial urban space is artfully designed to create a feeling "of being in all places while not really being anywhere."[11] Lost in a maze of well-lighted continuous display windows of architecturally transparent shopping malls with similar stairs, elevators, facilities, the consumer wanders disoriented in a flat homogeneous space trying desperately to remember which spiraling space is the parking lot needed for the escape back to reality.

Walter Benjamin commented on the way new knowledge is acquired through apperception and distraction: "The tasks which face the human apparatus of perception at the turning points of history cannot be solved by optical means, that is, by contemplation alone. They are mastered gradually by habit, under the guidance of tactile appropriation." In reducing experience to the efficient common denominator of information, aspects of the body and of the computer have begun to transmigrate. The body becomes more mechanized at the same rate as the computer becomes more "friendly." The boundaries between the spheres of the body and of technology have begun to transgress, overlap, and blur. The computer's capability to create completely simulated worlds has further distanced the body from tactility. Alice Yang comments that the body as a physical dimension is not only a *subject* of representation,

> but is the means through which we make and experience art. It is through the bodily process of looking, touching, and moving around in space that we have come to apprehend art. Thus the impact of technology has significant repercussions also for notions of art making and art viewing . . . slowly and perhaps inevitably, technology is uprooting aesthetic experiences located in the body such as tactility and human vision.[12]

A concrete example of this change is the degree to which the interactive CD-ROM has changed the bodily experience of reading and of looking at visual images. Instead of the touching and feeling relationship the the viewer has with the book as an interactive object, the computer provides an immaterial interactive experience. It allows for the branching out of visual or textual material to present choices to the viewer through a series of document blocks linked

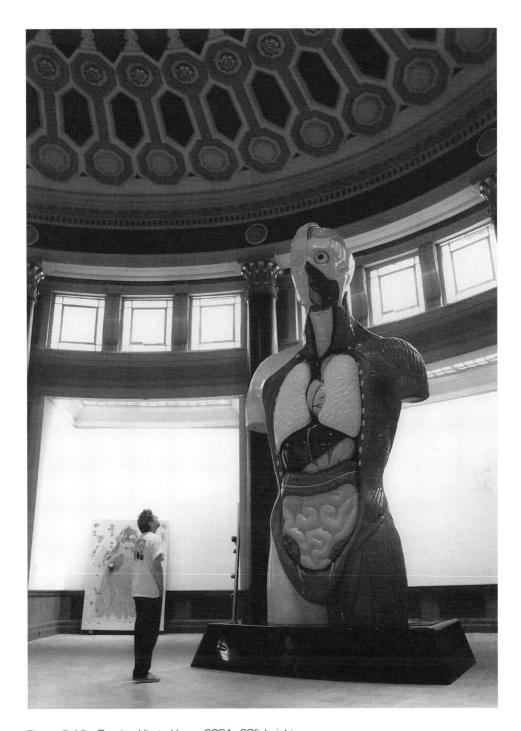

Figure 3.13. Damien Hirst, *Hymn*, 2001, 20ft height.

(Saatchi Gallery, London; Photo: Jonathan Player)

to different pathways. It creates interconnected webs of information and is able to link various kinds of image files and other types of documents, network them and create paths and nodes to connect them. CD-ROM multimedia imply visual or textual material or sound with possible electronic linkages which can be manipulated and rearranged at the viewer's command.

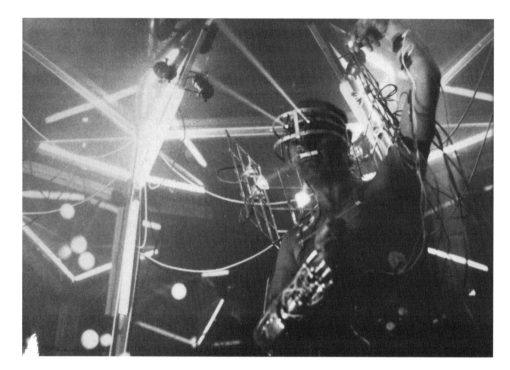

Figure 3.14. Stelarc, *Amplified Body, Automated Arm and Third Hand*, 1992, performance in three 15-minute segments.

This Stelarc performance event is meant as an interface and interplay of human and machine systems – of muscle and motor motion. The left arm is activated by muscle simulations, it jerks up and down involuntarily while the right side controls the attached third hand. Amplified body signals relate internal physiology to sound and motion. Later, eye pulse is in phase with the heartbeat.

(Stelarc. Photo: Tony Figallo)

Technological conditions lead to a more public art

Proliferation of electronic technologies has increased cultural participation of the public in art events (as a form of empowerment and education). With roots also in avant-garde art attitudes from the 1960s and 1970s, derived from the "Happenings" movement, which focused on public participation and performance and on conceptual projects, a more public art began to evolve. Conceptual art was immaterial with no object value. Its meaning resided not in the autonomous object but in its contextual framework. The postmodern idea that the physical, institutional, social, or conceptual context of a work as being integral to its meaning, took root and became the basis for expanded notions of sculpture and of a more public art in the 1970s.

This hybrid cultural practice with its intentions of connecting to a wider audience and as a means of subverting the usual commercial forms became an activist art which encouraged collaboration amongst artists. Some of these collaborations were anonymous group entities such as Gran Fury, and the Guerrilla Girls. Others challenge art-world notions of individual authorship, the cult of the artist and of private expression, by assuming group names, such as Group Material and Critical Ensemble. It was felt that anonymity provided a greater focus on the work itself instead of the usual attention to artists as personalities. The goals of these groups were to act as critical catalysts for change and to create an arena for public partici-pation. Their work took the form of a combination of grassroots activity using media tools. Reaching out for media coverage of their work is an important part of their strategy.

Group Material, founded in 1979, describes itself as an organization of artists "dedicated to the creation, exhibition, and distribution of art that increases social awareness." It believes strongly that art should not be just for "initiated audiences of the gallery and museum" but is intended to "question perceived notions of what art is and where it should be seen." Its work, also seen in exhibitions throughout the USA and internationally, bridges the culture gap between high and low, elite and popular. The group organizes public lectures and discussions

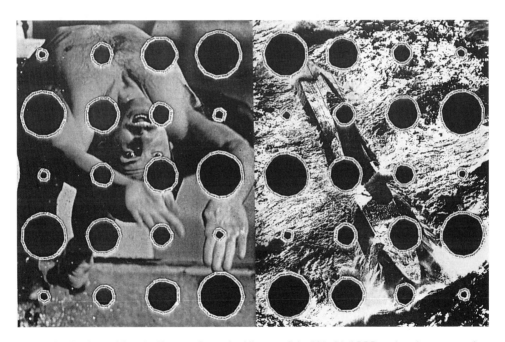

Figure 3.15. Larry List, *An Excerpt from the History of the World,* 1990, color photocopy print, 10½in. by 17in.

The copier is a natural interactive tool for Larry List, who is interested in "making an art that suspends one in a state of flux between seeing and reading, questioning and answering." Image and words are combined in innovative graphic ways like a labyrinthian puzzle, underscoring their function as they overlie the image structure beneath. This layering of intentions creates an extremely intense bonding relationship between image and word. The photocopy machine is used as an integral, characteristic aspect of his layered work.

(Larry List)

for important forums such as the Dia Art Foundation. For example, their part of the 1988 program centered on issues of the crisis of democracy. In this extension of their artists' public commitment, the artists' galleries – Mary Boone, Josh Baer, Barbara Gladstone, Metro Pictures, and John Weber – cooperated. Paradoxically, the artists themselves see that expanding their public image in the community helps them to attain the status and recognition which will increase interest in their public voice. Grants and sales of their work support some of their public activities.

In May 1988, Group Material (funded by the Public Art Fund) created a project called "INSERTS" – a twelve-page newsprint booklet to be inserted in the Sunday magazine supplement of the *New York Times*. The insert contained copies of ten art works created specifically for the project by well-known artists including Barbara Kruger, Louise Lawler, Richard Prince, Nancy Spero, Jenny Holzer, and Hans Haacke. Their project was designed to get art off the wall, out of the plaza, and into everyone's hands through the daily paper. The Guerrilla Girls have also created a powerful public dialogue through their strategies of anonymity, theater, irony, and humor. By their collective spirit and their strategy of using information and its print technology in the form of posters and billboards, they have scored stronger feminist points than any one painting could have done.

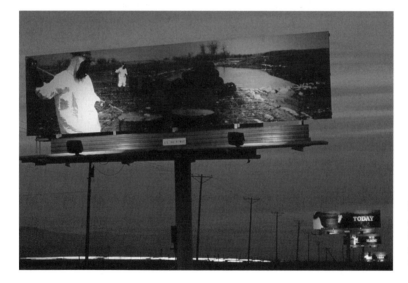

Figure 3.16. John Craig Freeman, *Rocky Flats Billboards*, 1994.

In 1987, John Freedman decided to break the public apathy about the extremely dangerous plutonium pollution at the Rocky Flats Nuclear Weapons Facility near Boulder, Colorado. He created a series of anti-nuclear billboards along Route 93 to dramatize the need for a major clean-up of radioactive materials. Using scanned-in photographs blown up by as much as 3200 percent and printed out as giant tile sections on a poster-maker printer, the final billboards were hand-assembled. The sequenced billboards read in one direction: "Today . . . We . . . Made a . . . 250,000 Year . . . Commitment." From the opposite side it read: "Building . . . More . . . Bombs . . . Is a Nuclear . . . Waste." Digital activist Freeman believes that a public art can circumvent problems of the gallery system such as the commodification of culture and the perpetuation of an exclusive, elite system for art. He believes in bringing art to the public: "If people are too busy to go to the gallery or museum, it makes sense to bring art to them. They don't even have to get out of their cars."

(Photo: Jenny Hager)

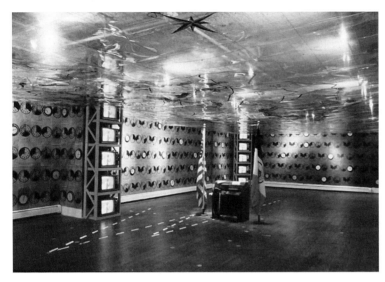

Figure 3.17.
Mierle Laderman
Ukeles, *Touch
Sanitation* show,
1984, Installation,
four-part video
environment with
television towers.

Through this immense multimedia installation Ukeles posits maintenance as a literal art work existing in real time. Five years in preparation, this exhibition has resulted in a new kind of public art. For the first time, a public service agency collaborated with an artist in a project that portrays the important relationship between culture and maintenance. Virtually every unit of the Department of Sanitation participated with the artist in the creation of these art-environmental works. The four-part video environment includes thirty-four monitors, twenty-eight of which are stacked into four fourteen-foot-high "television towers," running five different tapes in eight separate locations. The installation, some of it prepared by the sanitation workers themselves, also includes a 1500-square-foot transparent map of New York City suspended overhead, a special print installation of clocks in fifty-three colors, and forms designed for all the walls of the gallery.

(Ronald Feldman Fine Arts Inc.; Photo: D. James Dee)

Mierle Laderman Ukeles stands out for her strong social commitment and for the innovative video methods she used in producing the *Touch Sanitation* show. Ukeles chose to work with the New York Department of Sanitation, thus not only focusing on the stigmatization of those workers by the public but also showing that the work they do participates in an important relationship between culture and maintenance. She created a four-part video environment utilizing thirty-four monitors, twenty-eight of which were stacked into four fourteen-foot-high television towers in an environment which is a reconstruction of two sanitation lunch or locker room facilities. (These were literally taken out of the real workplace and reinstalled in the gallery space.) Ukeles dramatized her eleven-month involvement with the workers through a kind of performance where she criss-crossed the city making contact with all of them through her video documentation concept. She engaged them directly in the process of creating the installation.

Dennis Adams's bus shelter projects with their double-sided illuminated display panels are similar to regular bus shelters but use large photographic transparencies to comment on history or to underscore the politics of poverty and wealth apparent in city neighborhoods. Krzysztof Wodiczko's mammoth night projections beamed onto city buildings and monuments create a strong political statement whenever they appear. Using the idea of spectacle and risk in the urban environment, he dramatizes the architecture of public buildings to supply the real identity of its public function. For example, he projected the image of a missile

on a war monument; he projected the figure of a homeless man on a public monument in Boston.

Another aspect of the greater public stance of art made possible through the agency of technology is in the field of artists' books. Printed Matter, in New York, the leading distributor of artists' books, carries more than three thousand titles by 2500 visual artists. Artists such as Paul Berger, Keith Smith, Johanna Drucker, Paul Zelevansky, Warren Lehrer, Joan Lyons, and Sue Coe are committed to the project of creating part of their work in book form, thus creating a gallery of ideas available in bookstores as art for a broader public. Although artist book outlets exist mostly in museums and small specialty shops, the movement is being strengthened by good-quality and relatively low-cost electronic reproductive equipment such as inkjet printers, laser photocopy machines and computerized "desktop publishing." Recently, Galerie Toner in Paris took advantage of this technology and commissioned several artists to create books.

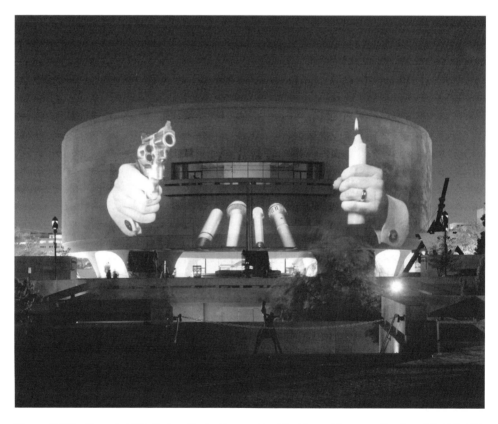

Figure 3.18. Krzysztof Wodiczko, *Projection on the Hirshhorn Museum*, October 25, 26, 27, 1988.

To draw attention to the power relations which exist between cultural institutions and the public, Wodiczko created an environmental projection work which covered the façade of the Hirshhorn Museum in Washington. The image was projected from three xenon-arc projectors.

(The artist and the The Hirshhorn Museum and Sculpture Garden, Smithsonian Institution, gift of Joseph H. Hirshhorn, 1966; Photo: Lee Stalsworth)

Extensions of modernism and cross-currents of postmodernism

Some contend that the very multifaceted inclusive nature of the postmodern paradigm allowed for modernism as one of its aspects to survive in the final part of the century, Most of the major formalist artists such as Johns, Stella, Serra, Lichtenstein, Martin, remain at the peak of their prestige – exhibited, commissioned, and collected. Even though modernism is dead, it is still dominant. Many in the art-world community, such as the curator of the 1995 Whitney Biennial, Kurt Oestenfoss, and Robert Storr, curator of painting at the Museum of Modern Art, do not accept that the project of modernism is at an end. They say that it simply needs adjustment, even though cultural conditions have been altered by such radical change in technological standards. A broad range of postmodern strategies exposed the "coded" languages of popular media and revealed the hidden context of art-world politics.

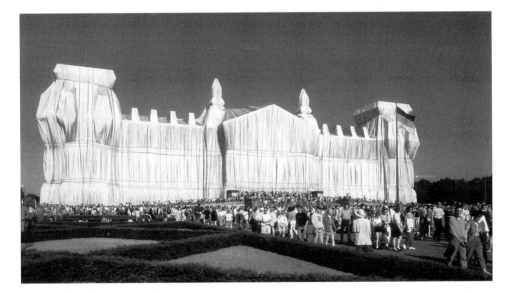

Figure 3.19. Christo and Jeanne Claude, *Wrapped Reichstag, Berlin*, front (west façade) view, June 25, 1995.

Christo and Jeanne Claude's huge public environmental works have become celebrated over the years not only because of their extravagant beauty but because they are inclusive and tend to bring people together. Financed by the artist through sales of the original drawings, photographs and sketches for each of the projects, the works are free from encumbrance from the usual funding problems. Each project is allowed to exist only for a brief two to three weeks. The original landscape the artists invade or "wrap" is returned to its original state, with photographs or video as the only documentation of the event. Often permissions to create such works take many years of negotiation to achieve. It took twenty-four years of such lobbying before Christo and Jeanne Claude succeeded in wrapping Berlin's Reichstag, a building which symbolizes a century of European strife. The project ultimately utilized 1,076,000 square feet of aluminized polypropylene fabric. The *Wrapped Reichstag* as an unexpected gleaming magic mountain seemed to package the past and to suggest the possibility for a new phase for a Germany, so unencumbered by its history.

(Marius A. Ronnett)

Postmodernism has led to new attitudes and to acceptance of old ones, such as "beauty," as well as new understandings and a pluralistic acceptance of many approaches to art-making, including formal ones. However, the impact of technology is gradually uprooting aesthetic practices which supplant art's mimetic functions, just as photography did. Computer imaging allows for the fabrication of new immaterial worlds which are increasingly severed from the human observer, and which are capable of invading the image and destabilizing it.

The split we have been following in artists' attitudes toward representation has continued to be present. Some see values eternal to the human condition inscribed in their work as overriding all other considerations. Others point to imperatives of today's issues and the need to reflect the technological culture we live in, commenting on it through the use of contemporary media tools. Rather than seeing that the postmodern thrust toward appropriation, instability, decentering, intertextuality, and acceptance of diversity, leads to decay of meaning, it is possible, say some, to see an enrichment of ideology and style taking place.

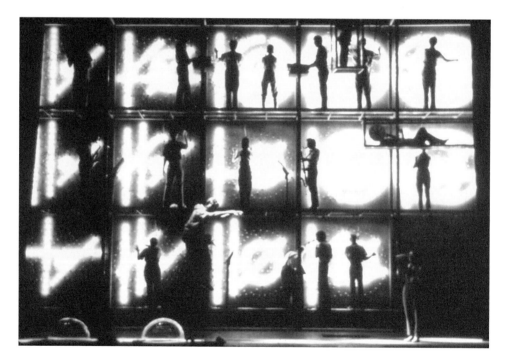

Figure 3.20. Robert Wilson, *Einstein on the Beach* (final scene by the lightboard), 1986.

Wilson's *Einstein on the Beach* is a new genre of work, a performance-visual-arts form that fractures language and content and alters our perception of the possibilities of theatrical experience. With composer Philip Glass and choreographer Lucinda Childs he has created a "cosmos" of the arts. As an evocation of ideas and elements covering the span of Einstein's life with the emphasis on technological advancements from steam-engine to space exploration, it brings together symbols and referents that seem to evoke a "fourth dimension" where time is atomized. The melding of space and time in Wilson's spectacle parallels scientific thought, where space itself is endowed with time attributes and vice versa.

(Photo: Babette Mangolte)

Looking back on the twentieth century, Roland Barthes remarked that "in a way it can be said that for the last hundred years, we have been living in repetition." When we examine his premise, from the vantage point of the visual arts, it projects an overview of all the major ideas and movements of the modern period from the early 1900s. Abstraction and Cubism, Constructivism, Dadaism, Expressionism have all been repeated through neo-Dada, neo-Constructivism, neo-Expressionism. In the 1980s and 1990s there was a replay of mainstream movements from the 1950s and 1960s including neo-Minimalist, neo-Pop, neo-Conceptualist. This has occurred with slight progressions and extensions, but with no real new break in the field of perception or systems of meaning which offer a serious challenge to Renaissance notions of representation. Technologized seeing and forms of representation have now, however, passed well beyond photography and cinema, to embrace the radically new aspects of electronic representation opened up by television, video, globalized electronic com-munications, and to the computer with its revolutionary capacity to create digitized structures which produce "virtual" images and interactive possibilities. As a means of representation, these media, like photography in the nineteenth century, have been, until recently, largely marginalized by the mainstream. Nonetheless, the social and economic implications of their use have affected society since the early 1960s.

New York Times critic Michael Brenson comments on the postmodern shift: Art can now "be conceptual, photographic, figurative, or expressive. It [can] mirror and engage the mass media, particularly the visual media like television and film. It [can] have mythical, personal, and social subject matter . . . It [has] something to say about the giddy excitement and awful conflicts of late twentieth-century life." Whether it is conservative or progressive, the need for aesthetic experience is felt more deeply than ever before by a larger number of people as they strive to situate themselves in the complexity of the electronic age.

Notes

1 Guy de Bord wrote *The Society of the Spectacle* (originally published 1967). By 1958, forty-two million American homes were fed by broadcasts from fifty-two stations. As a result of the wild barrage of images which flowed through its television sets from all over the world, the public participated collectively, in the comfort and privacy of their living rooms, in a new cultural condition. Apart from the commercial junk, they saw documentary reportage of the Moon landing, Kennedy's assassination, the faraway Vietnam War, Martin Luther King's funeral, and the civil rights marches. These compelling images were mixed in with an odd assortment of cultural manifestations including soap operas, game shows, religious sermons, science programs, cooking lessons, gym classes, and reruns of old movies.

2 Video was welcomed in the art community also as a means of documentation. Those artists doing large-scale Earth art environmental projects rely heavily on video films and photographs as documentation of their faraway work both for funding purposes and for public awareness of their work. In the spirit of fusing art and life and locating real objects in real space, the Earth artists engaged material reality – desert, sky, water, land – and executed their projects in real locales. As a testament, the photographs could never transmit the spirit and the experience of the work's true scale and presence. However, the concept of documentation of a project through the use of all aspects of photography and video became a firmly established practice for all artists, including those in the dance, theater, and performance genres. Funding sources for these costly environmental works also began to dry up during the economic depression of the early 1970s.

3 By 1967, EAT arranged for a juried exhibition, *Some More Beginnings*, at the Brooklyn Museum in the form of an international competition. Prize-winning works were to be included in the Museum of Modern Art's *The Machine* exhibition.

4 Calvin Tomkins, *Off the Wall* (New York: Penguin Books, 1993), p. 252.
5 Among the most virulent of the reviews was that of *Artforum's* Max Kozloff. According to the art historian Jack Burnham, "Multimillion Dollar Art Boondoggle" was "probably the most vicious, inflammatory and irrational attack ever written on the art and technology phenomenon." It posed the museum, Tuchman, and most of the artists connected with Art and Technology as lackeys of killer government, insane for new capitalist conquests in Southeast Asia. Kozloff depicted half of the artists involved as "fledgling technocrats, acting out mad science fiction fantasies." Jack Burnham, "The Panacea that Failed," in Kathleen Woodward, ed., *The Myths of Information* (Madison, Wisconsin: Coda Press, 1980), pp. 200–15. Later, bitterly, Burnham commented in the October 1971 *Artforum*: "Whether out of political conviction or paranoia, elements of the art-world tend to see latent fascist aesthetics in any liaison with giant industries; it is permissible to have your fabrication done by a local sheet-metal shop, but not by Hewlett-Packard."
6 Abigail Solomon-Godeau, "Photography after Art Photography," in Brian Wallis, ed., *Art after Modernism: Re-thinking Representation* (New York: The New Museum of Contemporary Art, and Boston: David R. Godine, Publisher, Inc., 1984), p. 80.
7 Peter Frank and Michael McKenzie, *New Used, Improved: Art of the Eighties* (New York: Abbeville Press, 1987), p. 90.
8 Roland Barthes, "The Death of the Author," in *Image-Music-Text*, translated by Stephen Heath (New York: Hill and Wang, 1977), pp. 146–7. Foucault wrote about representation in *The Order of Things* and in *What Is the Author*.
9 Michael Brenson, "Is Neo-Expressionism an Idea Whose Time Has Passed?," *New York Times*, Section 2, Sunday, January 5, 1986.
10 See Celeste Olalquiaga, *Megalopolis: Contemporary Cultural Sensibilities* (Minneapolis: University of Minnesota Press, 1992).
11 Ibid.
12 Alice Yang, "Cyborg Aesthetics," essay for the exhibition *The Final Frontier*, The New Museum of Contemporary Art, New York, May 7 to August 15, 1993.

part two

MEDIA

Video as time, space, motion

If two drawn circles are shown to overlap, the first representing independent film (with its crossover roots in both film and the visual arts traditions), the second representing television, the overlap can be seen to be video with influences from all these circular areas resonating one with the other.

Nam June Paik

Any image from everyday life will thus become part of a vague and complicated system that the whole world is continually entering and leaving . . . There are no more simple images . . . The whole world is too much for an image. You need several of them, a chain of images . . . No longer a single image, but, rather, multiple images, images dissolved together and then disconnected . . . Art is not the reflection of reality, it is the reality of that reflection.

Jean-Luc Godard

Away from the world of network television transmission and distribution, video, as a television tool used by artists, paradoxically began its existence as an independent medium in the cloistered space of artists' studios, galleries, and museums. Within the modernist framework of its beginnings, video production as a valid practice for artists did not seem at first to overlap with broader social attitudes about the congruency of culture, consumption, and ideology which were growing. However, the extremely rapid development of video technology itself brought it to the level where its capabilities began to converge with film and digital technologies where it could be used as a potential media tool – one whose productions could be broadcast and transmitted online. These developments have brought with them deep changes in attitudes toward the use of video as a medium in the fine arts. The relationship of artists' video to broadcast television, to cinema, and to the Internet and the differences between them, form the context of an important history and confrontation.

CONTEXT MEDIA ARTISTS for further information refer to website

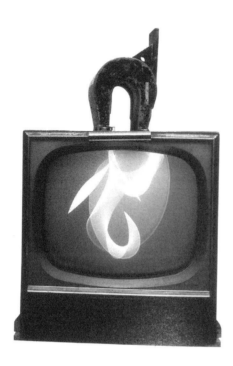

Figure 4.1. Nam June Paik, *Magnet TV*, black-and-white 17in. television set with magnet, 1965.

This is one of Paik's first works using television as a medium. Here he experimented with electronic effects through disruption of the electronic scanning components of television with magnets. His neo-Dada delight in subverting and playfully demystifying its invisible broadcast technology has proved to be a continuing theme of his work, in one form or another. For him, the television set itself is a mass culture icon which needs to be satirized, humanized. He saw that it could be used not only as sculpture but as a means of global communication for art.

(© 1996 The Whitney Museum of American Art New York; purchase, with funds from Dieter Rosenkranz)

Video, a new time, space, and motion medium

In 1965, the first video camera/recorder, Portapak, was released in New York by the Sony Corporation. Although the early equipment was relatively heavy and its black-and-white half-inch image quality poor (not of broadcast quality) and there was no editing equipment, it provided the first access to the potential creative use of video as an artist's television medium. Until then, video equipment existed only as enormously expensive, cumbersome television-camera-and-broadcast apparatus restricted to use within tightly controlled broadcast transmission facilities.

Nam June Paik and Wolf Vostell, part of the first generation to grow up with television, began using television sets as part of their neo-Dada assemblage combines. They were influenced not only by tendencies in the art of their times but also by the vagaries of commercial television. Their machine collages using readymade television sets were meant to comment on and subvert the presence of television as a mass-culture icon by placing it out of context in an art gallery. They playfully demystified its "invisible" broadcast technology by experimenting with the medium's scanning components. Paik's machine collages with their unexpected electronic effects were first exhibited at the Galerie Parnasse in Wuppertal, Germany, in 1963. That same year Vostell was displaying his brand of partially demolished television collage works at New York's Smolin Gallery.

The unique electronic recording capability of video provides immediate "live" feedback in seeing moving images recorded by the camera directly on a television monitor screen. Unlike film technology, there is no processing lag time in seeing what has been captured by the camera, and images are stored on inexpensive video cassettes which can be erased and

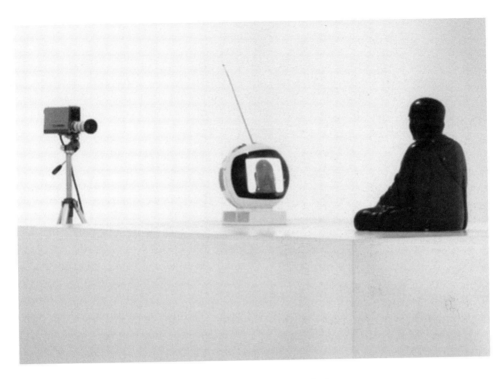

Figure 4.2. Nam June Paik, *TV Buddha*, 1974, video installation.

Paik's *TV Buddha* represents an important early phase of experimentation in video feedback in which the self-reflexivity of the transmission technology of the camera was exploited in various ways. The camera focused on a point which could then be seen on a monitor. In this piece, Paik captures the playful yet ironic distance that exists between the mindless technological stare of the television monitor and the Buddha's contemplative gaze.

(Museum of Modern Art; Photo: Peter Moore)

reused. Video is capable not only of recording images but of immediately transmitting them in closed-circuit systems on multiple monitors (or for long-distance transmission of its signal via cable or on the public airwaves). Part of the strong attraction of the video Portapak was its flexibility and ease of operation in the studio or outdoors without the need for special crews or operators. In their studios, artists could direct the camera at themselves to explore personal narratives or as a record of performance or body art. Out of doors, they could record real events as part of political statements or as experimental documentary interpretations of the urban or rural environment (to be played back later on a monitor). Some saw video as an agit-prop tool. Installed in closed-circuit elaborated gallery settings, the video camera with a delay feedback loop could confront and interact with the viewer in a new dialogue which placed the spectator within the production process as part of the formal conceptual intentions of the artist. Combined with sound, music or spoken dialogue and text, the medium opened up new aesthetic ground for exploring time, motion, sound, and image relationships in a broad range of contexts.

Figure 4.3. Ulrike Rosenbach,
Meine Macht ist meine Ohnmacht
(To Have No Power Is to Have
Power), 1978, video
performance.

One of the foremost European video
performance artists, Rosenbach
creates feminist rituals by projecting
images from art history and popular
culture iconography in which her
own presence is captured and
recorded within the scene. In this
early 1978 piece, she is shown
trapped as an unwilling victim in
front of television monitors that are
in turn reflected from an overhead
sphere.

(Ulrike Rosenbach)

Some artists, especially women, were attracted to the newness of video for the very reason that it had no past history, no objecthood, and no agreed-upon value. They attempted to distinguish it from other art forms by stressing its uniqueness as being an exclusive new category of its own and by denying its influence from other media. It was not film, not television, not theater. In his 1970 *Expanded Cinema*, Gene Youngblood separated the video medium from the history of film and of film language and theory because of its very self-reflexivity, its personalized ability to provide the immediate feedback of a mirror image. The individual artist could use it experimentally. It was seen as a personal rather than as a collective institutional enterprise such as film. In many ways, the early video screen had the fascination of projected "luminous space," suggesting a painterly but conceptually abstract site for the play of light and dark which in a metaphysical sense is reminiscent of Malevitch's 1918 *White on White* painting and Moholy-Nagy's early experiments with light and shadow. Its ability to organize a stream of audio-visual events in time suggested poetry and music.

Pioneering video

Because no editing equipment was available until the mid-1970s, and the tapes were not compatible with the broadcast signal, most of the early artists' videos focused on real-time

closed-circuit conceptual projects. Installed in public places or controlled elaborated sites in museums, the video camera, with a feedback loop, could confront the "on-camera" spectator who became part of an interactive dialogue as an aspect of the artist's intentions – a unique way of exploring fresh relationships in the triangle which exists between artist, object, and viewer. In Bruce Nauman's *Corridor* (1969–70), a passageway became a sculptural space surveyed and mediated by the video camera's point of view. The viewer, although he could never see his own face on the monitor, progressed through the corridor as part of a self-reflexive (art about making art and its own materials) interactive inquiry into time and space. The real time of the camera (which stays on continuously) is watchful of the viewer's intrusion into the space and the space becomes abstract, flattened information on the black-and-white monitors.

Other important pioneers who used video for exploring the camera's viewpoint as part of a study of illusionistic perception and architectural space relations were Dan Graham, Peter Campus, Ira Schneider, and Frank Gillette. Their closed-circuit multimonitor works took on a variety of forms as complex installations, where one could see immediately what the camera was recording or see it as part of a delayed playback loop, as part of an illusionistic play with space and time.

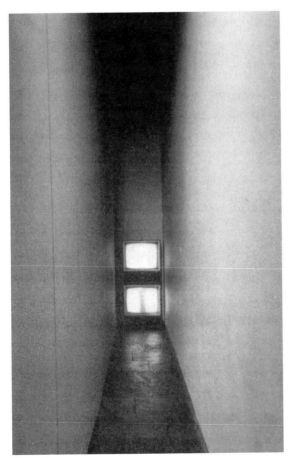

Figure 4.4. Bruce Nauman, *Live Taped Video Corridor, 1969–70.*

Corridor is a deceptively simple example of Nauman's early experiments with live feedback video as he attempted to redefine time and space through the dislocations possible with this potentially sculptural aspect of video technology. Just outside a corridor where two video monitors are stationed, a live video camera is concealed about ten feet from the floor. On entering the corridor, you look into the top monitor expecting to see yourself entering, but the top monitor shows only an empty corridor. You keep watching, waiting for an image of yourself entering but finally notice you are appearing on the bottom monitor with your back to the camera. The top live view of the empty corridor gives a sense of being absent, or being there earlier or later.

(Bruce Nauman and ARS; Photo: Rudolph Burckhardt)

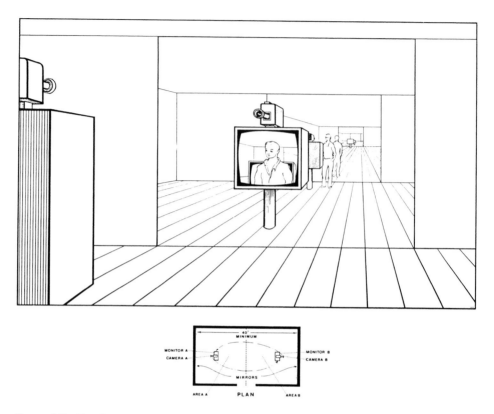

Figure 4.5. Dan Graham, *Opposing Mirrors and Video Monitors on Time Delay*, 1974, installation diagram showing position of mirrors, television monitors, television cameras, and recording decks.

Graham was one of the first video artists to fully explore the relation between video and the process of viewing and being viewed; between architecture, illusionary space, and the "time-present" transmission aspects of the medium. In this early experiment of time delay, he pointed the video camera mounted on monitors at opposing mirrors. The viewer became involved in a fascinating experience of illusion and perception. Interaction with the viewer in a closed space was important. The length of the mirrors and their distance from the cameras are such that each of the opposing mirrors reflects the opposite side as well as the reflection of the viewer within the area.

(Dan Graham)

Apart from these interactive video installations in site-specific architectural environments, other types of installations use multimonitor, multichannel forms as more self-contained sculptures and assemblages. Video sculptures are compact units and are usually composed of several monitors located within specifically built sculptural forms. Shigeko Kubota's *Nude Descending a Staircase* (1976) is a witty video tribute to Duchamp's key twentieth-century painting. Her contemporary work is a plywood staircase with four monitors inserted into the risers showing a colorized videotape of a nude repetitively descending a stairway. Other multimonitor installation works weave together prerecorded contrasting elements, as in Beryl Korot's *Dachau*, a video about the Holocaust. The audience views the interwoven carefully edited four-channel work from a single vantage point.

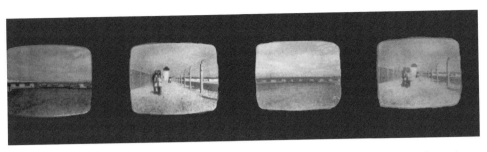

Figure 4.6. Beryl Korot, first four monitors of *Dachau*, 1974, four-channel twenty-four-minute multimonitor video work.

Dachau is a four-channel work which is structured like a weaving: two sets of paired images move together but the other two move with them in slightly different time relationships and are bound to follow them throughout the work as it proceeds in time. The non-verbal repetitive rhythm of the edited image sequences – outside walls, barracks, crematoria – beats out the kind of timing that evokes for viewers the experience suffered by Dachau's Holocaust concentration camp inmates many years earlier.

(Beryl Korot; Photo: Mary Lucier)

 Another direction in early video manifested itself as a variety of what critic Rosalind Krauss has termed "narcissistic" performance. Here, the body or human psyche of the artist took on the central role as the most important conduit in the simultaneous reception and projection of the image received via the monitor as a kind of immediate photographic mirror. Vito Acconci in his twenty-five-minute work *Centers* (1971) centered his body between the camera and the monitor and pointed to the center of the monitor. The viewer's line of sight could encompass simultaneously the artist's, sighting his plane of vision toward the screen along his outstretched arm and the eyes of his transmitted double on the monitor. Krauss describes this narcissism as a kind of psychological strategy for examining the conditions and traditions of the relationships between the process of image-making and the viewer's perception of it. Nancy Holt, Richard Serra, Lynda Benglis, and Chris Burden are a few of the artists who explored early conceptual aspects of performance-oriented video.

 The new apparatus separated itself from traditional representation and film by opening the way to exploration of a completely new way of communicating and transmission, involving elements of time and space, use of sound and performance, audience participation, and use of a moving camera, which, although video could not be edited at that time, could show and transmit different angles and vantage points from close-up to distant views. However, the same split developed amongst the practitioners toward issues of representation which, as we have seen, date to Renaissance times. On the one hand, artists such as Bruce Nauman and Dan Graham were interested in the more formal conceptual aspects of the medium, incorporating it as part of their existing outlooks on art. Others such as Nam June Paik were interested in exploring the new ways of seeing and communicating it offered and what could be learned about expanding notions about art and representation through a full understanding of the implications of this revolutionary new visual tool.

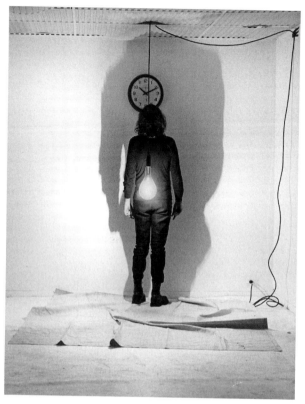

Figure 4.7. (left) Vito Acconci, performance at Reese Paley Gallery, New York, January 15, 1971.

(Photo: Harry Shunk)

Figure 4.8. (below) Vito Acconci, Dennis Oppenheim, and Terry Fox, performance at Reese Paley Gallery, New York, January 15, 1971.

Acconci thought of video "as a working method rather than a specific medium." Using the video camera as an impulse for witnessing and recording, he focused on the physical reality of his body-presence, orchestrating his movements and gestures, investigating interior and exterior dialogues between himself in relation to the viewer – role playing, conceptualizing his body as a container, as a locus for action or contemplation defined by its presence in a public space.

(Photo: Harry Shunk)

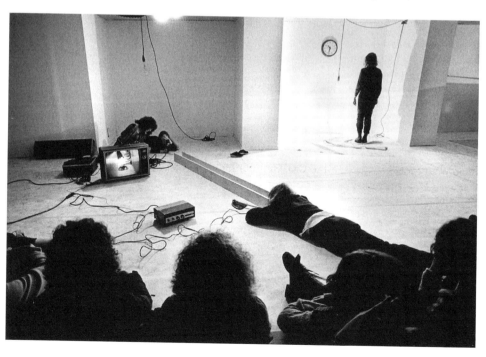

Art-world acceptance

The phenomenal early growth of museum response to video is due to two major factors: the growing interest by a diverse group of major artists in the medium's open possibilities; and important shifts in museum acceptance and evaluation of radical, conceptual work which questioned the museum's very role as preserver and collector of "art as object." Art movements at the end of the 1960s and early 1970s focused "on art as idea and art as action." Art became "dematerialized," as expressed through energy and time-space-motion concepts. The medium itself defies objecthood. It is dispersible through transmission; it is reproducible, interdisciplinary, and can call for interactive participation.

By 1969, Howard Wise, a New York gallery owner who later established Electronic Arts Intermix, one of the first organizations to distribute video and act as a post-production studio, created the first video exhibition, *TV as a Creative Medium*, featuring the work of Nam June Paik, Frank Gillette, Ira Schneider, Paul Ryan, Eric Siegel, and others. The works in the exhibition demonstrated strong differences in artists' approaches to video. Some saw video as a way of integrating art and social life through a critique of television as a dominant cultural force or as a social documentary tool. Others saw video as a new artists' tool for formal conceptual projects or for synthesizing and transforming images with electronic devices such as the computer.

One of the most interesting works in the Wise Gallery show was Frank Gillette and Ira Schneider's multimonitor multichannel installation work *Wipe Cycle*. The piece (with its nine monitors, live camera imagery of observers in the exhibition space, mixed with prerecorded tape units, delay loops, and unifying gray wipe that swept counterclockwise every few seconds) was an attempt at manipulating the audience's time and space orientation by including the viewer as an integral part of the "live" installation. The complex structure of the work, which fed live images from one set of monitors to the other, was typical of many video installation works which explored the self-reflexive formal codes suggested by the time-delay feedback aspects of the medium itself. As cameras recorded events within the installation, the events themselves were manipulated and transformed to create an illusionistic model of communication and dialogue.

Vision and Television at the Rose Art Museum (near Boston) in 1970, and *Kinetics* at the Hayward Gallery in London (international) are examples of interest in video as a viable art form. These exhibitions reflected the different attitudes toward representation we have been discussing and included examples of the leading artists in the United States, Canada, and Europe. As interest grew in the new medium,[1] the prestige of its practitioners and their innovative new work attracted the interest of funding institutions (such as the National Endowment for the Arts and the CAT Fund for Independent Video, amongst others), which began supporting video production centers and individual artist production grants. As networks of production centers grew, so did exhibition possibilities in Europe, Canada, Japan, and the United States. Annual video festivals and conferences[2] helped to promote exchange and broaden interest. These provided a forum and an intellectual meeting ground for artists as well as important exposure for their work. As a result, magazines which normally focused on photography and independent film such as *After-Image* and the *Independent* began to provide critical response to video work. New journals such as *Radical Software* and *Art Com* were established as a response to the growth of new media including video and the computer. These magazines helped to unify the video movement, to give it a history , a critical base and a sense of community. They also provided information on new technical advances, new media centers, and grant opportunities.

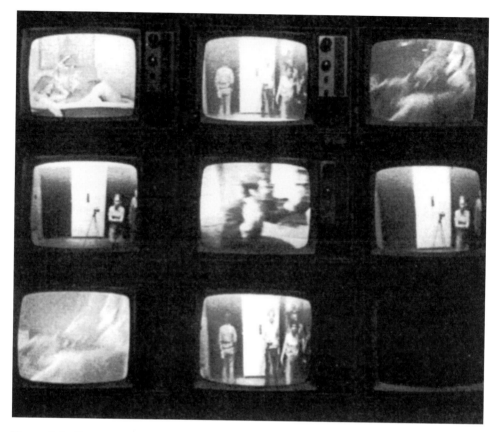

Figure 4.9. Frank Gillette and Ira Schneider, *Wipe Cycle*, nine-monitor time-delay installation at the Howard Wise Gallery, New York, 1969.

The concept for this work is based on the completely new unsuspecting awareness the public had about the medium of video as separate from conventional television they saw on screens in their living rooms. On entering the *Wipe Cycle I* installation environment, viewers found themselves appearing live in eight-second and sixteen-second delay images on television monitors in three places at one time-standing here and now – but also on a monitor there and then eight seconds ago and sixteen seconds ago. These seemingly interactive effects provided an entirely novel psychological and physical experience of space and time when it was first made available. The viewer experiencing these effects, instead of an object as art, became aware that art could be not just about vision only but be an integration of all the senses – physical and metaphysical.

(Electronic Arts Intermix; Photo: Allen Frank)

The first museum video department was established in 1971 by James Harithas and curators David Ross and Richard Simmons at the Everson Museum in Syracuse, New York, with a closed-circuit gallery. Two years later, Ross set up the Long Beach Museum program in California. That same year, video artists Steina and Woody Vasulka founded the Kitchen (in New York), which is still a major center for independent performance and video work. In 1973, the Whitney Museum of American Art included video in its important Biennial exhibition and soon afterwards added video as part of its independent film department headed by

John Hanhardt. The Museum of Modern Art instituted a video department in 1974 under the direction of Barbara London. *Video Art*, the first comprehensive video survey, was organized in 1975 as a traveling exhibition by Suzanne Delehanty at the Institute of Contemporary Art in Philadelphia. It consisted of single-channel videotapes and multichannel sculptural installations reflecting the wide variety of video usage by seventy-nine international video artists. By 1984, a major international exhibition of artists' video installation had taken place at the Stediljk Museum, Amsterdam.

Differences between independent film, artists' video and television

Early experimental emphasis on the conceptual, sculptural installation and formal image transmission and reception aspects of video technology separated it completely from the moving image mediums of cinema and television. However, artists who saw the use of video as a communication tool for social action and documentary were attracted to it because of its flexibility, immediacy, and its low cost in comparison to the use of film. By 1968, a diverse group of artists took their Portapaks into the streets to record real events or outdoor performance works. They faced difficult technical obstacles. Appropriate professional editing facilities[3] were inaccessible, Portapak batteries were heavy, image quality was poor. Tapes produced were not broadcast-quality and therefore could not be publicly transmitted. They could be exhibited only to small audiences on television monitors in corners of galleries and museums and not under the controlled darkened theatrical conditions normally provided for the projection of film.

Although these major technical differences separated video work from the cinematic medium of film, a link between film and abstract formalist tendencies in the visual arts had already been established by avant-garde independent filmmakers such as Jonas Mekas, Maya Deren, and Yvone Rainer, whose work with flexible hand-held 16mm cameras[4] had grown in opposition to the dominance of American commercial cinema since the 1940s. In Europe, independents such as Jean-Luc Godard found a greater public consensus for their important work. Independent filmmakers experimented with the dynamics of camera movement and the relation of image sequence through shooting and editing strategies that questioned the reality of spatio-temporal events. They broke away from the established theatrical storytelling "grammars" or conventions of commercial shooting and editing techniques and substituted intense, abstract "metaphors of vision." Some independents began to experiment with projecting their images on different surfaces such as objects, people, and screens placed in unexpected locations. Their use of edited repetition and juxtaposition to build psychological or poetic parallels created a different kind of visual structure with more complex layers of meaning.

Two broad tendencies exist in the aspirations and history of avant-garde independent film which somewhat parallel artists' intentions in video: film as related to, or associated with, the "formalist trajectory" of the fine arts; and film as the "ideological site for the mediation of social and political concerns."[5]

These two views are a touchstone to our ongoing discussion about representation. Although, technologically, film as a medium is radically different from video, the strong influence of the experimental vision of avant-garde cinema is apparent in the work of video artists who experiment with more conceptual projects rooted in performance and illusionistic

Figure 4.10. Juan Downey, *Information Withheld*, 1983, color video, 29 minutes.

In his work, Downey applies his fluid camera style to investigate the semiotics of culture and society. A native of Chile, he is familiar with government policies of internment and persecution of political enemies. Here he equates the transmission and reception of information with the "mind oppressive" nature of the television medium, which he sees as part of a coercive attempt to control.

(Electronic Arts Intermix)

concerns as well as those who attempt analytic and social documentary critiques. This split reflects the divergent approaches between Platonic idealism in search of purity of form and idea and the more Aristotelian question of how we go about doing things in the real world. Evidence of this divergence is useful because it provides a continuing framework for looking at new work and new media.

Artists design electronic image synthesizers

From 1965, many artists saw a strong link between the computer and video both as an extension of kinetic art and as a means for electronic visualization, animation, and processing of their images. Early filmmakers John and James Whitney, Stan Van Der Beek, Ed Emschwiller, and Lillian Schwartz, working out of facilities such as Bell Labs, New Jersey, and the New York Institute of Technology, used the computer to generate, animate, and mediate their imagery. Artist access to television of post-production equipment fired the imagination of first-generation video artists and created the energy to develop artist-designed imaging tools such as the Paik/Abe video synthesizer by 1970. Image-processing grew out of a sense of idealism combined with intense experimentation. In his first manipulations of the video signal,

Paik had used a magnet to interrupt and interfere with the raster scanning process of television, i.e., the beam of electrons which moves continuously across and up and down to form the image on the monitor. The Paik/Abe video synthesizer was a tool specifically designed to cause interference with the raster scan and to direct it in a controlled way. Other kinds of manipulation devices, such as colorizers, mixers, and synthesizers, could produce images which looked startlingly different from those on standard television – tools which could produce moving, swirling colors, distorted forms, and disjunctive patterns by extensive intermixing of signals to create totally new images – a new genre of "tech art" that had strong appeal because of its relationship to the formal modernist concept, "the medium is the medium." Many idealistically thought in terms of a kind of lingo of futurism where technology would somehow create new realities which could link up the universe with the unconscious energy flow of the nervous system to achieve total communication.

The new image-processing genre of video depended on the pioneering efforts of a dedicated few who designed flexible, relatively inexpensive tools. Because it is unusual to find both artistic and engineering ability in one person, the need to invent new tools led to important symbiotic collaborations such as Nam June Paik's with the engineer Shuya Abe, Stan Van Der Beek's with Eric Siegel, and Bill Etra's with Steve Rutt.

Some of these toolmakers – Steven Beck, Eric Siegel, Bill Etra – were obliged, in the end, to find outlets for their skills outside of the arts or to set up their own commercial companies. Some, like Tom de Fanti (Z-Grass) were able to get commercial video game commissions to design new equipment. Others, including Woody Vasulka (Digital Image Articulator), Dan Sandin (Digital Image Processor), Ralph Hocking, and Sherry Millner saw that sharing new development of tools could bring about important relationships in the video community. An awareness of easily learned inexpensive systems could counter the mentality that technology was too costly and unwieldy to be "habitable" or usable by artists. Sandin rejected the idea of marketing his device and instead offered to give the plans to anyone wishing to build it themselves. His Digital Image Processor (completed in 1973) combined many functions in one tool – keying, colorizing, fading – and was set up as a set of stacked boxes which could be rewired or reconfigured.

Hocking and Sandin have been "committed to the idea that artists should be able to work with video technology much the same way as a painter works with one's materials in isolation in a studio. In this sense, they both adhere to very traditional modes of artmaking."[6]

By 1977, image processors had been programmed and built which could achieve new visual effects such as the mixing together of live and taped images on a split screen and the digital painting and matrixing of forms – effects which had not previously been possible even through the use of then-available professional broadcast equipment. These pioneering innovations to the technology of visual transformation by independent video artists dramatically highlighted the possibilities for replacing outmoded models of film or video practice and production. Their contributions were vital to software and hardware developments in producing the new generation of powerful but inexpensive computer or video instruments later built commercially.[7]

Artists continue to play an important role in defining new areas where software can be produced to fill a specific need. Many firms have found that important benefits can be derived from granting after-hours access to artists. Their intelligent challenges to the use of equipment can often open up unexplored aspects of a machine's potential or raise important questions for the future which have direct application to the future development of a system.

Figure 4.11. Doug Hall, *The Terrible Uncertainty of the Thing Described*, 1987, three-channel video and electrical installation, steel (fence, mesh, frame, chairs), 144in. × 360in. × 480in.

Interested in contrasting powerful documentary images of natural meteorological phenomena with concepts of our alienated experience of a world of our own making, Hall has curated an installation where the theatrical artifice of artificial lightning is evoked intermittently. In this installation work, two large chairs and a ten-foot mesh barricade loom out at the viewer, hiding the existence of a Tesla coil which emits a large bolt of electricity at random points when the monitors depict extreme natural turbulence.

(Doug Hall and the San Francisco Museum of Modern Art. Purchased through a gift of the Modern Art Council and the Art Dealers Association)

Open Circuits: moving from modernism

Open Circuits: The Future of Television, a conference organized in 1974 by Douglas Davis, Gerald O'Grady, and Willard Van Dyke under the sponsorship of the Museum of Modern Art opened discussion of what was seen as the beginning of a new period for art. In a critical mode, Robert Pincus-Witten indicated that video works based on exhausted formal conventions of modernist practice were often dismissed, not because they were poor but because they no longer reflected relevant issues. He referred to the genre of video that relied overly on experimental self-reflexive "art about making art" – manipulation of the electronic image-making components of the medium. He commented that video art was "deficient precisely because it was linked to and perpetuated the outmoded clichés of Modernist Pictorialism."

He criticized it for aping Minimalist preoccupation with medium, and for overusing and becoming subservient to the powerful potential of electronic image-making media, itself becoming lost in its vocabulary of Lissajous pattern-swirling oscillations endemic to the capabilities of the medium at the time.

However, those video artists whose work resonated with their interests in other fields, particularly feminists who were less rooted in traditional media such as painting and sculpture, were critical of the hermeticism and separation from life that is often associated with modernism. They were the first to grasp and make use of the important technological changes coming to the fore to move their work to new territory. From the late 1960s, video became important to them as an alternative, progressive, and flexible medium for expressing their political and cultural objectives. Women's video collectives sprang up during the 1970s, and an annual women's video festival was organized, helping to unify the movement. Many of

Figure 4.12. Martha Rosler, *Vital Statistics of a Citizen, Simply Obtained*, 1977, 39:20 minutes, color, sound. Video: Brian Connell. Post-production: John Baker.

This tape asks the questions: "How do we come to see ourselves as objects? How do fragmentation and comparison assist in social control?" At the core of this probing tape about the objectification of women and others in a technological or bureaucratic society is a long continuous shot that reveals the part-by-part measurement and evaluation of a woman by a white-coated male examiner accompanied by a chorus of three women. Rosler's depiction of a formalized system of measurement and classification "is meant to recall the oppressive tactics of the authoritarian systems such as prisons as a means to emphasize and underscore the internalization of standards that determine the meaning of a woman's being."

(Electronic Arts Intermix)

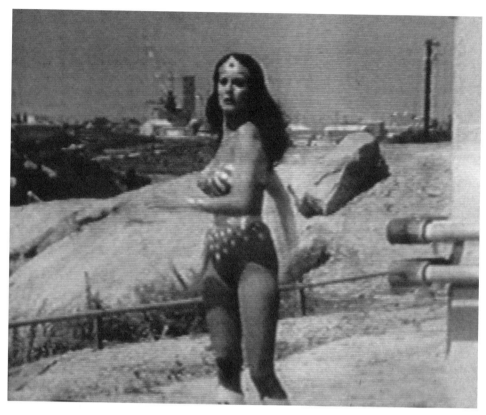

Figure 4.13. Dara Birnbaum, *Technology/Transformation: Wonder Woman*, 1978/9, video, 5:50 minutes, color.

By appropriating imagery from the television series *Wonder Woman*, and radically deconstructing it, Birnbaum subverts the ideology and meaning embedded in this pop-culture television series and distills its essence. She arrests the flow of images, condenses them, uses stuttering-like editing effects to isolate and repeat key moments symbolic to the narrative such as the one where the Real Woman is transformed into Wonder Woman. Birnbaum states: "The abbreviated narrative – running, spinning, saving a man – allows the underlying theme to surface: psychological transformation versus television product. 'Real' becomes 'Wonder'. Woman's power is shown to be sexual to 'do good' in an immoral world."

[Dara Birnbaum]

the early works were documentary in style, influenced by *cinéma vérité* and focused on issues of sexual difference and feminist consciousness. Part of its attraction was the newness of video as a medium and its lack of other cultural baggage and connotation.

Early videomakers neither used the camera as an objective observer nor clearly separated the filmmaker and subject. In their work these were combined, and the artist performed for the camera using it as a mirror. They would perform in front of the camera until the tape ran out – tape length became performance length. Video was perfect for this type of "real-time" performance. Warhol's experimental fixed-camera-position films (*Sleep* was eight hours long) had established the precedent and were a strong referent for performance artists such as Joan Jonas, Bruce Nauman, and Vito Acconci.

This intensely personal real-time video practice of some artists was far removed from the condensed time of commercial film and of the segmented, broken-up, regimented time of broadcast television with its highly produced, fast-paced programming. By 1975, when important advances in video technology became available – editing facilities and the time base corrector – some artists began to see video as a possible tool for television media production.

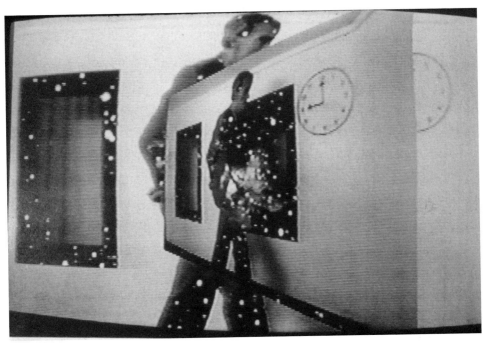

Figure 4.14. Joan Jonas, *Double Lunar Dogs*, 1984, video, 24 minutes. Created for the Contemporary Art Television Fund 1984. Directed by Jonas with Michael Oblowitz and Marion Cajori.

A science fiction piece which playfully orients us toward looking at and questioning our experience of planet Earth from different points of view. The travelers (two women and three men) on board the ship have long ago lost all contact with Earth and know about it only from stories passed down to them by their ancestors aboard ship. We study the relationships and power dynamics between these personae. The work uses poetic narration as points of reference for the impressionistic visual montages and scenes. Occasionally images of Earth appear, as do scenes of the ocean. Various art forms are incorporated into the work, including the painting of their own portraits on glass by the two women.

[Joan Jonas]

By the early 1980s, phenomenal technological advances (the introduction of color, radically improved computerized editing systems, lighter improved cameras, computer processing, and digital animation) brought video to an important point of ascendancy as an electronic (broadcastable) moving-image medium relatively accessible to artists.

Television itself had, from its very beginnings, appropriated film and coopted its existing commercial productions. It could broadcast film to a vastly expanded audience. It could challenge and sometimes rival, coopt, and absorb the industrial technology of film as a dominant mode of communication and representation.

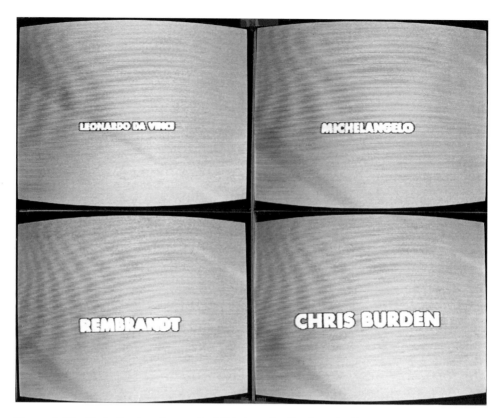

Figure 4.15. Chris Burden, *Leonardo, Michelangelo, Rembrandt, Chris Burden*, 1976, photo documentation of television commercial which appeared on Channels 4 and 9, New York, and Channels 5, 11, and 13, Los Angeles.

Best known as a conceptual artist, Burden is noted for his startling performances where he explores the psychology of personal risk. In 1973, he began to purchase commercial advertising time on local television stations in New York and Los Angeles. He showed short thirty-second clips of his work. In the illustrated commercial shown here, he drew attention to the idea of high art and its relation to the commercial world of advertising. The work has shock value in that "genius" is presented as a commodity like any other consumer product on television. Another commercial consisted of three statements: "Science Has Failed," "Heat Is Life," and "Time Kills." Burden spoke the statements, then they were flashed as graphics on the screen, followed by the words "Chris Burden sponsored by CARP." This commercial appeared a total of seventy-two times in a five-day period.

(Chris Burden)

Some artists using the video medium found themselves confronting the issue of seeking a different, mass audience for their work. For these, the convergence of artist's video with television raises important issues about public and private art, about access to the public airwaves mostly controlled by commercial interests, and about art as a means of communication or art as a cultural object.

The relationship of artists to television has always been complex. On the one hand, its potential as a showcase for reaching a broad audience is a strong attraction. Yet, it presents the danger of losing control over production of one's work because commercial network

television is dictated by a complex system of hierarchies, conventions, and economics, with its programming pitched toward mass audiences. It raises questions about how to reach this audience. For, in relation to the mainstream programming designed for specific audiences, the showing of relatively esoteric works by artists out of context is rather like reciting poetry in the middle of a soap opera or like seeing an Abstract Expressionist painting reproduced on the front page of the *New York Times*. This is a factor continuing to confront artists today as they prepare work also for the World Wide Web.

Early television: a "window" on the world

The concept of public broadcasting, of public service in mass communications centrally transmitted via the airwaves to private home receivers, was developed first for radio. Government commissions were established to license stations, to set laws, and to consider the implications of programming and its potential impact on the public. In the United States, television regulation was placed under the jurisdiction of the Federal Communications Commission (FCC) and followed a framework already set in place by 1937 for radio transmissions.[8]

By 1972, more than 90 percent of the seven-channel broadcast band was licensed to corporate networks. Access to the public airwaves is thus almost completely dominated by powerful commercial networks through sales of television time to advertisers who normally recoup the high costs of television production by using it to sell their products and a way of life based on them. Even in the 1980s, consumers invested at least ten times more for their home television receivers than commercial network owners spent on their transmitting facilities. In this one-way situation, the commercial network stations hold licenses to transmit on specific channels within the broadcast frequency spectrum, while the consumer or receiver pays for a selection of programs almost entirely mediated by corporate management, which allows for little, if any, programming innovation.

The viewer becomes a consumer – one who selects but cannot control. The experience of television, with its homogenized format of standardized packaged programs, with required edited content and formularized break-up of program time, has established an expectation for home viewers for its ideological and informational perspective. The familiar design of broadcast time, structured around thirty- and sixty-minute blocks punctuated by commercials, competes for audience attention in the home installation.[9] Today's commercials, often more visually interesting and compelling than the actual programs themselves, are oscillating with more and more frenzy. Time blocks are smaller and smaller followed by more and more commercials. Paradoxically, the time-bite format of the punchy commercial has given rise to a spate of artist works designed for television.

Encompassing film and different from it, television can transmit to the spectator at home fragmented edited versions of reality from every vantage point in real time. Its apparatus can deeply penetrate and transmit unmediated reality as it occurs from different angles, through close-ups and from multiple, sometimes hidden vantage points. Events can be seen as skewed, edited mediated events on the evening news, their original content carefully controlled while seeming to deliver the myth of television being an unedited window on the world,[10] with its transmitter/receiver production process invisible to the viewer.

Society of the spectacle

With roots effectively reaching back into the 1940s, television is no longer merely an activity of the culture. It is a powerful agent of culture – an electronic conduit via cable, network, and satellite services to a global public which is increasingly dependent on electronically communicated ideas and information.

The phenomenon of communications technology has created a different kind of meaning, not only in impacting on personal life but in the way culture as a whole is produced and experienced. A mass audience of millions participating collectively in powerful moments in real time, watching the same images – the historic moonwalk, the 9/11 attack, a world cup soccer final – before the perfectly regulated circuitry of television, is a major collective perceptual experience.

Guy de Bord, writing about commercial television in his *The Society of the Spectacle* in 1967, spoke about it as part of a dark vision.

> The spectacular character of modern industrial society has nothing fortuitous or superficial about it; on the contrary, this society is based on the spectacle in the most fundamental way. For the spectacle, as the perfect image of the ruling economic order, ends are nothing and development is all – although the only thing into which the spectacle plans to develop is itself.[11]

Figure 4.16. Daniel Reeves, production still on location for *Smothering Dreams*, 1981.

In this powerful videotape based on autobiographical experience, Reeves weaves myth with the reality of organized violence as seen through the eyes of a soldier and the imagination of a child. In this production still, we see Reeves shooting on location. The work was broadcast on PBS in 1981.

(Electronic Arts Intermix; Photo: Debra Schweitzer)

He saw that a distracted public relying on television as a source of news, information, and cultural products could become unaware of its political and commercial manipulation of the mind transmitted directly to their living rooms while feeling they were in control through their remote control options.

Television leads to a new kind of apperception

Television can transmit directly into the cultural mainstream a level of psychological effects (Walter Benjamin called them "unconscious optics") which have been deeply affecting the collective subconscious. The prime-time world of commercial television offers a seriously skewed picture of reality. Viewers tend to see the real world much as it is presented on television.[12]

It has brought about changes in the way we see, how our consciousness is formed, and the way we lead our lives. Television has trained us to focus on many planes all at once and to assimilate large quantities of information both obviously and subliminally. Within the frames of our household viewing space, we often do not watch television directly – we have learned to glance at its easily assimilated packaged time segments as a distraction while answering the phone or working.

For large numbers of people, the television stays on, an appendage to other aspects of life. It contributes to a diverse, multifocus experience, a way of consuming effects and information. Walter Benjamin examines for us the difference between the perceptual distraction produced by mass-media forms such as film and television and the concentration required by a traditional work of art. Before a painting, the viewers abandon themselves to their own associations, while before the technical structure of film or television they cannot. "No sooner has his eye grasped a scene that it is already changed . . . I can no longer think what I want to think. My thoughts have been replaced by moving images."[13] While the single viewer in a museum, concentrating on the art work is absorbed by it, the distracted mass audience absorbs the work of art as it travels into their own viewing spaces via television as part of a history-of-art cultural program. Often viewers stumble upon such a program while idly switching channels. The painting may be something totally foreign to them, something they know nothing about and cannot relate to. It becomes part of a distraction rather than a deep experience.

The habit of incidental perception, seen within a loaded visual field, creates a certain type of human optical reception where information or understanding is acquired gradually "by habit through constant exposure rather than by contemplation alone. The distracted person can form habits. More, the ability to master certain tasks in a state of distraction proves that their solution has become a matter of habit . . . Reception in a state of distraction, which is increasingly noticeable in all fields of art, and is symptomatic of profound changes in apperception, finds in the film (TV and Internet) its true means of exercise. The public is an examiner, but an absent-minded one."[14] Through distraction, the public is learning to deal with huge amounts of information created for their consumption in their home entertainment centers which now contain VCRs, DVD players, and computers.

Above all, the home-received television broadcast represents a radical compression of time/space. This perception that we are home participants connected to "live" events is reinforced by a technologically induced manipulation of the time and space of reality which seems to provide immediate access to what is seen and experienced. Disconnectedness to

real time and space affects our senses disproportionately and creates vicarious expectations for immediate gratification. This artificial change in the sense of duration and of time flow is characteristic of the speeded-up effects of electronic media not bound by time.

A confusion between spatial and temporal boundaries has occurred through exposure to high technology, collapsing it and sometimes erasing the conventions that formerly distinguished fantasy from reality. Instead of relying on a sense of reality gained from direct experience and belief in a single authoritative system, we depend on a variety of mediated information. We alternate and are suspended between the reality of daily life and the representation or edited copy of it that we respond to via television. This shifting response has contributed to an assault on the concept of the self as the center of a single reality with a single viewpoint.

The structure of television is about "asserting equal value for all the elements, including the advertisements within a programmed day. It is as if our continual stimulation by the programmed fusion of old movies, soap operas, depictions of family life news, and historical documentaries has contributed to a state where artificial representations of reality have become dominant features – an obstacle to direct personal meaning and significance." One of the first effects on the mind is the "marked mitigation of the distinction between public and private consciousness. A manifestation of this is an increasingly altered sense of ourselves as we become more media dominated; our tele-selves become our real selves. We lose our private selves in publicity."[15]

First artist access to television broadcast labs

The single non-commercial broadcast channel open to meeting the cultural needs of a sophisticated, diverse audience lay in the establishment in the United States in 1967 of government-funded national public television (PBS) and of cable transmissions. Government funding for PBS has been limited in comparison to the CBC in Canada, the BBC in Britain (especially Channel 4), and many other European countries. In the conservative climate which now prevails, public, non-commercial international broadcasts such as those in Britain, France, Germany, and the Netherlands, are in danger of being cut back completely. Even without adequate funding it sometimes demonstrates television's potential as a powerful cultural force. Some artists saw their video work as a possible new cultural voice with a special relationship to television.

By 1972, the Artists' Television Laboratory of WNET (Public Broadcast Corporation) was founded by grants from a variety of sponsors.[16] The TV Lab was founded to mediate between the fine arts and television. A few artists (including Stan Van Der Beek, Douglas Davis, and Nam June Paik) were given access to these television labs. At a time when most artists had no editing equipment, this access to broadcast facilities was vital. Independent funding for use of broadcast technology created the opportunity for creative risk. In the realm of television production, budgets are tightly regulated, leaving little or no room for experimentation. Use of sophisticated high-tech devices at the WNET television studio represented an unprecedented departure from common practice, for artists were allowed to experiment for aesthetic effect. Some artists such as Nam June Paik, Ed Emshwiller, and, later, Mitchell Kriegman, John Sanborn, Kit Fitzgerald, and Bill Viola received funding to do more than one artist-in-residence production. For these artists, multiple access to high-tech equipment represented a quantum leap in their professional growth in the video medium.

Early support of artist-in-residence institutional programs fostered visionary freedom and widespread utopian optimism that television could become a democratic alternative medium – one that could reject the priorities of the commercial industry and be used as a tool for cultural and social change. These hopes grew out of Marshall McLuhan's "global village" attitudes of the 1960s and did not take into account the huge distance between high-culture style and mass-media realities. Some artists were primarily interested only in seeing their work shown on television. Others were committed to subverting television's dominantly commercial voice. Some took their cameras to the street as a form of guerrilla tactics.

Public television screening of artists' video both in North America and in Europe created a clash of tastes. Video, growing out of prevailing philosophic and aesthetic currents in the arts, exists primarily for the art world as a special-interest group (and has received funding and encouragement for its experimental independence). Public taste has been formed by fast-paced formula entertainment and information programs punctuated with smooth advertising messages. Unaccustomed to video's "difficult," unfamiliar vocabulary and greater intellectual complexity and to the high level of attention and interpretative participation required, the average viewer tunes away and thinks of it as bad television. The mass audience seeks leisure-time distraction: art demands concentration – it is a process of exploration, inquiry, and discovery. This clash between artists and the realities of the television world brought into focus many issues about mass-audience appeal and the the more difficult language of the fine arts canon.

Video artists using non-professional low-tech equipment were accustomed to independence in developing their ideas through spontaneous improvisation where they had integrated control over all aspects of writing, directing, and performing. By contrast, standard broadcast programs are generally produced by a consortium of writers, producers, and film crews whose work is subject to strict regulation by unions and to control by network owners, commercial sponsors, and the FCC regulatory commission. Eventually, artist-made works and the video tools artists helped to produce had a strong stylistic influence on television production, although public broadcast of this work did not attract the popular viewing public.

Very few of these early experimental artist-produced works were ever broadcast. PBS owned the rights to them, which they annoyingly refused to relinquish. *Video and Television Review* (*Video/Film Review* by 1979), a late-night Sunday series, was grudgingly produced as a showcase for these works by PBS in 1975. The big-name artists at TV Lab attracted grants to the station. Although artists-in-residence were required to spend all their NYSCA funded stipends at the station, videomakers had no rights and WNET was not obliged to air works produced at the Lab. This situation did not satisfy major funding sources. NYSCA raised several serious questions. Rockefeller pulled out.

Funding difficulties caused the demise of WQED's National Center for Experiments in TV in 1975, WGBH gave up its studio in 1978, and the WNET-TV Lab ceased operation in 1984, forcing artists to find other support systems for professional-level broadcast-quality work. The Contemporary Art Television (CAT) fund in Boston, founded in 1982, continued until 1991 in promoting international symposia among curators and producers to promote the growth of video art.

It is ironic that, more than a decade after the first broadcasts in 1975, a late-night program on PBS finally aired these early tapes in 1988 on a program called *The Independents*, treating them reverently as historical documents. CAT Fund works were broadcast later as part of the *New TV* or *Alive from Off Center* programs.

Figure 4.17. Ant Farm, *Media Burn*, 1974/5, edited for television 1980, color and black-and-white videotape, 30 minutes.

The Ant Farm Collective – Chip Lord, Doug Michels, and Curtis Shrier – worked in the areas of architecture, sculpture, performance, and media in San Francisco from 1968 to 1978. Their trailblazing work in the social aspects of art led them to explore its relation to popular culture, the media, and violence. In their *Media Burn* Happening, presented before a large crowd, they created a performance spectacle where a car fitted with video cameras and driven by two of the group crashed through a pyramid of burning television sets. Beforehand, a mock address by a John F. Kennedy impersonator proclaimed: "Who can deny we are a nation addicted to television and the constant flow of media?"

(Electronic Arts Intermix)

Cable transmission and counter-culture: the right to be seen and heard

Although many video artists turned away from the issue of public broadcast and remained within the exhibition context of museums for showing their work, those with an activist or documentary commitment embraced it and sought to air their work on the more open flexible public access cable stations. Cable[17] represents one of the few vestiges of the public service concept of television communications still in place. Initially, FCC law required cable owners to devote a prescribed number of hours to community-based transmissions. The growth of cable broadband communications (non-over-the-air broadcasting in the VHF or UHF frequency band) opened the way for at least eighty and, ultimately, many more operating channels. Many early video artists saw the future expansion of cable television as a major opportunity for creating new cultural options, experiences, and perspectives as a public alternative to conventional network broadcasting.

By 1971, the counter-culture group Videofreex began regular low-power television programming in Lanesville, New York. Other groups began their own public access series – Byron Black, Clive Robertson, and Ian Murray in Canada; and Jaime Davidovich. The aim of these groups is to inject alternative insights and criticism of the media monopolies – its genres, editing, camera techniques, and politics. They reacted to the segmented, formulaic handling of significant events and issues as edited, blanked-out interpretations. Counter-culture video raised analytic questions about the hidden agendas behind standard programming formulas and challenged the delimiting power of commercial television to set the dominant agenda for public assumptions, attitudes, and moods through its interpretation of news and information.

From the early 1970s, counter-culture video artists such as Telethon (William Adler and John Margolis), Tom Sherman, and Stuart Marshall have appropriated elements of broadcast programs as "found materials" in their analytical critiques of the medium. The latter continued to produce video which addresses commercial television. Chris Burden took another tack when he bought a commercial time slot on network television in a mock advertisement for the value of his artwork-as-a-commodity product. (see fig. 4.15)

In 1972, the Time Base Corrector became available. Its arrival meant that "non-professional" independent video could now be broadcast on national television, for deviation errors in the video signal caused by inconsistencies in equipment could be electronically corrected. Among the first documentary videos made with non-professional equipment was Downtown Community Television Center's report on Cuba and coverage by Top Value Television (TVTV) of the 1972 political convention. Both were aired on WNET.

Founded much later, in 1981, Paper Tiger TV – a group that still actively broadcasts a weekly series on public access channels in New York – attacks corporate economic control and the ideology of mass media. Its producers state: "The power of mass culture rests on the trust of the public. This legitimacy is a paper tiger" (thus the group's designation). Although their shows are local, Paper Tiger TV "encourages its audience to consider global issues, to think about how communications industries affect their lives and their understanding of the world. Consciously mixing almost primitive video techniques with sophisticated ideas, adding humorous touches to enliven serious questions, Paper Tiger TV can be described as a 1980s version of Brecht's didactic theater [for it] weds analytic processes to popular forms in order to reveal social relations and social inequities."[18] Through its simple unveiling of its communications process, and its method of functioning as a broadcast apparatus different from highly stylized network productions, Paper Tiger TV raises questions for its audience about how television communicates. It reveals the power of broadcast communications and attacks the power and the economic structure of the mass-media cultural apparatus.

Costs for the half-hour program are about $200 as compared to the $150,000 normally spent on a typical half-hour commercial program (a comparison that is often stated for political effect at the conclusion of Paper Tiger programs). The style of Paper Tiger shows reflects practical and conceptual considerations. Their "talent" is a wide range of commentators, visual artists, writers, economists, lawyers, musicians, and psychiatrists. Their "live" format is eye-catching and spontaneous. Consciously avoiding the slick high-tech style of network programs, they opt for simplicity and low-budget effects. For example, titles and credits are displayed on a hand-cranked paper movie strip or hand-lettered cards are held in front of the camera. The flavor of their sets is equally inventive – often cartoon-like cloth backdrops depicting scenes such as the interior of a graffitied New York subway car; a homey domestic

Figure 4.18. (opposite top) Paper Tiger TV, *Herb Schiller Smashes the Myths of the Information Industry* at the Paper Tiger Television installation at the Whitney Museum, New York, 1985.

(Paper Tiger TV; Photo: Diane Neumier)

Figure 4.19. (opposite bottom) Paper Tiger TV, *Taping the People with AIDS Coalition Talk Back Show*, 1988, Paper Tiger TV Show.

Paper Tiger TV is a weekly series on public access television in Manhattan. The group is devoted to criticism of media monopolies and analysis of the politics of the communications industry. One of its leading advocates, Herb Schiller, is shown here giving one of his readings – a presentation of specific revelations critical of the press. The group's sets, intentionally designed to be striking for their simplicity and low cost, are an important commentary on the power principles involved in the economic disparities between the public's right of access to the airwaves and those commercial companies that can afford to "buy time" from commercial network companies.

(Paper Tiger TV)

setting with flowered wallpaper; or a stone basement wall with its pipes and meters. The overt effects and content are meant not only to engage and attract the viewer but also to question the issues and methods implicit in media seduction and production.

Mass culture/high culture

Although much of the guiding impulse for early artists' video experiments in the 1970s grew out of a rejection of the monolithic warp of US commercial television, there is no doubt that many of the new models they created outside of its mainstream were absorbed and eventually reflected in television production, editing, image-making styles, and new imaging tools.

Contemporary video continues to pose new questions which not only grow out of changes in the television industry itself but also arise from postmodern technological conditions, attitudes, and issues which are altering artists' view of television and their future challenges to it, at a time when video has become a widely accepted medium, available as a low-cost consumer item. Exploration of some of these issues involves distinctions between mass culture and high culture; their relation to a growing thrust toward democratic populism in the arts and how they might change the function and parameters of art through a more public cultural dialogue. These interests coincide with expanded viewer choice. Those video artists who take up the challenge to work within the construct of the television industry as a broader forum are unsure how it will change their art.

It is always the serious intentions of the artist that separate popular film from the art film, the popular novel from the more serious poetic work, pop music from symphonic, the Broadway musical from contemporary dance and opera. Although critical distinctions are made between these forms as to their popular or art intentions, the public perception is that they are democratically available by tuning into them via libraries, radio, cinema, television, or the Internet. Their cultural value is as special, relatively inexpensive forms of communication, not as material objects to be bought and sold. In the visual arts, the perception that art is a precious, unique object to be sold to the highest bidder is a concept that became common only following the Renaissance, and has served to create far greater perception of painting

Figure 4.20. The Wooster Group, *To You the Birdie*, 2002, Wilhelm DaFoe lying down – his face shown on the television monitor.

Through strangely haunting effects, this experimental Wooster Group production based on *Phèdre*, by the celebrated French playwright Racine, uses video as a major aspect of the play's development. Racine commented about his play: "I have never written a play where virtue triumphs so completely. The slightest transgressions are severely punished. The mere thought of sin is as horrible as sin itself. Emotional weakness is presented as moral weakness. Human passion is presented only to show the disasters it is capable of causing." The Wooster Group uses video screens and media devices in an extremely innovative way to create a compelling structure which helps to interpret the play's concepts in ways that are memorable. Their work creates a new aesthetic. In one instance, a discussion takes place between two onstage characters positioned over but behind a video screen. The images on the screen suggest the sexual play between them that is going on in their minds.

(Photo: Mary Gearhart and the Wooster Group)

and sculpture as elitist rather than as popular forms. The hierarchical conditions set up by the museum and commercial gallery system for validating the most important "art" has further set up strong distinctions as to what is popular or mass art, and what is high or elite art. Video became a crucial testing ground in what has become a major debate in the visual arts between "art as object" and art as "dematerialized" communication of ideas. (This is further discussed in Chapters 5 and 6.)

Artists' video and mass audiences

The traditions of "high" culture have always maintained a distance between artist and viewer. Unfamiliar "difficult" language has been used to frame the artist's vision and communicate

its autonomy and independence. A painting is not conceived for mass viewing or reproduction, whereas film is specifically designed for a simultaneous mass collective viewing experience to be seen by thousands in large cinemas. Responses to film experience are designed along pathways and sequences organized to demand direct, immediate personal response from audiences. Film is designed for reproduction to reach as large a viewing public as possible. Early experimental works produced at the television labs by artists coming from the visual arts traditions of painting and sculpture were utopian in their dream of reaching out to attract a broader audience for their art on broadcast television because they had no experience as yet in designing work to be seen by mass audiences. Yet they wanted to obliterate mainstream parameters of the medium, not just stretch them. They looked to the promised development of smaller cable networks as a way of reaching more specialized audiences. However, these hopes were dashed by the late 1970s when it was revealed that cable, too, had essentially been bought out by commercial interests.

Figure 4.21. Judith Barry, *Maelstrom* (Part One of a multipart video-environment work), 1988, video-beam projection installation shot from Whitney Equitable Installation Site.

In her installations, Judith Barry uses video cameras, monitors, and projection systems to explore aspects of our media-ridden consumer economy. She is fascinated by the way these systems function and the way they communicate with our private and public selves and how we are potentially controlled by them. In *Maelstrom*, she creates a video environment through the use of a video-beam projector installed in the ceiling. It projects on the floor where the viewer steps, flanked by two large panels displaying texts as questions. The welter of images engulfs the viewer while demanding interaction through a process of decoding the meaning of the messages displayed. The installation raises questions about real communication in relation to the information spewed out by electronic-media systems.

(Judith Barry)

By the early 1980s, a few artists – Dan Graham, Dara Birnbaum, and Richard Serra among them – came to the realization that unless a work was specifically made for television, by addressing the specific conditions and needs of an audience not made up of gallery-going specialists, they could not begin to free the weight of their art from its high-cultural practice to reach a larger audience. Bertold Brecht, struggling with the same problems of interpretation in the 1930s, had argued that "truth not only had to be beautiful but entertaining."

Artists put themselves at risk through evaluation of their work by a non-art public in a television framework that offers no special museums or gallery ambiance. Risk also lies in the possible eventual contamination and cooptation of their ideas, or compromise of their methods, by a powerful, inflexible system which normally assigns editorial control to business executives rather than autonomous individuals. Artists searching for a more public forum must create a consensus for ideas, in order to intelligently layer intentions and arguments within a given work in order to shift old perceptual habits of viewers to alternative ground. It involves the concept of working within the system for change, rather than from the outside. Just as the art world has its traditional institutional boundaries, such as the private collection, the gallery, and the museum, so does the world of broadcast television. These boundaries are defined by its programming formats, style of presentation, institutional setup of networks, channel distributors, and programming demands. For one to penetrate the other is so far extremely problematic.

Among the increasingly broad groupings of artists working in the video field, those who produce low-cost documentary or educational productions are closest to being able to subvert television by creating a commentary in an accessible style which has "a certain look" – i.e., immediately recognizable hooks – to attract the average distracted viewer who has no inclination for art-world poetics or polemics. Access to the public already exists through non-profit public cable stations which, like New York's Channel "L" and Global TV, are located around the country in most urban centers. Downtown Community Television has a special free training program oriented to expanding the use of media tools directly for those who wish to use them in the community.

Figure 4.22. Jean-Luc Godard and Anne-Marie Mieville, *Six Fois Deux (Sur et Sous la Communication)*, 1976, still frame.

(Electronic Arts Intermix; Photo: Marita Sturken)

Figure 4.23. Frame from *Six Fois Deux*.

(Electronic Arts Intermix; Photo: Marita Sturken)

Figure 4.24. Frame from Jean Luc Godard, *France/tour/détour/deux/enfants*, 1978.

Jean-Luc Godard's work is designed to raise questions about the relations between the media producer and the viewer. In the works shown here, he sets out polarities, drawing distinctions from the way information is presented to the public. He inserts these questions over a live news report to dramatize the dynamic questioning of the power in mediating or editing information. He tries to reveal the hidden economic and ideological assumptions in media presentations by "professionals" who are "just witnessing an event" – but who claim not to bring to it any bias of their own or of their producers or of the media network carrying the report. He asks questions about the currency in photographs: Who pays and who doesn't? What is the monetary value of news photographs colonized by photographers who benefit monetarily from their images of disasters – of wars, terrorist attacks, victims, etc.? He asks questions about captions – who writes them, and how they can be interpreted.

(Electronic Arts Intermix; Photo: Marita Sturken)

One of the most striking examples of artists who have used video directly and whose work has been successfully shown on broadcast television in Europe is Jean-Luc Godard, the well-known avant-garde French filmmaker. He has always seen his ideas and his goals as being conjoined in subverting the broadcast medium to create new cultural debate and meaning. He illustrates the relationship between its structure, its economics, its social relations, and its use as an instrument of repression. He has always been aware of the loaded, hidden agenda of images and his public forum for the use of them with words or captions or words standing in for images has been an important strategy in his television work. In *France/ tour/détour/deux/enfants*, he explored the specific relationship between mass media and his avant-garde work in film.

Can vanguard artists participate successfully in a public television forum for their work?

From among the many strands of new artists attracted to video coming from traditional documentary, performance, film, and visual arts, there is a new breed whose background is less in the traditional academic discipline of art but comes rather from film or media studies. Their concepts and vocabulary are oriented to the more public cinematic and media forms.

Because of the intense amount of viewing (fifty hours per week is average), audiences themselves have become more sophisticated in their ability to understand complex story structuring such as flashbacks and dream sequences, highly metaphorical dreams and fantasies, and dealing with half a dozen interwoven stories, some left unresolved. Music videos have accustomed viewers to surrealist image sequences and editing tied completely to the rhythms of music.

Driven by synthetic rock soundtracks, glossy style, high-key lighting, and simplified plastic-colored graphic images, the new populist videos capture the slickness of media while commenting on it. Charles Atlas's *Parafango* and Ken Feingold's *The Double* are good early examples of catchy television images used as a form of collage to state very different inten-tions. The work grows out of a sense that a continuum exists – a circular relationship between television, which makes the public, which in turn makes television. Some artists see themselves as one of the links in the exchange.

Competition with the experience of film and television

Video critic Marita Sturken wrote as early as 1984 that "Network television as we have known it is slowly becoming obsolete. Vast, expensive, centralized, inflexible, it is the dinosaur of the 1980s and 90s gradually giving way to an electronic cable entertainment industry that includes multiple channels, increased distribution via satellite, interactive shopping services, home recorders, and, for viewers, a radically new element of choice." Economic forces that control distribution and new interactive technologies are prime factors in the state of commercial transition that is currently taking place. Joanathan Crary comments: "Television as a system which functioned from the 1950's into the 1970's is now disappearing, to be reconstituted at the heart of another network in which what is at stake is no longer representation, but distribution and regulation." The ongoing refinement of high-resolution television and of the large home screen is seen as a way for television to significantly compete with the experience of film.

Influence of independent film on music video

Appropriation by popular music video of the legacy of visual ideas and poetic techniques used in early experimental independent film and video is testament to the influence of these genres. Recent rock videos have, for example, freely raided ideas from such films as *Un Chien Andalou*, *Blood of a Poet*, and *Scorpio Rising*. Here, resonating and overlapping with each other are Independent film (with its roots in visual arts traditions), and commercial television in a circular overlap created by the influence of video.

A new generation, turned to music television (cable MTV or network broadcasts) or to videotaped[19] versions of the latest music/dance productions, grew up on a steady daily diet of coopted editing and shooting techniques, an extraordinary vocabulary pioneered originally by independent filmmakers. Though vulgarized and commercialized, the popular music video form is elaborated and propelled by a broad front of new innovators. In a sense, music video has "upped the ante" in the dilemma about artists' access to television. Commercial cooptation and promotion of music video can or may create popular acceptance of avant-garde innovation; but it could also trivialize, consume, control, and corrupt the independent artist's voice. To work in more commercial areas, artists have always had to give up the pure, formal aspects of their work.

The problem is that music television isolates and appropriates visual ideas and techniques out of the context of their artistic application within coherent statements. Bill Viola remarked in *Reasons for Knocking at an Empty House*:

> The thing about the industry that I resent very much is that they're into the
> business of image appropriation, images as they relate to fashion, and fashion
> as it relates to capitalist economics . . . like a fashion designer from Paris going
> into Central Africa, not caring about the culture or cosmology of the people, just
> looking at decoration on spears so they can take them back and make a lot of
> money . . . As experimental as people like to think music video is, the little parts
> of it that are experimental are also being consumed by the system. In only two
> years it's as pat as the standard dramatic narrative structure. And unfortunately,
> for a lot of people, it has become their avant-garde experience.

The conglomerate control by record companies and television industry financing allows little chance for independents to create works which go beyond the usual sexual titillation and "star hype." A few more mature recording artists with enough vision and clout to gain control of their productions have realized important videos. For example, 1980s works such as David Bowie's *Ashes to Ashes* present haunting views of identity changes where gestural choreography and camera presence suggest mysterious rites of passage, psychological alienation, and the mystical isolation of the self. David Byrne's Talking Heads group and Peter Gabriel have also explored important themes about alienation and contemporary artificiality: the loss of instinct and anima; the confrontation between dream and action; the sense of living out of time.

Interdisciplinary performance artists such as Laurie Anderson and David van Tiegheim whose work integrates theater, dance, and music make highly developed, coherent contributions to artists' music television. Laurie Anderson's mature vision represents a developed critique of the politics of contemporary life and of technology. In *O Superman* and *Sharkey's Day*, she has created work which exploits the qualities of the television medium. *Sharkey's Day*, a re-enacted performance by Bauhaus choreographer Oskar Schlemmer (and dedicated to him) is a meditation on Nature and Art, Man and Machine, Acoustics and Mechanics. It is designed to demystify technology just as much as it comments on its influence. Although Anderson produced her work with state-of-the-art electronic technique, she always employs simple elements to create sophisticated effects, e.g., using a light projection as a way of creating a huge shadow as in *O Superman*, or a slide wipe made of cardboard coins and a string as in *Sharkey's Day*. Laurie Anderson's successful work as a performance artist, with feet in both popular Broadway productions and avant-garde camps, is an international phenomenon.

Figure 4.25. Laurie Anderson, *O Superman*, 1981, video, 8 minutes. Art director Perry Hoberman.

Released shortly after her audio recording of it, the video *O Superman* demonstrates the emergence of Anderson's personal signature of merging projected light with the figure. Because video lacked, for her, an essential element for her art, live performance with its alive, open scale – difficult to convey on the small monitors available at the time – she began to develop special devices for either the body or the camera to be able to better dramatize works that could be seen repetitiously. (Coinciding with the first years of MTV, *O Superman* was aired frequently, especially in Europe.) For the body, she began to clone herself in different ways by altering the voice and violin using a vo-corder, or created other mechanical devices, surrogate dolls, or creatures. She observes: "I was also very aware of magnifying gestures." In some sequences of the video, she appears as a cut-out figure on colored backgrounds; in others, such as *O Superman*, the image of her raised arm and fist was projected as a shadow.

(Laurie Anderson)

David van Tiegheim, working with John Sanborn and Kit Fitzgerald, constructed dance performance videos which encompass the streets themselves in *Ear to the Ground*. Digital visualization techniques and elaborate high-tech post-production are pursued more and more by video artists as integral aspects of their approach to developing a new vocabulary of images.

Some artists use the brief intense visual music format ("operatic cinema") as a base for works which are important for their experimental contributions to its form. Max Almy, Bill Viola, and Michael Smith are artists whose videos, although they were not made specifically for television, embraced both the museum context and television. Public taste may gravitate from MTV, once there is a realization that there are other kinds of things to look at – and in the process, discover the type of work that is normally found only in museums. Most music videos

are dull, have no soul, do not sustain repeated viewing unless they are the work of someone who has unusual vision and a vast technical skill.

Is it possible that the very nature of television's multiple viewing presentation of music video encourages more absorption of meaning than a museum or gallery can? Some music videos because of their extremely compact format may require a number of viewings to absorb all their ideas per minute (IPMs). The sheer exuberance and innovation of the well-conceived music videos produced by good video artists makes them viably interesting. Many high-budget productions are originally made in 35mm film – consciously encouraging the concept of a mini-movie style or "look." The pressures of changing technologies and of a different aesthetic climate has brought about a new relationship between film, video, television, and now the Internet.

Although it cannot be classed as music video, Robert Ashley's visual opera *Perfect Lives* was produced as a three-hour video and was shown on Britain's Channel 4 in 1983. Five years in the making, the television opera was composed by Ashley and visually produced by John Sanborn and Dean Winkler. Its seven half-hour episodes are based on repeated

Figure 4.26.
Robert Ashley,
Camilla, 1970
and 2003, opera
with video
featuring
Margaret Benczak
and Nancy Heikin.

Ashley has been creating multimedia chamber opera since the 1960s, and has often used the same cast. *Camilla* is one of the earliest of his unconventional experimental operas for which Ashley began to use projections. These became a model for his later video operas (such as *Perfect Lives*). *Camilla* fuses rock and chamber music in a gothic tale of lesbian vampires. When it was premiered in 1970, the use of video projection was so unusual that the critics debated whether to call it opera. Seen through today's eyes, exposed to countless multimedia spectacles, it doesn't appear to be radical, but it still holds its own because of the clarity and excellence of its production values.

(Photo: Richard Termine)

"visual templates." These structure and illustrate the story of two traveling musicians who finally arrive at the last whistle-stop, a contemporary Our Town, USA. As composer-librettist Ashley sees it, *Perfect Lives* is meant as a comic opera – a curious metaphor for the *Tibetan Book of the Dead* – as a prayer spoken into the ear of a corpse to speed it through the seven chambers toward reincarnation. Ashley worked closely with Sanborn, who developed the concept of visual templates as a structural foundation for the piece corresponding with each of its seven episodes.

Another aspect of video combined with opera form is Miroslaw Rogala's innovative video opera installation presented at the 1988 Chicago International Art Expo. This complex production featured a five-channel sound, programmed multiscreen video-wall, with live dance and performance elements. Entitled *Nature Is Leaving Us*, its theme is the destruction of the ecology by human misuse of technology. The video installation includes fourteen parts, each of which portrays a different aspect of contemporary life: birth – arrival; life – movement; death – leaving and absence. In another work produced with the Piven Theater (and Optimus Inc.) in Chicago, Rogala conceived of using projected video as an onstage presence of the "witches" as part of a live performance of Shakespeare's *Macbeth*. His witches offer us a radical revision of Shakespeare for a technological age: "They are pixelated, solarized, colored in, frozen still and spun around at various times, their electronically processed speech never fully in synch with their electronically processed images. Rogala brings a heightened and immediate sense of doom to Shakespeare by infusing this work with modern-age apocalyptic imagery."[20]

Figure 4.27. Miroslaw Rogala, *Nature Is Leaving Us*, 1988, video theater opera, scene 10; The Electronic City.

This complex, electronically extended mixed-media production employs a programmed multiscreen video-wall display system, live vocals, dramatic performance, dance, and five-channel sound. It acts as a contradictory commentary on humanity's frightening misuse of the environment while proposing a new electronic landscape.

(Miroslaw Rogala and the Museum of Contemporary Art, Chicago)

New territory

Although some of the early pioneers gave up the medium around 1978, discouraged by financial, technical, distribution, and access problems, early artists such as Nam June Paik, Dan Graham, Joan Jonas, Juan Downey, Mary Lucier, the Vasulkas, Bruce Nauman, Bill Viola amongst many others have matured in the medium and have helped in defining its shift toward new territory.

As an artist who has effectively used the multichannel video installation form combined with still imagery, Dara Birnbaum stands out for her forceful exposition of television's hidden agenda and manipulation of public consciousness. She uses as texts a vivid fusion of television commercials and popular news programs. To exhibit her 1982 work *P.M. Magazine*,[21]

Figure 4.28. Dara Birnbaum, *Damnation of Faust: Evocation*, 1984, video installation of two-channel video in the sectioned photographic enlargement 168in. × 90in. Partial installation view, 1985 Whitney Biennial.

Evocation is the first part of a trilogy based on the Faustian myth of hidden forces within the soul. Faust bargains with the devil to have what he desires and, in return, loses his humanity. The work is a dreamlike introspection of the internalized self and the external world. *Evocation* is derived from the longing for innocence and renewal, a desire to transcend everyday experience which is evoked through the awakening of a young woman's lost childhood. Footage for this section was shot in a playground with its swings and balances. Birnbaum uses these elements as an expressive pictorial language to explore past and present, memory and reality. The photographic mural she created for the museum installation made use of several fanlike shapes, based on the swinging movements of the work. The placement of the monitors within this mural allowed for an important dialogue to emerge between them.

(Dara Birnbaum)

she papered the museum walls with enormous still photographs and set five monitors into the panels in an architectural environment dramatically lit to create an artificial video-like luminescence. The effect she achieves is to surround the viewer literally with the media, a headlong plunge into it – as an invitation to examine critically our relation to it. The densely layered images on five monitors are hypnotically repeated and manipulated against a raucous background of rock-oriented music to articulate the alienating influence on the human psyche of messages appropriated from commercial television.

Two important exhibitions featured the video work of well-established women artists – *Revising Romance: New Feminist Video* (a traveling exhibition organized by the American Federation of the Arts [AFA]) and *Difference: On Representation and Sexuality* (a traveling show originating at the New Museum of Contemporary Art, New York). Although the intentions of the shows were different, they were both based on the premise that there is a specifically different outlook and aesthetic related to gender issues and the way social and cultural issues are perceived. The New Museum exhibition explored the question of sexual difference and emphasized psychoanalytical approaches to discussing art. The AFA show broaches the issue of romance – a subject often associated with women – and asks, in effect, what are the psychological, political, and aesthetic consequences of popular ideals of eternal passion and transcendent love? Stereotypical sexual roles are addressed through these tapes which portray the use of romance in popular culture.

Although often marginalized as avant-garde video, or as a minority voice in a male-dominated culture, the work of many women video artists continues to be an exploration of the mythologies and stereotypes, the economic and social realities that form the content and perception of female experience. Ranging in style from low-tech grainy images to the high-tech gloss of expensive post-production collaborations, the work is diverse, intelligent, and provocative. Artists who raise issues that the dominant culture has suppressed – women, minorities, gays, political activists – now face far fewer problems of access to support production and distribution of their work than previously.

Early high-tech collaboration

Some recognized artists are able to put together enough funding for complex projects that involve high-tech collaboration. For example, in the early 1980s when Dara Birnbaum received a large grant, she used it to gain access to the costly world of a commercial post-production video house where special-effects tools for state-of-the-art electronic and computerized effects are available. Artists' access to these special-effects tools represents access to extensions of video's visual vocabulary. For *Damnation of Faust: Evocation*, she collaborated with well-known New York video editor John Zieman who served as the work's post-production supervisor and co-editor.

Instead of using "found" or appropriated television images as in previous work (such as *PM Magazine*), Birnbaum chose to shoot her unstaged images "live" in a fenced children's playground. The work has a different style and range. She worked with the technical limitations of a one-tube camera to create the unreal special mood and lyrical quality of the piece. As she explained: "I love to shoot but I'm not an experienced camera person. Zieman advised me not to use my budget to rent an expensive camera, but to save the money for post-production . . . [he said to] use my own single-tube camera, push it to the limits and take advantage of that single tube, knowing it can't give realism. A lot of what looks like special

The computer as decisive editing controller

Computer-controlled video editing allows for freer decision-making and for a different set of conceptualizing strategies which lead to a completely new vocabulary of image/motion/sound. The graphically represented Edit Decision List is somewhat analogous to a musical score, for it represents the entire composition as a whole as it will unfold in time. Thus conceptualization of a work can even be predetermined via the Edit Decision List and approached holistically from many aspects – so that idea, image, and sound become an organic unity like a music composition before orchestral detail is determined. Added to this, the entire composition may be fed into the computer before any of it is edited.

Developed in 1974, the first viable computer-controlled editing system, the CMX, provided the equivalent of cinematic "sprocket holes" for video, and created the first opportunity for the editing of the original onto another tape and for rerecording the signal. However, basic optical techniques typical of film (such as slow-motion control) could not be accomplished in video until the one-inch helical Video Tape Recorder (VTR) was introduced in 1978, when both the order and duration of motion sequences in video could be controlled by the logic of the computer as an addressable time code. Different from the tedious technique of hand-splicing film and audio mixing on an added soundtrack, video editing involves transfer of electronic image signal and sound to an auxiliary tape where it is assembled, viewed, and played back on a different tape. Electronic push-button controls are used instead of the slow hand work in splicing the original film and processing it. Multiple video-signal transfers can result in loss of image quality. But advances in computer-assisted video technology have made possible far more accurate, less costly editing procedures than in film, while retaining quality.

Video previewing techniques to assist in shooting, and computer-controlled editing, are now regarded as indispensable by large numbers of leading filmmakers, including Francis Coppola, Jean-Luc Godard, and George Lucas. For example, unedited film footage is scanned by a video camera and etched by lasers into videodisks. In seconds, frames or sequences of frames can be located and flashed onto the preview monitor. Sequences are electronically marked and stored on a computer. When insertion is required, the editor calls back images needed and adds them to image footage already compiled. The computer list of marked frames is then turned over to a film lab where the actual film, rather than the video version of it, is copied in edited order.

The aesthetic potential of this approach, where sound and image are both recorded and addressable as electronic signals and digital information in the data space of the computer, has now been realized with new digital editing software packages which have emerged as a major advance. Some artists note that using a non-linear editing system such as AVID or Final Cut Pro is like "drawing with video."

The handling of large amounts of digitized information for both complex sound and image formulations now requires less time of "digital rendering" than it did before important research on image compression speeded up the process.

effects in Faust were actually done in the camera."[22] *Faust* is a layered, highly structured three-part work which uses its centuries-old theme simply as a touchstone in an evocation of a free-floating memory and a shifting dream of loss and change in the contemporary world. Zieman worked closely with the artist during the entire project by getting to know her ideas and footage and suggesting some of the final editing process. Birnbaum's multichannel installation was exhibited at the Whitney Biennial in an installation aspect.

Video moves to museums and galleries

By the 1980s, video was seen as a mature international art form in the sense that it had influenced other art works or had become part of them. It had developed a visionary corps of recognized practitioners, as well as an expanding body of criticism and analysis through such serious journals as *Afterimage*, *The Independent*, *Screen*, and many important interpretative books such as *Transmission* (D'Agustino), *New Artists Video* (Battock), *Video Art* (Schneider and Korot), and *Illuminating Video* (Hall). Catalogs of video exhibitions and festivals contain history and analysis. (See Bibliography.)

The great majority of video artists had built their reputations through international museum and gallery exhibitions.[23] Some curators regarded independent video as being at the forefront of theoretical and aesthetic thinking in the arts, and, in its nexus with the media, as a vital link to interpreting the world around us. The conviction grew amongst curators that, because technology is changing our way of living so rapidly, artists and the museum itself must respond to cultural changes positively by providing alternative experiences to viewers.

New York Times critic Grace Glueck commented that video passed the point where the public need be video-shy because of its newness or its considerable claim on time – for a video piece unfolds in time, and therefore demands a time commitment from the viewer:

> We're accustomed to looking at art that addresses us in a more or less known grammar and time-honored materials, art that can be "placed," both in a critical-historical context and literally – on a fixed site within the walls of a room . . . The video screen lacks the surface richness to which art has accustomed us. While the basic property of video is that it moves and changes, we are used to an art that we can contemplate, that stands still for our eyes to return to in sensuous or cerebral appreciation. Yet we'd do better if we stopped trying to relate video to fine art, film, or even commercial television, and began to regard it as a developing medium in its own right.[24]

In 1982, video made a striking impact on the museum-going public through a major retrospective of Nam June Paik's video work at the Whitney Museum. By now identified as the "father of video" because of his long history in working with the medium and because of his strong influence on the entire field, Paik contributed also to the identification of video as the art form of the future. Paik comments: "As collage technique replaced oil paint, so the cathode-ray tube will replace canvas." Paik's early video works – *TV Bra*, *TV Bed*, *TV Cello*, and *TV Buddha* – combined the genres of performance, installation, and sculpture. His work now not only encompasses his early neo-Dada works, using television as building-block icons, but has passed on to include his personal and intuitive, highly edited, single and multiple-channel tapes which make use of chaotic stream-of-consciousness montage using image-processed

materials from many sources. Paik's open strategies for video sculpture include an assemblage approach. He installs large numbers of monitors in elaborated contexts – from the ceiling, or, for example, set among plants in an out-of-context garden environment completely alien to normal television usage. His intention is to subvert the viewer's normal visual relations with the familiar television monitor by challenging the viewer's referential reading and interpretation of television. Assemblages of television sets are piled in pyramids, arches, or as multiple channel "video wall" works in which twenty or more monitors are hooked together. His adventurous experimentation and wily analysis of the medium itself is a playfully irreverent pastiche of the language of the commercial reality of broadcast television. Interested also in broadcasting itself as a form of public art, especially in "real-time" international satellite communications, Paik has produced a number of live performance works which bridge continents, East and West (Chapter 6). "I think video is half in the art world and half out," he says, drawing two overlapping circles, one labeled ART and one INFORMATION, "I think I am here," he comments, pointing to the overlap.

Another major video artist, Bill Viola, whose work has completely different intentions from Paik's, was also accorded a major retrospective (1987–88, Museum of Modern Art), where he showed both single-channel works and installations. His works, drawing more on the traditions of independent film, are like "visual songs" which have all the elegance and music of a poet's voice. He has achieved a remarkable synthesis in using video – the technological medium of his time – with personal vision. His work has the quality of touching an inner core in his viewer through effortless exploitation of his technical medium in a radically

Figure 4.29. Nam June Paik, *TV Garden*, 1974–78, video installation with live plants, 2000 version, two-channel color video and stereo installation with monitors and live plants.

In the *TV Garden* installation, television sets lie face up in a garden of live plants, making them appear to be organic. The manipulated colorized images playing on their screens seem to be exotic electronic flowers exuding image-processed abstract forms as a new kind of bio-video language. A pioneer of complex multimonitor video installation as a sculptural form, Paik's structures echo the Fluxus movement's emphasis on subverting the everyday to demystify it. His continuing influences over time in creating the intuitive structures of his larger and more complex multimonitor installations demonstrate his continuing involvement with Cageian ideas about chance in art and music and the influence of cinema's stream-of-consciousness montage.

(Photo: The Guggenheim Museum)

expressive way. His use of slow motion, rapid editing, deep zooms, and panoramic scans is never obtrusive, but seems rather a natural process of perception. Several themes recur in his work: powers of the human mind; passage of time; personal identity; and contemplation of the nature of species. For example, Viola shares with us those images which have powerful archetypal significance for all time: landscape is seen as a sacred setting for humans and animals; metaphors for life and regeneration are suggested in the way he uses fish, bread, and wine by contrasting them with their antithesis in nature, decay, overcrowding, industrial pollution.

Attracted early to the teachings of non-Western traditional cultures, which regard life as a continuum lived in its reference to nature, Viola has traveled and worked in the Far East, Africa, and the Pacific. In a 1986 single-channel work, *I Do Not Know What It Is I Am Like*, he contrasts a view of prairies in long, slow sequences showing movement of birds and buffaloes as a way of seeking, asking, who are we? At the tape's end, as a way of reaffirming the power of the mind, we see a view of Solomon Islanders walking on fire.

In his 1983 installation *Room for St John of the Cross*, Viola focuses on creating a metaphor for understanding the mind's capacity to escape the confines of any restrictions. He places within a larger room, containing a black-and-white landscape with sound, a miniaturized reconstruction of the cell where the seventeenth-century Spanish mystic St John was imprisoned for his heretical beliefs. On a tiny television monitor within the enclosed cell, a small color

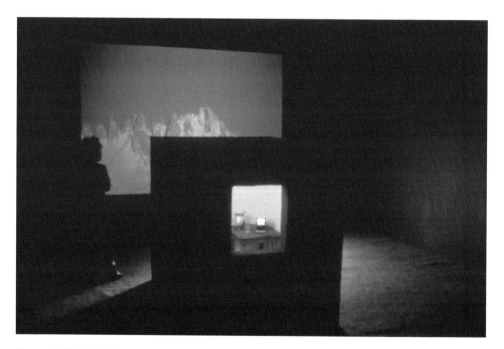

Figure 4.30. Bill Viola, *Room for St John of the Cross*, 1983, video installation.

A black cubicle with a single illuminated window stands in the center of this video installation work. Inside the tiny lighted room, which is filled with amplified sound, is a small color monitor that transmits the same mountain view projected in black-and-white on the larger wall screen of the room.

(Collection Museum of Contemporary Art, Los Angeles; Photo: Kira Perov)

image of the mountain is shown with a voice-over of the monk's verse in Spanish. Viola helps the viewer to realize that St John continued to write his ecstatic poetry despite confinement.

Viola's five-room installation at the 1995 Venice Biennale was entitled *Buried Secrets*. Its title was inspired by the thirteenth-century Persian poet Rumi. "When seeds are buried in the dark earth, their inward secrets become the flourishing garden." In the first *Hall of Whispers*, the viewer passes between two rows of five projections of heads with throttled, gagged mouths and sealed eyes. Alternating projections on opposite walls dominate *Interval* which shows, on one screen, the unhurried motions of a man showering while the opposite screen displays fragmented views of a slowed-down view of a chase and of a fire accompanied by frightening effects of deep sound. *Presence* offers reprieve in a murmuring choral sound-work. In *The Veiling*, overlapping and merging figures of a man and of a woman in different sizes and juxtapositions are projected on ten different scrims which the visitor walks through.

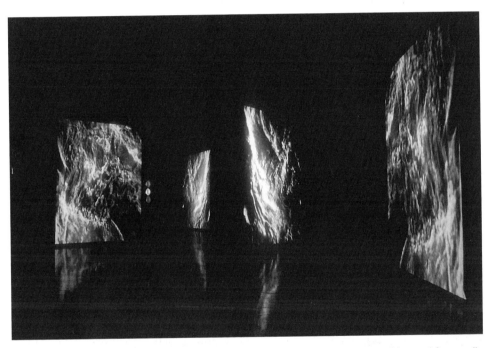

Figure 4.31. Steina, *Borealis*, 1993, projected video environment with two video and four audio channels.

Steina's work, with roots both in urban culture and her own Icelandic origins, speaks about nature and its relation to technology through stormy electronic images. By editing and manipulating stunningly beautiful clips captured in the remote Icelandic landscape, turning the video images on their sides and projecting them in sequences, she is able to achieve an experience of living abstractions on a scale taller than that of the human body. The installation environment is spatially oriented so that viewers can walk amongst its eight screens. Projectors laid on their sides provide an upright ratio for large transparent two-sided screens placed vertically in the exhibition space. Mirrors placed in the pathway of the projections split the images in two different pathways to double the number of projections. From the context of the installation environment with its sound system, one experiences the dynamic energy of natural forces in a poetic, yet disturbing way through their relationships to the technology that has produced them.

[Steina]

In the final room, *Greeting,* Viola has chosen to slow down the action of a greeting between three women – an older and a younger woman who are joined by a pregnant woman in red. Their forty-five-second greeting movements have been slowed (using film) to a duration of ten minutes. This slow-motion effect is an eloquent meditation on psychological engagement and interaction between individuals. The experience of the work as the audience travels through darkness to light is of a passage from extreme isolation to one of social interaction and continuity. The implication of *Buried Secrets* seems to be that our truest nature, and our rootedness and growth come from inner spaces before coming to the light.

Art goes video

Video represents an astonishingly diverse range of ideological viewpoints, stylistic currents, and interpretations of aesthetic issues. Many artists whose major medium is painting or sculpture, theater, or dance have made videos a natural crossover for their art ideas (e.g., amongst a host of others, Robert Wilson, Merce Cunningham, Robert Ashley, Joan Jonas, and Laurie Anderson). This diversity was reflected in the important Whitney Biennials beginning in 1985 and continuing to the present where, relative to the other art forms represented, large numbers of video works have been featured. Works have ranged from figurative to non-figurative, using animation and image-processing, and the use of autobiographic and diaristic formats. Issues often involved investigation into the meaning and relationship of word and image as they relate to representation itself, and explored through interpretations of historical and political texts and events. These were strong commentaries on the media itself and on the forms and styles appropriated from it. Some restate mass-media style directly or simply appropriate its entertainment format and mix it with other vestiges of popular culture, such as Lyn Blumenthal's two-part *Social Studies.*

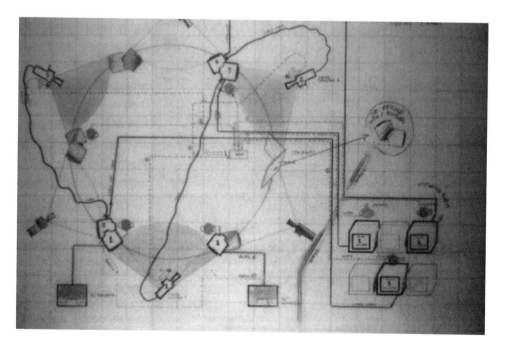

Image-processing and glossy high-tech style characterize many video works which rely on electronic effects and computer-controlled editing such as Woody Vasulka's *The Commission* or Joan Jonas's *Double Lunar Dogs* – a science-fiction parody with dramatic lighting and futuristic music. Other works, such as the Yonemotos', quote pseudo-psycho narrative to show the hollowness of their characters. Doug Hall's *Song of the 80's* presents brief, high-concept vignettes which convey anger and meanness below their glossy surface. He captures the look of media slickness with terrifying accuracy while exposing its rules and its strategies.

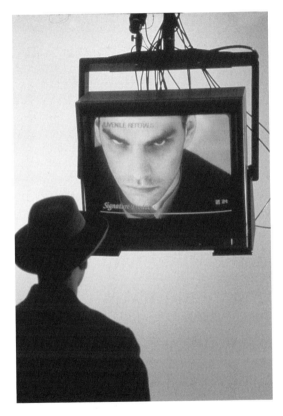

Figure 4.33. Julia Scher, detail from *I'll be Gentle*, 1991, four-monitor video installation.

Scher is interested in exposing the power machineries behind the video surveillance camera. Her strategy is to contaminate the easy flow of video and computer information against themselves. Image scans of sites within the space flash across selected screens while, on others, projections appear of the viewer passing through the installation. Ominous techno-security jargon texts slide over the screens such as "interrogation and bio-merge centers"; "chemical castration." Seen over the image of the viewer, these serve to classify the status of the viewer as an object under the control of the surrounding surveillance technology. Soothing, nurturing female voices warbling continuous sugar-coated anomalies create a sound environment which masks the installation's malevolent connotations.

[Julia Scher]

Figure 4.32. (opposite) Dieter Froese, *Not a Model for Big Brother's Spy Cycle* (*Unpräzise Angaben*), 1984, Bonn Kunstmuseum installation, installation diagram, 8½in. × 11in.

In his extensive gallery-wide installation, Froese combines closed-circuit television with a two-channel pretaped video work, using both real and dummy surveillance cameras and monitors. Walking up the stairs through the corridors and into the gallery space, viewers become aware that they are part of a spectacle while they are also watching individuals being questioned about their political activities. Froese's intentions are to create a situation where the public postures and private lives of the viewer are observed and heard throughout the gallery spaces. Avoiding simple parody, he comments on video as a surveillance tool.

[Dieter Froese; Photo: Kay Hines]

Video as installation

Installation works are a major interest of many artists. Judith Barry's *Echo* uses a video projection device to focus sound and image in unexpected places where the viewer is least expecting to receive a message. Some installation works combine video and film, others such as Shigeko Kubota's consist of sculpture-like video objects. Bucky Schwartz combines his interest in perceptual problems into a work which intrigues the viewer into a balancing act of discovering relationships between all the parts. The rich possibilities offered by multi-channel video walls have by now engaged the attention of serious video artists: Nam June Paik, Marie Jo LaFontaine, Steina, Mary Lucier, and Miroslaw Rogala amongst many others.

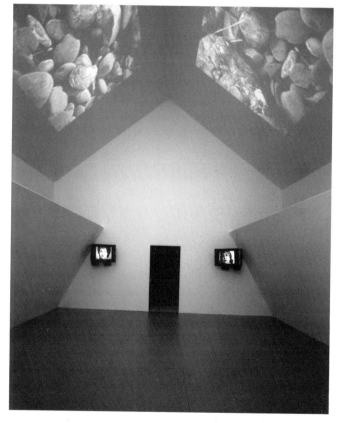

Figure 4.34. Mary Lucier, *Oblique House*, 1993, four monitors, two video projections, five channels of laser-disc video and audio.

Within the form of what she terms her "cinematic sculpture," Lucier explores questions of memory and of survival and of extinction. *Oblique House* is the setting for the retelling of the effects on the inhabitants of Valdez, Alaska, of an earthquake and of an environmental disaster. While Lucier interviewed hundreds of people who had experienced the trauma of both massive events, she chose only four who inhabit and tell their stories via monitors at each corner of the House. We experience the way each managed to reconcile the reality of survival, how they healed, how past traumas become integrated through the continuum of time. We hear their stories via processed sound but we witness through the slowed-motion action of each face a dimension of emotion far beyond what words can convey. Overhead projections of the rocky shore add the sound of foot hitting rock.

(The artist; Photo: James Via)

Exhibitions which are not video-specific integrate video as an important aspect of their theme development, such as the *Sexual Difference* exhibition at the New Museum New York. While exhibitions of video installation works such as the 1984 Stedelijk Museum show or the Bill Viola retrospective in 2000 are costly to mount, single-channel videotapes can easily be shared by mail. An indispensable network of international festivals, conferences, and distribution centers has grown in Europe and South America as a video support system and cultural circuit. Video is also shown actively in a wide range of alternative settings such as rock clubs and libraries as well as on cable and public television.

Many institutions have ongoing video collections and exhibition programs. Video study and research centers exist at the Paris Centre Georges Pompidou, the Amsterdam Stedelijk Museum, the New York Museum of Modern Art, the Whitney Museum of American Art, the California Long Beach Museum, the Boston Institute of Contemporary Art, the London Institute of Contemporary Art, the Vancouver Art Gallery, and the National Gallery of Canada, Ottawa, amongst many others internationally.

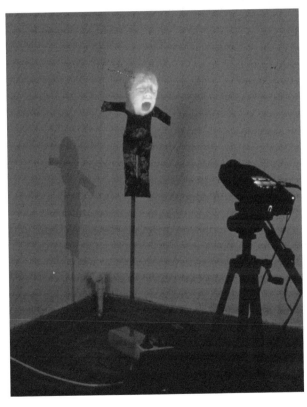

Figure 4.35. Tony Oursler, *Horror* (from *Judy*), 1994, video sculpture.

Oursler's up-close discombobulated video sculptures combine projected or onscreen faces, discarded furniture, or scarecrowlike figures. Using miniature video projectors to illuminate the faces of objects he is addressing, Oursler aims to make the psychological real. In *Horror*, the tiny cloth figure is eerily brought to life and becomes a small talking object railing at us, nattering and cursing. We cannot ignore this emotional exposure that seems close to that of a mental patient hallucinating in a state of torment.

(Tony Oursler and Metro Pictures)

Film and video: breaking the boundaries

As we have seen, those video artists who saw their work as vehicles to be transmitted on television to reach a mass public audience became increasingly frustrated at lack of access and moved to show their works at national and international video festivals and within museum and gallery venues by the mid-1980s at a time when the video medium benefited from technological advances which brought the medium closer to the medium of independent film (see p. 103) in terms of editing, image resolution, and manipulation.

An early bridge between them had been created by museums such as the Whitney and MOMA through development of film programs for the best works of the independent

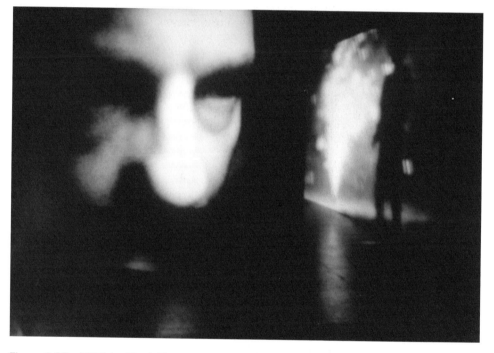

Figure 4.36. Bill Viola, *Slowly Turning Narrative*, 1992, computer-controlled installation with two video projectors and two sound systems.

In this poetic work, images are projected onto a freestanding wall with one side mirrored. The wall rotates on a vertical axis. Two video projectors face the turning screen from each end of a large darkened room. One projects a black-and-white video close-up of a man's face. He seems distracted and, at times, strained. He repeats phrases, chanting them. The second projects a series of color scenes which are full of turbulent light and color – a house on fire, children on a carousel, a carnival. The image angle of each image is narrowed or widened in relation to each projection as the wall rotates. These warped effects from the projector beams spill over onto every surface in the room, encompassing and including the viewers, who also see themselves reflected in the mirrored wall as it revolves. The work is a meditation on the inclusive nature of the self and of the potentially infinite (therefore unattainable) states of being, all revolving around the workings of the constantly turning mind as it engages in absorbing perpetual change.

(Bill Viola Studio; Photo: Gary McKinnis)

filmmakers by the 1970s – a program that included single-channel video works, especially when the new technology of video projection equipment reached an important new stage of development by 1984. By the mid-1990s artists were increasingly able to access video projection equipment. This development created a dramatic new potential for artists attracted to the scale and drama of projected moving images.

The fixed industrial system of mass production and distribution to cinemas positioned viewers in dense rows before a 35mm single screen in a darkened room. By contrast, some early independent filmmakers had used their 16mm projectors to focus on different kinds of screens and surfaces including ceilings, floors, and architectural forms. For example, the 1967 International Expo in Montreal saw dynamic experimental development of image and film projection. For *Labyrinth*, an NFB production about the archetypical stages of a person's life, a special building had been constructed to house this new filmic experience. It was designed to present the film in sections. The public moved through several rooms experiencing projections seen from different vantage points – from walkways on high to see floor projections; from midway to the downstairs level to see wall and ceiling projections.

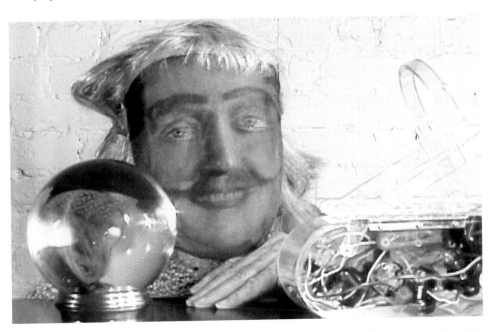

Figure 4.37. Joan Jonas, *Lines in the Sand (Based on Helen in Egypt and Tribute to Freud)*, 2002, still of video installation and performance. Commissioned by Documenta.

At the core of each of her works is Jonas as a performer, exploring issues of identity and desire across boundaries of very different materials and practices. She combines an extremely wide range of references in her work moving from music to drawing to folk tales, to contemporary news reports, and objects unearthed from flea markets. In this installation/performance, Jonas returns to writer H.D. (Hilda Doolittle) and her poem *Helen in Egypt* (1951–55) which reworks the myth of Helen of Troy as a possible reference to contemporary rhetoric. Relocating Helen from Troy to Egypt, H.D. renders her role as catalyst in the Trojan war as a narrative myth, employed to obscure a conflict between Greeks and Trojans over control of East–West trade routes.

(Joan Jonas and Documenta)

As we have seen, from its inception as a medium, video was first identified as a form of sculpture which was reactive and transmissible where participants could be recorded in space and time (Graham, Nauman, Gillette, and Schneider) in experimental room environments or as sculptural objects. Video monitors were often disguised as objects in connection with room-sized installations and used outright in gallery settings. Single-channel works were most often shown in small back rooms with one or two benches in front of a single monitor. By the mid-1980s when VCRs and projectors first became available, Bruce Nauman, Bill Viola, and Nam June Paik, amongst others, began the move from the confinement of the ubiquitous video monitor to single-screen projected image in room environments. The arrival by 1999 of ever more powerful, relatively low-cost small analog or digital projectors provided a new moment, a large-scale shift to use of video by a wide range of artists.

However, the cultural opposition that existed between the entertainment mass audience spectacles of the commercial film world and that of television in contrast to the meditative and experimental aesthetic of the high-art settings of museums and galleries was profound. "Among different oppositions that have structured the culture of the twentieth century that we have inherited has been the opposition between an art gallery and a movie theatre. One was high culture; another was low culture. One was white cube; another was black box."[25]

White box to black box: dynamic screen installation

In the Whitney Museum exhibition *Into the Light: The Projected Image in American Art 1964–1977*, curator Chrissie Iles provided a historical context to the present experimental works by artists coming from sculpture, film, sound, drawing, earthworks, performance such as Michael Snow, Vito Acconci, Peter Campus, Joan Jonas, Mary Lucier, Andy Warhol amongst many others. These early works, many of them as 16mm film loops and multichannel monitor works, explored darkened room settings which can be seen as the foundation for the present phenomenal shift from art works presented as still objects in lighted rooms to an acceptance of projected, moving imagery in darkened room installations as a major shift in the visual arts.

In her catalog essay, Iles comments that a new language of representation had been created "when artists used film, slides, video, and holographic and photographic projection to measure document, abstract, reflect, and transform the parameters of physical space." She reviewed the four-hundred-year trajectory of linear perspective to the experiments of the Minimalists, who, she claimed, "engaged viewers in a phenomenological experience of objects in relation to the architectural dimensions of the gallery – not to pictorial space – transforming actual space into a perceptual field." In the darkened open space of room installations, participation to explore is invited rather than the discouraging rigidity and lack of physical exchange experienced as viewers become encased in the cocoon of a closed cinematic theater. It is as though the viewer in a projection installation environment becomes related to camera movement – and contexts in the shifting experience of seeing lighted moving images presented as "split, overlapping, multiplied, serialized, mirrored, rotated, made miniature or gigantic."

Galleries have become sites for gigantic experimental projection works such as those by Chris Marker, Shirin Neshat, Isaac Julien, Eija Llisa Ahtila, Steve McQueen, Douglas Campbell,

Stan Douglas amongst many others. The growth of spatial projection installation works was reflected in the 2002 *Documenta XI* exhibition (see Chapter 7), which was predominately made up of black-box installation rooms where projection experiments created new experiences from that of a single projection on one wall to screens placed in and around rooms to achieve important multiscreen viewing experiences happening over time, tied to both the content and the context of the work.

> Media installations formed a permeable membrane, a demarcation between species of projective and interactive technologies, circumscribing technology and perception, and constituting a mediating instance between the architecture of the museum gallery, movie theater, and public concourse, with their respective histories, desires, and dreams. They are, in short an interface.[26]

Figure 4.38. Eija Liisa Ahtila, *The House*, 2002, three-screen DVD projection installation with sound, 14 minutes.

Ahtila's dense yet concise narratives probe a range of human experiences, both commonplace and extreme, while extending the media's formal and expressive range. In her documentary style, narratives which mix footage of real situations and people with fictitious insertions – time and events are often discontinuous or recurrent; unrelated events have the same symmetry; an accident happens both in the recent and in the remote past. These shifts seem to suggest the confused boundaries between contemporary art and media as much as they do the subject matter of *The House*. A pleasant young woman hears voices. She is going quietly mad one summer night at an old seaside resort. Cause and effect are suspended. We experience the woman's mounting confusion between objective reality and her interior life when whatever she sees or hears commandeers her consciousness in an unnaturally intense way. A cow that appears on her television ambles through the room. At one point she finds herself levitating and tries to grasp a pillar to bring herself down to earth. In general, Ahtila's discontinous narrative style allows her to find formal equivalencies in experiences ranging from losing a coherent sense of space and time to a breakdown of perceptive logic.

(Documenta and Klemens Gasser and Tanja Grunert Inc., New York City)

Figure 4.39. Doug Aitken, *New Skin*, 2002, four projections onto elliptical X-screens with sound, 12 minutes.

Commissioned by the Pompidou Center, Musée d'Art Moderne, Paris.

Essential aspects of Aitken's work in video, film, installation, photography, sound, and artists' books – time, perception, memory, and an evocation of inner life – are to be found again in his installation work *New Skin*. In it, Aitken seeks to waken the audience to the power and value of everyday perception and challenges a questioning of it. We follow the trajectory of a young Japanese woman who is losing her sight. The four-channel video is projected onto screens that intersect with each other at the center of the room. We shift back and forth between images of the woman in a room crowded with books and picture albums and with depictions of her interactions with the world outside. She speaks about holding onto the images fading from her sight. We are left with an awareness of the preciousness of sight and an inescapable sense of the strangeness of the real world. Fade to black . . .

(303 Gallery , New York, and the Galerie Hauser, Wirth and Presenhuber)

Structure and grammars of the spatialized moving image

When multiple projection screens are staged together in variable contexts and in a projected environment, traditional film grammars of montage such as flashback which apply to the con-straints of single-screen narrative film are thrown into a new territory of hybridity. The very distribution of multiple screens of different sizes within spatialized juxtapositions within varying distances of each other creates different intensities and confusions when related to traditional viewing of moving images. There may be different strategies of compression and

Figure 4.40. Gary Hill, *Still Life*, 1999, twelve-channel video installation with five monitors, DVD player, video switcher, projection screens.

Hill's art is about making technology into an instrument of poetic inquiry in order to retrieve a sense of self and memory. He has often positioned cameras on his own body or used text in ways that engage the viewer to form new relationships between nature and philosophy. In *Still Life*, Hill constructed an expansive environment where the viewer experiences the forms themselves as sculptural entities – different-sized screens and monitors exuding colored light. The viewer walks among them reading the images and text narrations from different distances and perspectives.

(Barbara Gladstone Gallery, New York)

image editing, some parallel, others out of sync, some outside of screen space on monitors, or on architectural forms or objects. Time becomes fractured. Some may be networked or digitally altered in various layered ways such as image and text projected with historic film or video footage. The logic of these hybrid works is increasingly complex.

Once, the critical divide between the sculptural time-based art of video and film was narrative logic. Now, however, this barrier has shifted so that the understood distinction between them has moved to another territory. As yet, there is no new critical language for untangling the many issues that are evolving in the new hybrid forms being explored by a growing number of video, new media artists, and filmmakers.

Sound is affected by multiscreen environments. There is confusion as to where speakers are distributed and which sets of images are affected in their segments of localized space as the viewer/participant moves through the environment (see Chapter 5).

Figure 4.41. Shirin Neshat, *Untitled (Rapture* series – *Women Scattered)*, 1999, two-channel video installation.

Shirin Neshat's projection installations draw viewers into a transcendental realm brimming with metaphor. Her reduced allegorical plots are entirely without dialogue and develop from a thematically and formally dualistic narration. Her interests lie in drawing parallels between socially, culturally and religiously coded and controlled spaces and the female body. In this work from the *Rapture* series, viewers are forced to decide between two films projected on opposing surfaces. Through this process of having to stand between them and decide which to follow, the viewer of these double projections is able to experience the emotional condition of a woman caught between two worlds. The work becomes a poetic dialogue between cultures and conditions.

(Documenta XI and the Barbara Gladstone Gallery, New York)

Montage in film as described by Eisenstein referred to the edited juxtaposition of two differing sets of images moving in time with the intention of creating a space between them where the viewer seeks meaning. Montage may use the technical forms of fast-forward cutting, cross-cutting, jump cuts, flashback. However, these temporal strategies lose their power when moved outside the single viewing frame of the cinema. Once multiple screens with multiple layers are introduced, these grammars lose their intensity.

Future Cinema: The Cinematic Imaginary After Film, a 2002/3 ZKM exhibition[27] curated by Jeffrey Shaw and Peter Weibel, brings together significant new forms that diverge from works by artists using video, new media, immersive environments and online configurations. The international exhibition of current art practice was the first to anticipate new cinematic techniques and modes of expression which diverge directly from film. One strategy for digitally extended cinema explored in the exhibition was development of modular structures of narrative content which permit "indeterminate very meaningful numbers of permutations" which could be used interactively within a participant's space relations. Further to this was

an algorithmic design of narrative content that could be modulated by participants who then become inhabitants and agents crucial to the narrative development (see Chapters 5 and 7). New descriptive territories in the digital expansion of cinema include terms such as *remapping, recombinary, transcriptive, interpolated, navigable, screenless.*

Explorations of new forms of installation and of display using new "smart " materials added to the complexity of issues raised by this exhibition. Cultural engagement with these new mutable issues and genres varies widely, and changes so rapidly that boundaries that existed between film, video, the Web, and new media have become extremely porous.

Figure 4.42. Chantal Akerman, *From the Other Side*, 2002, three-part installation with twenty monitors with streaming video.

Known primarily for her significant film works, Akerman has begun to explore room-sized installation in order to exploit the narrative possibilities which are opening up means for creating new experiences of the issues she is presenting. This large project made particular use of live streaming video Internet connections with effective organization of screens in the viewing space. *From the Other Side* was shot at the US–Mexican border region and concerns the plight of many thousands of people who attempt to migrate northwards and who, even at night, are hunted down by the Border Patrol with infrared sensing devices or are incarcerated by local ranchers in improvised concentration camps. Akerman presented the work both in New Mexico and at Documenta, providing a technological direct link to a pressing political issue.

(Documenta and the Marian Goodman Gallery)

The future of video is digital

In a purely technical sense, the history of video as a medium can be seen as a history of its gradual convergence with the mediums of film, the computer, and the Web by offering

further control over optical effects, motion, and time; improved audiovisual storage, editing, image resolution, compression, and transmission of streaming video; and, finally, projection possibilities on the scale of theater events.

These changes have brought about the demise of analog technology in favor of the digital sphere. The rate of technological change through the convergence of telecommunications with the computer (Chapters 5 and 6) has now become very great and is happening with such speed that it is difficult to comprehend and predict all of its consequences.

Given the new technologized conditions – the melting away of traditional distinctions between genres; the explosive growth of communications; the strong desire by audiences for program options; the television industry's transitional growth, through development of interactive telecommunications (see Chapter 6); the valuable learning experience gained through models of past mistakes and gains; the miniaturization of digital video cameras, editing software, and availability of consumer VCRs and DVD players; and the broadened base of video practice (which now includes many genres) – an opening to the expansion of

Figure 4.43. Josely Carvalho, *Book of Roofs: Codex dos Sem Teto, Page/Title #0001*, 2001, video installation, three thousand clay roof tiles, sand, and projection.

The *Book of Roofs* installation is part of a media project which includes website, print, video, and sound components. Based on exploring issues regarding the human need for shelter – our abiding need for home both physical and psychological – the projects seek to touch on and interpret the effects and experience of the contemporary world. Going beyond often painful issues of readjustment, the work invites a commentary about the vast displacement of people in our time. The three thousand Brazilian clay roof tiles featured in the video installation represent the hope for rebuilding and form the sculptural setting for projections of images from various pages of the book of roofs as they have been compiled. The Internet aspect www.book-of-roofs.com allows online submissions by narrating a concept and submitting it as text or image documents.

[Josely Carvalho]

digital public-access cable television art could eventually develop. The struggle to break down barriers, find support, and attract new audiences is bound to engage artists well into the twenty-first century. Many also look to the developments of the Internet as a means for gaining access to worldwide audiences (see Chapter 6).

A more public discourse?

The New York Video Festival now parallels in importance the annual New York Film Festival. In a review of the 1994 Festival, a *New York Times* critic proclaimed that video is a more intimate medium than film, its small low-light camera can be less formal, thus less conspicuous, more body-oriented. It allows the videomaker greater voice in production control because it requires less collaboration. Miniaturized camcorders with complex capabilities are now standard consumer items. With a sophisticated public now accustomed to choosing from a wide variety of television, film, and video materials, and with video festivals aimed at a larger mass audience, video has reached a dramatic new stage. Artists are also producing expanded video installations for major museums such as the Museum of Modern Art, The Whitney Museum of American Art, The Guggenheim, Tate Modern, The Pompidou Center amongst many others, as well as for inclusion in international festivals such as Documenta and the Venice Biennale. A Danish group of filmmakers calling themselves the Dogme Group (Chapter 7) are using their small digital cameras to create narrative films which are being shown in mainstream movie theaters.

As yet, although digital video is a "mass media" tool, the projects most artists have produced with it are still not mass audience works, many of them continue to be conceptually formal with personal vision a major aspect of the expression rather than an attempt to communicate with a mass public. However, a major aesthetic impetus is, for many, to comment on the influence of contemporary media culture by reacting to it, quoting from it, and seeing everything in relation to the cultural conditions it creates.

Notes

1 The Rockefeller Foundation (by 1967); New York State Council for the Arts (1970); and the National Endowment for the Arts (1972). The Canada Council and European government-based arts funding also began supporting video activity. Early grants went to facilities such as the newly founded Electronic Kitchen in New York and the Experimental TV Center in Binghamton, NY (later, Owego), where small-format and post-production equipment were made available to artists together with gallery screening of video.
2 In 1972, the First Annual National Video Festival took place at the Minneapolis College of Art and Design and the Walker Art Center. Later that year, the first Women's Video Festival was mounted at the Kitchen in New York. Video also became part of the annual New York Avant-Garde Festivals. It was widely exhibited in new media centers such as the Visual Studies Workshop in Rochester, NY. In 1970, the magazine *Radical Software*, published by the Raindance video group in New York, began disseminating both technical information and news about individual artists' productions.
3 Film was normally cut and spliced together by hand, using the film frame and sprocket holes as a guide. In video, the electronic signal is transferred to another tape and reassembled onto another generation of tape through the editing console. Loss of image quality occurs in this transfer.
4 The lightweight 16mm Bolex camera has been used by "independents" since the 1940s.
5 Phillip Drummond, "Notions of Avant-Garde Cinema," from the catalog *Film as Film: Formal*

Experiments in Film 1910–1975, London: Hayward Gallery, Arts Council of Great Britain, June 3–17, 1979, p. 13.

6 Lucinda Furlong, "Tracking Video Art: Image Processing as a Genre," *C.A.A. Art Journal* 45(3) (Fall, 1985): 235.

7 Such as the Fairlight CVI, the Modified Dubner, introduced in 1985, and the Amiga "Toaster." These developments have been superseded by Macromedia and Avid software, and Final Cut Pro which are revolutionizing video editing allowing for nonlinear methods.

8 The key paradigm development period of modern times (1820–1965) brought together a complex of scientific advance and technological invention which made television possible: electricity, telegraphy, photography, motion pictures, and radio. The discovery of the cathode ray tube (Campbell Swinton and Boris Rosing, 1908), the concept of a scanning system (Paul Nipkow, 1884), and picture-telegraphy transmission (Herbert Ives, 1927) were further discoveries along the way that led in 1928 to the introduction of the first low-definition television system (thirty lines). In 1936 the first BBC television broadcast was made from Alexandra Palace, London – and in 1939 from the World's Fair, New York.

　　By the 1920s modern urban industrialized conditions and improved transportation systems created new kinds of social organization which led to tendencies toward the self-sufficient family home, sometimes far from the workplace. This "privatization" of the small family home carried "as a consequence, an imperative need for new kinds of contact . . . a new kind of 'communication': news from 'outside', from the otherwise inaccessible sources . . . Men and women stared from its windows, or waited anxiously for messages, to learn about forces 'out there', which would determine the condition of their lives." Raymond Williams, *Television: Technology and Cultural Form* (New York: Schocken Books, 1975), p. 27.

9 In the US, recent surveys show average television consumption as seven hours per day (almost half our waking hours). An average two- to five-year-old watches television four to four and a half hours per day; an average twelve-year-old, at least six hours.

10 John Hanhardt, "Watching Television," in Peter D'Agostino, ed., *Transmission* (New York: Tanam Press, 1985), p. 59.

11 Originally published 1967. This translation was published in 1992 by Zone Books, MIT Press.

12 From Third World countries to highly industrialized ones, the "public resource" of television is dominated by those countries which can afford to produce programming for hungry global needs. Domination of television programming by commercial influences reflects erosion of the autonomy of individual nations and communities struggling to voice and project their own social, political, and cultural concerns. Mass television thus represents a danger, despite its possible transformative benefits in broadening international communication and cultural exchange. "Since the 1950s, the US.-made TV programs have saturated the schedules of industrialized and non-industrialized countries alike. Italian television, for example, is practically an affiliate of the American networks. US commercial television has been a major source of programming for Third World countries as well." Herbert Schiller, "Behind the Media Merger Movement," *The Nation*, June 8, 1985: 697.

13 Walter Benjamin, "The Work of Art in the Age of Mechanical Reproduction."

14 Ibid.

15 Willougby Sharp, quoted in Carl Loeffler, "Towards a TV Art Criticism," *Art Com #22* 6(2) (1983): 32.

16 These included the National Endowment for the Arts as well as the Rockefeller Foundation and the New York State Council for the Arts. (See also note 1.)

17 Community Antenna Television (CATV) was developed in the 1940s to provide clear reception to communities where normal broadcast reception was poor owing to distance from the main transmitter or to the topography of the terrain. The broadcast signal was received by a high antenna, amplified and retransmitted via coaxial cable to the homes of subscribers. (See Glossary for a history and more information about cable.)

18 Martha Gever, "Meet the Press: On Paper Tiger Television," in *Transmission* (New York: Tanam Press, 1985), p. 225.

19 Music videos and music CDs are now widely popular, with consumers often "burning" their own music CDs directly from the Internet.

20 Brochure notes for the performance, 1990.

21 The three On Line production facilities (two in New York and one in Owego) provide independents with access to three-quarter- and one-inch CMX and AVID digital editing equipment, and ADO and Quantel "special effects." Video artists can shoot on inexpensive video 8mm or half-inch formats and then post-produce onto the three-quarter-inch or one-inch format. *P.M. Magazine* was a popular news and entertainment television program directed at the "happy consumer" family.

22 Quoted in Robin Reidy, "Video Effects Art/Art Affects Video," *Art Com #24* 6(4) (1984): 58.

23 A small sampling from the years 1983–90 includes: *Video as Attitude*, Museum of Fine Arts, Santa Fe; *Electronic Vision*, Hudson River Museum, Yonkers; *The Second Link: Viewpoints on Video in the Eighties*, Walter Philipps Gallery, Banff; *Video, a Retrospective, Parts I and II*, Long Beach Museum of Art, California; *The Luminous Image*: Video Installations, Stedelijk Museum, Amsterdam; *Video: A History, Parts I and II*, Museum of Modern Art, New York; *Alternating Currents*, Alternative Museum, New York; *Video Art: Expanded Forms*, Whitney Museum at Equitable Center; Bill Viola, *Installations and Videotapes*, Museum of Modern Art, New York; and *Documenta Seven* (and *Eight*), Kassel, Germany.

24 Grace Glueck, "Video Comes into Its Own at the Whitney Biennial," *New York Times*, April 24, 1983.

25 Lev Manovitch, e-mail September 29, 2003 nettime, "Learning from Prada," Part 3.

26 Tom Zummer, "Perception and Disembodiment," essay in *Projected Light* catalog, Whitney Museum.

27 ZKM Center for Media Art (www.zkm.de) is located in Karlsruhe, Germany.

5

Art in the age of digital simulation

> The computer represents the end of Renaissance space in art – the demise of Euclidean geometry . . . Digitization represents the new world order, the transition from simulacra to simulation, from copying to modeling.
>
> <div align="right">Andrew Menard</div>

> The computer . . . begins to assimilate representation itself . . . video, film, and principally photography are being challenged to hold their authority against visual modeling systems that are emerging which eclipse their forms . . . As representation and technology converge, a crisis emerges.
>
> <div align="right">Timothy Druckrey</div>

Computers represent a challenge to conventional notions of visual representation

Until recently, images have been created through acts of human perception either through skills based in eye/hand coordination or through the lens of photocopying processes of media tools such as photography, cinematic film, or video, where what is seen is recorded through various chemical or electronic processes as an immediate copy of reality. However, the computer reads electronically scanned aspects of reality as information about light structures, storing this numerical information in its database, which can eventually be programmed to appear as visual imagery.

Computers greatly accelerate the process of mathematical abstraction in the visual arts. Digital images simulate the real by mathematically modeling it rather than imitating it through a copying process. Simulations cannot be considered as "simulacra" or copies, for there is no point in regarding digital information models as simple fakes or reproductions. They can

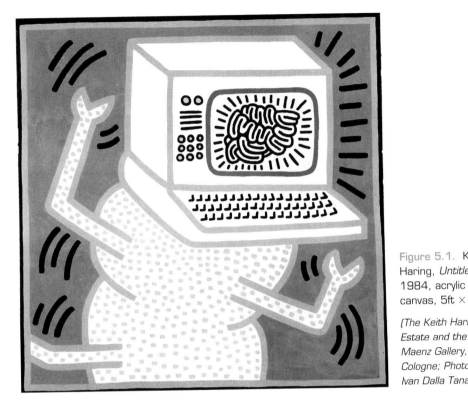

Figure 5.1. Keith Haring, *Untitled*, 1984, acrylic on canvas, 5ft × 5ft.

[The Keith Haring Estate and the Paul Maenz Gallery, Cologne; Photo: Ivan Dalla Tana]

generate any kind of imagery or any kind of "reality." Although the Cubists and Constructivists challenged classical notions of linear space, they retained the line, the plane, the forms so characteristic of Euclidean geometry with the body still the measure underlying the structure. Within the logical world of computers where number, not shape or volume defines geometric space, nature and the body as we know them do not exist.

Although a digital image looks like its photographic counterpart, it is very different from the light-sensitized granules of film or the electronic variation of light intensities in video. A digitized image is composed of discrete elements called pixels each having assigned precise numerical values, which determine horizontal and vertical location as well as a specific gray-scale or color intensity range. Such a structure of pixels is controllable through a series of enormously complex effects.

> A digital image does not represent an optical trace such as a photograph but provides a logical model of visual experience. In other words, it describes not the phenomenon of perception, but rather the physical laws that govern it, manifesting a sequence of numbers stored in computer memory. Its structure is one of language: logical procedures or algorithms through which data is orchestrated into visual form.[1]

A digital photographic image is, then, a representation made through logical, numeric-based mathematical language structures achieved through encoding information about the

Figure 5.2. Joseph Nechvatal, *The Informed Man*, 1986, computer/robotic-assisted Scanamural (acrylic on canvas), 82ft × 116ft.

In making the decision to enlarge his image to epic proportions using the Scanamural process, Nechvatal wanted to make a specific point in reference to *The Informed Man*, a painting produced electronically, that is composed of degraded information patterns. The airbrush guns that reproduce the image are guided by computer-driven robotic arms fed with information derived from scanning the original art work (as a small transparency) and enlarging it to 82ft × 116ft onto a canvas support.

(Collection Dannheisser Foundation)

lights, darks, and colors of reality captured and digitized through any kind of lens or scanning procedure. The computer reads electronically scanned (digital) information about a scene and transforms it into numerical data which can be made visible as imagery. Once an image's structure of lights and darks, its "information," has been digitized by the computer into its numerical data space, its picture elements or pixels can be controlled individually. They can be altered, manipulated, weighted, warped, or repositioned to create not only a simulation of a photograph but also an artificial or parallel "virtual" reality.[2]

Seeing is no longer believing

Photographs were once recognized as the epitome of truth. A photograph is actually, of course, an illusion of the "true." It is through photography that many artists have examined questions of originality and authenticity. Now a photograph's information can be processed or changed by manipulating or warping its structural light components in the computer to create images

which are complete simulations. The computer's artificial simulations of reality are indistinguishable in appearance from photographs. The capability to invade images and create invisible alterations to photographs, thereby undermining its accepted "truth," authority, and authenticity through a seamless process of retouching and editing is a destabilization of the image. It has created a crisis of belief which has political implications. We can no longer rely on the old system of "truth in images." For example, during the 1991 Gulf War, a photograph of Iraqi dictator Saddam Hussein, seamlessly manipulated on the computer so that his mustache was made to resemble Hitler's, was produced as wall posters for the city streets. Writing in the catalog for the *Infotainment* exhibition, George Trow commented:

> No wonder art has had another nervous breakdown: the invented image had been its specialty, its raison d'être ever since photography took over "lifelike rendering" more than a century ago. Indeed, art's current crisis is analogous to that which occurred when photography was introduced, only now the crisis in art . . . has finally reached vision itself. The discovery that seeing is no longer believing is not so frightening when you consider that truth itself can only be leased.[3]

Figure 5.3. Nancy Burson with David Kramlich and Richard Carling, *Androgyny (Six Men and Six Women),* 1982, simulated photograph, 8in. × 10in.

In this composite image, the portraits of six men and six women have been scanned into the computer and fused into one simulated portrait. The work suggests the tension and fascination of "face value" – i.e., whether male or female characteristics predominate in a face. Yet, information simulation resonates with the impossible, revealing what refers to nothing, a ghostlike personality without real substance and history. Burson taps an important postmodern vein in her subject matter and in her use of information as simulation.

(Nancy Burson)

Global vision

Figure 5.4.
Woody Vasulka,
Number 6, circa
1982, computer-
manipulated
images.

These visual investigations make use of the process of scanning or digitizing the information about lights and darks into the computer. The information is then altered by a scan processer, an analog device, or other image-processing equipment. Vasulka has played a pioneering role in developing such image-processing tools.

(Woody Vasulka)

Operating independently of the body's visual senses, the computer has subsumed all of visualization within the realm of mathematics. Paradoxically, the computer's capacity to "see mathematically" is helping us to see more completely than we can with the human eye alone. Vast amounts of visual information about a particular subject or scene can be encoded on a digital video disk, or DVD as a visual database. For example, a landscape view could comprise sequences of satellite photos which first show aerial views of a coastline, and compare them with multiple views of other coastlines hundreds of miles apart, then closer portions of the

region. Distant views of New York City and of Philadelphia can be explored in detail through closer views of their street patterns, and finally, through isolation of individual buildings, with a tour of their rooms. The computer can sort out in a complex way the ordered structure of programs stored in its database as coded information for later retrieval and display on command. Bill Viola, video artist, referred to the phenomenon:

> What fascinated me was that the progression was not a zoom or a blow-up. It's not as though they used four different lenses and made four different pictures. All the buildings in the close-up existed already in the global view because it's actually a computer data base and they're in the information so the image doesn't lose detail or become grainy when it's enlarged because it's computer enhanced. That's not zooming. You determine the scale of what you're seeing by processing information that's already there. Everything is encoded into the system and as a viewer or producer you just determine what part you're revealing.[4]

This new computer-enhanced, expanded "global information" vision, where a particular image or sequence of images can be called at will from the data bank, goes far beyond conventional photography to an area termed *digital image processing.*

The new alphabet: sound, text, and image as digital information

Because the computer, with its new digital alphabet, is capable of encompassing all aspects of information – sound, image, text within a single database – a new fusion of disciplines is under way which will affect the way knowledge is acquired and created. The universality of the computer as a tool for working in the humanities, the sciences, and the arts is creating interesting interdisciplinary effects whose promise we are only beginning to fathom. Scientists are now using visual images as a way of verifying visually their research experiments, in such areas as meteorology and geology. Writers incorporate sound and visuals in their texts. Artists access sound, text, and image in their multimedia productions.

Digital technologies have thus become the catalyst for tendencies in the convergence of disciplines, for the universal computer is both a tool *and* a medium. The new cognitive linkages and means of production are creating fresh relationships between fields of knowledge and understanding. These represent a major shift, in the paradigm of representation, one that goes beyond the crisis described by Walter Benjamin when he referred to the edited, moving grammars of film as a shattering of tradition. Photographic technologies acted as the underlying structure for the evolution of nineteenth- and twentieth-century visual culture. However, digitization has superseded and subsumed them, in a completely new paradigm for representation.

Figure 5.5. Janet Zweig, *Mind Over Matter*, 1993, computer, printer, rock, rope, pulleys, basket.

Janet Zweig is an artist fascinated by exploring the possible ways of pitting her interest in words and meaning against the randomness of the digital database. Could there be philosophic responses from a computer? In this work, she fed it with three well-known sentences: *I think therefore I am* (Descartes), *I am what I am* (Popeye), and *I think I can* (The Little Engine That Could). In the gallery setting, the computer randomly generates all possible grammatical sentences from the parts, for example: "I think I can think," I am what I think I am, I think," "I think I am what I am," "I can think what I can," etc. The text falls into the basket, slowly lifting the rock. She comments: "I was surprised to find that, from these three very declarative sentences, the computer generated sentences that seemed to be filled with self-doubt."

(Janet Zweig)

Simulation: virtual or hyperreality

As we have seen, the term *simulacrum* refers to a copy of a copy of the real. We can call a photorealist painting a simulacrum because it was a painted copy of a photograph, which was itself, inherently, a copy of the real. Through mechanical reproduction copies of copies of the original circulate in the culture in a way that changes their meaning. However, the term *simulation* refers to the creation of fundamental models which appear to be perfectly natural or real but in reality have only been made to appear through the agency of programmed digital information. The simulation is thus a system of computerized mathematical instructions which can be made to imitate or approximate a kind of reality we can term "virtual" because it does not in fact have an existence as an object nor is it a copy of the object in the sense that it is a photographic trace of it. Simulation is a mathematical model of the real, a new kind of representation.

Electronic image-production is immaterial, existing only as an image structure or accumulation of data, without physical substance. It does not lead necessarily to the production of a material art object unless the artist makes a conscious decision to translate it into one that can maintain a physical presence with a particular dimensional level within a perceptual field.

Virtual reality is virtual precisely because it is both abstract and real. The remarkable nature of simulation is that there are no limits to what can be realistically represented. However, the new virtual reality, three-dimensional environments are only structures of human knowledge. They are the sum of our human knowledge about any one subject such as a bird or a human body. We can create models of objects and animate them to move around in virtual space using ultra-sophisticated programming and millions of polygons.

The French philosopher and critic Jean Baudrillard described simulation:

> Generation by models of a real without origin or reality: a hyperreal. The real is produced from miniaturized units, from matrices, memory banks, and command models – and with these it can be reproduced an indefinite number of times. It no longer has to be rational, since it is no longer measured against some ideal or negative instance. It is nothing more than operational. In fact, since it is no longer enveloped by an imaginary, it is no longer real at all. It is hyperreal – the product of an irradiating synthesis of combinatory models in hyperspace without atmosphere.[5]

The Platonic dilemma is that art can never transcend artifice. Anything that is represented as reality, even one's image in a mirror, or a photograph, is understood as a fake, a copy. This is a classical position which still informs the postmodern debate about aura, the copy, and the original. Art critic Andrew Menard comments that "The transition from simulacra to simulation, from copying to modeling"[6] brings into conflict the philosophical boundaries presented by Plato's questioning of the relationship between appearance and reality with that of Aristotle. Copies (e.g., photographs, or copies of copies – simulacra) are encompassed within Plato's debate about art where "even the best imitation of nature is a fake" and that appearance can never merge with reality. However, Aristotle's philosophical position is that art is *supposed* to imitate reality. Plato's understanding is illustrated in the myth of Pygmalion, who sculpted a perfect copy of a female form (Galatea) so cleverly that his art concealed its artfulness and he fell in love with his own copy of reality – until the imitation was brought to life by Aphrodite – proving that art can never merge with reality.

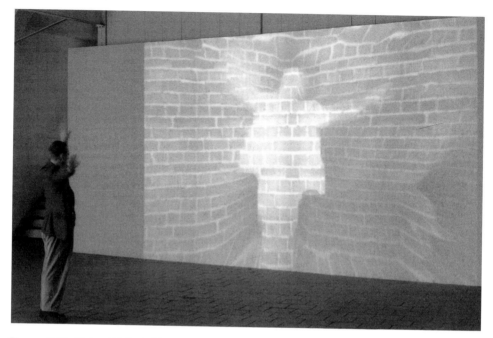

Figure 5.6. Peter Weibel, *The Wall, The Curtain (Boundary, which), also Lascaux,* 1994, interactive computer installation with video cameras, beamer, VGX computer. Programming by Bob O'Kane.

According to Plato, humans exist in a cave with their backs to the light, seeing only the reflection of the world as shadows on its walls. We sit inside and look at a world not directly accessible to us. Aristotle sees the world as a stage where we are observers in a realistic and objective model of it. For him, the present laws of nature lead and direct the state of things and the turning of the world. Weibel's piece is part of the "Butterfly Effect Project" which refers to a phenomenon explored in chaos theory. The sensitive dependence on world interactions understood in this theory has been colloquially described: "If a butterfly flaps its wings in Tokyo, then a month later it may cause a hurricane in Brazil."

(Peter Weibel)

Aristotle's outlook could be more relevant for us in our exploration of changes in representation brought about by technological means. In his view, "art isn't a question of authenticity, but of precision – the exactness of the imitation, its verisimilitude. What for Plato was a crisis of knowledge, is for Aristotle a technical problem. Authenticity depends on the quality or essence of imitation, on the virtuosity of artifice. Art = Artifice."[7] Menard stresses the point that even if we are never able to resolve the opposition between real and fake, copy and model, technical developments now take us into a territory where a parallel reality exists – one that resides within reality – where the perfection of mathematical modeling creates a reality which has been called "virtual reality."

Figure 5.7. Craig Hickman, *Signal to Noise #1*, 1988, computer drawing

Signal to Noise is not a sequential book, designed to be read cover to cover, but rather one whose structure is more like music. Tuning in signals makes for a kind of "cultural stew" of different mixtures of music, noises, whistles, and overlapping sound distortions which join and superimpose themselves. His interest in short-wave radio led him to be fascinated by the space between receiving a signal (or message) and its bleeding out of focus to mere noise. The book explores three kinds of messages and plays with the system used to decode them.

(Craig Hickman)

Information as simulation: living with abstraction

Figure 5.8. Ken Feingold, *If/Then*, 2001, close-up, mixed media, silicone and steel with electronics.

"Two identical heads, sculpted in the likeness of imaginary androgynous figures, speak to each other, doubting the reality of their own existence. These two, in ever-changing and outrageous conversations with each other struggle to determine if they really exist or not, if they are the same person or not, and if they will ever know. I wanted them to look like replacement parts being shipped from the factory that had suddenly gotten up and begun an existential dialogue right there on the assembly line. Their conversations are generated in real time, utilizing speech recognition, natural language processing, conversation/personality algorithms, and text-to-speech software. They draw visitors into their endless, twisting debate over whether this self-awareness and the seemingly illusory nature of their own existence can ever be fully understood" – Ken Fiengold.

(Ken Feingold and the Postmasters Gallery)

Indicative of the change in the times is the fact that the curator of the *Les Immatériaux* exhibition at Paris's Centre Georges Pompidou[8] was Jean-François Lyotard. One of the foremost theoreticians of postmodernism, he used the exhibition to provoke questions about contemporary states of simulation, artificiality, and synthetic "nonbeing" which grow out of the instabilities and changes inherent in postindustrial society. The primacy of the manufactured object has been dissolved into other states of energy (or microelements) rather than into concrete matter: a "disappearance of the object" in favor of its artificial or virtual facsimile.

The exhibition space, designed as a labyrinthine tour of "sites" or hanging islands, each with a separate theme, interpreted and defined many of the major features of postmodernity as a new moment in culture. It offered a significant perspective on how the terms of our cultural conditions and their relation to historical and philosophical issues have brought about a crisis of outlook in contemporary times. "A series of key themes was brought forth and reiterated: the primacy of the model over the real, and of the conceived over the perceived. That we live in a world in which the relation between reality and representation is inverted was made clear by countless examples. Much attention was paid to the copy, to simulation, and to the artificiality of our culture." In fact, *Les Immatériaux* suggested nothing so much as our common fate in living with abstractions,[9] for example, completely artificial flavorings, fragrances, experiences are an inversion of former experience of "the real thing" as part of new but artificial states. The exhibition's dramatically lit theatrical spaces, where suspended objects and images loomed out of the darkness, demonstrated the already pervasive artificiality of our present existence – for example, *Site of Simulated Aroma*, *Site of All the Copies*, *Site of the Shadow of Shadows*, *Site of the Indiscernables*, *Site of the Undiscoverable Surface*.

Lyotard comments on this major change in the relations between the modern concept of mastery and production as opposed to the postmodern:

> Whereas mechanical servants hitherto rendered services which were essentially physical, automatons generated by computer science and electronics can now carry out mental operations. Various activities of the mind have consequently been mastered . . . But in so doing . . . the new technology forces this project to reflect on itself . . . It shows that man's mind, in its turn, is also part of the "matter" it intends to master; that . . . matter can be organized in machines which, in comparison, may have the edge on the mind. Between mind and matter the relation is no longer one between an intelligent subject with a will of its own and an inert object.[10]

The postmodern self is distracted and atomized into multiple heterogeneous domains sheared away from conscious life.

Database art as a new cultural form

Lev Manovich, in his *The Language of New Media*, discusses the database as the center of the creative process in the computer age.[11] He sees it as a new symbolic form – as "the projection of the ontology of the computer into culture itself." He speaks about modern media as a battleground between a system which relied first and foremost on the narrative form and the new culture based on the database: "After the novel, and subsequently cinema, privileged narrative as the key form of cultural expression of the modern age, the computer age introduces its correlate – the database."[12]

Manovich points out that two kinds of software create art works – data searchable structures for creating hypernarratives and algorithms which represent the hidden logic that is the foundation for creating gamelike objects. Many new media works don't contain stories and have neither beginning nor end. They do not have any formal development although they may take on the form of a hypernarrative – a multiple with trajectories through a database of collections of items with no hierarchies.

A database is a structured software program which allows quick search access for sorting and reorganizing millions of records and documents. Since each search record itself may contain a number of fields with user-defined values – anything from financial records to movie clips – we can say that it is a multi-indexing device with both simple and hyperlink levels depending on the design and needs of its structure.

Both the database itself and the three-dimensional virtual space it exists in can be thought of as "true" cultural forms. We are by now accustomed to move easily through spatialized, designed formats which set up procedures for participation in "media objects." These run the gamut from encyclopedic resources such as those used by libraries and museums to search their records, to those used for work or business or for fun or leisure activities. Databases take on different forms. They may be hierarchical with treelike structures, or be relational – for investigating, parallel worlds; or they may network or have chain operations for viewing, investigating, and searching.

The main goal of a database is to provide an interface to information-processing tasks for pulling relevant records, some of which may be embedded in many other databases through a data-mining process (especially via the Internet); using spreadsheet technologies; or searching the Internet (see Chapter 6).

Build ...
- ... the home of your dreams with powerful architectural design tools
- Decorate walls and floors in any style
- Create your own private paradise with landscaping tools

Buy ...
- ... hot tubs, swimming pools, topiaries, pool tables, giant-screen TV's ...
- Over 150 different objects to furnish your homes and keep your Sims happy

Live ...
- Create an endless variety of characters and families
- Follow a wide range of career paths
- Make friends, have conversations, insult neighbors, fall in love, have children ...

Figure 5.9.
www.thesims.com, 2000 ongoing, screen shot from commercial site.

Is life a game? This celebrated, sophisticated, and complex game attracts adults as well as children and raises fascinating, and sometimes puzzling questions about the choices we make for ourselves and others in the way we lead our daily lives and what constitutes a life in itself.

(The Sims)

Information aesthetics

In order to understand the basics of a new media "object," it is important to understand the dynamics of information aesthetics. Because we are still so accustomed to narrative being the strongest component of a work, we must now think in terms of its inversion. The design aesthetics of the work with its symbols and concepts now create the most important and evident "pull" of the work. It must be designed to engage the interest of others sufficiently to make them want to participate in the experience of finding connections in the elements of narrative that are provided. The storytelling action content always provides the dynamic system which moves a narrative forward. The context for the story, its descriptive elements, provides the important background information of the story. In the new territory of the digital media object, narration and description change roles. The prime focus in designing an "object" is now on information/description. This now takes the lead in the narratology gambit.

The prime focus in creating a media object is on developing the aesthetics of designing efficient passages through the work to make discovery and participation as efficient and dynamic as possible to provide a strong, tantalizing level which will have the effect of pulling the viewer into the work in which one will participate. One approach is to simply construct an efficient interface to information access. Another would be to provide a psychologically focused context by designing navigation which leads to immersion in an imaginary universe.

The computer as a dynamic *interactive* partner

Possibilities for change in the relationship between the viewer and the art work are affected by increasingly sophisticated interactive systems for controlling art works which are capable of responding to viewers' commands . The viewer must choose between the options to receive a single message from the many. Electronic nonsequential viewing affects how art is produced and how it is accessed by the viewer. It calls for a new way of viewing based on visual icons or touching devices and time blocks. Electronic media promote perspectives on aesthetic experience as well as on artistic production because they change the experience of art-making and ultimately the nature of what is seen.

Creation is dependent on collaboration between the intelligent system designed by the artist and the actions of the participant which trigger causal relationships. The computer then perceives and interprets incoming information from the viewer and responds intelligently through database searches. Another type of interactivity is environmental – where the viewer's presence is monitored and sets up a pattern of interference, triggering different aspects of a computer-programmed display of lights or shapes which may appear on a large screen, allowing for physical contact with the program.

Interactive viewing is completely different from linear activity. For example, a painter's outlook on reality is from a natural totally linear distance while a filmmaker penetrates reality through multiple fragments of it, edited together to make a new "whole" seen at a different speed, with added sound. Interactive multimedia work permits creation of a new kind of viewing which may take the form of an interactive synthesis of animation and sound. In effect, watching television provides an everyday interactive experience. Imagine television as a web of image blocks from which we draw our own meanings while choosing our way through the day's programming choices.

"Hypertext," first discussed by Theodore H. Nelson in the 1960s as "non-sequential writing as a text that branches and allows choices to the reader" has come to mean an informational

medium where blocks of texts are linked electronically. However, *hypermedia* extend the original concept of hypertext by encompassing in the work other forms of information such as archived databases of visuals, sound, and animation. These are changing the nature of what is seen and what is read.

Interactive CD-ROM and DVD multimedia works typically link blocks of images and electronic functions to each other or to other video segments mixed with still images, animations, and sound. These can be manipulated and rearranged at the viewer's command. A computer provides the possibility for interaction by allowing for the branching out of visual or textual material to present choices to the viewer through a series of document blocks linked to different pathways. The computer creates interconnected webs of information. It is able to link various kind of image files and other types of documents, network them, and create paths and nodes to connect them.

The words "link," "node," "path," "network," used by Roland Barthes in his 1970 essay in *S/Z* have become literalized in the actual functioning of the digital medium itself:

> In the ideal work, the networks are many and interact, without any one of them being able to surpass the rest; . . . it has no beginning; it is reversible; we gain access to it by several entrances, none of which can be authoritatively declared to be the main one; the codes it mobilizes extend as far as the eye can reach, they are indeterminable . . . ; the systems of meaning can take over this absolutely plural text, but their number is never closed, based as it is on the infinity of language.[13]

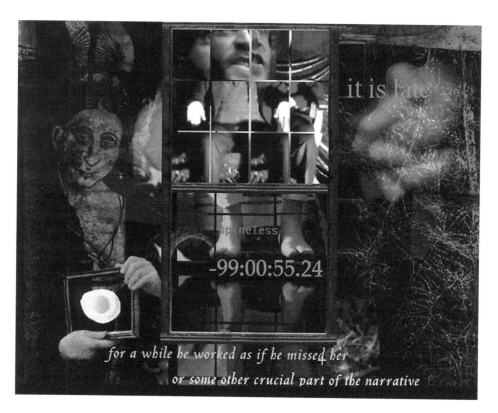

Implications of interactivity for the artist

Interactive implies that the viewer has the power to be an active participant in the unfolding of a work's flow of events, influencing or modifying its form. A typical interactive multimedia work is one which allows choice in moving through combinations of text, sound and still or motion images. It is a flexible, non-linear interactive system or structure, one designed and coded with linking capabilities which allow the viewer to make choices in moving along different paths through the work. It is a system-based approach to creating work which has viewer participation as a primary focus built into it.

Interactivity deeply entwines the functions of viewer and artist. In the process, the artist's role changes. This convergence transforms what had been two very different identities of artist and viewer. What interactive art now solicits from the viewer is not simply reception but an independent construction of meaning. In interactively participating, the viewer derives power somewhat parallel with that of the artist: to choose one's own path and discover one's own insights through the interactive work.

Artists, in designing a collaborative piece meant for interaction, place themselves outside their traditional roles vis-à-vis the viewer. For the artist this can contribute to the loss of the self and of the single voice in favor of a democratic, collaborative dialogue. The artist now becomes an agent who does not create specific images but, instead, creates novel processes for generating new elements and experiences, which are now designed to attract participation – a form of public art.

In *The Aesthetics and Practice of Designing Interface Computer Events*,[14] Stephen Wilson discusses the relationship of traditional cultural forms to interactivity. Some aspects of interactivity are more inherently present in traditional cultural forms because they must be accessed through close viewer attention. A book is the cultural form which allows for the ultimate in rapid, easy access to all its pages, without the immediate presence of the technology that reproduced it. VCRs and DVDs have fast-forward and reverse capabilities in accessing movies or other video materials. There is a level of emotional engagement and internal viewer adjustments or identification which forms part of most art forms including theater and music events. Most successful art is psychologically interactive. Critics of interactive art works claim there is too much disruption in the viewer's focus of concentration. Their defenders claim that the richness and opportunity to explore more differentiated aspects of a discrete work make the art work a potentially revolutionary form which will force change in how we see and understand.

Figure 5.10. (opposite) Tennessee Rice Dixon, *Count*, 1998, interactive movie in ten sections with responsive sound component. CD-ROM.

Two people share memories of time previously spent together. Their memories overlap into one landscape and the experience is being re-formed as they remember. In *Count*, a memory and a conversation occurs, sounds fade in and out, and layers of images unfold. A dialogue rambles on which can be interrupted or changed. Their words are reordered in a way that reveals their personal twist on the situation. The movie is responsive to sound levels and mouse activity. Viewers' input is monitored and in turn it directs movie elements such as text, sound, duration, and motion vital for the many aspects of the work to appear or change.

(Tennessee Rice Dixon)

Interactive media have special qualities. They avoid the linear sequencing of a film or novel. They allow instead a less linear choice system structured into the work which is designed to function only through viewer action. The viewer will be able to understand the work's meaning or its conceptual structure only by exploring the many layers and margins which form the context of the piece. Information about parallel related texts or images can be accessed in the data space of the work and brought onto the screen for review as part of its potential to unfold many archival levels .

Up to now, art works have always been shaped by visual artists, poets, writers, composers, choreographers who assumed the total responsibility, opportunity, and challenge of creating their own discrete work without invasion of the work from outside participation. They had to decide on content, format, style, sequence, materials, medium. However, with interactivity, readers, viewers, listeners can pass through the boundaries of the work to enter it. This puts them in a position to gain direct access to an aspect of authoring and shaping the final outcome of a work in a way that never existed before the advent of the computer. The viewer can now have a significant position of power in the work. The artist gives up total control in favor of a new kind of viewer communication and experience, one which offers an active position for the viewer, one which also celebrates the inherent creative capacities of all individuals. The work becomes more of a frame or context which provides an environment for new experiences of exchange and learning. Interactivity offers important new avenues to cognition to take place, where works can begin to flow with the more psychological internal associations of the individual viewer's consciousness and identity in mind.

Interactive systems utilize processes of exchange, learning, and adaptation and foreground the premise that meaning in a work of art is dependent upon exchange and communication between individuals and groups. They provide a context for participants to reflect their personal understandings about their own social and political contexts.

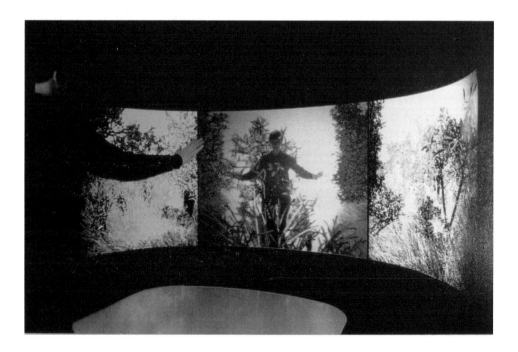

This fundamental change in the relationship between the artist, the art work, and the public creates important potential for change in the arts for expansion into new territory. Although, as we have seen, there has always been a continuing questioning and refusal of the boundaries of traditional forms in the evolution of art, interactivity as a new aspect of representation is different from the earliest attempts to include in their work some aspects of audience response by the Dadaists, Constructivists, Fluxus, and Conceptual movements when they invented new forms such as performance, free-form installation, and diverse kinds of theater events (see Chapters 2, 3, 4, and 6).

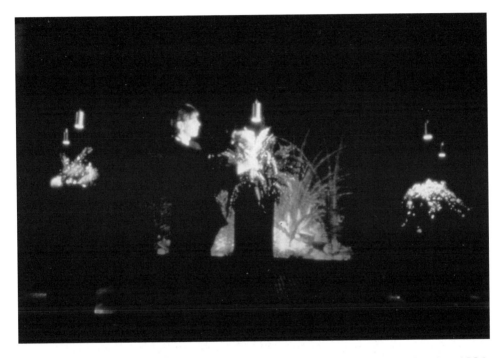

Figure 5.12. Christa Sommerer and Laurent Mignonneau, *Interactive Plant Growing*, 1994, multimedia installation.

Figure 5.11. (opposite) Christa Sommerer and Laurent Mignonneau, *Interactive Plant Growing*, 1994, multimedia installation.

This real-time 3-D interactive work uses principles of plant growth in an installation setting featuring real plants, allowing the viewer to influence and control the growth of "virtual" program-based plant forms such as ferns, mosses, trees, vines, cactus displayed on a screen. It asks the question "what is life?" The appearance of these "virtual" plants can be modified and varied depending on the movements and distances of the viewer's hand. Plant size, color, appearance, choice of plant type are some of the coordinates which, with rotation possibilities and location positioning, can be changed in combination. The viewer's interaction between "real" and "virtual" plants allows for the discovery and awareness of the structure and variety of natural growth.

(Christa Sommerer and Laurent Mignonneau)

In order to understand how far we have come in relation to the profound crisis in representation brought about by digitization, interactivity, and simulation, it is important to review the brief history of how the computer has impacted the visual arts. Such a perspective can put into context the major issues and technical developments that have led to this major break in the visual field.

An interface for high-speed visual thinking

In his historic 'Systems Aesthetics' and 'Real Time Systems' articles published in *Artforum* in 1968 and 1969 respectively, sculptor Jack Burnham explored a systems approach to art. At that same time, *Artforum* also published "Computer Sculpture: Six Levels of Cybernetics,"[15] by sculptor Robert Mallary. These articles are still part of theoretical discourse about digital art.

Mallary analyzed the benefits of the computer as a tool for "high-speed visual thinking" in art-making. His understandings grew out of research into the possibilities for kinetic sculpture and optics at the end of the 1960s, although developments in computer science were still in their infancy and few artists were able to gain access to computer labs to experiment and innovate. He grouped computer functions into two major categories: as a means of calculation (a tool), and as an optimum creative interface between artist and machine (a medium). In the first grouping, the computer performs calculating chores to specify articulation of color and form, sorting out visual data on receding planes of objects in space. It adds randomness to a structured idea to test variable solutions and new proposals where speed and precision lessen the need for tedious work, thus making possible a new level of interactive decision-making. The relationship between artist and computer can be symbiotic – for each depends on the other, and both do together what neither could do alone. However, this relationship may not always be advantageous, and at every step the artist may need to veto and monopolize the decision-making process, accepting, rejecting, and modifying while prodding and coaching the machine in the right direction. Another aspect of calculation can lie in the area of using the computer as a medium. Here programming is used to move in a set way over a prescribed route according to a scenario of set commands that contain guidelines and criteria designed by the artist for making tests and permutations on an existing idea. Such research can be stored for future reference and further decision-making.

In the second context of artist–machine interaction, the computer begins to make decisions and generate productions even the artist cannot anticipate. At this level, all the contingencies have not been defined in advance. In fact, the program itself manufactures contingencies and instabilities and then proceeds to resolve unpredictable productions, not only out of random interventions (which dislocate and violate the structured features of the program) but out of the total character of the system itself, modifying and elaborating its own program. At this stage, there can be a redefinition of relationship between artist and machine – where the computer is alternatively slave, collaborator, or surrogate. The artist operates the machine, monitors it, or leaves it to its own resources. "He is active and passive; creator and consumer; participant and spectator; artist and critic." The computer can check against past performances of consensus criteria stored in its program file, for the heuristic[16] program embodies its artist's preferences. At this optimum creative level, the true synergistic potential of the artist–machine relationship can be achieved.

A broad range of both European and North American sculptors interested in music and kinetics were particularly drawn to the computer both as an influence and as a tool. This group, which included Nicholas Schöffer, Nicholas Negroponte, James Seawright, Aldo Tambellini, Takis, and Otto Piene, used the computer to control and move their constructions. Some artists sought collaboration with scientists or engineers. In some cases the enthusiasm for "techno-science" made too little distinction for art between artistic imagination, scientific innovation, and technological experimentation.

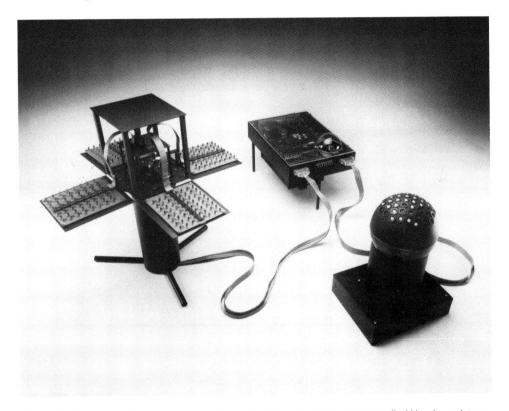

Figure 5.13. James Seawright, *Houseplants*, 1983, microcomputer-controlled kinetic sculpture, room installation.

Houseplants is an interactive computer-controlled sculpture that can respond to changes in environmental light levels or follow pre-programmed patterns of movement. The "plants" open to reveal their LED-studded "leaves," and the flip disks on the domed plant click open and shut creating a whirring sound. Seawright has been producing interactive works since the mid-1960s.

[James Seawright; Photo: Ralph Gabriner]

Early years of computing sound and images

Since computers had been developed originally[17] for solving scientific and engineering problems, it is not surprising that their use for producing digital sound and textual and visual images was initially limited only to those scientists who had access to the cumbersome

mainframe machines located in remote air-conditioned settings in university research labs such as the Group de Recherches Musicales in France. As early as 1955, electrical acoustical compositions such as Pierre Henry and Pierre Schaeffer's *Symphonie pour un Homme Seul* and Karlheinz Stockhausen's *Gesang der Jünglinge* were created by altering and manipulating sounds on prerecorded magnetic tape. Because music and texts represent coded information, it was possible to program these into computer language. Composers such as Lejaren Hiller, Iannis Xenakis, and Herbert Brun used the computer as a major compositional tool. This moment marks the shift in musical production rooted in cultural traditions of narrative, rhythm, or melody to one based in technological research and development where innovation of new sounds and musical forms became the focus. While this experimental sound output was of interest in academic circles, it was too esoteric to appeal to a general public. However, these early experiments opened the way for later extensive development of music software and computer synthesizers as the popular musical instrument in use today (see pp. 201–5 and Chapter 7).

Figure 5.14.
Manfred Mohr,
P-159/A, 1973,
plotter drawing (ink on paper), 24in. × 24in.

Mohr's intense and imaginative investigations of the cube and its spatial relations have for many years been carried out through programming the computer and printing the results of his work using a plotter on paper or canvas. There is a rigorous, philosophic, aesthetic, and mathematical structure to which all of his work refers in its countless transformations and variations. In this early Minimalist work, the process is revealed as Mohr uses the set of twelve straight lines required to create a cube in two dimensions. The cube's twelve lines are assigned numerical values in order to unleash a compelling scheme of line arrangements, suggesting a form of movement and harmony. Mohr is a hybrid artist, at ease with both programming and visual innovation.

(Manfred Mohr)

1. David Rokeby, *N'Cha(n)t*, 2001, interactive installation, seven computers intercommunicating and responding to visitors' voices.

Interested in the fact that the computer can manipulate systems of language but not understand them, Rokeby seeks in this project "to hear a community of computers speaking together: chatting amongst themselves, musing, intoning chants." He is interested in exploring resonance between synonyms and similar sounding words and working through different formulations of different statements until they finally reach connection. In the installation, each entity is equipped with a highly focused microphone and voice recognition software. The ears visible on the computer monitors show the state of receptivity of each system. While a gallery visitor speaks into one of the microphones, these words from the outside "distract" that system, stimulating a shift in the entity's "state of mind." If a system hears a sound, it cups its ear to concentrate. When "thinking," a finger is pressed to the ear. If the system feels overstimulated, it covers its ear with a hand to indicate unwillingness to listen.

(*David Rokeby*)

2. Graham Weinbren, *Frames*, 1999, interactive installation, three-channel video, input, and frames. Commissioned by the NTT Inter Communications Center, Tokyo.

By pointing through hanging picture frames at projected video images, a viewer can gradually transform portraits of contemporary young women into memories of nineteenth-century ones. The three-screen interactive projection work uses infra-red sensor arrays to detect user input, combined with accessible video under computer control. The work suggests a bridge between the most recent technologies and the breakthrough technology of 150 years ago: black-and-white portrait photography. *Frames* uses Hugh Diamond's photographs – the first to be taken in a mental institution as a starting point for an examination of photographer-to-subject relations in the representation of mental disorder.

(*Graham Weinbren*)

3. Char Davies, *Ephémère*, 1995, digital frame captured in real time in 3-D virtual reality immersive environment during live performance with head-mounted display.

The many realms Davies creates in her virtual reality works are rich in abstract texture, color, and light effects which seem to facilitate awareness of one's own consciousness. The experience of being enveloped in the space she creates is akin to being inside a painting, that is moving with the direction of one's breathing. The work becomes a space for exploring the perceptual interplay between the self and the world. Davies comments: "The experience of seeing and floating through things, along with the work's reliance on breath (the interface) and balance, as well as solitary immersion, causes many participants to relinquish desire for active 'doing' in favor of contemplative 'being' . . . I have come to believe that full-body immersion in an 'unusual' virtual environment can potentially lead to shifts in mental awareness. That this may be possible has many implications, some promising, some disturbing."

(*Char Davies*)

4. Bill Viola, *Going Forth By Day*, 2002, single-frame image from Panel #5, "First Light", video/sound installation, dimensions variable. Video installation room, the Guggenheim Museum, New York, September 21 to January 12, 2003. See Chapter 7.

(*Bill Viola Studio*)

5. Ben Rubin and Mark Hansen, *Listening Post*, electronic audiovisual installation at the Whitney Museum, December 17, 2000 – March 9, 2003. A project created under the auspices of BAM and Lucent Technologies.

Random words and phrases being gleaned from Internet chat rooms light up more than two hundred tiny LED screens suspended in a curving curtain-like grid formation. Drawing from a live Internet connection, several networks of computers (located in separate control areas) collect and analyze data from thousands of chat sites, bulletin-boards, and other real-time public forums. Some of these synthesize spoken and sung voices, tones, and other sounds to create an immersive ten-channel audio environment. Random words flow in waves across the screens or move slowly like stock-market figures. The work's Cageian reliance on the concept of chance operations is not new, but the installation casts a new perspective on random operations, as though one is eavesdropping on the world in real time. Rubin, an artist who works in audio, video, and digital electronics, collaborated with Hansen, a statistician at Bell Labs and at Lucent Technologies through the auspices of the Brooklyn Academy of Music to create the work.

(*Ben Rubin Photo: David Alison*)

6. Jenny Holzer, *Arno*, 1996, installation commissioned by the Guggenheim Museum, Bilbao, Spain, two-sided LED sign columns, red and blue, 1300 cm × 16 cm.

In a splendid, tall installation that dominates the ground floor of the celebrated Bilbao Guggenheim designed by Frank Gehry, Holzer has created a dynamic dialogue with the public. The slender, two-sided tall LED screens are in English on one side and in Spanish and Basque languages on the other. Their personal messages constantly change as they seem to travel through the floor and up through the ceiling.

(*Cheim and Read Gallery, New York*)

7. Irit Batsry, *These Are No My Images, Neither There Nor Here*, 2000, video, 80 minutes, with soundtrack by Stuart Jones. Produced in Association with the Academy of Media Arts, Cologne, ARTE/France and NYSCA. Winner of the Bucksbaum Award, Whitney Museum of American Art for the best work in the Biennial Exhibition 2002.

Batsry's film, set in southern India, shifts between documentary, experimental narrative, and personal essay. Her intense questioning of what constitutes truth, fiction, reality, and memory is a meditation on the otherness so deeply felt in shifting populations today. These questions are reflected in her fusion of film and video techniques. Her characters – a Western filmmaker journeying through southern India, a half-blind guide, and a local filmmaker – all relate personal views on the meaning of place. The setting is both an actual location and a metaphor for remoteness. Throughout the film, Batsry denies the viewer a clear visual sense of the place through which all three are travelling. Richly colored footage of the journey gives us elusive glimpses quickly blurred through soft focus: images shot from moving trains sweep the landscape into streaks of color. This hybrid space crossing between cinema and electronically processed imagery serves as a device which distances us to a place where truth becomes stranger than fiction.

(*Irit Batsry*)

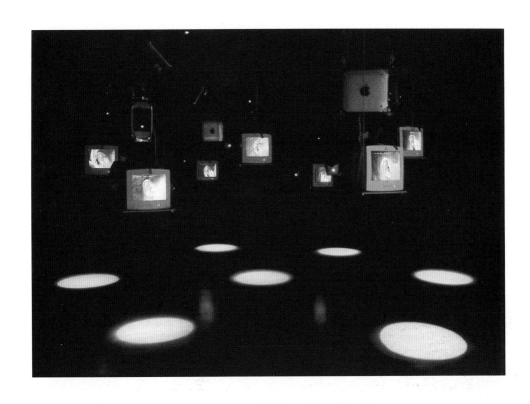

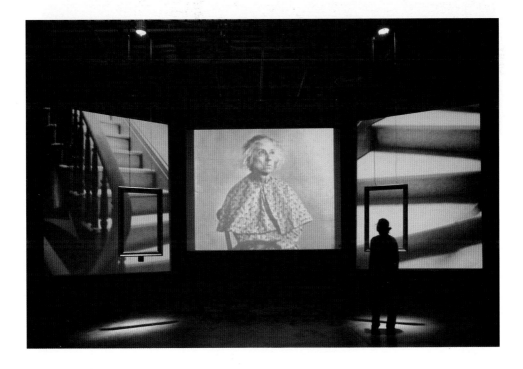

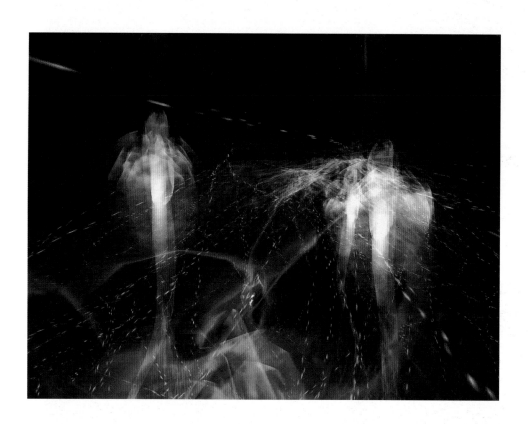

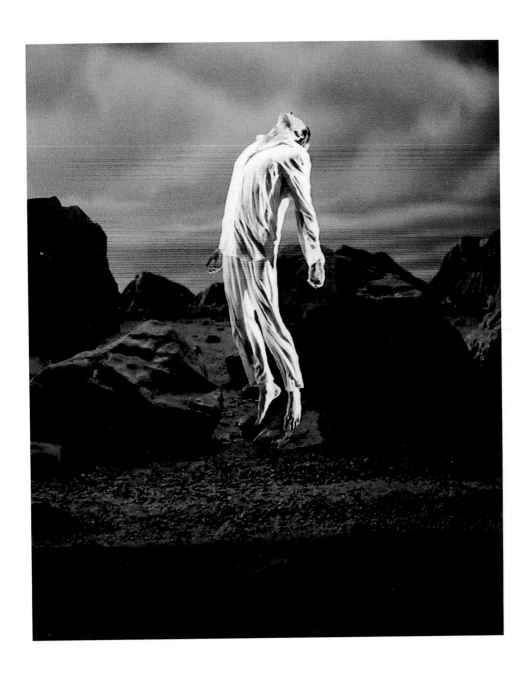

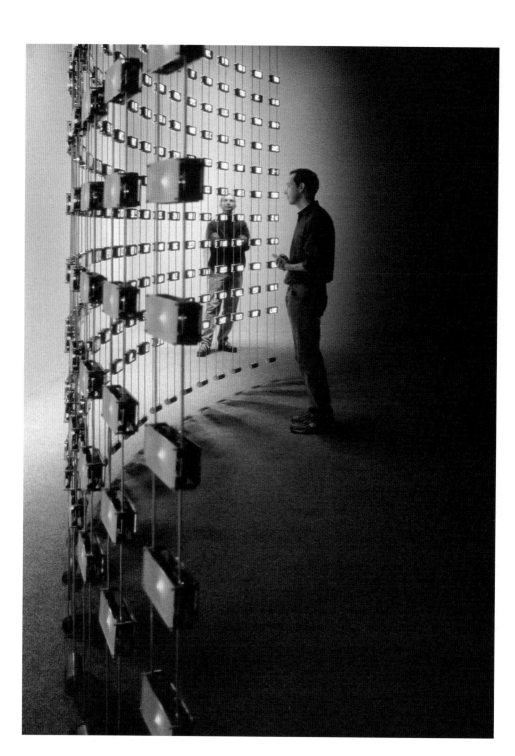

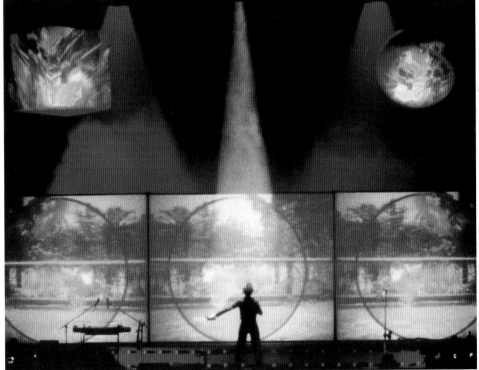

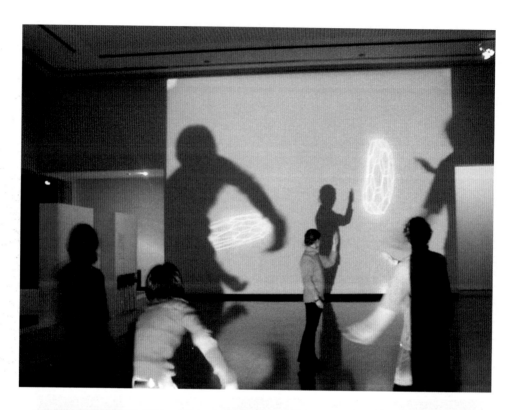

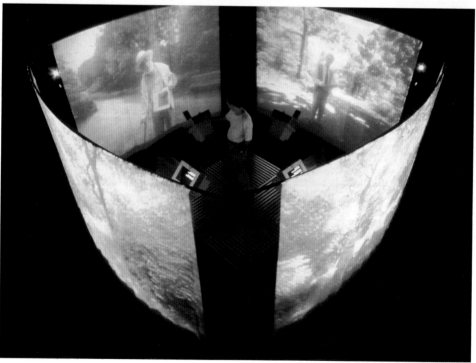

8. Anwar Kanwar, *A Season Outside*, 1997, video still frame, 30 minutes. Shown at Documenta, 2002.

A documentary videomaker, Kanwar engages topics as diverse as, for example, the history and politics of harvesting water in the desert, the physical and mental spaces carved out for men and women within the family, and the opposition between globalization and tribal consciousness in the heart of rural India. Kanwar's *A Season Outside* inquires how national identities are enacted on an India–Pakistan border crossing at Wagha where people are drawn every day to a thin white line around which a ritual opening and closing of the border is performed. He uses views of this scene as a confrontational strategy for investigating the constructing of an Indian masculinity divided between the demands of nation state, the family, and the very different traditions presented by Tibetan refugees. His work looks at power and its perpetuation through culture – clothes, jobs, football, and festivals – and also seeks to find out where love might fit into the picture.

(*Anwar Kanwar and Documenta*)

9. Lyn Hershman, *Conceiving Ada*, 1996, still frame from 35mm film showing virtual sets. With Tilda Swinton, Karen Black, Timothy Leary, John Perry Barlow.

A consistent theme in Hershman's work is how people engage in media-derived fantasies. In *Conceiving Ada*, her first feature film, she explores a fantasy connection to the life and mind of a nineteenth-century woman, Lady Ada Lovelace, who was the first to conceptualize the idea of software while she was working with Charles Babbage. Owing to both time and funding issues, Hershman decided to employ unconventional production techniques. The process involved creating two channels: a composite master tape with the backgrounds in place, and an "alpha" channel (a process which allows the later separation of background and foreground, if desired). The actors were videotaped against a blue background. The blue was keyed out and replaced with the digitized background. In post-production, the background images of the virtual "set" were manipulated digitally to zoom and pan as the scene dictated. According to Hershman, "the immediacy of shooting live action while simultaneously manipulating digitized backgrounds was . . . exhilarating. The actors' reactions became more spontaneous, and their relationship to the otherwise totally blue environment much more interactive."

(*Lyn Hershman*)

10. Laurie Anderson performing *Stories from the Nerve Bible*, 1995. Originating at the Neil Simon Theater in New York, this multimedia work traveled internationally (see Chapter 7).

(*Laurie Anderson; Photo: Adriane Friere*)

11. Victoria Vesna with Jim Gimzewski, *Zero@wavefunction*, *Nano Dreams and Nightmares*, 2002, interactive installation with rear-view projection.

In parallel with her artistic concerns over the last decade, Vesna has always engaged in direct dialogue with scientists. As a result of this deep interest, she gradually began her collaboration with Jim Gimzewski, a scientist working in the field of nano systems. Reflecting on some of the major issues of this new aspect of science, with its implications of both danger and immense opportunities for global economies, environments and social structures, she has begun to approach her work with nano issues from a questioning philosophical point of view to bring to the general public an understanding of the impact of this emerging science on the culture at large. The Zerowave project is based on the way a nanoscientist manipulates an individual molecule – billions of times smaller than human experience – projected on a monumental scale. When viewers step in front of the interactive installation screen, they cast larger than

life shadows on the molecule and activate responsive hexagonal forms which allow exploration of the hidden meanings within them.

(*Victoria Vesna*)

12. Luc Courchesne, *Landscape One*, 1997, interactive video installation, 24 ft × 24 ft × 8 ft, four-channel 360-degree panorama.

Although the subject matter of Courchesne's work has been about interactive viewer dialogue with virtual characters, in *Landscape One* he has chosen space itself as its subject. He sets out to explore it, through using virtual characters who take on the role of virtual guides. Each character represents a strategy about exploring the garden space in which the action takes place. According to Courchesne, its virtual journey is colored by the type of relationship it has with visitors. The space is thus more metaphorical than real and the language used to navigate mostly points to relationships and attitudes to life. Twelve participants can enter the installation at the same time, with the interaction shared between four stations. The work uses four rear-view projection screens with panoramic views of different times of day videotaped in areas such as Montreal environments, gardens and parks.

(*Luc Courchesne; Photo: Richard-Max Tremblay*)

By 1965, computer research into the simulation of visual phenomena had reached an important level, particularly at the Bell Labs in Murray Hill, New Jersey. Here the pioneer work of Bela Julesz, A. Michael Noll, Manfred Schroeder, Ken Knowlton, Leon Harmon, Frank Sinden, and E. E. Zajec led them to understand the computer's possibilities for visual representation and for art. That same year Noll and Julesz exhibited the results of their experiments at the Howard Wise Gallery, New York, concurrent with Georg Nees's and Frieder Nake's exhibition of digital images at Galerie Niedlich, Stuttgart, Germany. Research in Germany at the Stuttgart Technische Universität was conducted under the influence of the philosopher Max Bense, who coined the terms *artificial art* and *generative aesthetics*, terms which grew out of his interest in the mathematics of aesthetics.

Some of the earliest computer experiments related to art included the ones by A. Michael Noll in which he simulated existing paintings by Piet Mondrian and Bridget Riley in an effort to study existing style and composition in art. In approximating the Mondrian painting *Composition with Lines*, Noll created a digital version[18] with pseudo-random numbers.

An artists' tool programmed by artists

Although computer graphics research was, by the late 1960s, being conducted internationally in the highly industrialized countries, Robert Mallary was one of the few artists who had access to equipment or were trained in the specialized programming needed at that time to gain control over the machine for their work. However, these artists saw the computer as a means of researching their visual ideas and sought the collaboration of computer scientists and engineers as programmers.

Ken Knowlton, in his book *Collaborations with Artists – A Programmer's Reflections*, points to important differences in temperament and attitude between artists and programmers as a major difficulty. He describes artists as "perceptive, sensitive, impulsive, intuitive, a-logical," and often unable to say "why" they do things; whereas programmers are "logical, inhibited, cautious, restrained, defensive, methodical ritualists" with layers of logical defenses which help them to arrive at "why." Although these antitypes are obviously stereotypical, they illustrate the difficulty of finding in one person all the qualities which created that hybrid breed – an artist-programmer.

By the early 1970s, a new generation of artists began to emerge who were able to retain their intuition and sensitivity while exercising a logical, methodical approach to work. For example, artists Manfred Mohr (self-taught in computer science) and Duane Palyka (with degrees in both fine arts and mathematics) began to program their own software as a result of frustration with existing programs and systems which did not serve their creative needs. "Hybrid" artists have since made important contributions to the field of visual simulation. Some have custom-designed paint systems and video interfaces for interactive graphics as well as working with robotics in sculpture. Following development of powerful new microprocessing chips, their work was simplified by the advent of microcomputer turnkey systems which freed them at last from large mainframe support.

By the mid-1970s, important advances in technology opened possibilities for the computer to become a truly personal tool for artists. The invention of the microprocessor and more powerful miniaturized transistor chips (integrated circuits) changed the size, price, and accessibility of computers dramatically. Commercial applications in design, television advertising, and special image-processing effects in film and photography became an overnight billion-dollar industry, providing the impetus for incredibly powerful image-generating systems.

The need for intimate collaboration of scientists and engineers with artists was no longer so essential, for custom "paint system software" and "image synthesizers" began to appear on the market. Programmed and developed by "hybrids" such as John Dunn (Easel, or Lumena Paint software), Dan Sandin (Z-Grass, a digital image-processor), and Woody Vasulka (Digital Image Articulator), out of their own imperatives as artists, new interface software for the computer provided easy access to two-dimensional and three-dimensional image-processing in combination with animation and video. As a result, artists may now come to the computer with their visual arts training intact, without the need to learn programming (in the same way that using a modern camera does not require full knowledge of optics). Learning to use a contemporary turnkey system with contemporary software is somewhat comparable to a semester's studio course in lithography. However, programming is essential to any pioneering of new use of equipment. This need has continued to lead many artists, especially those interested in interactive applications, to collaborate with engineers or scientists or to study computer sciences for themselves.

Computer exhibitions launched in the spirit of modernism

The use of computers for art grew out of existing formalist art practices, especially with regard to 1970s Minimalist, neo-Constructivist, and Conceptual aesthetic tendencies. However, use of the computer for art touched a deep nerve in an art world fearful of the use of a mechanical device such as the computer for the making of art. As we have seen (Chapter 3), Hultén commented in his catalog essay for the *Machine* show, "since the computer is not capable of initiating concepts, it cannot be truly creative, it has no access to imagination, intuition and emotion." In the catalog of the 1968 London ICA exhibition *Cybernetic Serendipity*, the first devoted entirely to computer applications for poetry, sound, sculpture, and graphics, curator Jasia Reichardt commented:

> Seen with all the prejudices of tradition and time, one cannot deny that the computer demonstrates a radical extension in art media and techniques. The possibilities inherent in the computer as a creative tool will do little to change those idioms of art which rely primarily on the dialogue between the artist, his ideas, and the canvas. They will, however, increase the scope of art and contribute to its diversity . . . This dizzying display of technology presented a paradisical vision of the capacity of the machine, and to this day it remains one of the central projections of a technological utopia based on the notion of modernization. Underlying it was the premise of "technoscience" as a prosthetic, or aid to universal mastery; the cybernetic revolution appeared to accomplish man's aim of material transformation, of shaping the world in the image of himself. Cybernetic Serendipity was launched in the name of modernity, an ideal that, since the time of Descartes, has focused on the will and creative powers of the human subject.

Many artists, such as Thomas Shannon, Jean Dupuy, and Hilary Harris, used the computer as a means of programming their kinetic sculptures which emphasized interactivity between optics, light, and motorized, controlled movement. A witty attempt to humanize the computer was Edward Kienholz's motorized *The Friendly Gray Computer.*

In the catalog essay for the 1970 exhibition *Software: Information Technology: Its Meaning for Art* at the New York Jewish Museum in 1970, Jack Burnham used the body-machine-controlled-by-the-mind metaphor when he quipped: "our bodies are hardware, our behavior software." Curated by Kynaston McShine, the *Information* exhibition at the Museum of Modern Art demonstrated the concept of systems analysis and its implications for art. *Information* explored groups of networks of interacting structures and channels as a functionally interrelated means of communication. The computer was a natural metaphor for this exhibition. Agnes Denes, Hans Haacke, Les Levine, Dennis Oppenheim were among the artists who explored use of computer concepts in their works. This was one of the first exhibitions to espouse the reductive, Minimalist principles of Conceptual art where the idea is the total work (no object is produced). Information as art.

As we have seen, the hostile response of the critics to the costly 1971 *Art and Technology* exhibition at the Los Angeles County Museum was a backlash against technological "corporate art" as it was termed. The Vietnam War and its aftermath of instability and fear of technology signaled a rupture with modernist philosophical ideals and optimism about the future.

In the short history of computer use in the visual arts, the first ten years ("first wave," 1965–75) was dominated by computer scientists with easy access to equipment. In the "second wave," significantly larger numbers of artists began to gain access and realize the potential benefit for their work. Many of these were interested in kinetic and interactive aspects of the computer. In the next decades, the continuing work of many pioneer artists probed at the edge of the computer's potential, participated in developing new software tools, and made vital contributions in laying the foundation for future achievements. In the early 1970s the computer was still cumbersome, outrageously costly and with limited access for artists. It was still better used as an analytic tool for formal modernist conceptual works rather than as an interactive medium. As a result, it became stigmatized as a medium for art production and receded into the background without its potential for the arts being fully realized in the onrush of developments which now took place.

Simulation: quest for a new realism – reality is just a test

By the early 1980s, the thrust toward simulating an artificial reality that is convincingly real was being approached seriously, with missionary zeal, as a major goal by high-level computer scientists who were now analyzing how to make persuasive simulations of trees, clouds, water, reflections, transparencies, textures, shadowing. They hoped to coax the perfect cloud, mountain, or shining goblet with reflections and shadows from the computer. Charles Csuri, head of Ohio State University's computer graphics group, kept a reproduction of *The Origin of Language* by René Magritte on his office wall. The image is of a huge rock suspended above a shimmering sea, surmounted by a soft cloud of the same size. "It reminds me of what we cannot yet do realistically – water, clouds, rock, fire, smoke. These are the major problems in computer graphics now. Natural phenomena, things that change shape over time, and things that are soft."[19] The problems that artists have always faced in creating illusion – solving problems of rendering light, form, texture, and perspective – have now fully entered the computer realm of artificial simulation through mathematical calculation. Reality, however, is always vastly more complex than it seems.

Technologists and scientists are devoting more attention than ever before to solving problems of vision and optics, color perception, perspective. They are also investigating speech simulation and the workings of the mind through research in the field of artificial intelligence.

Because these areas are of great interest to artists, collaboration and exchange of information and ideas has begun to take place more seriously than it did during the 1960s (Chapter 3). The complex relations which have always existed between art, technology, and science are explored in Chapter 7.

IBM's Watson Research Center scientists have generated persuasive computer imitations of landscapes and clouds. More than just pretty pictures, these scenes are proof that the branch of mathematics they work with, called *fractal geometry*,[20] accurately describes the real world. They can create programs using real data that simulate the growth of what seem like real clouds, and, in this way, obtain a better understanding, for example, of how real clouds do in fact grow.

> Nobody's quite got it yet. In every image there's something that's a little off: the vase that looks more like plastic than glass, the shadow that's too sharp-edged, the city streets that are too clean. They're all missing detail, the richness and irregularity that our eyes and brains crave. And the world of computer graphics is mostly static and rather lonely – a viewer may swoop over a seascape or whirl around bottles on a table, but no waves lap at the shore and no people sit at the table. It's all a matter of the right instructions. Computers, of course, can't do a thing without instructions. But it's hard to think up a routine of steps that automatically and randomly puts cracks in sidewalks or mimics the action of wind.[21]

Figure 5.15. Jill Scott, *Beyond Hierarchies*, 2000, interactive environment. In the former coal mine Zeche Zollern II, now a museum of industrial labor.

Jill Scott's installation is meant as a tribute to the working people of this Ruhr region of Germany. She states: "I believe history is about ordinary people and their collective and shared desires and struggles." The script for this work was constructed from research she conducted in the area's oral history and film archives. She then created composite lives of six personas, including a kitchen worker, a car mechanic, and a Polish miner. Using actors to portray these roles, she made six films which can be accessed interactively from a cetral podium.

[Jill Scott]

Figure 5.16. Paul Kaiser and Shelly Eshkar, *Pedestrian*, 2002, public art installation projected at Eyebeam Atelier, Rockefeller Center, New York City, and The Studio Museum, Harlem, with digital rendering and animation. Sound design: Terry Pender, Columbia's Computer Music Center; Motion capture design: Lisa Naugle, U.C. Irvine Dance Department. A Co-production of Art Production and Eyebeam.

Pedestrian is a completely digital simulation of crowds. Thematically, the work draws on Elias Canetti's classic text, *Crowds and Power*, in which groups of crowds are analyzed almost biologically, as having lives of their own. The work makes use of advanced motion-capture technology for its animation. While all the figures have been created on one computer, their individual motions derive from real human movement. These disorganized, unregimented movements of hundreds of moving figures' real motions are then arranged in complex patterns by means of digital choreography. The pedestrian animations are all pre-rendered.

(Paul Kaiser; Photo: Peter Cunningham)

A variety of simulation techniques called texture mapping, ray tracing, three-dimensional modeling, and figure animation interpolation grew out of this high-level research which puts mathematics at the service of the quest for the "new realism."

One of the most formidable tasks the computer can accomplish is to simulate a three-dimensional shaded model. Once all the physical measurement information about the object has been fed into the computer's data bank, the simulated object then materializes on the screen. It can then be rotated, skewed, made to zoom in and out of space in perspective, with a choice of where the light source originates. According to instructions, the computer will calculate the range of highlights and shadings which define an object (depending on the choice of light source), add appropriate shadows, and animate it in full color.

At Lucasfilm, the computer graphics team perfected the technique called procedural modeling, in which the computer is given the general characteristics of a class of objects and then makes many such objects, each unique. For example, the computer "grew" the flowering plants from a program that "knows" how a plant grows. Grass is simulated by providing the computer with information about range for the height and angle of the blade of grass and letting it draw different blades; fire is produced by telling the computer the basic characteristics of a flame and letting it do the work. "Reality is just a test, like controls in an experiment. If you can make a convincing computer picture of a silk scarf falling on a wooden table, then you can make a convincing picture of a wooden scarf falling on a silk table."[22]

The computer can sort through all the instructions and models which describe the scene: its tone, color, optical laws – factoring in all the instructions, checking and sorting out what each piece the mosaic of pixels should represent. The more powerful the computer, the more image information the computer can process at greater speed. The more complexity and resolution demanded of the computer to create more lifelike simulations with reflections, highlights, and the like, with sound and movement, the more memory the computer needs to calculate the information, and the more time it will take to render it.

Computer animation

Computer-animated films have been produced by artists since 1961. A remarkable early example is Cannes Festival prizewinner *Faim* (*Hunger*) made by Peter Foldes at the National Film Board of Canada in 1974. Foldes not only computer-generated the film's intermediary motion frames but used interpolation techniques to make transitions between two different themes – images of the starved "have-nots" as transposed against the greed of the "haves."

Films and videos were being designed in the 1990s for insertions of animated figures with live photographed ones in the most complex interactions of reality and fiction. In *Hard Woman*, the Mick Jagger music videotape by Digital Productions, the aggressive line-drawn animated figure seems to be in total control of the real-life action. At Lucasfilm in California, Pixar, a powerful computer graphics machine was designed to capture the essential character of real forms and textures through the programming of digital instructions designed to simulate the diminishing size of tree branches as the trunk rises from the ground. The Lucasfilm team was able to recreate the blur of motion that is caused by a wave striking the shore or two billiard balls colliding. Various computer programs which built in a randomness factor were developed to make images seem more lifelike.

Apart from generating specific images, the computer can calculate in-between frame of movement between separate drawings. This is the "interpolation" technique used by animators, where the computer is issued commands to compose as many slightly different intermediate images as required in the metamorphosis of a movement from one stage to the next. The animator's task in movement simulation and color transformations is enormously facilitated by the computer.

Computer-simulated graphic images or animated passages can be encoded as a video signal and inserted into a work as part of its totality. Entire video passages can

continued

be digitized and edited from software, reformulated, manipulated and again reformatted as a video signal. This provides for an unprecedented expansion of pictorial variety and texture. The computer is beginning to play a greater role than the camera in filmmaking. Although they have the look of photographic reality, many backgrounds and locales in Hollywood films are being computer-generated. The actors may be electronically keyed in, using computer or video techniques. In many cases, expensive "special effects" such as morphing and creation of convincing digital characters are used in formulaic productions instead of the focus being on good storylines and shooting. By the early 1990s, computer animation to perfect human or animal imagery produced the first examples of three-dimensional actor-simulated, feature-length animation. Amongst others were *Who Framed Roger Rabbit*, *Forrest Gump*, and *Terminator 2, Judgement Day*.

Computer-assisted animated effects now dominate commercial advertising and have been used extensively since the early 1990s for special effects in films such as *Toy Story*, *Monsters Inc.*, *Shrek*, and *Ice Age*. Artists' use of animation "paint" effects and drawing interpolation methods combined with special-effects generators are no longer a new phenomenon now that software support animation packages are widely available. Expressive three-dimensional modeling of the human face and of the figure in motion has reached a high level of development because more powerful computers with compression software have been developed to manipulate the immense quantity of digital information involved.

Although it was not a box-office success as a full-length motion picture, *Final Fantasy: The Spirit Within* was the first to create full-length photorealistic computer-generated film meant to portray real people on the big screen. It included close-ups showing animated lifelike elements such as pores in the human skin, strands of hair moving in the wind, and other textures. However, in his 2003 sequel to *The Matrix*, director John Gaeta went beyond this achievement and claimed that *The Matrix Reloaded* demonstrates that you will now be unable to discern whether or not a persona has been digitally created and that it is no longer possible to distinguish between live and artificial in the way bodies look and move.

New research has developed a technique beyond the high-quality number-crunching conventional ones to create a newer type of animation which requires far less processing power. A 3-D model of a universal form such as a face is modified by a stream of animation cues which are wrapped onto the generic face and manipulated by mapping points to create the animation. The amount of data involved is so small that it is suitable for use over dial-up Internet connections or cell phones. Key points on the face are clustered around the mouth, the jaw, and the eyes to make lip-syncing and non-verbal expressions as real as possible (*New York Times* article "Automated Avatars Take the Strain Out of Animation," January 9, 2003).

Many artificial intelligence research institutions have been developed in the United States, Europe, and Japan. New York University's Media Lab has developed software for an artificial intelligence environment called *Improv*. Its narrative mechanisms include real-time personality and behavior attributes which create interactive, live, improvisational animation where the characters decide to respond to the actions of the viewer based upon their mood and personality. Their reactions are generated in real time as 3-D color animation.

New potential for the fine arts creates a quickening of interest

Harold Cohen, an internationally known British artist, has been involved with computers since his 1968 visit to the University of California, where he became a faculty member. Cohen thinks of the computer as a medium, an "interface for the creation of his work – a collaborator, and an assistant in the drawing phase."[23] Cohen's drawing program was what he termed a formal distillation of the rules and habits a human artist follows during the process of drawing. The computer sifted through programmed rules and drove an artist-built drawing machine (called a "turtle") by steering it with separate commands.

Cohen applied artificial intelligence techniques to the process of image-making. He instructed the turtle to be interested in such issues as spatial distribution, figure–ground relationships, and figure integrity (avoiding the drawing of one figure over another); and to be aware of "insideness" and "outsideness." Cohen defined the rules for image-making, but, because the rules combine and interact in a complex, dynamic way, the results are satisfyingly unpredictable. If both wheels of a turtle moved at the same speed, the mechanism would go in a straight line; different ratios make it move in arcs. The changing location of the turtle's path is defined for the computer by sonar devices installed at two corners of the paper. The complex works

Figure 5.17. Harold Cohen, *Brooklyn Museum Installation*, 1983, drawing, India ink on paper, 22in. × 30in.

The drawing turtle is an "adjunct" artist guided by a computer program designed by the artist, and used to generate drawings that investigate cognitive principles that underlie visual representation. Called AARON, the knowledge-based program addresses fundamental questions – what do artists need to know concretely about the world in order to construct plausible representational objects? What kind of cognitive activity is involved in the making and reading of these?

(Robert A. Hendel; Photo: Linda Winters)

contained closed and open figures, embracing abstract asymmetric forms which resemble natural shapes such as fish, stones, and clouds. In 1983, the Tate Gallery in London and the Brooklyn Museum in New York both featured Cohen's mural-sized computer drawings.

Since the 1980s, a growing tide of international exhibitions in galleries and museums demonstrated the quickening of interest in the computer's use for art.[24] Many countries including, for example, Britain, Canada, Germany, Spain, Italy, Japan, and Mexico have either originated exhibitions of computer-assisted art or hosted traveling exhibitions such as the Siggraph *Art Show*.[25]

Up to now, the major museums have tended to acquire works which incorporate computer influence rather than computer graphics as part of their photography, video, and sculpture collections. Works such as Jon Kessler's electronic kinetic sculptures, Bill Viola's DVD projection installation (*Going Forth By Day*), and Jenny Holzer's computer-controlled electronic message-boards tend not to isolate the computer aspect of the art but, rather, to integrate and enhance its overall conception.

Use of the computer raises particularly thorny problems for some artists who fear they may lose control of their autonomy to a machine which has a powerful agenda of its own. It is invasive – replacing publishing mechanisms, photography, text-processing, and sound. It has crept into every visual artist's studio as a tool for some functions (much as the camera did), raising questions about what aspect of it can be used as a tool for their work, although most have not yet contemplated its use as a medium in its own right.

The computer as a tool for integrating media

Digital potential leads to multimedia productions, where the computer operates the entire program (for example, the audiovisual, computer-controlled projection installation works of Toni Dove, Dorit Cypis, and Carolee Schneemann, which include live performance, video, slide projections, and music).

The subject matter of Gretchen Bender's computer-controlled video work is the medium itself. Seeing television as a powerful machine spewing out symbols, signs, referents, and image materials which have often been reprocessed and again subjected to reprocessing, she confronts in her work the uncontrollable torrent of information with which we are flooded. She asks how an image, once having been absorbed into the undifferentiated flux of television, can also have meaning by being brought into a system of control imposed by the artist and then by the viewer in a process of critical awareness. In effect she removes the image in order to examine it. Another system of control she makes use of and examines is the technological reduction of all image components, so they are addressable by a computer and video system. An image that can be created, edited, controlled, and manipulated digitally and reproduced for dissemination on a flat digital plane, where all aspects of it are undifferentiated, creates a very different kind of fragmentation from that of a Rauschenberg collage in which images have been placed together compositionally according to form, color, line. Bender's work took on the form of a multichannel video-wall, sometimes with accompanying film loops as in *Total Recall* (1987). Part of her strategy in commenting on our social and perceptual experience of watching television is to intensify this experience of watching, to create an ambiance of "overload" to force the viewer to extreme experiences of fragmented, multiplied versions of watching. Her quickly exploding collages, full of swirling logos and frantic speeded-up movement, take advantage of digital systems to address any single part of any image.

Figure 5.18. Gretchen Bender, *Total Recall*, 1987, electronic theater, twenty-four monitors, three film screens, eight video channels.

Total Recall is meant as a critique of the optical overload in the media culture of today. Employing sophisticated editing effects to manipulate a powerful array of logos and images appropriated from television, Bender inquires into cultural desires and the techniques and seduction of media representation, as she investigates the networks of information-communication transfer. Bender uses the computer to control the video multiple-monitor performance film and synchronized installed effects. In this ambitious work, she bombards the viewer with high-speed images.

(Gretchen Bender)

Figure 5.19. Gretchen Bender, diagram of monitor arrangements for *Total Recall*.

The message is the medium: a public art

⬤ ⬤ ⬤ ⬤ ⬤ see color illustration 6

Jenny Holzer makes use of computer technology to animate her aphorisms on topics such as anger, fear, violence, war, gender, religion, and politics. Invited by the Public Art Fund in 1986 to create a work for their computerized sign project "Messages to the Public" above Times Square in New York City, she used the spectacolor board. It changed the direction for her art. The possibility of producing her text-based work fitted perfectly with the capacity of her computer-based medium. Her conceptually based art works, in the form of tersely written texts with iconic images, embody conventional truisms but with a strong wry twist. They refer and update the Conceptual movement with their immateriality and their strong social commentary. *What Urge Will Save Us Now that Sex Won't* has its moving image and text information equalized and written in raw color sign lights. Her work is intended as a form of communication with the public: "I try to make my art about what I am concerned with, which often tends to be survival . . . My work has been designed to be stumbled across in the course of a person's daily life. I think it has the most impact when someone is just walking along, not thinking about anything in particular, and then finds these unusual statements either on a poster or a sign." Her work argues that art is an accessible language. If it is placed in a public environment by electronic means, the impact can be profound.

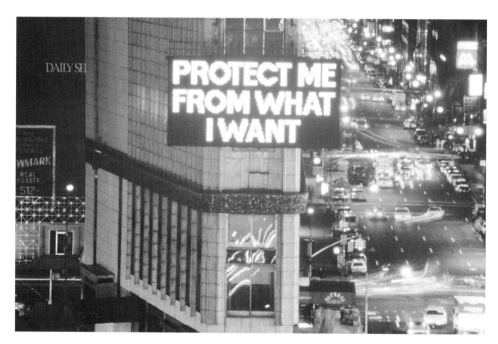

Figure 5.20. Jenny Holzer, *Protect Me from What I Want*, 1986, electronic, spectacolor billboard over Times Square, New York.

Influenced by her experience in creating messages for the spectacolor board, Holzer went on to use electronic signboards as a personal medium for her truisms. Holzer's work speaks to many viewers because it uses the commonplace to voice the subconscious. *(Cheim and Read Gallery, New York. Sponsored by the Public Art Fund)*

Figure 5.21. Jenny Holzer, *Laments*, 1989, installation view, Dia Art Foundation.

In *Laments*, words pass up and down via vertical columns of light emitting diode (LED) displays as fragmentary first-person confessions of pain, fear, greed, flying by in the dark in glowing reds, greens, and yellows. Occasionally, the spectacle stops, the room goes black and the columns glow in pure color before starting up in motion once again. In an adjoining room, the same texts were etched into stone sarcophagi.

(Cheim and Read Gallery, New York)

Following her first use of the computerized spectacolor board, Holzer began to use electronic message boards as a major medium of her own as her art work. Her programs for LED (light-emitting diodes) machines have various levels of complexity but have been seen around the world from Paris to Documenta, to the Venice Biennale and back, some on huge message-boards and on mobile boards mounted on trucks. In the same public spirit as her electronic signs installation was her intention to buy fifteen-second blocks of commercial time on television to feature her texts – which she adapted for television. People may buy her LED signs and objects but her art is not confined to the context of museums and galleries: it is out in the streets. Holzer resists the traditional notions of art as a rare and precious object. Her works are unsigned. They question power. Her words and voices make room for thoughts and feelings that people generally keep to themselves and that art has generally excluded.

Les Levine has always used media tools for his work. He was one of the earliest artists to become fully identified with the use of video and the computer. Both a public and a private artist, Levine produces video projects and paintings and installations which are regularly exhibited in major galleries and museums. However, a large part of his work is also devoted

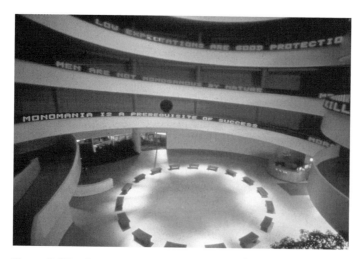

Figure 5.22. Jenny Holzer, *Survival Series*, installation at the Guggenheim Museum, New York, 1990. Etched red granite benches with selected texts on LED signs.

The spiral ribbon of LED electronically programmed letters girding the Museum's circular architectural space could be experienced differently depending on the vantage point they were seen from. The work depends on the tension created between the conceptual memorial style of the installation spectacle and the new more transient informational one. It seemed to be a summing up of a poetic public confession of loss, violation, and entrapment. In this work, Holzer sought to capture the spiritual crisis of the decade.

(Cheim and Read Gallery, New York; Photo: David Heald, Solomon R. Guggenhem Museum)

Figure 5.23. Jenny Holzer, installation view, US Pavillion 44, Venice Biennale, 1990

Holzer resists traditional notions of art as a rare and precious object and of art confined within a museum or gallery context. Her technological works present different voices which question power. Holzer's work argues that art is an accessible language, one which can be electronically blended into a public environment for the public at large, an experience which can be as profound as any traditional painting or sculpture.

(Cheim and Read Gallery, New York)

to reaching a much broader audience through his billboard projects which are sited within the flow of urban public life. Levine consciously decided to use mass advertising effects in his work to get attention for his messages. Like Warhol, he maintains that "Advertising style is the most effective means of communication of our time because it is specifically designed to capture public attention." In the confusion and complexity of city streets, the eye is bombarded with thousands of messages and details. Levine's pieces work at many levels so that an investigation would demand a response which keeps on resonating in the mind – similar in character to the power of an advertising message which cleverly hooks itself, by its own form of power, to the consciousness of a distracted public, which does not want to be bothered but is nonetheless a participant in the circuit of desire which is part of the way we inhabit the present. (See also Chapters 3 and 7.)

The artist as publisher

A form which also enjoys a wider audience is that of the book. The book form allows an artist to explore ideas and concepts as sequenced images, a "gallery of ideas," a record which lasts far longer than an exhibition, and one which may have a wider audience. Prior to the arrival of desktop publishing, artists experimented with the photocopier for book production. In the same tradition, today's book artists self-publish text/image works with the computer. The kind of planning and decision-making about the work puts it in the category of conceptually driven idea art which originally drew strength from Conceptualism and the Fluxus movement in the 1960s.

Sometimes conceived as multiples, in order to reach a larger audience, they have appropriated mass-media production modes while rejecting the seamless corporate aesthetic of conventional high-volume publishing. Artists' books are independently produced artistic statements in book form. They are a small but important site for the aesthetic investigation of image, text, and concept. Emerging from the context of painting, sculpture, music, and dance, artists' books explore new forms related to the conceptual premises of the arts more than the humanities. The aesthetic issues book artists explore are specific to the book: linearity, timing, sequence, image and text relations, narrative tension, image frequency, page design, structures and materials, openings, turnings, margins, and gutters. At their best, artist books have the essential complexity, density of ideas, and intimacy of any art form.

The computer has replaced the photographic darkroom in the production of books, for it can produce the half-tone film output required by offset printing. It allows for unlimited image and text manipulation in the same space and for rapid pre-production that some think represents a democratic ideal in publishing. It transforms what was once an industrial process – requiring services of a typesetter, a graphic artist, a printer, a designer, and an editor – into a largely private one where the author becomes the producer.[26]

In his essay "The Author as Producer," Benjamin pointed out that, with the accessibility and growth of reproduction technologies, everyone can now become a writer, not only through letters to the editor in the daily press but also, now, through publishing opportunities made possible by advances in (electronic) technology. "For as literature gains in breadth what it loses in depth, so the distinction between author and public which the bourgeois press maintains by artificial means, is beginning to disappear." The new electronic publishing technologies[27] open communications possibilities to artists which were never before available.

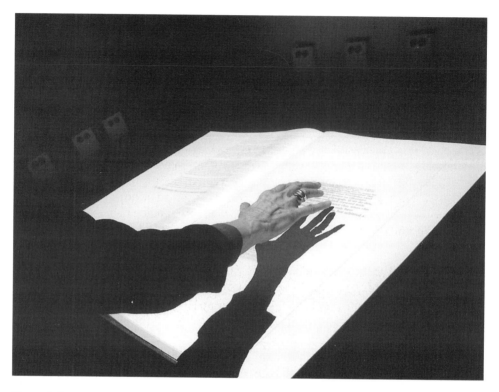

Figure 5.24. David Small, *Illuminated Manuscript*, 2002, computer book project, 25in. × 33in.

This work concerning the UN Declaration of Human Rights explores the communicative possibilities of spatialized language in electronic media. Combining physical interfaces with purely typographical information in a virtual environment, it explores new types of reading in tune with human perceptual abilities. A hand-bound book is set in a spartan room. Projected typography is virtually printed into the blank pages with a video projector. Sensors embedded in the pages activate the computer as the pages are turned. In addition, sonar sensors allow visitors to run their hands over and to disrupt, combine, and manipulate the text on each page. The book begins with an essay on the four freedoms – freedom of speech, freedom of religion, freedom from fear and freedom from want. Each page explores a different text on the topic of freedom. Moving away from the domain of sheer visuality into the realm of the tactile and interactive, the corporeal capacity of language is dissected into workable spatial and temporal applications.

(David Small)

Transformations of the book form dissolve boundaries between media

Electronic and print versions of a work often coexist in various ways. A printed book is functionally interactive. It seems natural to simply pack a disc into a printed book work as further outcropping to its ideas – as is "Swallows," a floppy disc inserted into the back of *The Case for the Burial of Ancestors* by Paul Zelevansky (1986) or *ARTINTACT* magazine produced

by ZKM which has its DVD disc inserted in its cover. Hypertext on a DVD may hold webs of texts which interactively connect to visual materials, with sound. Sometimes, a work originally produced as electronic communication (such as a video disc which holds moving images as well as sound and text), is reduced to a print format.[28]

The electronic book today appears in several forms – not only as CD-ROM or DVD but also online, located on the Internet, eons away from the traditional material-bound, costly processes of hand-printing and binding. CD-ROM and DVD have become a mass medium for the publication of interactive works now that DVD players, like VCRs, are becoming standard in new computers. More and more artists are attracted to this medium because of its potential for harnessing, in the same format, text, sound, and both still and moving images. With CD-ROM and DVD, the disc becomes "the gallery" and its accompanying text "brochure" book becomes the "catalog." Some publishers have tried to introduce their books in e-book formats, but this move has not been successful. On the whole, the reading public still prefers the experience of reading words on paper rather than on a lighted screen.

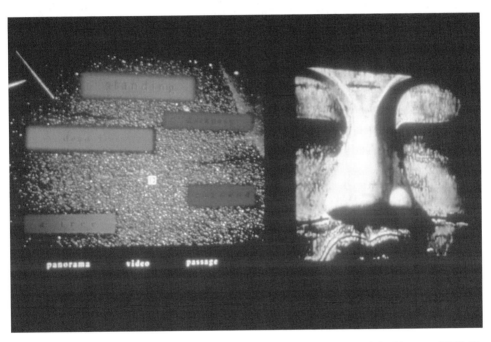

Figure 5.25. Bill Seaman, *Passage Sets/One Pulls Pivots at the Tip of the Tongue*, 1994/5, interactive audiovisual installation, and CD-ROM, collection ZKM Center for Art and Media. Programming by Zeigler, image from "Mediascape" exhibition, Guggenheim Museum, Soho, New York City, 1996.

A wall-sized projection work in two sections in which the viewer can select words and phrases from changing streams of language and explore different avenues of imagery. The work provides a significant experience of simultaneity, "like being surrounded by a poem that's writing itself, an apotheosis of the image-text formula of Conceptual art."

(The Guggenheim Museum and Bill Seaman)

Pioneers of interactivity

The whole process of creating interactive works is a pioneering experience of completely new territory where there are, as yet, no traditions, no grammars, no guidelines. We are shackled by our training. "It's very hard to throw off all the vestiges of those previous forms. It will take a whole new generation that grows up inside of this medium to really find out what it's all about."[29]

Originally, interactive media grew out of developments in electronic computer games[30] in the 1970s and 1980s. Owing to the popularity of "games," the early technology became so developed that many artists decided to use the game concept of branched-out situations to involve the audience in a different kind of imaginative experience. Jane Veeder, Nancy Burson, and Ed Tannenbaum created different genres of interactive works.

About Face is an early example of an artist-designed interactive project. It was designed by Nancy Burson and prepared by the Reuben H. Fleet Science Center. *About Face* is also an example of how many interactive works originated in science museums, such as San Francisco's, rather than in fine arts institutions. The projects are designed so that visitors will become engaged in the exhibition, losing themselves in an interaction with a variety of experiences related to the range of "information" communicated by the human face. For example, when does a visual pattern become recognized as a face? (or, is it easier to mask an expression of anger or one of surprise?). The viewer can choose from among many sites where their faces are scanned and digitized and then manipulated according to the software programmed by the artist. The exhibition draws on findings in the fields of anthropology and psychology. *About Face* deals with questions of identity and desire by allowing, for example,

Figure 5.26. Lynn Hershman, *A Room of One's Own*, 1993, interactive installation – miniature video monitor and video projection in miniaturized room, 18in. × 24in. × 36in.

Continuing her feminist discourse about voyeurism in a *Room of One's Own* by forcing the viewer to see her work through a periscope peephole, Hershman adds the elements of how one responds to being looked at. The viewer's eye movements themselves are digitized and inserted into a small television set within the tiny specially constructed bedroom scene. The eye movements send signals to a computer which causes the video disc to access significant segments for viewing on the room's television. Thus the viewer or voyeur becomes a "virtual" part of the scene being viewed. Depending on whether one turns the periscope toward the bed, the pile of clothes, the telephone, the chair, or a monitor, one of the three screens on the back wall is triggered. For example, looking at the bed reveals unpleasant scenes of the woman shaking bars that resemble a sexual prison.

(Lynn Hershman)

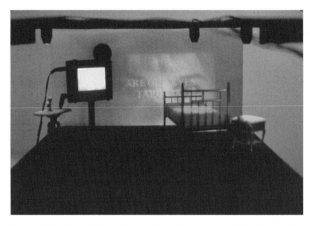

Figure 5.27. Lynn Hershman,
A Room of One's Own (detail),
1993.

Lorna, Hershman's heroine, suffers from agoraphobia (fear of open spaces) and hides in her apartment, relating to the world only through objects that make her neurosis worse: the television and the phone. Viewers can choose various channels to explore Lorna's persona by accessing her possessions. When touched on the screen, these open out individually to comment on many issues – from women's rights to the threat of nuclear war.

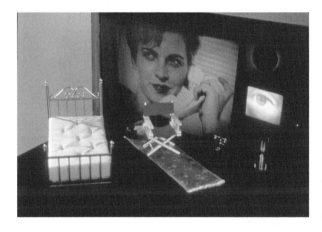

Figure 5.28. Lynn Hershman,
A Room of One's Own (detail),
1993.

(Lynn Hershman)

playful manipulation of programs which allows people to create their own computer self-portraits by inserting on their own face a nose, eye, forehead, and so on, from famous prototypes.

Earlier work by Nancy Burson,[31] a series of "Warhead" portraits, combines the faces of the leaders of countries possessing nuclear weapons, statistically weighted by the number of warheads at each leader's disposal. She scans individual portraits for her composites into a computer by means of a television camera, encoding their images as digital information. Each of the scanned-in images is interactively adjusted as to size and format and then they are stacked and "averaged," stretched and warped. (See fig. 5.3, p. 155.)

Lynn Hershman is one of the first artists to have taken interactive laserdisc[32] technology beyond commercial exploitation. Her project *Lorna* was produced by the Electronic Arts Archive, Texas Tech. It represents an important beginning artistic involvement with a potentially

powerful interactive medium. Hershman is attracted to the interactive disc medium because its branching-out possibilities provide for a more intense way of dealing with reality, and because of her desire to actively involve her audience by empowering them to self-direct the video screen.

Narrative has always been a dominant cultural force

By 1915, all the story moves in cinema were in place. Early twentieth-century experimental narrative by writers such as Gertrude Stein and James Joyce was appreciated by the avant-garde, but the new forms they explored never became mainstream. Now, however, stories are no longer fixed. New media allow the morphology of storytelling to become entirely elastic and randomized with everyday challenges to broad audiences that occur on all sides. This new potential for constructing stories is today one of the major shifts occurring in any aspect of culture including film, video, and the Internet, challenging also more traditional forms such as the novel and theater.

According to Graham Weinbren, we consciously construct personal stories in order to find effective ways of getting at the insights we want to convey to others. We know a story can begin at the beginning, the middle, or the end. But responsive digital tools allow for completely non-linear narrative which allow for development of many alternative story forms which are unlike time-based media. Stories can move front and back, sideways or up and down, incorporating radically different points in time as the story develops. They may have layers that mesh at climactic moments. Multi-threaded ones may have different aspects of a story going on at the same time. Some may have embedded features which are connected to other stories in a related archive.

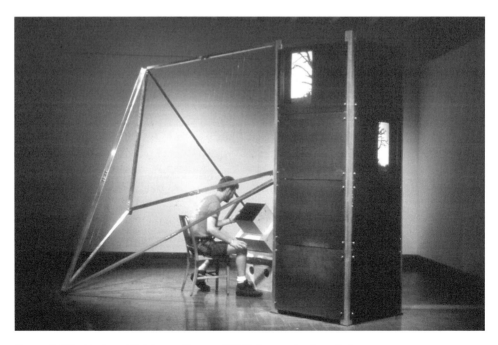

Figure 5.29. Graham Weinbren, *Sonata*, 1993, interactive installation.

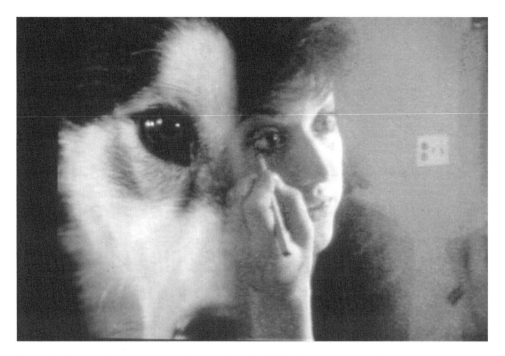

Figure 5.30. Graham Weinbren, *Sonata* (detail), 1993, interactive installation.

In a deliberate investigation of the possibilities for a new kind of interactive cinema, Weinbren aspires to lay its foundations in a moment-by-moment collaboration between viewer and filmmaker. In *Sonata*, he juxtaposes a Tolstoy story of jealousy and mistrust leading to the murder of the wife with the biblical theme of Judith and the enemy general Holofernes. The general is decapitated by the heroine Judith, who thereby saves her people from a calamitous invasion. A primary aim of this multivalent narrative is to examine extremes of emotion. Weinbren structures the stories so they can be easily accessed by the viewer by pointing at the screen at any time. For example, the Tolstoy narrative segment is set on board a train as the protagonist, pardoned for the death of his wife, recounts his story. The viewer can interrupt the narrative flow at any time to visit the actual visual scenes being described verbally and then loop back to the main story. The viewer navigates around the narratives using a unique interface system where up, down, left, right all represent different temporal directions. Right and left move us forward and backward in time; down renders expansions of the present; and up, introduction of material outside time. Weinbren has found ways also to elaborate on these inputs.

(Graham Weinbren and The Internationmal Center for Photography)

The non-linear relates us to our daily experience of the real world, which we can affect in many ways whereas the world of cinema and television can only offer us stories we can look at in a single direction with no power to control the way it plays out. Stories can be structured like games using the interactive grammars of multiple image streams. These kinds of stories do not offer the closure of linear narratives, but place the participant in the center of the storytelling space. Online journals such as www.LiveJournal.com allow for joining others in creating daily narratives that develop a level of community connection that is personally meaningful. Interactive games offer the sense of empowerment and mastery that the user may miss in real life and allows for the kind of fantasy that can be extremely powerful. For some, these games become a form of psychological addiction.

Graham Weinbren's and Roberta Friedman's complex interactive video disc project *The Erl King* (1983–86), based on Schubert's song of the same title ("Der Erlkönig"), also exploits laser disc technology to shape a contemporary way of telling a story with images. It is a multidimensional narrative in which the viewer manipulates and reconstructs its images by touching the monitor's screen. In *Sonata* (1993), Weinbren creates even more subtle relationships in his non-linear narrative. Weinbren wants to explore multiple points of view in his work with a more response-type interface to create a subtle effect on viewers that seems more like a psychological flashback than a separate response. In *Erl King*, the viewer had to actually touch the screen of the monitor to activate changes. In *Sonata*, the infrared sensor beams are several inches in front of the monitor screen so that the viewer needs only to move the hand, as though directing, to make changes. In general, his work stays closer than most to the concept of cinematic expression and creates a sense of the psychological workings of the mind – creating a fluidity of movement and montage that is deeply satisfying as a result of improved image compression software. In *Sonata*, Weinbren used two stories – Tolstoy's *The Kreutzer Sonata* juxtaposed with the biblical story of Judith and Holofernes. He also placed in the same data bank the text of Tolstoy's family diaries. At yet a further intertextual level of relationships, he inserted dreamlike images that are condensations of his feelings. While the viewer is free to move quickly and easily through the piece, Weinbren exerts control of the interactivity in one or two places where the viewer is not allowed to pass on at the high point of the intense climactic scene, such as when Tolstoy's character murders his wife. In his new work, he is exploring complex audience reaction to works that are projected from a DVD source.

●●●●● see color illustration 2

Crafting work where there are pathways, nodes, links, networks, and connecting loops between visual, sonic, textual, and graphic elements calls for enormous skill. Multifaceted procedures and coding require collaboration, a difficult aspect in a culture which promotes heightened individualism. Interactive multimedia bring us into the type of collaboration that makes a film, a theater piece, or an opera production a reality. The collaboration can be one where the director or producer is in charge of others; or it can be a more open-ended one where there is equal input and joint decision-making by all of the players. The latter, more democratic model is full of difficulties but, on the whole, could produce the most innovative work. As the new media culture changes, increased collaboration will be necessary.

In the future, technological advances will include alternative inputs to the keyboard or the mouse. Video and computer games are not the only models. Virtual reality (VR) hardware now exists for head and hand motion; for the use of body characteristics such as touch, motion, eye focus, gesture or voice, and brainwaves. These possibilities as yet have been little tapped by artists. Access to robotics and artificial intelligence labs is not always available. New ways of compressing and representing complex information and the procedural tools needed for users or audience to navigate them are being developed rapidly, particularly in relation to the Internet and the World Wide Web (see Chapter 6).

The most common multimedia interactive works are designed for presentation on computer screens, although some artists take the route of immersive virtual reality environments because they feel that computer screens confine their access to create new experiences with both materials and spatial relationships. However, similar problems confront both types of interactive producers. For example, the interface with the viewer: How does communication

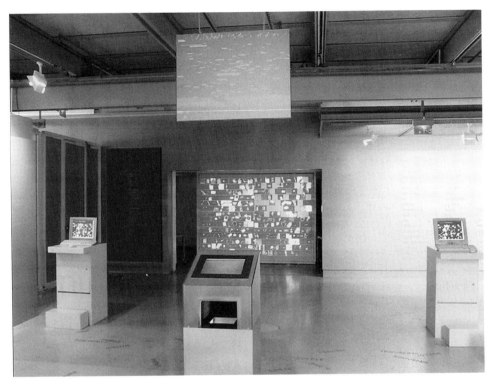

Figure 5.31. George Legrady, *Pockets Full of Memories*, installation at the Pompidou Centre, Paris, scanner and website, 2001.

At the core of this project is the notion of memory as an archive which operates on the threshold between logical classifications and meanings that cannot be quantified. The installation invites visitors to digitally scan an object they personally possess and submit answers to a set of questions about it. (This can also be performed online.) The Kohonen Self-Organizing Map Algorithm then classifies the scanned objects based on similarities of their descriptions and enters them into a maplike grid. Participants can view their own objects and see those of others. They can also add their own personal comments and stories. The result of the project is a generative cultural map of possible relations between simply functional objects and those that have real personal value. The archive collection of objects represents the community of participants.

(George Legrady)

take place to indicate how interaction should occur? How can the viewer be motivated to interact and to want to continue? What most interactive producers have found is that the interaction itself must be intuitive, meaningful, simple, attractive, familiar-feeling, and noticeably responsive to the user.

Most artists are interested in providing as much freedom of exploration as possible while still taking control of shaping the experience cohesively. Those who have been struggling the longest with the media speak of the need for a rich lode of source material as a database for the construction of the work.

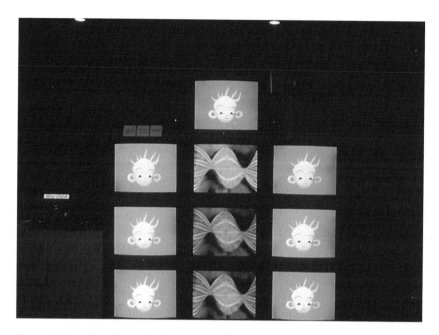

Figure 5.32. Naoko Tosa, *Talking to Neuro Baby* (detail), 1994. An interactive performance system with voice input response and neural network software. Created in collaboration with Fujitsu Laboratories.

With *Neuro Baby*, we have the "birth" of a virtual creature with computer-generated baby face and sound effects made possible by neurally based computer architectures. It represents an interactive performance system capable of recognizing and responding to inflections of the human voice which can trigger changes in facial expression of *Neuro Baby*'s "emotional space." *Neuro Baby*'s logic patterns are modeled after those of humans, making it possible to simulate a wide range of personality traits and reactions to various experiences. Tosa comments: "I created a new creature that can live and meaningfully communicate with many modern urban people like ourselves who are overwhelmed, if not tortured by the relentless flow of information, and whose peace of mind can only be found in momentary human pleasures. *Neuro Baby* was born to offer such pleasures . . . It is a truly loveable and playful imp and entertainer."

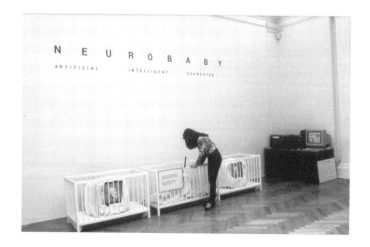

Figure 5.33. Naoko Tosa, *Talking to Neuro Baby*, 1994.

(Naoko Tosa)

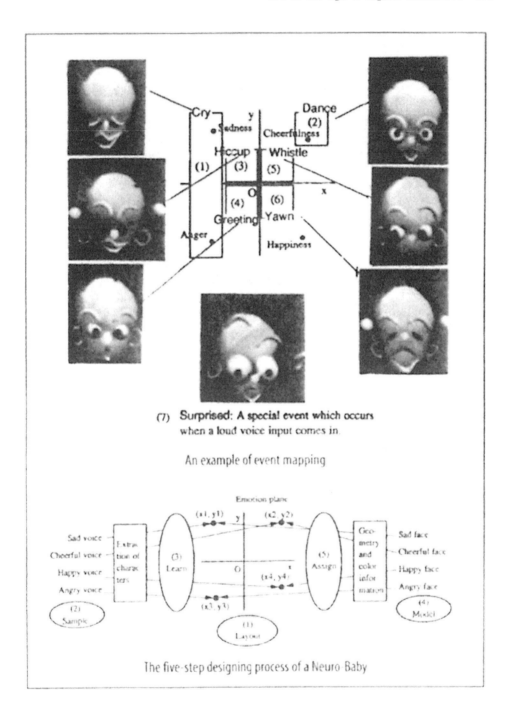

Figure 5.34. Naoko Tosa, *Talking to Neuro Baby*, 1994.

(Naoko Tosa)

Figure 5.35. Zoe Belloff, *The Influencing Machine of Miss Natalija A*, 2002, video, electronics, silkscreen.

Zoe Belloff states that her work deals with the relationship between imagination and the technology of the moving image both in terms of content and through rethinking the apparatus itself. She wishes to show that machines are not simply tools, ideologically neutral, but grow out of our deepest unconscious impulses. Just as we think through our machines, by the same token they structure the limits of our thoughts. The installation consists of a large stereoscopic diagram simulating the "Influencing Machine," placed on the floor. Inside it is a small frosted glass panel onto which video images are projected. The participant, wearing red/green stereo glasses, looks down at the diagram. Now they see an actual three-dimensional structure. They touch a designated point on this virtual machine with a pointer. All at once moving images appear on the screen, sound blares from the apparatus. They take the pointer away and the projection vanishes. Different points on the machine trigger different movies. From the moment they don the glasses, participants enters into a virtual world invisible to those around them, very much as one would when actually hallucinating. "Virtual Reality is not simply a recent computer technology but has its roots deep in history and hallucination."

(Zoe Belloff)

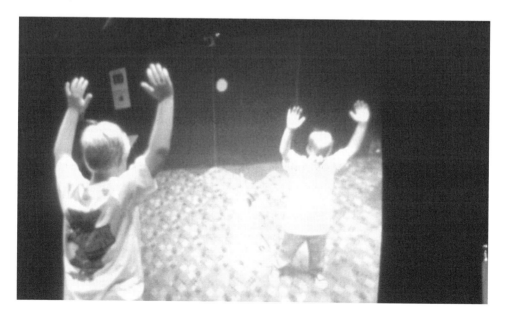

Interactive installation environments

Other forms of interactivity extend beyond the computer monitor to include a room-sized venue as an interactive installation space. Here, various mechanisms of interactivity can be considered, depending on the artists' work. These could include sensing devices such as those for sound, movement, and temperature, or those which focus on communications sensibilities such as speech, touch, and gesture. Questions most frequently asked by artists contemplating use of interactive media concern the loss of their usual control over a discrete work. How much control will the viewer have in directing the flow of the piece? How much can be altered or changed in the work? Will its intentions become diluted? At what point does it seem less interesting to artists if there is too much loss to the work's original intent or meaning? What kinds of new programming will evolve? Will they be able to develop modes of interaction which will offer more complexity and flexibility?

Lovers Leap by Miroslaw Rogala is an interactive installation environment in which shifts in the viewer's movements control a continuously evolving perspective. Produced in 1995 at ZKM (Center for Media Art in Karlsruhe, Germany), Rogala's work comments on aspects of representation itself. His digitized images, from two separate contexts (a bridge intersection in Chicago and a satellite scene in Jamaica), are capable of being turned completely inside out, first showing a digitized fish-eye view taken with a conventional camera, skewed as the viewer moves through the piece (wearing a movement-sensitive helmet) to become a transposed digitally reformulated view from a 360-degree turnabout like a sock being turned inside out, only digitally. The images are projected at each end of a large room with high-quality projectors.

 see color illustration 1

David Rokeby's long-term ongoing interactive project *The Giver of Names* is an exploration of various levels of perception that allow us to arrive at interpretations. It is a computer system that literally gives objects names by trying to describe them. The installation is made up of an empty pedestal, a video camera, a computer system, and a small video projection. Participants can choose an object or set of objects to place on the pedestal from those provided in the installation space or any object they may carry with them. Once the object is placed on the pedestal the computer "grabs" its image by means of the observant video camera and begins to perform image-processing at many levels (outline analysis; division into separate objects or parts; color and texture analysis, etc.). These processes are visible on life-sized

Figure 5.36. (opposite) Pattie Maes, *Alive: An Artificial Life*, 1994, virtual immersive environment.

The goal of *Alive* is to present a virtual immersive environment in which a real participant can interact in natural and believable ways with autonomous semi-intelligent artificial agents whose behavior appears to be equally natural and believable. Normally, navigation through a virtual space requires the wearing of gloves, goggles, or a helmet – cumbersome equipment tethered to a computer workstation. However, in *Alive* a single CCD camera obtains color images of a person which are then composited into a 3-D graphical world where 3-D location and the position of various body parts are contained. This composite world is then projected onto a large video wall which gives off the feeling and effect of a "magic mirror."

[Pattie Maes]

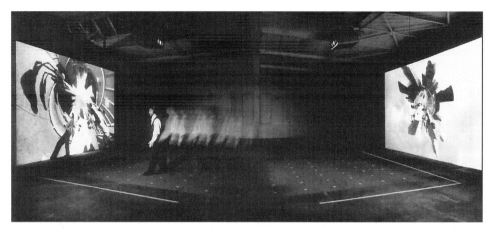

Figure 5.37. Miroslaw Rogala, *Lovers Leap*, 1995, design environment produced in collaboration with Ford Oxall and Ludger Hovestadt.

In Rogala's interactive installation. a collision takes place between emotion and technology. As in a leap of trust and faith, Rogala explores the totally untried frontiers of representation. He questions the very parameters of perspective by turning its space 360 degrees in upon itself through digital means. The installation consists of two synchronized screens displaying opposite perspectival views with four layers, each with a different set of photographic information. When viewers enter the space, they are aware that their movements are changing what is seen. If the viewer keeps moving through the environment, a series of abrupt shifts is created – the same relationships from a dramatic new perspective – which leap over the lover/viewer. Once the viewer/lover stands still or exhausts the relationship, there will be a sudden thrust into a new landscape – a vista that is out of the viewer's control.

(Miroslaw Rogala)

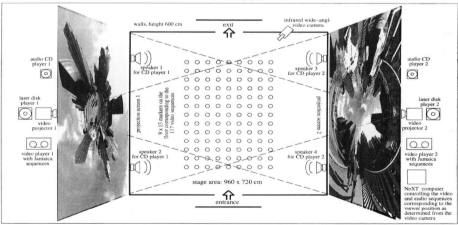

Figure 5.38. Miroslaw Rogala, *Lovers Leap*, 1995, floor plan with two simulated projection screens.

(Miroslaw Rogala)

video projections above the pedestal. As the system tries to make sense of them, the objects effect the transition from real to imagined to increasingly abstracted. They create an anatomy of meaning as defined by associative processes as the results of the analytical processes are "radiated" through a metaphorically linked database of known objects, ideas, sensations, etc. These could lightly be described as a "state of mind." From the words and ideas that resonate most with the perceptions of the object, a phrase or sentence in correct English is constructed and then spoken aloud by the computer.

In an associated Internet project to the *Giver of Names*, Rokeby created *n-Cha(n)t* (a 2001 Banff Center Commission) as an installation of multiple computers and monitors with microphones and voice-recognition software. These act as a community of computers chatting together and intoning chants. When a gallery visitor speaks into one of the microphones, these words from outside the system disrupt or distract it and, as a result, that computer falls away from the chant, causing the community chanting to lose coherence.

The ears visible on the computer monitors show the state of receptivity of each system. When the system is ready to listen, a listening ear is shown on the screen. If the system hears a sound, it cups its ear to concentrate. When "thinking," a finger is pressed into the ear. If the system feels overstimulated, it covers its ear with a hand to indicate its unwillingness to listen.

(Exhibiting) sound as art

Until now, the two disciplines of visual arts and music have been separated through art historical traditions and attitudes. However, as we have seen, for many composers in the 1950s and 1960s, digital experimental innovation shifted the ground from traditional musical forms to experimentation with abstract electronic sound forms, paralleling moves in the visual arts. (See pp. 171–2.) Open attitudes toward experiments with sound and the influence of John Cage in the performance, Happenings and Fluxus movements of the 1960s, created the moment for an inclusive, cross-disciplinary field (see Chapter 3). Even though many visual artists and poets performed as musicians in the 1970s – Tony Conrad, William Burroughs, Laurie Anderson, Patty Smith, La Monte Young, Alvin Lucier, Meredith Monk amongst many others – their cultural productions were never included in the institutional gallery world as cross-disciplinary, sound-based realms of creative expression. Although sound works paralleled Performance art, accepted as an activity of the visual arts, it was not integrated as part of it. In certain exhibitions, such as *Les Immatériaux* (see pp. 162–3) in 1985 and later in exhibitions from 1994,[33] musical or sound works began to be part of new multidisciplinary approaches in the arts, especially in the field of sculpture, as "sound-emitting visual objects or installations."

In her interactive dynamic sound installations, Liz Phillips calls into question the basic philosophic divisions between subject and object, between space and time. She is interested in testing the sonic possibilities of 3-D architectural spaces and objects and engaging participants bodily in both listening and reacting to the "hidden" potential of the time/space audible contexts she creates. She writes:

> the presence and movement and/or absence and stillness of the audience
> determine the combination of the soundscape . . . Voltages (potential energy
> changes) will first reflect movements near objects; then can be made to react
> to speed, change in direction, and save information about presence and

nearness of participants. This information can then activate sound events, shift
their pitch, timbre and duration, and amplitude. Therefore, time duration and
physical dimensions become weighted and proportioned into intervals that
make vibrant density visible.[34]

Acceptance of sound work as an element of visual culture has also taken place as a
result of technological conditions arising out of independent experimental film, video
and digital media art works in which soundtracks are integral to the work. As a result of the
great interest in electronic means of creation and production that now exits, sound culture
has gained momentum as vibratory, immaterial, shimmering elements. From the perspec-
tive of the means of media production and of electronic sound production, parallel cultural
conditions and interests exist in the visual arts – sampling, appropriation, layering, collage,
flowing, and immateriality. These elements now acquire new meanings. Acceptance of sound
work as elements of visual culture has taken place as "a dance from one body of knowledge
to another, constantly plundering, rearranging, and juxtaposing different disciplines."[35]

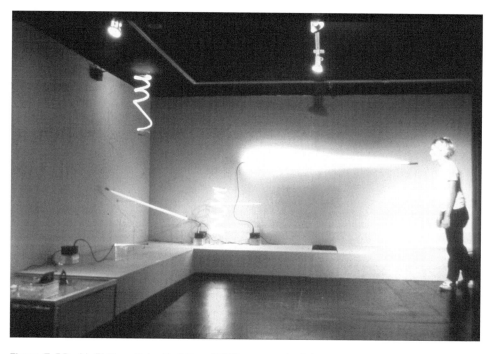

Figure 5.39. Liz Phillips, *Echo Evolution*, 1999, responsive light and sound installation. Software
by Michael Wu, neon by Ken Greenberg.

This interactive sound and light installation is tuned to come alive as a tactile synaesthetic experience.
The audience can wander and forge trails in its open system multimedia landscape. The collective activity
of the audience is sensed with ultrasonics to transform sound and light structures. The installation is
modeled to be fragile and resilient like a plant, always adapting to a changing environment. Events in 3-
D space and time are weighted, balanced, and proportioned, initially as potential energy (voltage) and
later as digital material.

(Liz Phillips; Photo: Tania Saimano Palacios)

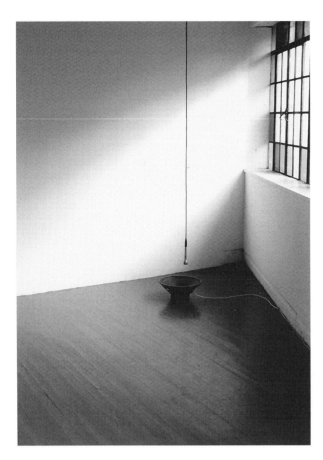

Figure 5.40. Stephen Vitiello, *Frogs in Feedback*, 2000, sound installation – speaker, rotation motor, microphone, mixer, ring modulator. Private Collection, London.

Vitiello started his versatile body of sound work by using contact microphones on the windows of the World Trade Center during a 1999 residency there. Much of his work is based on natural sounds, which he amplifies and processes digitally. He often uses small photocell devices in his mixing board to read differing levels of light that can be directly translated as a set of digital sound frequencies in site-specific works. Although his work does not reside in the visual world, it contains the same raw experimental energy that makes it part of a lineage of experimental artists' work such as that of Bruce Nauman and Vito Acconci.

(Stephen Vitiello and The Project)

Other exhibitions more specifically related to the realm of sound bring into focus the rapid growth of a culture more and more based in electronic music and sound as a result of the accessible creative potential of the electronic sphere. Christine Van Aasche, one of the curators of the international exhibition *Sonic Process: A New Geography of Sound*, refers to "sonic" as a term which attempts to bridge the borders of the realms of "sound" and "musical" to grasp the "creative flux" which now exists. The latest generation of computers and software has made music and sound extremely easy to record, create, produce, and edit alone, without other musicians, in a home studio. It is now possible for anyone to eqip themselves with the necessary tools and software for sound creation. The work can be listened to immediately without necessity of initial instrumental performance and can be easily distributed (e.g., online) without the test of first transcribing it, thus eluding the traditional circuits of music publishing companies. The sound artwork now moves to an era of digital hyper-reprodicibility. There is no longer an original since everything takes place through duplication.

> This scrambling, in the division of roles between production and consumption, creation and reception, at the same time renders fragile two modes of traditional totalization in the artistic field: in intention, the author, synonym of the closure of the work's meaning; in extension, the work itself, which loses its physical and temporal limits – fantasy rendered to the flux of a universal sound material.[36]

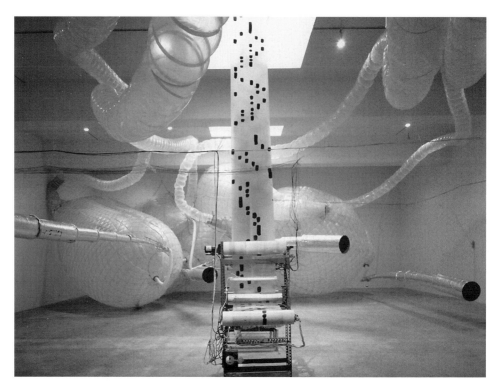

Figure 5.41. Tim Hawkinson, *Uberorgan*, 2000, sound sculpture installation. Woven polyethylene, cardboard tubing, nylon net, and various mechanical components.

Uberorgan is a massive musical instrument installed within several rooms. Visually it insinuates the chest cavity and internal organs of a large living organism. The viewer, passing through its enormous inflated structures room-to-room, may suddenly come across its piano-like mechanisms which with their various switches form a nervous system, responding to stimuli, giving commands to the organs. This player console or "brain" is a sound score for the work. A long roll of mylar, painted with dabs and dashes, winds over twelve photoelectric sensors resembling piano keys. When a mark on the mylar roll passes over a photo cell, a valve is opened in a reed assembly which corresponds to it. A full force of air is released, creating blasts of sound. Hawkinson has made switches which alter the quality of individual notes. The movements of gallery visitors are captured by motion sensors which also trigger the switches. These respond by shifting tonal combinations played through the organ pipes.

(Tim Hawkinson and the Ace Gallery of Los Angeles)

Figure 5.43. (opposite) Greg Lock, *Commute (on Location)*, 2002, virtual 3-D object constructed from GPS data superimposed in the artist's studio.

Using GPS (global positioning system), Lock collected geographic data of his travels to and from work. The journeys are collected in 3-D coordinates – longitude, latitude, and altitude. Using a software program he developed, he manipulates his data and translates it into 3-D objects. These completely simulated forms can now be seen as actual sculptural objects. They can be played with and digitally assigned other qualities such as mass and friction – coordinates which already exist as both real and virtual objects.

(Greg Lock)

Figure 5.42. Mary Ann Amacher, *Music for Sound-Joined Room* series. Installation/ performances. Kunstmuseum, Bern, Switzerland, 1998.

In this work, an entire building or series of rooms provides a stage for the sonic and visual sets of Amacher's installations or performances, produced almost exclusively in large expansive architectures. The idea is to create an atmosphere that gives the drama of being inside a cinematic close-up, a form of "sonic theater" in which architecture magnifies the sensorial presence of experience. "Rooms, walls and corridors that sing."

(Mary Ann Amacher)

The most advanced form of interactivity is hypermedia: virtual reality

Although sophisticated VR simulation technology was developed by the military during the Cold War, it was directed solely at the concept of a sedentary operator following the movement of a vehicle through a 3-D virtual world. Myron Kreuger, one of the artists who pioneered VR, commented that it is artists who have pushed farthest in the imaginary uses of the medium.

> The sense that virtual reality was of fundamental importance came from artists who communicated it immediately to the public through their work. In addition, many aspects of virtual reality including full body participation, the idea of a shared telecommunications space, multi-sensory feedback, third-person participation, unencumbered approaches and the data glove all came from the art, not from the technical community.

Figure 5.44. Virtual reality gloves, circa 1994.

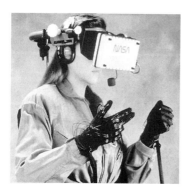

Figure 5.45. Virtual reality headset, circa 1994.

These wired virtual reality sensor accoutrements contain the sensors which make visible to the viewer changes triggered by the body's movements within a specifically wired environment.

(NASA)

Most artists attracted to work with virtual reality[37] as a medium want to create imaginative interactive environments where they can control all the objects or all the spatial coordinates and sound in order to achieve an aesthetic effect. Powerful computers are used to generate visual experience and to track body movements through the use of prosthetic devices such as data gloves, head-mounted displays and body-suits which encase the body in fiber-optic cabling. Fully immersed in a completely controlled artificial environment, the visual, aural, and

tactile capabilities of the body become totally absorbed in following three-dimensional representations which are continuously modeled and tracked through computer monitoring of the body's every movement. Participants experience environments which seem to be located in three-dimensional real space. The effect is that of a technological invasion of the body's senses and a relocation of what can be seen and experienced to the realm of a synthetic private world severed from other potential observers. Jeffrey Shaw, artist-director of the Center for Media Arts (ZKM) in Karlsruhe, Germany, describes it:

> Now with the mechanisms of the new digital technologies, the artwork can become itself a simulation of reality, an immaterial "cyberspace" which we can literally enter. Here the viewer is no longer consumer in a mausoleum of objects, rather he/she is traveler and discoverer in a latent space of audio visual information. In this temporal dimension the interactive artwork is each time re-structured and re-created by the activity of the viewers.

A small band of artists[38] in Europe and North America have challenged the potential of virtual reality by exploring it as an imaginary space. Some project their "virtual Images" in space; some employ headgear connected to sensing devices which control the flow and placement of images within the space. There are no guidelines for these new kinds of work – no vocabulary, no blueprints – because the medium, not in existence until recently, has been approached by relatively few artists to create new works. It is a wide-open medium without boundaries. There is little critical writing about its use.

Working with a team of engineers in the late 1980s to design the software program *Softimage*, Canadian artist Char Davies began to imagine an interactive virtual experience for viewers where they could incorporate the intimate emotional territory of the body into an encounter with a virtual world. In her landscape paintings, Davies was interested in exploring the specific ways people encounter nature where the physical self rather than the conscious mind is in control. She began to build an immersive virtual space with this principle in mind, along with a sense of the floating poetics of space she wished to encompass in the work. In *Ephémère*, 1995 (Plate 3), the viewer participant is swathed in special wired suiting with wide-view headmount, data gloves and special sensors that enable a participant to navigate as a reflection of their own breath and body balance. This system is different from the conventional hand-oriented methods such as joystick, wand, track ball, or glove – which, according to Davies, tend to support a "distanced and disembodied stance toward the world." In *Osmose*, she comments, participants experience an "intense feeling of realness . . . and feelings of freedom coupled with emotional levels including euphoria or loss at the conclusion of the session." In addition, after becoming accustomed to the the work's breath and balance interface, and the experience of seeing and floating through things, most participants "relinquish desire for active 'doing' in favor of contemplative 'being'."[39]

 see color illustration 3

Brenda Laurel, Perry Hoberman, and Toni Dove were all invited in the period 1993–94 to create works produced through a one-of-a-kind artist-centered high-tech program at the Banff Center for the Arts supported by the Canadian government, where costly, complex equipment exists with the unusually knowledgeable staff necessary to build and operate it. The works are experimental, like upper-echelon scientific research, because of the specialized

Figure 5.46. Jeffrey Shaw, *Configuring the Cave*, 1999, computer-based video installation utilizing the CAVE technology. Produced at the ZKM Center for Visual Media with Leslie Stuck, Agnes Hegedus, Berndt Linterrnan. Collection of the NTT InterCommunication Center, Tokyo, Japan.

This complex work assumes a set of pictorial procedures to identify various paradigmatic conjunctions of the body and space. It uses the CAVE technology's stereographic virtual reality environment with contiguous projections on three walls and the floor. The user interface is a near life-size wooden puppet that is formed like the prosaic artist's mannequin. Viewers handle the figure, moving its body parts to dynamically control real-time transformations of the digitally generated imagery and sound compositions. The work is constituted by seven differentiated pictorial domains which can be explored through moving the limbs of the puppet interface. The experience of the work brings up questions about relationships between physical and conceptual relationships and exposes the fragile relations of the surrogate body now located in a measureless dimensional space of forms and texts.

(Jeffrey Shaw and ZKM)

environment, and are not likely to be widely seen in the near future. The artists were invited to produce their works in a structure that became lab-like in its devotion to finding solutions to problems presented by the artists.

Artist Brenda Laurel is drawn to VR because she believes that adults, unlike children, need a certain anonymity or ability to change hats to mask out reality in order to play. They need enhanced props and tend to like the electronic "smart costumes" they must wear in order to explore the interesting dramatic potential of the immersive narrative environments she creates. She believes in a mixture of freedom and constraint in her work. She calls VR costumes "prostheses for the imagination." Laurel observes that "the relationship between human and machine has ceased to be purely technical and has entered the ancient realm of theater."[40]

On entering the exhibition space of Laurel's *Placeholder*, participants find themselves in an environment featuring two ten-foot circles surrounded by river rocks. On donning the head-mount display, participants first experience darkness and then find themselves located inside a "virtual" cave where creatures – a spider, a crow, a snake, and a fish – talk, and seem to entice the visitor toward their locations as petroglyphs on the cave wall. On approaching each, the participants "become" the creature, assuming its physical features and experience spatialized distortion of their own voice through the HMD (head-mounted device) speakers. A character called "The Goddess" offers advice, although her voice, unlike the other sounds, is not spatialized. To create the work, Laurel collaborated with Rachel Strickland. They shot video footage near Banff National Park of a natural cave, a waterfall, a sulphur hotspring, and a fantastic rock formation. They digitized their images, added high-quality spatialized sound, and created simplified character animation of the creatures.

In Perry Hoberman's *Bar Code Hotel* (1994), viewers see objects within a real space juxtaposed against 3-D representations of virtual objects projected in a virtual space. The virtual ones can be controlled interactively by the participants acting from their position in the real space. Hoberman believes that there should be a "one-to-one predictable relationship between a user's action and a system's response. It should work like a light switch . . . With interactivity, it's better to have nothing to say than to try to say something. It's better for meaning to come out of the interaction rather than controlling the experience."[41] This model is favored by many contemporary artists over older ones based on choice modes or interactive narratives. Hoberman feels that the best scenario for interaction is not a model which interrupts the action by offering choice and interactive stories but rather one which initiates action in a program structure which is totally responsive.

When interactive technology is combined with three-dimensional virtual reality modeling, the viewer can be projected and immersed into the narrative space itself, far from the confines of the computer or film screen – more like an environmental theater. Experimenting with collaborator Michael McKenzie at Banff's Art and Virtual Environments program, multimedia artist Toni Dove[42] in 1994 created *Archaeology of a Mother Tongue*, which involved a theater-sized rear-projection screen with interactive computer graphics, video, and 3-D scrims for animated slide projections. In an article published in *Leonardo*, she writes about her experience as an artist in creating an interactive virtual reality Immersion environment:

> I approached the concept of interactivity with some resistance, wondering why I should replace intellectual challenge with multiple choice . . . I saw it as more of an extension of the passive television metaphor than an engagement with options that have substantial ramifications. What I discovered was a world of possibilities that I feel I have barely begun to explore.[43]

What she finally decided on was a system for producing a potentially vast number of non-linear, unpredictable responses based on her interest in the alternative concepts of immersion. Contrary to film, the experience offers a variety of entry points, a different, fuller sense of real time passing, particularly when it is decided on by the viewer. For her, the potential of an immersive interactive environment was to create a work that is more fluid than lines, a multilayered structure which accessed text, both the written and the spoken, with visual elements and responsive sound. She describes the immersion experience as "a movie sprung free from the screen . . . In film, time passes with a cut. VR is continuous space." In virtual reality, it is possible to have multiple streams of different media bombard the viewer in a "field of constantly changing experience."

Figure 5.47. Perry Hoberman, *Bar Code Hotel*, 1994, interactive environment.

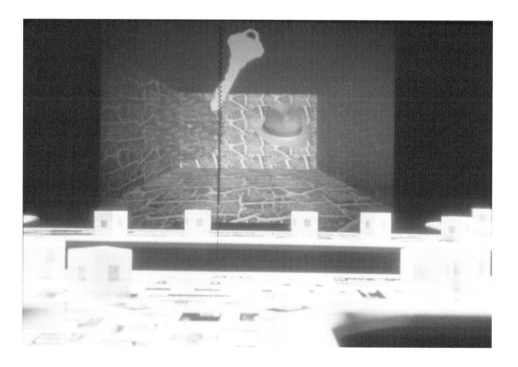

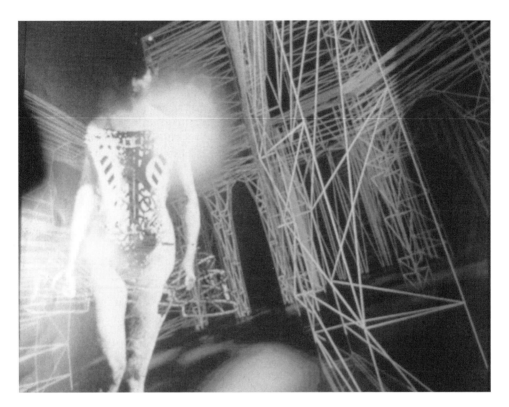

Figure 5.49. Toni Dove, *The Coroner's Dream from Archaeology of a Mother Tongue*, produced in collaboration with Michael MacKenzie, 1993, a virtual reality installation with interactive computer graphics, laserdisc video, and slides.

Developed at the Banff Center for the Arts, Canada, this piece is an interactive narrative comprised of three navigable environments. *The Coroner's Dream* is the first section – a dream sequence in which the audience and/or interactive users are in the point of view of the dreamer. Segments of spoken text and sound are attached to sections of the architecture and are triggered by touching animated figures that follow narrative paths.

(Toni Dove)

Figure 5.48. (opposite) Perry Hoberman, *Bar Code Hotel*, 1994, interactive environment.

Bar Code Hotel participants receive 3-D glasses before positioning themselves behind long tables plastered with the familiar black-and-white bar codes which are such an unpleasant fact of contemporary life. By running a light pen over one of them, viewers find that the ugly black-and-white bars can be energized digitally to release the most wondrous colorful shapes which are shown as large wall projections. Some of the bar codes release every which way the word "jump" or "flee" and, with those, the viewer can manipulate the fantastic objects – a rolling spiral; a lightbulb surrounded by pulsating globes; a strange porcupine sphere. Other commands include ones which make the whole room grow smaller or larger, turn 360 degrees or change color completely. The bar code turns out to be the means for inhabiting an exotic virtual world.

(Perry Hoberman)

One of her first decisions was focused on choosing the best interface for presenting the work. It meant examining various response mechanisms such as whether to use a VR headset with liquid crystal display or data gloves (other tracking devices can also be added to the body through a headset fastened by cords to the control unit). Because the forty-minute piece was too long to be seen comfortably in a VR headset, and because she was more interested in providing a more dimensional experience than that allowed by the headset, she decided on using the data glove as a more open type of interface. Once wearing the glove, the viewer was allowed to touch, move forward or backward, and was allowed to make choices. Guided by the glove's graphic icon, and by a Polheus tracking device (contained within a toy camera) which allowed observation within graphic space, the viewer became the "Driver."

> The driver – a combination performer and camera operator who navigates through the adventure for the audience. This mode of presentation had powerful theatrical aspects, but curtailed the experiential possibilities for one person in a virtual space because of the constraints of entertaining an audience. It also kept the audience somewhat outside the interactive experience. For me, the most compelling aspect of this environment is the sense of being immersed in a narrative space.[44]

Working from the premises of a fractured fictional narrative, she takes her viewer through a dream sequence located in a wireframe architectural space. One of the characters, the Coroner, speaks aloud in the dream. The sound reverberates spatially with both local outposts and those attached to special locations within the space.

Dove hopes to further the possibilities for integrating organic sound in her work such as breathing, or other body sounds, as a way of suggesting the sensuality of a human or animal connection to that of a machine. She feels that using response interfaces based on touch rather than conscious choice as a means for navigation could tap into different emotional responses.

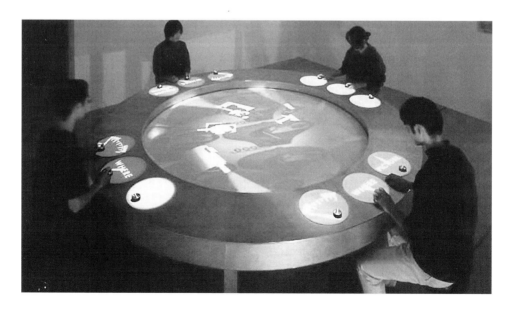

Access

In Germany, Austria, and France, particularly where there has been a long tradition of government support for the arts, the financing of technology and art centers has provided an important level of support up to now . Other residencies have also been available at the Banff Center for the Arts in Canada; the American Film Institute's Advanced Technology Program in Los Angeles; the Center for Art and Media in Karlsruhe, Germany; and the Institute for the Arts at Arizona State University. One of the most advanced is the previously mentioned Center for Media and Art, a technology center which has been able to offer artist-in-residencies to artists to design and produce works with the help of programmers. The Museum houses an art and technology collection but acts primarily as a site for exhibiting new work, which tends to be a mixture of virtual reality, modeling, animation, and interactive installation.

Recent advances in computer chip development point to further miniaturization of equipment, adding to its lightness, reducing its cost, and increasing its more sophisticated possibilities for integration with other electronic media. A question which has long plagued artists using electronic media is whether the aesthetic cutting edge need be tied to high-tech innovation. Without a store of ideas and strength of conviction, the artist can become sub-servient to the control of technological production issues. Crucial to the independence of committed, technologically based artists can be adequate funding grants and access to post-production media technology. This is a major political and economic issue for those who need to innovate and thus take risks as they rethink existing artistic forms and invent new ones (see Chapter 6) "appropriate to the energy of our time."

resources — for further information refer to www.digitalcurrents.com

Figure 5.50. (opposite) Perry Hoberman, *Timetable*, 1999, interactive installation – real-time 3-D rendering engine and sound. Code and interface Assistant, Juha Huuskonen. Produced by NTT Inter Communication Center for the ICC Biennale.

An image is projected from above onto a large circular table. Twelve dials are positioned around its perimeter. The functions of these change and mutate depending on what is projected onto them at any given moment. They can become clocks, gauges, speedometers, switches, steering wheels, etc. The real 3-D scene at the center of the table is controlled and influenced by the movements of the dials. The table represents a giant immersive clock, but, according to Hoberman, could as easily be described as "a board game without rules, a top-level meeting with no agenda, or a séance without spirits. At the end of a century in which all our ideas about time have been shattered and radially reconfigured, *Timetable* is an to attempt to play with concepts of time – to buy time and to spend it, to save time and to waste it, to find time and to lose it, to borrow it, to run out of it, to kill it."

(Postmasters Gallery; Photo: Peter Meretzky)

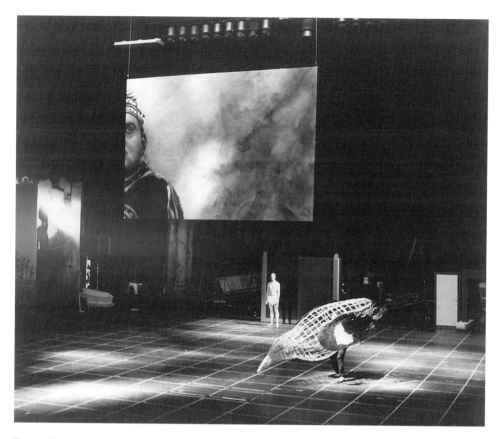

Figure 5.51. John Cage, *Europeras I and II*, 1988, multimedia opera with electronics.

John Cage combines elements of chance, randomness, information, and a fusion of genres in his *Europera*, first performed in Frankfurt in 1987. A combination of opera fragments (no longer protected by copyright), music scores (photocopied at random), singing types (chosen at random from the nineteen styles), arbitrary stage backdrops (chosen from a range of available photographs), and sets moved in random time form the main scene, while a computer program, compiled by chance operations, controls the computer-assisted lighting process, generating 3500 separate cues. Having combined this wealth of disparate elements into a giant collage, Cage proceeds to add elements of his own, including amusing visual jokes and puns interwoven with twelve alternating plots, thus creating a beguiling and entertaining pastiche of cultural productions of the past as a gaming collage for the present.

(Summerfare, International Performing Arts Festival at SUNY Purchase)

Figure 5.52. Robert Wilson, director/designer and Philip Glass, composer, *Monsters of Grace*, 1998, digital opera in three dimensions. Lyrics by Jelaludin Rumi, thirteenth-century Persian poet.

The 70mm computer animated film was viewed stereoscopically through custom-designed polarized glasses. The film was created in collaboration with Diana Walczak, director and Jeff Kleiser. The stage production included live music.

Figure 5.53. Still frame from Robert Wilson and Philip Glass, *Monsters of Grace*, 1998.

The creators of this work described it as a kind of meditation. In extremely slow motion, scenes change and new views become apparent. The imagery is abstract in meaning, yet hyperrealistic in its portrayal of real objects. A severed hand opens its fist and is sliced by a floating blade. A Japanese tea-tray floats in mid-air and turns into television static. A sleeping polar bear is caressed by a child's hand. A helicopter and a bird fly over the Great Wall of China. In a dramatically different scene, multicolored lines move gracefully across the screen like a motion painting. Robert Wilson comments, "the visuals are simply to help us listen to the music." Experienced in opera houses internationally, the work's huge projections created a virtual stage for audiences wearing the special glasses. Jedediah Wheeler, the show's producer, considers that the work is bringing about a new technological means for transporting and presenting major experimental cultural events to new audiences internationally.

(The Byrd Hoffman Foundation)

Figure 5.54. Still frame from Robert Wilson and Philip Glass, *Monsters of Grace*, 1998.

Notes

1 George Legrady, "Image, Language, and Belief in Synthesis," *CAA Art Journal* 49(3) (1991): 267.
2 Throwing a television image out of sync provides a clear example of imagery as coded electronic information, for the screen's colored images break down to reveal multicolored points of light, much like the Impressionist pointillist paintings. In focus, the screen image seems, because of the phenomenon called "persistence of vision" (conventional film images screened at twenty-four frames per second seem continuous) to be stable and real, although the tiny phosphors of the screen are constantly being rescanned and refreshed many times per second as information about light values and color relationships composed of the basic formulations of red, green, and blue light.
3 George Trow, *Infotainment*, catalog (New York: J. Berg Press, 1985), p. 21.
4 Bill Viola, quoted in Gene Youngblood, "A Medium Matures: Video and the Cinematic Enterprise," in *The Second Link: Viewpoints on Video in the Eighties* (Banff, Canada: Walter Phillips Gallery, Banff Center of Fine Arts, 1983), p. 12.
5 Jean Baudrillard, *Selected Writings*, ed. Mark Poster (Stanford: Stanford University Press, 1988), p. 167.
6 Andrew Menard, "Art and the Logic of Computers," *Journal: Art Criticism* 8(2) (1993), SUNY Stonybrook.
7 Ibid., p. 62.
8 1985.
9 Kate Linker, "A Reflection on Postmodernism," *Artforum* (September, 1985): 105.
10 Quoted in ibid., p. 10.
11 Lev Manovich *The Language of New Media* (Cambridge, MA: MIT Press, 2002), p. 237.
12 Ibid., p. 218.
13 From Roland Barthes, S/Z (Paris: Editions du Seuil, 1970), translated by Richard Miller (New York: Hill and Wang, 197).
14 I am indebted to Stephen Wilson's important article copyrighted in 1993 and presented in the 1994 Siggraph catalog, *The Aesthetics and Practice of Designing Interface Computer Events*. Stephen Wilson is Professor of Conceptual Design and Information Art, San Francisco State University. He also adapted his article for a CD-ROM version of the catalog.
15 Cybernetics, a term coined by Norbert Weiner, is defined as "an interdisciplinary science linked with information theory, control systems, automation, artificial intelligence, computer simulated intelligence and information processing."
16 Heuristic: helping to discover or learn, guiding or furthering investigation; designating the educational method in which the student is allowed or encouraged to learn independently.
17 With roots extending as far back as the seventeenth century when mathematicians, philosophers, and scientists such as Pascal and Leibniz began to cope with problems of calculating and storing

information, the digital computer or "all-purpose machine" began its precipitous ascent to its major place in contemporary life. Charles Babbage's proposal for an analytic engine (1830s), Herman Hollerith's electromechanical counting machine (1890s), Alan Turing's paper "On Computable Numbers" (1936), and John Mauchly and Presper Eckert's first programmable room-sized ENIAC computer (1946) are all milestones in the long developmental search for efficient "intelligent" machines. ENIAC filled an entire room and used nineteen thousand vacuum tubes, some of which could be expected to burn out in a given hour. It was capable of making about five thousand calculations a second, although it was wired to carry out only one mathematical task at a time. Mathematician John von Neumann suggested a vitally important improvement in the way instructions could be sent into the machine through the use of electronic signals to approximate the data about mathematical sequences. This "soft" form of electronic signal known as a program, instead of the "hard" form of wiring, came to be known collectively as software.

18 Black-and-white photocopy reproductions of both compositions were shown to a test group of one hundred people. The computer-generated rendition was preferred by fifty-nine of those tested.

19 Quoted in Susan West, "The New Realism," *Science '84* 5 (1984): 31–9 (pp. 36–7).

20 "Fractal geometry describes the irregularities and infinitely rich detail of natural shapes such as mountains and clouds. No matter how many times it is magnified, each part of a fractal object contains the same degree of the detail as the whole. In science, this new geometry feeds into existing theories about randomness and chaos in nature and has important implications in the overall study of the universe. For computer graphics, fractals represent new possibilities for mathematically mimicking the diffuse irregularity of nature. Using the new geometry, an entire mountain range can be rapidly created from just a few numbers, and it will look more realistic than one made of cones or triangles. Fractals are a category of shapes, both mathematical and natural, that have a fractional dimension. That is, instead of having a dimension of one, two, or three, theirs might be 1.5 or 2.25. A line, for instance, has one dimension, and a plane has two, but a fractal curve in the plane has a dimension between one and two. While dimension usually pertains to direction, such as height and width, the fractional part of a fractal's dimension has to do with the way the fractal structure appears under magnification. This is another peculiar characteristic of fractal objects: they contain infinite detail, no matter what scale at which they are viewed. Take, for example, a mountain from half a mile away; a mountain has countless peaks and valleys. From an ant's eye view, a tiny portion of one rocky ledge on that mountain also has countless peaks and valleys" (ibid., pp. 32 and 37).

21 Ibid., p. 32.

22 Ibid., pp. 36–7.

23 Quoted in Grace Glueck, "Portrait of the Artist as a Young Computer," *New York Times*, February 20, 1983.

24 From East Village galleries of Manhattan (International with Monument, the New Math Gallery) to Soho (Metro pictures), to 57th Street (Tibor de Nagy Gallery), to New York Museums (the Whitney, International Center for Photography, the Bronx and Brooklyn Museums), exhibitions included work that began to bear a mature, integrated stamp. At the Musée d'Art Moderne, Paris, the *Electra* exhibition in 1982 linked computer work both to kinetic art tradition and to interactive influences. Two *Artware* exhibitions curated by David Galloway have been exhibited at the Hanover Fair, which brought together European and American artists working in the field. The 1987/8 traveling exhibition *Digital Visions: Computers and Art*, curated by Cynthia Goodman, originated at the Everson Museum in Syracuse and traveled to other museums including the IBM Gallery in New York. It was meant as a survey of works, over the past twenty-five years, by artists who have used the computer either as a direct tool for their work or as an influence. It included work by most of the medium's pioneers, among them Lillian Schwartz, Ken Knowlton, Ed Emshwiller, John Whitney, Charles Csuri, Manfred Mohr, Robert Mallary, and Otto Piene. The show was the largest and most recent of its kind – exhibitions which have served to introduce the computer as a site for art production. By including the work of Andy Warhol, David Hockney, Jennifer Bartlett, Jenny Holzer, Keith Haring, Howard Hodgkin, Les Levine, and Bruce Nauman, proof was established that the computer has entered the studios of mainstream artists.

25 *Siggraph* is the computer graphics special interest group of the Association for Computing Machinery.

26 Quoted by Ben Templin, "Museum of Monitor Art," *Computer Entertainment* (August, 1985): 77–8.
27 Laser copiers now provide the capability of printing on-the-spot, "on demand," entire books from a compact optical disk or from a microfiche the size of a playing card. Justification for this trend comes from savings in traditional printing, inventorying, and monitoring for reorders. Backlist and out-of-print books can be digitized and printed on demand. Many publishers are considering the release of materials in the form of compact DVDs that can store thousands of megabytes of information. Users could then print out the material as needed. Electronic storage systems are of especial importance to libraries already running out of shelf space. Such systems are about to revolutionize not only the printing industry but the dissemination and use of information. (See Chapter 6 for issues of print culture and of the future library on the Internet.)
28 Images can be imported from other files and moved, cropped, reshaped, reduced, and reproduced in different tonal patterns using software designed for text or image manipulation. Black-and-white text can be reviewed, with full color images floating behind the masked holes in the white page, to be positioned for close-ups or details. A variety of typefaces is available in all sizes, including thick and thin, italic, condensed, uppercase, and lowercase. Xerox scientist Robert Gundlach suggests that improved speed and reproduction quality (particularly of laser technologies) is affecting book publishing and seriously challenges the lower-cost conventional offset-litho industry.
29 Quoted in Paul Gardner, "The Electronic Palette," *Art News* 85 (February, 1985): 66–73.
30 The first computer games were developed in 1952 as simulation games by the Rand Defense Lab in Santa Monica, California. That same year, at Bell Labs in New Jersey, a computer was especially designed to play *Hex*, a game without an exact solution. Formula games and dictionary look-up games were developed independently at other labs around the United States and Europe. Owing to their popularity and usefulness, gaming became an enormous force behind rapid development of computer hardware and software, fostering aspects of interactive participation which have by now entered the fine arts.
31 Nancy Burson works with her scientist collaborators Richard Carling and David Kramlich.
32 Every one of the over 54,000 still-frame pictures on a video disk can be assigned a number. This frame number can be coded along with the picture for the disk player to "read." By punching in selected programmed instruction key numbers, the machine will advance to those frames and hold them on pause for viewing and possibly propose textual multiple-choice questions for further selections. The machine would then reverse or advance to another frame, depending on choices made – and further opportunities for decision-making. Images do not lose detail or become grainy because they are computer-enhanced. Laserdiscs are analog, not digital technologies. Thus laserdisc images cannot be manipulated by computer, but they offer higher resolution with more flexible programming than their CD-ROM counterparts. Laserdisc technologies have not gained the same commercial distribution as CD-ROM technologies and are used mostly by artists and image professionals. A number of designers build their CD-ROMs using the popular software package called Macromedia Director. They can have it programmed in C Code, which runs faster.
33 Quoted in Christine Van Assche, "Sonic Process: A New Geography of Sounds," in *Hors Limites*, Centre Georges Pompidou, Paris, 1994: *Out of Actions*, MOCA, Los Angeles, 1998; *Crossing*, Kunsthalle, Vienna, 1998; *Minimalismo*, Centro Reina Sofia, Madrid, 2001; *010101: Art in Technological Times*, SFMOMA, San Francisco, 2001.
34 Artist statement for Lincoln Center Festival, Walter Reade Theater Roy Furman Gallery Exhibition, July 8–28, 2002.
35 Ian Andrews quoted in Nicholas Gebhardt "Can You Hear Me? What is Sound Art?" *Scot Art* in *Sound Site Culture*, http://autonomous.org/soundsite/texts/hear.html).
36 Elie During, "Appropriations: Deaths of the Author in Electronic Music," in *Sonic Process*, ibid.
37 Support for the groundwork development of virtual reality technology originally grew out of a complex of military needs (flight simulators, computer animation, robotic image recognition, ray tracing, texture mapping, motion control), and the video games entertainment industry.
38 I am indebted to Myron Kreuger for this note. Computer-controlled responsive environments date back to the 1969 work by Dan Sandin and Myron Kreuger at the University of Wisconsin around the same time that the PULSA group at Yale led by Patrick Clancy created large-scale outdoor

environments. Aaron Marcus created an interactive symbolic computer graphic environment in the early 1970s. Through a grant from NEA, Dan Sandin, Tom Defanti, and Gary Sayers at the University of Illinois invented the data glove. Mike McGreevey was involved in the original development of the head-mounted display used at NASA. Early development involved the work of many artists, especially musicians Jaron Lanier and Tom Zimmerman.

39 Char Davies, "Changing Space: Virtual Reality as an Arena for Embodied Being" in Randall Packer and Ken Jordan, eds, *Multimedia: From Wagner to Virtual Reality* (New York: Norton, 2001).

40 Quoted in Myron W. Kreuger, "The Artistic Origins of Virtual Reality," *Siggraph Visual Proceedings* (New York: ACM, 1993).

41 Quoted in Barbara Bliss Osborne, "Write on the Money," *The Independent*, January/February, 1994.

42 Prior to her work at Banff, Toni Dove worked with multiple computer-programmed slide projection and video projections controlled by laserdiscs on 3-D scrims. Her performance/installation works included sound and text.

43 Toni Dove, "Theater Without Actors: Immersion and Response in Installation," *Leonardo* 27 (4) (1994): 281–7.

44 Ibid, Toni Dove

6

Art as interactive communications: networking global culture

We shape our tools and thereafter our tools shape us.

Marshall McLuhan, 1984

If the arts are to take a role in shaping and humanizing emerging technological environments, individuals and arts constituencies must begin to imagine at a much larger scale of creativity.

Kit Galloway and Sherrie Rabinowitz

The threat to independence in the late twentieth century from the new electronics could be greater than was colonialism. The new media have the power to penetrate more deeply into a "receiving" culture than any previous manifestation of Western technology.

Edward Said

To engage in telematic communication is to be at once everywhere and nowhere. In this it is subversive. It subverts the idea of authorship bound up within the solitary individual. It subverts the idea of individual ownership of the works of imagination. It replaces the bricks and mortar of institutions of culture and learning with an invisible college and a floating museum the reach of which is always expanding to include the possibilities of mind and new intimations of reality.

Roy Ascott

I am a citizen of the world.

Diogenes

A new system of representation: seizing the future position

In the relatively short period since 1994, technological conditions brought about by the Internet have transformed everyday life with increasing intensity and significance. An entire parallel virtual world has been invented and constructed online for siphoning major (and minor) forms of information directly into homes, businesses, government agencies, and cultural institutions. Such major changes in communications systems foster enormous shifts in societal connectivity.

Writing in the historical context of the 1930s – a time of technological revolution and economic depression with war looming ahead – Walter Benjamin addressed the issues surrounding the relationship between the arts and technology from a vantage point in time that is in some ways reminiscent of our own. His essays[1] in many ways are still feel surprisingly up to date, thanks not only to parallels between mechanical and digital reproduction but also to the historical context, which begged to reconsider possible connections between cultural production and technology. In his essay "The Author as Producer,"[2] Benjamin described the major recasting of artistic forms that were beginning to take place: authorial roles were challenged while social function was emphasized. He urged artists to be aware of the potential of new technologies and to position themselves not only in terms of their responsibility to a wide public but also with regard to their power to create meaningful work that could reverberate within society (although he was also fearful of the fascistic impulse in the use of technology). He posed the questions: What is the relation of a work to the modes of production of its time? What is its position in them? Does it merely supply a system that already exists without changing or transforming it? Benjamin asks those using new technologies to choose a production medium that induces others to participate: "this apparatus is better the more consumers it is able to turn into producers, that is, . . . spectators into collaborators" (p. 222). Benjamin was already aware of the changing distinctions between the author and artist and of the role of participants as producers of potential forms of personal agency.

However, he warned that, if the artists and producers do not fully understand their role in using technology, its very power can possess and enmesh them in conditions they cannot control and that may in turn control them with sophisticated effects. He urged artists to avoid merely aestheticizing a work and making it part of an existing stylistic moment. He asked them to challenge the system and transform it, instead of merely supplying it. He wrote astutely about how technology has transformed art's social function.

There are dangers involved when artists' work is shown on the Web outside traditional contexts for art. Will their works become no more than a series of globally coordinated databases that are not really located anywhere but as interstices between commercials? How will this powerful new medium affect art? Can it be effective as a new art form? How will it be able to find an online audience and provide meaningful cultural experiences? Can we control it?

The Internet as art: issues of content and context

As we have seen, major advances in technology tend to act as breeding grounds for the growth of new forms and to challenge prior paradigms of representation. Forms of photographic and cinematic representation were encompassed by the development of video with its new electronic properties of transmission and feedback. The computer shattered the existing

paradigm of visual representation by converting visual information about reality into digital information about its structure. Digital media can model the visual rather than copying it and allow for interactivity and searchable data-based archives composed of imagery, sound, and text as a new aspect of representation. This interactivity makes it very different from television transmission. While the Internet is a medium like television, because it involves audiences sharing from great distances experiences real or imagined while staring at a glowing monitor, the participatory aspect of the Internet makes it completely different from television. We are experiencing not a computer revolution but rather a communications revolution. The Internet is a new kind of dialogic public space. Without a direction for it, we are moving into uncharted territory which holds great promise but presents great challenges.[3]

As a new form without fixed entry points and narratives, the Internet challenges us to explore fundamental aspects of representation that have acquired new meaning and significance such as content and context. While, up to now, we have understood how context can change the meaning of an art work, the Web creates extremely different conditions where the two are interchangeable.

What is content? It is usually the subject matter of an art work chosen by the artist and takes the form of still or moving images, texts, forms, colors, sound. Works can be made up of different segments of data instead of traditional forms. (There are many possibilities for giving data visual form.) Content is also what the art work means – what the viewer takes away from the encounter with the art work. Good art affects consciousness as well as the unconscious – the content of an art work is not just its contents. Its meaning lies in the tension created between form and subject matter.[4]

On the Internet, context is intimately connected to content. The dynamics of the Web bring information elements along different routes from different sources which are combined only when the participant activates the screen. Display commands are connected to the structured programmed code of the site which is made available through a local server connected in the context of a globally reachable territory .

Contexts for viewing art works can be thought of generally as locations chosen by artists or art institutions from indoor to outdoor spaces. But on the Web, an inherent dis-location takes place, where ideas of context take on different character and meaning which influence a work. Through means of transferral and transmission, context can also become its content.

Figure 6.1. (opposite) Rafael Lozano-Hemmer, *Vectorial Elevation, Relational Architecture 4*, 1999–2002, eighteen robotic xenon searchlights controlled over the Internet. 3-D Java interface.

The historic center of Mexico City, the most populous city in the world, was transformed through the use of xenon arc robotic searchlights controlled over the Internet. By ensuring that public participation was an integral part of this large-scale interactive installation, the artist attempted to establish new creative relationships between control technologies, urban landscapes, and both a local and a remote public. Visitors to the project website could design ephemeral light structures which played out over the National Palace, City Hall, the Cathedral, and the Templo Mayor Aztec ruins. These could be seen from a ten-mile radius and were rendered in the numbered sequence of their creation on the Internet. Every six seconds the searchlights would automatically re-orient themselves and three webcams would document a participant's design. These were archived with commentaries, information, and photos of their design. An e-mail message confirmed for each participant when their archive page was completed.

(Rafael Lozano-Hemmer; Photo: Martin Vargas)

Figure 6.2. *Blinkenlights*, October, 2002, representation of Einstein created through soft-code computer and website display. Illumination of windows in the Bibliothèque François Mitterand, Paris.

A collaborative European intercity project, *Blinkenlights* attracted the attention of thousands of participants when it began in Berlin in 2001 with the installation of 144 lights behind the windows in the upper eight floors of the Haus des Lehrers, at Alexanderplatz. A computer controlled each of the lamps independently to produce a monochrome matrix of 18 × 8 pixels. An interactive aspect of the work allowed viewers to participate in creating new images and text in the matrix using their mobile phones. A Blinkenpaint program was developed and made available to the public, enabling viewers to create their own animations.

(Blinkenlights)

The Web is organized in terms of servers and code languages where its browsers, information archives, databases, search engines, and connection to servers are the major elements of its territory. Artists experimenting with these elements challenge the potential of the new medium in different ways.

Without a browser, for example, conventional ones such as Explorer or Netscape, one is unable to tap into the data space and connectivity of the virtual world to locate particular archives of data which could be in the form of sound, text, and image formulations of all kinds. The browser, connected to the local server, provides the means to easily connect the vast data pool of the web along different paths. The directions on these paths chosen by Web users form a dynamic route, one which is infinitely repeatable by the computer. This process of reconfiguring can be thought of as a form of *mapping*.

Development of networked art forms has dynamic distinguishing features that place them in a different category to other digital forms. These networked forms exploit the potential of

database systems using hypertext linkages, mapping (as in the works of Mark Napier and Mary Flanagan), and other forms of connectivity which bring us in turn to new forms of agency and context creation. They rely on multi-user input from thousands of different contexts and can react to real-time data transmission. By now, the category we call Web art or Net art

Figure 6.3. Scott Paterson and Marina Zurkow, *PD Pal*, 2002, mixed-media installation object with PD. Created in collaboration with Julian Bleecker.

The goal of *PD Pal* is to use mobile and networked platforms as a mediating and recording device that reactivates our everyday actions, transforming them into a dynamic portrait of our urban experience: a way of "writing our own cities." At the core of the *PD Pal* application is an "Urban Park Ranger" (UPR), an individual software persona who, once downloaded into a PDA, encourages the owner to log his or her momentary experiences, actions, proximities, and perceptual phenomena in iconic broad strokes as she moves about the environment. The UPR helps to create personal and idiosyncratic maps of our "temporary Personal Urbanisms." *PD Pal* provides the tools to create maps as place-based memory shells or to stand as a narrative shorthand – marking personal intervals of place and experience, which can later be uploaded to a central website and shared as a made-up city of individuals who share a subjective and poetic language in ways that can render the visible and invisible.

(Scott Paterson and Marina Zurkow)

acts as a way of referring to a broad set of art forms. There are tele-presence and tele-robotics works that focus on connectivity between remote sites or allow manipulation of these through robotic devices (as in the work of Adrianne Wortzel; Emily Hartzell and Nina Sobell). There are time-based projects that are performed within a certain period but which can be experienced globally (Marek Walczak and Helen Thorington). There are hypertext experiments consisting of text segments threaded together electronically which allow users to choose from many different routes (Yael Kanarek), allowing for experiments in non-linear narrative. Online activism ('hacktivism' – Alex Galloway's *Carnivore*) consists of projects which allow for intervention to exploit the Net as a means for instant distribution and "cloning" of data that can be used as a way of questioning corporate or political structures or as a support for special groups. Other projects rewrite or subvert the usual conventions of major browser systems such as Netscape or Explorer (e.g., Mark Napier's *Riot*) or create totally new browsers. Software as coded art forms (Robert Nideffer) can also be considered as part of Net art because it can be distributed over the Web from a single user's computer.

An online exhibition, Codedoc,[5] curated by Christiane Paul, the Whitney Museum's curator of new media, presented as art the underlying computer code languages used to create digital works of all kinds – the secrets of its creative digital production. Instead of seeing the final work in visual form, viewers were provided with only a work's programmed animated lines or the logic of its interactive elements.

Art as interactive dialogue

Technological dynamics set in motion through mechanisms of the Internet shatter the paradigm of communication of a traditional art work's construction of meaning – active dialogue. Traditional forms of art have always created a desire or interest to participate in negotiating the meaning that a work communicates. The experience of the traditional art object is in the transposition from the look of the eye to the eye of the mind. A dialogic process where meaning is negotiated occurs between the viewer and the art work. All arts can be called participatory if we consider this viewing and interpreting of a work as a means for reaching understanding as part of a communicative dialogue. In interactive digital works, however, the interface meeting point between art work and viewer becomes an interplay between form and dialogue similar to that which Bakhtin located in literature – "stratified, constantly changing systems made up of sub-genres, dialects, and almost infinitely fragmented languages in battle with each other." Such systems, with their inherent contradictions, are a force for forging new unpredictability in aesthetic territory, in a process Bakhtin termed the dialogic imagination.[6] Since digital media are often literally dialogic (as opposed to a dialogue that configures itself as a mental event), the position of "making" and the relations between artist and audience are altered, their roles and identities changed, and perhaps temporarily exchanged.

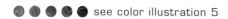 see color illustration 5

The premise of display and of representation as we know it has been deeply challenged. This new medium of art as communication matters because it defines an arena of consciousness and feeling. It leads to forms of agency and forms of shared authorship and social exchange. It allows for freedom to create change or to act as a proxy for someone else. It

is deepening the challenge to artists struggling to connect visible to invisible, to create works of independent witness, and to articulate meaningful responses to contemporary life.

The global network as a highway, a web, a system of plateaus

"Information Super Highway" (often called the "Eye-Way" or "I-Way") was one of the first potent metaphors for this global database network.[7] It was thought of as a massive online road system complete with freeways, feeders, and local routes accessed anywhere. The access is through computers connected at each intersection, and capable of transferring information from country to country through telephone modems.[8] Another metaphor for the Net, described by Michael Benedickt in his book *Cyberspace*, is more organic:

> From vast databases that constitute the culture's deposited wealth, every document is available, every recording is playable, and every picture is viewable . . . The realm of pure information, filling like a lake, siphoning the jangle of messages transfiguring the physical world, decontaminating the natural and urban landscapes, redeeming them . . . from all the inefficiencies, pollution (chemical and informational) and corruption attendant to the process of moving information attached to *things*.

By now, the metaphor of a network or web has evolved as the infrastructure – the paths, interconnections, and points of intersection where telematic[9] communication takes place. A network is a phenomenon which links together a wide range of disparate entities. It has no sides, no top or bottom. Rather, it is many connections that increase interaction between all its components. It is open-ended and non-confining with no beginning and no end.

Participatory systems such as the Internet replace conceptual systems founded upon ideas of center, margin, hierarchy, and linearity. The metaphor of a web replaces these systems with those of nodes, links, paths, networks. Roland Barthes speaks about the interactive nature of networks and their lack of hierarchy as a metaphor for the postmodern. Access is through several entrances without any one being more important than another (much like television). It has no beginning. It is conceived of as a series of networks and links. It is never closed, and is based "in a system of references to other books, other texts, other sentences. It is a node within a network . . . [a] network of references."[10] Barthes's description of intertextuality in "From Work to Text" embodies the concept that a text is like a woven fabric. It is not only a coexistence of meanings but also a passage, an overcrossing. Thus it answers not to an interpretation, even a liberal one, but to an explosion, a dissemination of meaning "in which every text is held, it itself being the text between another text." Knowledge no longer exists in fixed canons or texts with epistemological boundaries between disciplines but rather it exists as paths of inquiry seeking integration and meaning by passing through them without any precise limit or location (see Chapter 5).

The writings of Deleuze and Guattari in *A Thousand Plateaus*[11] also suggest to us something that resembles the Web – a map system of "plateaus" rising from an unlimited plane where one is passing from one articulated point to another in a series of connections which are the opposite of fixed coordinates. Their orientation lies away from the commonsense logic of Kant but toward seeking and finding unforeseen directions. Theirs is a map of data flows as agency

Figure 6.4. W. Bradford Paley, *Text Arc*, 2002/3, textarc.org, online Java Program. The entire text of *Alice in Wonderland* in a single, interactive frame.

Text Arc is a visual representation of an entire text on a single page created through computer processing but used interactively as a tool to aid in the discovery of patterns and concepts which can be further leveraged by human visual processing. *Text Arc* reveals word associations, distribution, and frequency within a text. It exposes the nature and style of a document's content, not by algorithmic winnowing but by arranging and showing every word. It taps into the ability we all have of pre-attentively reading and associating words at a much greater rate than we consciously read. The eye and mind scan for ideas, then follow the ideas down to where and how they appear in the text. *Text Arc* represents the text as two concentric spirals on the screen: each line of text is drawn around the outside in a tiny one-pixel font, starting at the top; then each word is drawn in a more readable size. Frequently used words stand out from the background more intensely. Key characters such as Alice, King, Queen, and Gryphon stand out, as do other words evocative of the story: *poor, dear, door,* and *little*. One can click on these words to find their associative lines in those located in the surrounding text spiral.

(W. Bradford Paley)

"meant for those who want to *DO* something with respect to new uncommon forces, which we don't quite yet grasp, who have a certain taste for the unknown, for what is not already determined by history or society."[12]

Insights such as those of Barthes and Deleuze and Guattari reflect the instability of the times where there is a blurring of boundaries due to the "electric shocks" we are experiencing in every field. Such systems are emblems of a "globalized" postmodern world that we experience as very real dislocations and disruptions of real people and whole communities.

Networks for Planetary Artmaking

Works that fully make use of the Net as a medium are interactive dynamic forms which are incomplete without some form of participation by others. Such works change the role of the artist to one who creates a conceptual structure which evolves and generates itself over time, one in which participants may submit contributions which can be reviewed and commented on by others as forms of agency for a wide public – art that provides community and social critique. Often, to produce such works, the artist in the end will need to become an inventor and adventurer in collaboration with many others, including programmers, scientists, designers, and musicians, to create new forms of experience.

There is as yet no common interpretative ground for an analysis of these because they usually employ a complex array of visible and invisible technologies such as software and other programmed aspects which can result in works all the way from environmental installations using sound and motion detectors to networked projects. The Net allows space for responsive forms to develop that open up fresh directions in the articulation of space and time. These affect identity, agency, and consciousness through the creation of new symbolic orders and metaphors. A limitation of much of the work on the Net is that it is seen as flattened images as a result of being viewed on monitors. However, a new breed of small projectors is making possible more interesting spatial displays of all kinds.

Beginnings

Without a known direction, over the years, especially from 1977 onwards, artists with a utopian concept of a global culture have pioneered telecommunication arts through collaborations between North and South American and European cities to create interactive telecommunications activity in the arts, using, at first, videophone technology and long-distance "telematique" transmission of computerized information.

Early excitement and visionary hope about art and communication technologies from every field parallels that of early video, which also attracted interdisciplinary usage by performance artists, visual artists, and filmmakers. However, unlike video, which never achieved the vision of many artists to reach a mass media public for their work, the immediacy and interactivity of new media intersect with the potential of a networked audience where the public transmission access restrictions endured by video do not apply.

Roy Ascott, one of the earliest pioneers of "telematics," spoke of early global interactive communities as "a set of behaviors, ideas, media, values and objectives that is significantly unlike those that have shaped society since the Enlightenment. Whole new cultural configurations will bring about change in art practice, forcing new strategies and theories for art; creating new forms of display and accessibility; and developing new networks where exchange and learning can take place." His point is that "meaning is created out of interaction between people rather than being 'something' that is sent from one to another." Communication depends not on what is transmitted but "what happens to the person who receives it. And this is a very different matter from 'transmitting' information."[13] There is a difference between information and experience. He calls attention to what seems to him a now obsolete distinction between artist and viewer and calls for a composite construction where viewers are participants in an inclusive system for creating meaning. For him, Art = Communication.

Figure 6.5. Roy Ascott, *View of the Laboratory Ubiqua,* planetary networking and computer mediated systems. Venice Biennale, 1986.

Based on the principle that each computer interface is an aspect of the unity of all the others which are connected to it in a network, Ascott coined the term *holomatic* to describe the phenomenon. Data exchanged through any network access point is equally and simultaneously held in the memory of the entire network. It can be accessed through cable or satellite links globally from anywhere, any time. A wide range of telematic media was used, including e-mail, videotex, slow-scan television, and computer conferencing. This holomatic principle was well demonstrated by the "Planetary Network" project during the Biennale where the flow of creative data generated by the interaction of artists networking all over the world was accessible everywhere, not only in the rarefied elite atmosphere of the exhibition site itself. *Ubiqua* opened up the idea of the immediacy of global exchange in the arts.

(Roy Ascott)

Figure 6.6. (opposite) Roy Ascott, *Organe et Fonction d'Alice au Pays des Merveilles,* 1985, videotex from the *Les Immatériaux* exhibition, Centre Georges Pompidou, Paris.

La Plissure du Text was a creative action of "dispersed authorship," a fairy tale based on Lewis Carroll's *Alice in Wonderland.* It involved a network of orthodox computers and keyboards. The many participants on the line throughout America, Europe, and Australia (both artists and public) became involved in the layering of texts based on the original concept of Alice in a strange new world and in the semantic ambiguities, delights, and surprises that can be generated by an interactive authorship dispersed throughout so many cultures in so many remote parts of the world. The text was projected by a data projector, dramatizing the presence of the project – a demonstration of the "immaterial" concept of the exhibition (see Chapter 5).

(Roy Ascott)

One of the most compelling early art projects on the Net was *La Plissure du Texte: A Planetary Fairy Tale* conceived by Ascott as a homage to Roland Barthes's *Le Plaisir du Texte*, as a project for the Electra exhibition at the Musée d'Art Moderne in Paris in 1983. It was designed as a way of involving groups of artists located in eleven cities around the world[14] in the creation of a transmitted text. "Each group represented an archetypal fairy tale role or character: Trickster, Wicked Witch, Princess, Wise Old Man, and so on."[15] The story unfolded as the group typed in text at terminals (located in public places), from the point of view of their assigned roles. Each day, the theme would be addressed as it developed from previous entries. Because each computer terminal was linked to data projectors located in the same space with the audience at the museum or gallery, the text could be seen and read. The public was able to contribute to the fairy tale through keyboards available at different locations. "Many layers of meaning from such diverse sources became embedded in the text; a feast of cultural allusions, puns, flights of imagination and political criticism in an unpredictably meandering and branching story line were pleated together for this *Plissure du Texte*. Often the text was ingeniously manipulated to create simple visual images as well."[16]

In another large Internet project for the 1986 *Art, Technology and Computer Science* section of the Venice Biennale, Ascott acted as one of four curators, together with Don Foresta, Tom Sherman, and Tomaso Trini, who were appointed as International Commissioners. The project included over one hundred artists dispersed throughout three continents. Organized through an extensive electronic mail network, the project used a digital laboratory, *Ubiqua*, which included interactive video disk works, personal computers with paint systems, and cybernetically controlled interactive electronic structures and environments. The interaction of artists generating a flow of creative work from all over the world had the effect of releasing the exhibition from its rather rarefied and elite domain in Venice by contextualizing it in a wider sphere.

In the best sense, these projects reflect a playful and open attitude to negotiate interactively with other minds and sensibilities through a process of participating in a diverse intertextual play of different personal, social, and geographical concerns.

Precursors: the image as place

It is difficult to imagine now, as we easily tune into the World Wide Web, the enormous difficulties faced by the early communications pioneers. They were committed to the role that artists have to play in the use of telecommunications technology – "so that we don't just end up as consumers of it." Since 1975, collaborative artists Kit Galloway and Sherrie Rabinowitz have focused on researching, exploring, experimenting, and developing alternative structures for video and television as an interactive communications form. As early as 1973, Galloway became interested in live television and its real-time technology as a communications system which could support live performance and conversations between sites internationally. Performances between artists in different countries took place in a special composite-image space he had invented. Live images from remote locations could be mixed at each receiving location so that performers could be seen on the same screen with their partners dancing together in "virtual" space. This is an exploitation of the phenomenon of the power of communication technologies to be able to mix spaces or exchange spaces.

Figure 6.7. Sherrie Rabinowitz and Kit Galloway, *Satellite Arts Project: A Space with No Geographical Boundaries.* 1977, virtual space. The world's first interactive composite-image satellite dance performance.

The dancer on the far right, Mitsouko Mitsueda, was at NASA Goddard Space Flight Center in Maryland, and dancers Keija Kimura and Soto Hoffman were in Menlo Park, California. Their electronically composed image appeared on monitors around them. Through the live image, they could see, hear, and appear to touch each other.

(Sherrie Rabinowitz and Kit Galloway)

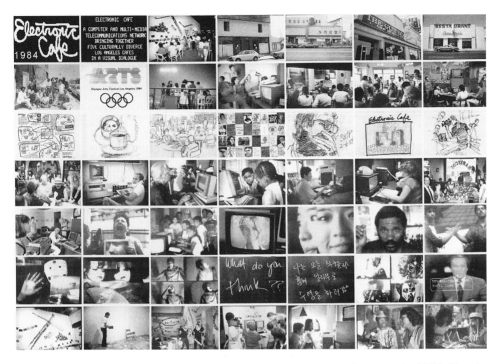

Figure 6.8. Sherrie Rabinowitz and Kit Galloway, *Electronic Cafe Network 1984 Mosaic,* 1984–2003, various media images from the Electronic Cafe project, www.ecafe.com.

As pioneers of the Electronic Cafe idea, Rabinowitz and Galloway have by now created a unique international network of multimedia telecommunications venues with over forty affiliates around the globe. They continue to be vitally involved in developing multicultural community projects and are researching the aesthetics and functioning of real-time networked collaborative multimedia environments.

[Sherrie Rabinowitz and Kit Galloway]

> The video image becomes the real architecture for the performance because the image is a place. It's a real place and your image is your ambassador, and your two ambassadors meet in the image. If you have a split screen, that defines the kind of relationships that can take place. If you have an image mix or key, other relationships are possible. So it incorporates all the video effects that are used in traditional video art, but it's a live place. It becomes visual architecture.[17]

Together, these pioneers created major projects over the years, including the Electronic Cafe concept which began in 1984. and has operated internationally out of sites in Europe, the United States, and Asia. For the 1984 Olympic Arts Festival, the group designed a project based on "the concept of a new electronic museum, a way to link people, places, and art works in an electronic environment."[18] The Museum of Contemporary Art in Los Angeles officially commissioned Electronic Cafe to link MOCA and five ethnically diverse communities of Los Angeles through a state-of-the-art telecommunications computer database and dial-up image bank designed as a cross-cultural, multilingual network of "creative conversation."

From MOCA downtown, and the real cafes located in the Korean, Hispanic, Black, and beach communities of Los Angeles, people separated by distance could draw or write together.

By 1989, the Electronic Cafe had opened a global-scale multimedia teleconferencing facility in Santa Monica, California. This project supported artists' networking but did not feature an ongoing online network. Instead, in a cafe cabaret setting, it promoted interactive events such as tele-poetry, tele-theater, tele-dance in exchanges between artists in more than sixty locations worldwide[19] using video, fax, audio, e-mail, and computer-driven telecommunication technologies. These have by now been widely adopted by commercial interests. Now webcam software and streaming video allow for the immediacy of video capture on the World Wide Web from real-time performance.

The technology of the Electronic Cafe is configured "to build a context in which artists could experience new ways of collaboration and co-creation, with geography no longer a boundary." Dance, music, and Performance art proved to be popular forms being beyond the need for language or translation. Video teleconferencing equipment transmits near-television-quality audio and video with little time lapse. The more low-tech videophone line provides small black-and-white images that move slowly every three seconds.

Live television as global disco

Live via satellite from New York, Paris, and San Francisco in 1984, Nam June Paik's interactive television broadcast *Good Morning Mr. Orwell* was seen throughout the North American continent, Europe, Japan, and Korea as a form of what he termed "global disco." The piece, a collaboration of many artists and broadcast facilities, was meant to refute the "Big Brother Is Watching You" auguries made famous by George Orwell's *Nineteen Eighty-Four* as they relate to media. Paik explains: "Orwell only emphasized the negative part, the one-way communication. I see video not as a dictatorial medium, but as a liberating one. That's what this show is about, to be a symbol for how satellite television can cross international borders and bridge enormous cultural gaps . . . the best way to safeguard against the world of Orwell is to make this medium interactive so it can represent the spirit of democracy, not dictatorship."[20] After a three-year process of assembling the necessary international funding and sponsors, Paik masterminded a complex program that mixed diverse aesthetics – Pop and the avant-garde, superstars of rock-and-roll, comedy, avant-garde music and art, Performance artists, Surrealism, dance, poetry, and sculpture. John Cage played amplified cacti, Laurie Anderson presented her new music video, Charlotte Moorman performed on Paik's television cello, surrealist painter Salvador Dalí read poetry, and French pop star Sappho sang "television will eat our brains." Host George Plimpton presided over the array of global interactive events with all the aplomb of an avant-garde Ed Sullivan despite technical hitches due to the show's "live" international satellite format.[21]

Paik's decision to create a live interactive broadcast which challenged technological structures derives not only from his knowledge of the medium and what it represents but also from his usual risk-taking sense of fun. "Live TV is the mystery of meeting onceness." Paik's excitement about global satellite communications as real-time live international performance is found also in works by other pioneers such as Douglas Davis[22] and Don Foresta, who have used real-time television broadcast systems as a locus for their work.

Art = Communication

Creative networking involves explorations of community-building, cross-pollination of user interaction in the virtual space of the Internet, and the building of links between communities previously unable to communicate with each other because of language or other difference. Telematic art can create "operative new realities. Its meaning lies not in what it is (identity or objectification), but what it effects or what it does."[23]

The Art Com Electronic Network (ACEN), originally conceived by Carl Eugene Loeffler and Fred Truck,[24] evolved as a communications network in the years 1986–90. Based originally in the imperatives of the magazine *Art Com*,[25] it gradually "evolved through the process of investigating the constructs and geographies of a working system of communications media defined by its users and the scope of its distribution axis." ACEN became an ongoing organic process of creating cultural formation with the emphasis on participation. "Art = Communication." To the extent that technological tools can generate a more participatory culture, through, for example, shared storytelling and community-building, these processes can engage the collective imagination.

In this collaborative work, technology is used to question the nature of communication between species: interaction between a plant and a bird is presented as a dialogue which is as unpredictable as human communications are. A canary in a tall white cage located in Kac's installation at the Center for Contemporary Art in Kentucky sings in response to the electrical fields of a plant which have been converted to sound at the Science Center in New York. The bird's response is transmitted back as electrical fields that the plant can sense. Just by standing next to the plant and the bird, humans immediately altered their behavior and began a new round of interaction. The piece about an isolated caged bird having a telematic conversation with another species acts as a vivid metaphor for the role of telecommunications in our own lives.

(Eduardo Kac)

Figure 6.9. Eduardo Kac and Ikuo Nakamura, *Essay Concerning Human Understanding*, 1994, interspecies telematic interactive installation.

Figure 6.10. Eduardo Kac and Ikuo Nakamura, 1994, *Essay Concerning Human Understanding*, interspecies telematic interactive installation.

Attaining meaningfulness in an interactive work is "tied to the ability to change a work or add to it in some way." An interactive work adds a new dimension to the process of providing agency for collective communities and shifts the role of the artist to that of one who creates the framework and tools for interactive dialogue. In a community-based work, meaning is often constructed through a retrieval of data that can be indexed, translated, and categorized according to the diverse perspectives of participants who contribute to the project.

Dialogue in cyberspace as art

Prior use of communication technologies by artists from the 1970s to the 1990s created an amalgam of new forms. These included videophone, satellite transmissions, mail and fax projects, interactive computer and video works, and virtual reality projects.[26] Such experiments in the use of communication media led to opportunities for dialogue where work can be shared in a larger cross-cultural community than through the confines of the gallery and museum system. In 1984, an international project called *Electronically Yours* was undertaken by CAT (Collective Art × Technology).[27] Artists' images were networked back and forth by fax between Morocco, Vienna, Toronto, San Francisco, and Japan. Receivers would add to the

textual messages or images and send them on. Fax provided an immediacy that Mail art, its predecessor, could never provide. Now however, the open system of communications on the Net goes much further in immediacy and participation – providing, besides the possibility of e-mail and teleconferencing, vast online flows of data archives and streaming video. Art works based on the potential of these new media are new forms of representation and require new names and categories. These works raise new questions about how much the public wants to participate in the immediacy of these works. Do they provide access to personal issues or are they forms of entertainment?

In the creation of a dynamic dialogic work, the artist tends to become a mediatory agent. The openness to play in a work essentially depends on the grounds for communication that are constructed and on the boundaries and poetics of control established through interfaces and navigation structures. Navigation and process, as well as creation of meaning in an environment without fixed entry points and hierarchies, are amongst the issues that challenge traditional ideas about art.

Figure 6.11. Paul Sermon, *Telematic Dreaming*, 1992, interactive telecommunications.

Interested in the process of human transcendance between the technology and media that is taking place, Sermon's work reflects the transition to the visual. In 1992, he discovered that a live body projection on the surface of a real bed five hundred miles away could demonstrate an alarmingly accurate out-of-body telepresence experience. It is the reality of the bed space that bestows the projection on the bed with what Sermon calls the sense of *Telematic Dreaming*. In this work, Sermon exploits the bed as a heavily loaded object, rich in metaphor, meaning, fantasy, and dream – a psychologically complex object. Cameras at two locations point at two different beds and the two participants lying on them, generating live video feeds that are then mixed and projected on each bed surface next to the participant at each location. Sermon's exploitation of such a culturally loaded subject completely transcends the lowly technology of teleconferencing which is the basis for the transmissions.

(Paul Sermon)

Figure 6.12. Paul Sermon, *Telematic Vision*, 1992, interactive telematic installation.

In a similar vein, Sermon links two sites via video cameras located where two identical sofas allow for interactive participation. A participant at each location can sit on the sofa (at one site on the right, at the other, on the left) while their live images appear projected at either location on the real sofa via monitors in front of or beside both sofas. This kind of intimate site, a couch, or a bed, is what creates endless opportunities for viewers to interact by moving close, shaking hands, cuddling, or employing other forms of interperonal communication with someone who exists only as a projection or on a screen. Attracting lively attention wherever the works are sited, with line-ups of people who want to "play," the work raises the question of whether there is a boundary between art and techno-entertainment.

(Paul Sermon)

Because new media art inhabits the shifting relations between context and content, interactive work travels with the viewer rather than the viewer to the art work. In their travels their generative potential for creating meaning multiplies and is diversified. John Berger comments:

> When, via the internet, an art work enters the context of one's home surrounded by the accoutrements of one's life – its wallpaper, furnishings, mementoes – it becomes one's talking point. It lends its meaning to one's meaning. At the same time it enters a million other houses and in each of them, is seen in a different context.

If a work is an open source work,[28] the very actions of participants may alter it in myriad ways or may add to a community of voices which is generating on site. "Open system" art works lead to agency, a place where negotiation takes place as a form of shared authorship and

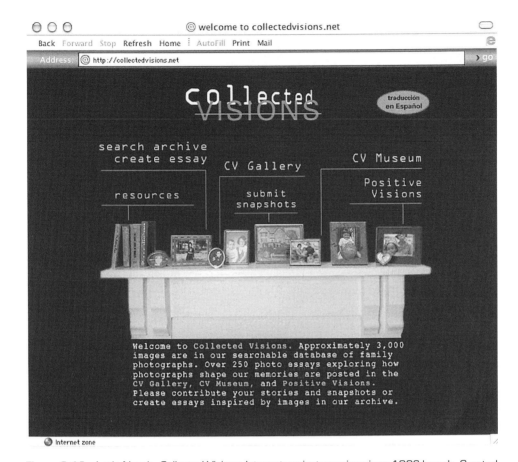

Figure 6.13. Lorie Novak, *Collected Visions*, Internet project ongoing since 1996 launch. Created in collaboration with Clilly Castiglia, Betsey Kershaw, and Kerry O'Neill.

The concept for *Collected Visions* grew out of Lorie Novak's use of family snapshots and images from the media to explore the relationships between personal and collective memory. She is interested in how memory is shaped. The site provides the ability for a wide public to submit images to its growing archive of family photographs and to create photo stories by searching the large archive for images that trigger creative concepts. Tools for writing, designing, and submitting essays are provided onsite. These can be shared and viewed online along with photographic submissions in the site's Gallery and Museum areas.

(Lorie Novak).

social exchange. Agency is a fundamentally important aspect of the new medium of the Internet because it fosters one's power to participate in a web of connected communities without parallel.

Web works that are designed as comprehensive systems for engaging contributors dynamically evolve and respond through their collaboration. Such community-based projects utilize processes of exchange, learning, and adaptation and are built on the premise that meaning in a work of art is dependent on dialogue between individuals and groups. These systems provide a context for participants to reflect their personal understandings about their own social and political narratives as an aspect of social memory. The Internet becomes

Figure 6.14. Yael Kanarek, *World of Awe*, 1995 ongoing, varied web and installation project.

At the core of this interdisciplinary project is an original narrative in the form of a journal which uses the ancient genre of the traveler's tale to explore the connections between storytelling, travel, memory, and technology. The imaginary journal was found on a laptop built by a traveler in the search for lost treasure. The narrator's determination to find the treasure meets his or her nostalgia for imagined technology and a longing for a loved one left behind. Included in the journal are twenty-one love letters, three travel logs, and three unique navigation tools. The site also features a "Love Letters Delivery System" and "Nowheres," a series of renderings of the territory being explored. In *World of Awe*, a personal worldview is transformed into a shared narrative which gradually indicates to us the way we construct our own realities through the filter of technologies.

[Yael Kanarek]

a form of collective social consciousness. Such sites are a reflection on the ways new media are influencing and changing notions of the individual in a social context.

Fantasy as part of representation

Communication on the Net allows the participant to be invisible, anonymous. Because at this time it is primarily a text-based medium, a psychological level of imagination and fantasy is released. In a sense, *fantasy becomes part of representation*. Some feel that the Internet acts as a mirror where incarnated bodies float as avatars of other kinds of beings. Anonymity

Figure 6.15. Nomeda and Gediminas Urbonas, *Transaction*, ongoing since 2000, collaborative online project including film archives, video projections, sign system, www.transaction.lt.

The concept of the *Transaction* project is based on the pattern of the dramatic triangle of victim, persecutor, and rescuer, taken from transaction analysis. The object of its research is female representation in media images and its impact on the social behaviour of women. The structure is a three-way dialogue between Lithuanian feminist intellectuals introducing female scripts and commentary about the "life scripts of victims" in Lithuanian films (from a 1947–97 archive). *Transaction* provides theoretical insight and a platform for communication and an interface for arranging and rearranging its spatial narratives through using the tools of web design.

[Nomeda and Gediminas Urbonas]

becomes a powerful opportunity – for the Internet makes possible a special kind of interaction and experimentation in which, since we can't see others, we are forced to form a picture of them based on limited information. For example, a man threatened by the reality he inhabits may want to see what it's like to portray himself as a woman – old, young, black, white, or yellow. What kind of responses would he receive from other males (or females) as a method of expanding his understanding through such role playing and acting?

In *Life on the Screen: Identity in the Age of the Internet*, sociologist Sherry Turkle commented that experiences on the Internet can be understood only in the context of the "eroding boundaries between the real and the virtual, the animate and the inanimate, the unitary and the multiple self." She comments on the fundamental shifts in the way we experience development of our identities. Could these experiences be a flight from the body?

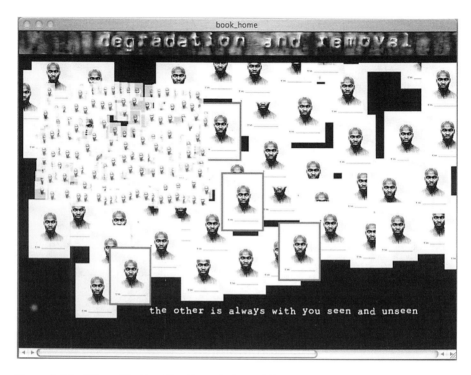

Figure 6.16. Wayne Dunkley, *The Degradation and Removal of the/a Black Male*, 2000/1, Web project.

Sharemyworld.net provides a Web-based context where people can express how racism has affected their lives. Though the project begins with the author's own experiences in the form of stories and images, it soon broadens to consider racism as an element of the human condition. Viewers' stories are combined with photographs to foster an online community of storytelling with respect to the issue of racism. The experience of reading these stories shepherds one through feelings of guilt or anger toward a place where participants can reflect on their role in the presence of racism.

(Wayne Dunkley)

For in our connection to the real-time communities of cyberspace "we are dwellers on the threshold between the real and the virtual, unsure of our footing, inventing ourselves as we go along."[29]

This deeply psychological interactive medium is now unleashed through links to uncalculated millions of possible participants. Fulfilling personal fantasies has led to phenomenal growth of the online sex and pornography industries as well as the evolution of online dating services. The kinds of relationships (or non-relationships) growing out of this kind of connection are openly changing social attitudes. Like the growth of other aspects of intimate personal agency linked to the Web, no one can yet gauge the undefined cultural implications. Understanding cyberspace is a factor for understanding the inner space of identity as much as outer space.

CyberSpeare, a pioneering hypermedia adaptation of Shakespeare's *Midsummer Night's Dream*, produced by Marah Rosenberg and Hal Eagar, was an early multimedia performance which took place over the Internet in 1995. Out of their discussion about the increasing popularity of electronic escapism on the Internet, they made the connection to Shakespeare's

play about the escape of urbanites to build a fantasy world in "The Woods" (which, in their production, became cyberspace). The individual players created their own electronic identity or Cyber Egos as a "Home Page" designed as a personification of their character in the play. The pages also represent their needs, wants, and desires as fulfilled by technology in an electronic universe. The concept of the project was to connect the audience as interactive participants via technology in the unfolding of the play. It took advantage of the hypermedia version of the play just as the audience would participate in Shakespeare's day. It took advantage of the actors' familiarity with the Internet's Relay Chatline (IRC) as well as their personal experience with technology to develop the rules and the script. The play was presented as both live performance and as "Home Page" sites in a computer laboratory. "Home Page" files on each of the characters could be opened for the exploration of a range of background material about each one as the actor performed amongst the audience. The live computer performance was videotaped using Cu-See-Me[30] software for uplink to the Internet.

A further example of live imagery being uplinked to the Web is a telerobotics piece *Alice Sat Here*, a pioneering 1995 project by Emily Hartzell and Nina Sobell in conjunction with computer scientists and engineers from NYU's Center for Digital Multimedia. The goal of the piece is to route what a telerobotic videocam "eye" directly sees to a page on the Internet. This "in effect" turns the Web inside out to create a real physical 3-D space which Web-users

Figure 6.17. Emily Hartzell and Nina Sobell, *Alice Sat Here*, 1995, detail.

Parked at the gallery entrance, a wheeled "throne" with its telerobotic webcam mounted on a pole and its closed-circuit monitor mounted on the handlebars is available for gallery visitors who navigate through space directed by "virtual" participants online or by passersby touching pads in the front window. They may use it to ride either through the exhibition or into nearby streets.

[Emily Hartzell and Nina Sobell]

can explore through a collaborative navigation with people who are actually in that place. A combination of software and hardware is used to create an interface which gives to Web-users control over an aspect of this physical environment. Feedback comes through the use of video monitoring which shows physical visitors the shape of the piece.

These artists also committed themselves to a live performance each week on the Web, using their interactive equipment, ArTisTheater Performance Archive. At NYU CAT, in 1994, Emily Hartzell and Nina Sobell used one of the Web's first remotely controlled cameras to transform their studio into a time-based public Web installation in order to research the nature of Web video as a medium. The Web gave visitors twenty-four-hour real-time access, through the eye of the camera, to watch them work, so at times their actions were heightened by their awareness of unseen Web visitors. At other times they felt themselves dissolved in the ubiquitous surveillance which now erases the boundaries between private and public. That year, they launched the Web's first live performance series, ArTisTheater, whose archive of non-narrative, improvisational works now contains over eighty performances (including works by guest artists). The series' archive reflects the evolution of technology from the first telerobotic black-and-white pinhole camera to experimental color, true color, and sound. They have experimented with the Web to discover its potential for collaborative expression. Their stated objective is to explore and sculpt the boundaries between physical space and cyberspace.

The "Alice" of their title, referring back to Lewis Carroll, suggests perhaps, "Alice in Cyberspace"?

> Alice opened the door and found that it led into a small passage, not much larger than a rat-hole: She knelt down and looked at the passage into the loveliest garden you ever saw. How she longed to get out of that dark hall, and wander among those beds of bright flowers and those cool fountains, but she could not even get her head through the doorway; "and even if my head *would* go through", thought poor Alice, "it would be of very little use without my shoulders. Oh how I wish I could shut up like a telescope! I think I could, if I only knew how to begin". For, you see, so many out-of-the-way things have happened lately that Alice had begun to think that very few things indeed were really impossible.

First high-resolution video on the Net

Wax, or the Discovery of Television Among the Bees by David Blair was one of the first feature-length fiction videos transmitted over the Internet. Even in the extremely limited version of the Internet then available, *Wax* gained considerable attention through online exposure and discussion. When it was broadcast over M-BONE – "multicasting backbone" (developed in 1967 by the Federal Defense Department and later licensed to the scientific research community) – the video was carried in a live, sophisticated, continuous multicast requiring extraordinary bandwidth, available so far only on NASA's space shuttle feed, the Internet's first digital-video channel. Only about ten or twelve research lab sites – Australia, Finland, and the US West Coast – tuned into this first Netcast.

Now regular household terminals using a cable modem or DSL (digital subscriber line) telephone lines can offer sufficient bandwidth to act as carriers because of improved digital

Figure 6.18. David Blair, *Wax, or the Discovery of Television Among the Bees*, 1994, still from the videotape.

Wax was the first feature-length fiction video that went out over the World Wide Web's digital video channel called M-BONE (multicasting backbone). This feed originates with NASA's space shuttle and cannot be accessed with a phone connection because it requires the type of receiving bandwidth and software available only through a few thousand universities and research labs. Blair presents science-fiction concepts as he explores the civilization of a new race of bees who have a knowledge of the ghosts of past technologies.

(David Blair)

compression and streaming video software. Originally designed as a multicasting video conferencing tool, M-BONE allows users to call up multiple video windows at the same time. This kind of system is now becoming widely available through digital-surveillance-type cameras (webcams) and appropriate software. It offers an easy way for individuals to see each other in the same database and share images.

Limitations and difficulties of creating visual works for the Net

The limitation of the Net is that because of the bandwidth it doesn't yet allow the production of a richly visual art in relation to the large amounts of data it takes to create visuals by digital means with dial-up telephone modems. However, this problem is being resolved with the rapid spread of broadband access via cable modems and DSL telephone connections. For those

consumers not yet able to access broadband, the Web is still basically a conceptually oriented text-based medium tied to the speed of dial-up telephone lines.

One of the earliest "labs" for developing artist sites, ada'web, provided both a forum and a virtual setting for artists to create experimental projects. Benjamin Weil, its founder, believed in creating an atmosphere where an understanding of new processes, programming and critique were available to interested artists. 'Ada'web's goal was to "function as a laboratory, documenting an ongoing thinking process." Weil worked with artists beginning in February, 1995 to explore the Internet as a new medium and to participate in its aesthetic definition. It offers website visitors exposure to the evolving ideas of the artists and the creative process. The complete site with all its links has now been archived as a pioneering site by the Walker Art Center, Minneapolis. It includes the work of many artists including Jochen Gertz, Julia Scher, Doug Aitken, Vivian Selbo, Lawrence Weiner, David Bartel, Jenny Holzer, Darce Steineke. It is a website devoted specifically to exploring new forms of visual creation and to engaging a different type of relationship between cultural production and the public.

Because they are being viewed on a relatively small monitor between the screen's control bars top and bottom and scroll bars on the sides, the visual images are necessarily small and difficult to "read" unless they are prepared graphically with this in mind. The artist may decide that the "loading" speed of work is a paramount issue. Greater image compression is a vital technical consideration which could affect better image delivery in the future. Uploading images, which need a greater amount of information space online than text, has forced artists to evaluate options regarding the quality of their visual images and the way they are used.

Opening out

When the technology of film was developed, Walter Benjamin wrote that it had the effect, similar to the Internet, of assuring us of an "immense and unexpected field of action."

> The film, on the one hand, extends our comprehension of the necessities which rule our lives; on the other hand, it manages to assure us of an immense and unexpected field of action. Our taverns and our metropolitan streets, our offices and furnished rooms, our railroad stations and our factories appeared to have us locked up hopelessly. Then came the film and burst this prison-world asunder by the dynamite of the tenth of a second, so that now, in the midst of its far-flung ruins and debris, we calmly and adventurously go traveling. With the close-up, space expands; with slow motion, movement is extended. The enlargement of a snapshot does not simply render more precise what in any case was visible, though unclear: it reveals entirely new structural formations of the subject. So, too, slow motion not only presents familiar qualities of movement but reveals in them entirely unknown ones 'which, far from looking like retarded rapid movements, give the effect of singularly gliding, floating, supernatural motions.' Evidently a different nature opens itself to the camera than opens to the naked eye – if only because an unconsciously penetrated space is substituted for a space consciously explored by man.[31]

Today's digital communications provide parallel worlds. These new Net channels in combination with GPS systems, satellite transmissions and nomadic wireless devices "are allowing dynamic forms of interactive personal and collective cinema on a digital basis."[32]

The radical potential of online digitally expanded cinema and of distributed virtual environ-
ments allows participants to become active in disruptions and additions to narratives. Those
who can access the technology are in daily contact with a far wider world than that afforded
by film or television.

> The essence of the interface is its potential flexibility; it can accept and deliver
> images both fixed and in movement, sounds constructed, synthesized or
> sampled texts written and spoken. It can be heat sensitive, body responsive,
> environmentally aware. It can respond to the tapping of feet, the dancer's
> arabesque, the direction of a viewer's gaze. It not only articulates a physical
> environment with movement, sound, and light; it is an environment, an area of
> dataspace in which a distributed art of the human/computer symbiosis can be
> acted out, the issue of its cybernetic content.[33]

Connectivity from mobile phones and other nomadic wireless devices which can also
connect to the Internet has provided popular public access, especially in Europe. The social
and cultural experience of new technologies is toward interaction and communication – the
kind of inclusivity which encourages global exchange through which fresh insights can evolve
through experimentation with diversity and difference. The new forms of representation are
completely enmeshed in the modalities of popular culture. "High art" content and language
(as we have seen in Chapter 4) are being seriously challenged by the contextual power of
all-pervasive home-received media which can penetrate the public mind and create forms of
public address and agency.

What happens to the audience when it is placed in the position of agency? Commercial
influences aside, there is an awareness of the specific cultural engagement possible on the
Web and the types of personal and social communication it enables within today's cultural
context. In *Network Culture: The Cultural Politics of Cybernetic Communications*,[34] Titziana
Terranova speaks about the validity of virtual social movements and about the dynamics and
contradictions between television and the Net and appeals to the concept of collective
intelligence:

> The interface with the mainstream media is a confrontation between two
> incompatible modes of communication. In this sense, the encounter between
> the NET and the SET manifests itself again and again as a conflict between two
> different types of cultural forces, the culture of representation and the spectacle
> and the culture of participation and virtuality.[35]

An online electronically produced public art work

Sherrie Rabinowitz comments that the implications of the new technological conditions are
that we must begin to imagine a much larger scale of creativity – one which opens to the
possibility for new communication across all disciplines and boundaries. This idea of using
the interactive potential of the medium to empower other people instead of one's self creates
a powerful opening for a new role for the artist and a new kind of public art – one with all the
constraints and freedoms to communicate within a wider sphere. It implies a new way of being
and communicating in the world. Viewers become collaborators in an interactive dialogue,

Figure 6.19. Muntadas, *The File Room*, 1995, online censorship archive.

Initiated by Muntadas and produced by the Randall Street Gallery at the Chicago Cultural Center with the assistance of many individuals and institutions.

As a pioneering ongoing Internet archive of acts of cultural censorship, *The File Room* addresses questions of power relations in society. It challenges definitions of what constitutes censorship and creates a forum for discussion for the many issues surrounding acts of cultural censorship. As a collaboration drawing on the resources and expertise of many organizations and individuals around the world, the archive is symbolic of both the need for free and open communication and of the Web as a perfect medium for this task. Included among instances of cultural censorship are the suppression of artists' careers; bans on entire media or subject matters at different times in history; self-suppression by those in fear of reprisals; denied or limited access to information on cultural achievements by entire groups, or non-inclusion of such information in "authoritative" sources compiled by majority representatives. The continually self-generating nature of the project is being shaped by ongoing research and by submissions globally.

(Muntadas and the Kent Gallery, New York)

adding notes, drawings, and comments at the site of the exhibition or printing out sections of images or texts for exchange or discussion. It can act as an enormous bulletin board – a space where communication takes place.

The File Room, an ongoing pioneering project about censorship by Antonio Muntadas[36] inaugurated in 1994, was one of the first art works on the World Wide Web. This important historical work takes the form of a cultural archive of censorship infractions from the time of the ancient Greeks. It opened with 450 well-researched entries. Members of the public still add new entries to its interactive database online concerning current harassment around religious, intellectual, and sexual orientation. Current as well as historical issues are being

Figure 6.20. Giselle Beiguelman's *Egoscopio*, teleintervention on two electronic billboards 13ft × 16ft displaying open public streaming of participants' submissions in São Paulo, Brazil, for two weeks, August 2002. DHTML and SQL database.

This public Web work was created to be manifestly displayed in public rather than as a work received only on one's intimate personal computer. However, it has both simultaneous online and offline elements which blur the lines between the virtual and the real worlds – a kind of "cybrid" realm that is a combination of cyberspace and physical space. The work is directly in line with Beiguelman's research on the cultural impact of the Internet. These submissions can be seen as an updated computer-enabled form of "Messages to the Public" (see p. 184). Between 10:30 am and 3:00 pm in intervals between ads on billboards located above heavily trafficked streets where they could be seen by an estimated 120,000 pedestrians daily, visitors to the online version of *Egoscopio* could submit the address of a webpage and within moments have that page appear on the large outdoor screens. A webcam focused on the transmitted images back to online viewers while another camera monitored reactions of passersby. Website participants could interact with the works displayed and alter them from afar.

documented. Visitors to the site each day also find links to directories of information about free speech organizations such as the American Civil Liberties Union amongst, by now, large numbers of others. Muntadas's determination to move his work from its original form as installation at the Chicago Cultural Center to exploit the Internet as a significant cultural information resource reflects his interest in using communication systems to decentralize and subvert power structures. In early notes about the project, he referred to it as a social sculpture *à la* Joseph Beuys[37] which "gains its meaning through a group effort

of individuals, organizations, and institutions." The site allows, for example, anonymous documentation of offenses by totalitarian regimes, some of which are still in power.

Two Internet works created in 2002 contrast the personal, intimate way one might access a website on a home computer with a manifestly public way. These two have been created to be exhibited in public streets. One work, *Egoscopio* by Brazilian artist Giselle Beiguelman, is displayed on two electronic billboards in a major traffic area in São Paulo. The other, *Telescape*, by a British collaborative known as Greyworld, is a work designed to be seen through a pair of computer-enabled telescopes. Although they are different, both web works are simultaneously online and off, blurring boundaries between the real and virtual worlds, between

Figure 6.21. Perry Bard, *Walk This Way*, 2001, rear-screen projection inside a truck. An e-directed video installation. Commissioned by Community Informatics Department, University of Teesside.

Following on earlier public works she created about cultural history and memory, Perry Bard was commissioned by the University of Teesside, UK, to conceptualize a project focused on the transitory nature of place. A website was set up for this collaborative project to act as a production staging area for exchange between New York-based Bard and the Middlesbrough UK teenagers involved in creating a work about their North Ormesby community. The teenagers engaged local community members in a discussion about their environment and collected interviews for the project. They researched images from the past as well as collecting contemporary ones of the town. Images and sound were uploaded to the website in the UK, sequenced first through a discussion process, a forum which took place online, then downloaded and edited in New York. Bard's footage of the industrial landscape videotaped on a previous visit to the area was layered with images captured by the UK group. The resulting nine-minute loop was projected from the rear of a truck at Market Square, an active and lively site within the community itself.

(Perry Bard)

real space and cyberspace and between personal and private. Online visitors to the sites can still manipulate the works from afar. Carol Stenakis, curator for *Creative Time*, which commissioned the Greyworld work, commented: "Being able to send a message to a local public even though you're not there is provocative. It will be interesting to see how people use the system."[38] The impulse to create a digital art work to involve the public is very different than merely placing a work on the Net.

A number of artists interested in public art are experimenting with the moving location positions of nomadic devices such as mobile phones and PDAs. They are creating art works in the context of social environments where people live and work to negotiate dynamic user actions as rules of engagement. Hand-held text-based messaging (SMS) devices are intimate and can be seen to explore social effects of technologies within the interface of urban space. Working out of the Media Center in Huddersfield, UK, Matt Locke began to experiment with issuing quick text suggestions and questions to users, who tend to be constantly in touch with their devices "on" as they wait for buses or subways or walk along. At first, messages introduced to users ideas of social risk such as "act strangely" or "get too close to people" with the request to report back by messaging their responses about "looking around and seeing who's looking." These first experiments evolved into Locke's designing an "easy-to-enter" competition inviting users to write poetry and submit to the *Guardian* newspaper's mobile phone competition. The rules were that a panel of poets would choose a shortlist. But jurying of the winners would be by those who submitted to the contest. Winning poems were published in the newspaper. In a third project, Locke used voice-recognition software to translate phone responses into text which could be projected on to the side of a building. The street became an interface for a project which could also be seen on a programmed website.

Perry Bard, a New York media artist, was commissioned to create public work at CIRA (Communications Informatics Research and Applications Unit at the University of Teesside, UK). The video elements she created in the community were edited in New York and then sent online to the Teesside Festival. Direction for the project was also done online since there was no funding for her to return. The resulting project was rear-view projection of community actions from the back of a truck which drove through the streets at night during the festival as a moving theater for local people.

Browsers, and experiments with data

Art works that experiment with transferral and transmission of data question and subvert the conventions of browsers. Their works make it possible for Web users to deconstruct and reconfigure existing sites. Mark Napier disrupts the territorial boundaries of particular sites, whether personal or commercial, squeezing together different sites' information such as corporate logos, brand names, and artists' pages onto new pages. The functioning of his site *Riot*, once software is installed, uses a similar format to conventional browsers by entering URLs into the location bar on the browser attached to bookmarks to sites already visited. However, the resulting pages that are built are combinations of images, links, and text from sites recently visited. By challenging conventional notions of ownership and authority, Napier questions the boundaries and territories not only of the Web but of the circumstances of everyday life.

They Rule by Josh On and the Future Farmers is a site that uses browser links to examine the power structure of corporate relationships in the United States. Users browse through a

Figure 6.22.
Mark Napier,
Riot, 1999,
alternative Web
browser with Java
Script.

Riot is an alternative browser work, a software "melting pot" that mixes and blends Web pages from separate domains into one browser window. The work disrupts accepted rules of possession, authority, and territorial boundaries acting as a reflection on the clashing diversity of New York's cultural and economic environment. It also points to how information can be recycled and reproduced in seemingly endless ways and distributed in ever-shifting contexts. The basic functionality of the site still seems to be conventional – entering a URL into the location bar or by selecting from existing bookmarks. However, *Riot* builds its pages by combining and mixing together images, texts, and links from pages the user has recently touched on.

[Mark Napier]

Figure 6.23. Josh On and the Future Farmers, *They Rule*, 2001, screenshot of a map constructed with this Web project.

By creating its own sub-networks of power relations, *They Rule* uses the Web as a means to invoke its original goal as a democratizing medium, subverting its use as a mere marketing tool by revealing the underlying power connections of the most influential American companies it maps, such as General Motors, Coca-Cola, and Bristol-Meyers Squibb amongst many others. As a many-to-many broadcasting system and expanding information resource, the Web is used as a tool for making visible intricate networks of control.

[Josh On]

variety of graphic maps that link and access directories of corporate boards of CEOs and directors of major companies such as Coca-Cola, Microsoft, and Procter and Gamble. They are represented as icons holding briefcases. The site becomes a kind of user virtual research project to discover the weight their influence may wield because they sit on more than one of these powerful corporate boards.

The open system of the Internet allows for recontextualization of any data, including information from commercial or government sites, and cloning it to be reinserted into new contexts. Activist artists' projects that are based on the tactic of "cloning" or hacking information from other sites are usually constructed as a form of agency, a political statement. Hackers have the attitude that knowing how to program software gives them a form of power. (This power, however, is making them increasingly suspect by the Web police as ones to watch when there are serious global Internet attacks.) *Carnivore*, a work by Alex Galloway, makes use of early FBI software to hack and collect data from various kinds of sites (most often corporate ones) to shift institutional messages. The new site that is then displayed in various configurations can be added to by those who download the software.

Figure 6.24. Alex Galloway and RSG, *Carnivore*, 2001–3, mixed media surveillance tool for data networks.

The collaborative, open-source nature of this project embodies a central issue in Internet art. By examining and critiquing the closed nature of FBI software originally used for forms of surveillance that it both uses and critiques, Carnivore allows everyone access to its code to tap into the data stream in creative, aesthetic ways.

(Alex Galloway)

Through the use of mapping processes, John Klima's *Ecosystem* and Nancy Paterson's *Stock Market Skirt* explore different approaches to understanding financial datasets. Both of these online examples are typical of works which seek to produce effects that can be understood in a political sense. *Ecosystem* explores global currency data as an increase or decrease of a flock of birds. Each flock represents a nation's currency while branching tree structures relate to a country's leading market index. Changes in daily currency values against the dollar are reflected by behavioral movements in the size of the flocks. If the daily volatility of the market changes, the territory inhabited by the flock becomes smaller and the hungry flock feeds on its own country's resources.

Nancy Paterson chose a gender-defined position in her work about the stock market by creating a work having to do with the raising and lowering of a woman's skirt line which responds to the stock data that control the installation. When the stock market rises, the hemline is raised: when the stock market falls, the hemline is lowered. Her piece is interactive with the flow of data within the Internet itself. A script is written which sets the skirt's range of movement on the basis of the selected stock's previous day's performance.

Figure 6.25. John Klima, *Ecosystem*, 2001, commissioned software.

Klima invites an examination of real-time data sources not only as a tool for understanding but as a reflection on the possible aesthetics of real-time data sources. This work plays with the potential forms for mediating and processing facts while pointing to the relativity of our worldview as manifested in processed representations.

(John Klima and Zurich Capital Markets)

Figure 6.26. Nancy Paterson, *Stock Market Skirt*, 1998, Web-based Installation.

In this work, Paterson twists media into forms that reveal the mechanisms and means of seduction, exposing the powers of desire that are manipulating us. She uses the powerful data-processing potential of the Web to address issues such as the convergence between technology, feminism, and art.

(Nancy Paterson)

Software works on the Web

Mary Flanagan creates downloadable software for networking the collection of bits and pieces of data from a participant's hard drive. These create a dynamic collage of images created from the user's own ephemera such as e-mails, graphics, sound files, images cached by a Web browser. In her work *Collection* Flanagan combines and re-presents both personal and previously chosen computer information to create constantly changing new visuals as a form of a virtual collective unconscious, a memory space which uses the Internet as a fresh medium.

Robert Nideffer creates open-ended software programs which contain what can be described as online "agents." (See Chapter 5 and the Glossary for the functionality and intelligence of these). These agents filter and customize data, create user profiles, and track user behaviors. Such agents can live on your hard drive, manage your files, and remind you to "empty your trash." In his work *Proxy*, he uses a group of intelligent agents in a gaming context called *Proxy*. Players in the game can personalize their agents by rating them in ways that make them aware of a range of emotional issues that might be present in other players' agents. Once their agents are programmed and ready, players can use different levels of gaming experiences. In the cultural environment he created for *Proxy*, Nideffer set up a virtual "art world" complete with monsters such as curators, professors, or collectors as well as hackers and the like. You can actively be involved in the game or sit back and watch your agents at work. *Proxy* reminds us that software can be playful as well as useful and can explore questions of identity and forms of communication in ways that are both engrossing and meaningful about "how we live, how we imagine, and who we are."

Figure 6.27.
Mary Flanagan,
Collection,
2001,
networked
computer
software which
maps users'
hard drives.

By exploring parallels and borders between human and computer memory, Flanagan's software explores the visual potential of the new data relationships revealed by the promise of hypermedia. It can also be seen as a collaborative version of concrete poetry in which language and images are given an equally mesmerizing and abstract presence. *Collection* with its networked collective unconscious is a reflection on the profound impact of new media on our culture.

[Mary Flanagan]

Figure 6.29. tsunamii.net, Charles Lim, Yi Yong, and Tien Woon, *Alpha 3.3*, 2002, GPS positioning device, mobile phone, and antenna.

The alpha series of projects by Singapore-based group tsunamii.net have all explored the relationship between physical space and cyberspace. For *Alpha 3.3*, the piece they created for Documenta, the two artists walked from Kassel to Kiel, Germany, with their movements tracked by a global positioning device. The GPS data were sent by a mobile phone to a base station that initiated a sequence of Web browsing in Kassel, showing images creating a bridge between the real and the virtual. Their various locations triggered specific Web pages related to where they had walked, demonstrating the levels of overlap between real communities and Web ones and how real space interacts with Web space.

Figure 6.28. (opposite) Robert Nideffer, *Proxy*, 2002, Web project with Java application software.

Proxy is a head game about agents and agency that revolves around what the artist calls "unorthodox methods of information discovery, file-sharing, data mismanagement and role-play" in relation to networked identity construction and collective behavior. The term *agent* is used to describe a software program that filters and customizes data, creates user profiles, and tracks user behaviors. By facilitating distributed, collective, and slightly out-of-control data processing, *Proxy* is a reminder of what software agents can be: a playful exploration of identity, community, and information exchange. However, these agents also raise rather serious questions about who we are and how we behave in online public space.

(Robert Nideffer)

 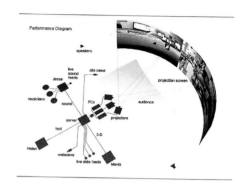

Figure 6.30. Marek Walczak, Helen Thorington, and Jesse Gilbert, *Adrift*, 2001, collaborative project with Martin Wattenberg, Jonathan Feinberg, Hal Eager, and Max James, intercity performance presented in different configurations since 1997.

Adrift works as a performance somewhere between theater, cinema, and "drifting" or "surfing" the Web. The context for the work is a ferry ride across a virtual harbor, using the sounds, images, and actual feeling of being in transit, afloat as in a moving ship. As a Net performance, the piece consists of three streamed channels of media originating from different physical and virtual locations converging as sound and as a projection onto a rounded screen. The perspective is that of floating over a digital sea of images, adrift in light, sound, text, and computer code. The evolving event combined movement through 3-D space, multiple narratives, and richly textured sound streaming between virtual and real geographies. Recent performances of the piece were designed for presentation as "spectacles" in physical locations such as the New Museum in New York. The piece made use of the output of VRML cameras and was received by three computers, projected by three projectors onto a semicircular screen.

(Marek Walczak)

Art on the Internet: can it find an audience?

The "polyvocal" art work is potentially a democratic form. In the shift of emphasis from the creator's total control over the art work to the participant's active negotiation, major responsibility for the work's outcomes is shared. Now that the social construction of interactive works has become more ambitious and is subjected to distribution beyond local geographies (as on the Internet), a more complex model of democratic art experience is evolving. As a many-to-many broadcasting system, the Internet embodies a certain promise of democracy. Net art exists within the public sphere and is potentially available to anyone, anytime, anywhere – provided that one has access to the network. Mailing lists and other forms of networked communication (from mobile phones to PDAs) have become a form of agency as activists make use of connectivity as a form of political participation.

However, questions of democracy pose global issues about the power of rhetoric and of access. Only a small part of the world population has access to computers.[39] Differing geographical and cultural contexts as well as language also raise issues concerning global access and understanding. Because electronic files can be so easily altered, questions of authenticity arise. Mediated images of real events can be edited in ways that produce meaning according to the creator's agenda.

The Web's potential for democracy also is inextricably linked to commercial and corporate influences. The World Wide Web originally was dominated by the research and educational organizations and institutions that established the first nodes of the Internet. The boundaries

of its free information space are constantly being negotiated in the face of its growing commercialization and the corporate control over many of the technologies being used (from the Web browser to tools for the creation of content).

Can an artist's Net art project challenge the attention of a Web surfer who is subjected to the sheer volume of sites within the commercial context of the Web – saturated with all its promotional banners and rude interruptions based on sex and price comparisons to garner attention? Net art projects, with all their community-building potential, exist in an environment that is commercially saturated. Access is also a matter of filtration. The number of Net art projects that are discovered accidentally is relatively low. Much of the public are unaware of the presence of artists' Web projects and think of the Web as only a commercial medium, much in the way they see television (excluding one or two publicly supported stations).

Figure 6.31. Andreja Kuluncic and collaborators, *Distributed Justice*, 2002, Web work.

This Web project deals with the topic of distribution of goods in society as a central issue of moral reason-ing and political philosophy. It has been developed by a team of collaborators from different disciplines (philosophy, sociology, anthropology) and consists of two basic sections – a virtual game for onsite visitors (www.distributive-justice.com) in which participants in the project freely distribute material and nonmaterial goods building a "society" that undergoes dynamic changes. Several types of societies emerge as a result of this game. The second part of the project is the exhibition space, a "working space" filled with both theoretical and practical materials. Participants in the project read materials, listen to lectures, chat, join the discussion, participate in the polls, surf the Web, print from the base, copy materials, or videotape or audiotape the events. All the parts of this project were later integrated in a Web portal. The participants thus gained a virtual space of their own designed for exchange of information for creating archives. In this way the project has eventually developed into a permanently open forum.

(Andreja Kuluncic)

Can art institutions, while providing important support for artists' work, sustain participatory digital and Net art projects as a form of mass agency when the work is canonized to institutional status? While the characteristics of the medium itself to a large extent resist traditional forms of "institutionalization," the degree of assimilation by an institution also depends on how deeply rooted the work is in community or how much subversion of corporate power there is. Presented in the public space of the museum in the form of an installation or in a kiosk set-up, Net art does not lose its "network contact" with a larger community outside the institution. Because Net art projects simultaneously exist exterior to any museum, they could also gain even more agency as a result of the attention drawn to them by the institution. On the one hand, a Net art project validated by an important institution may attract a wider following; on the other hand, the filtering and stamp of approval provided by an art institution establishes circumstances that Net art tried to circumvent in the first place.

A non-institutional art community structure for Net art has been established through online communities such as Rhizome and Nettime, e-journals, mailing lists, conferences, and independently organized exhibitions. Artists' homepages create an unorthodox community of links that allow for important exchanges between artists while providing information about artists' work to curators and researchers in the arts.

Despite a loss of the early utopian rhetoric surrounding the potential of the Web, the continued growth of access to computers in the contextual development of national and international networks is producing a remarkable body of Net art that again and again confirms the Web's power as a cultural medium and as a new form of representation and agency. Inherently pluralistic and democratic, the Internet and networked communication represent an openness that is refreshing, particularly to societies whose structure has not been open or democratic. Eastern European countries, for example, which have been seeking new identities following the Cold War years, also have a prominent online presence in the cultural realm. For many isolated groups and nations, the Internet can become an opening to change, new forms of identity, and expanded consciousness.

Museums online: Will anyone come?

More and more museums have digitized their collections for study purposes and as a catalog reference for the public. Walter Benjamin observed that mechanical reproduction of a work of art changes a viewer's relationship to it. Reproductions of works of art tend to build an audience far beyond those lucky enough to own the original. In fact, the museums which embrace the new technologies do so in order to build audience. The Carlos Museum in Seattle, which opened in 1993, is the first to be built with computer wiring and was the first to go on the Internet, offering images of some sixty of its works. Since then, most museums have dramatically developed their own constantly updated websites.

Museums and galleries, private dealers, and auction houses are linking up to the Web because it offers them international coverage. It is possible to see an image, point and click, and wait for it to appear, home-received, onscreen ready to be printed out. While it is no replacement for the tactile experience of art objects, this is another way of

engaging an audience and attracting more visitors. It creates ways of communicating about art using new tools. According to Stacy Horn, who ran Echo, an early bulletin board service, "The potential of the Web is millions. If you have something generally cool, within a matter of days everyone around the world knows about it." Word travels fast in cyberspace. The museum offers access to selections from its permanent collection, to its archives, and updated current offerings. Museums can talk to one another and users can talk to museums.

The Web serves different needs for different participants. It offers commercial opportunities for artists, galleries, and collectors. One of the first pieces of Web art, *The World's Longest Sentence*, by Douglas Davis, was bought by New York collector Eugene Schwartz. The work, designed as a site where Web users are invited to keep adding to the sentence, is described ironically by Schwartz: "It's like buying an infinitely valuable piece of art that's for eternity."

Internet exhibition activities allow artists to bypass cultural gatekeepers. Some service providers charge galleries for "posting" art on their site. Exhibitions of conventional art work have been placed on websites by individuals, galleries, and museums and can be downloaded and reproduced through a normal computer printer. This may include the artist's bio and price list for the original with links to the artist's homepage where more information is stored. These conditions are rapidly becoming the norm in everyday cultural practice.

The homepage of an artist, an introductory screen with graphics and text resembling a kind of magazine, may contain an interactive art work linked to information about past work, résumés, personal writings, and reviews. Thus the art work has a close relation to other information. Both reside in the same data bank simultaneously, raising questions about the relationship between the art work and its ancillary connectors. Links between artists' homepages are creating a virtual art community online.

Commissioned works by museums

With public access to the Web reaching an increasingly wider audience, art institutions see it as a way of expanding cultural consciousness. For the Dia Foundation and the Whitney Museum both online from New York, the Net provides a forum for artists to create digital projects especially for the Web and displays them online for periods of one to two months at a time. As early as 1996 Laurie Anderson's *Green Room* has been displayed on the Whitney's site. At Dia's site, *Fantastic Prayers*, a collaboration by the writer and performer Constance de Jong, artist Tony Oursler, and composer Stephen Vitiello, is a performance work adapted for the Web. It is a sophisticated melding of text, sound, and moving images, which later became a CD-ROM, about a fantastical place called Arcadia. Other commissions include ones by the Guggenheim Museum, Eyebeam Atelier, and The Walker Art Center amongst others. The Whitney Museum established Artport in January, 2001, as a space for showing works of individual artists whose online works have been important in the development of the Web as a new medium.

continued

Museums sell digital documentation of their collections

Pioneers of the new technology are finding it easy now to predict that one day images from the great museums will be available digitally on the bookshelf as a CD-ROM or available online on the Internet. A viewer can already call up a Rembrandt or examine the pieces of a triptych by Van Eyck close up, or call up a retrospective of Cézanne although the originals are literally oceans apart. Because the originals are digitized, the viewer can zoom in to explore the detail. This advance is of major interest to art historians conducting their research internationally. The Internet provides a medium of visual information as well as textual research exchange. Browser software makes it possible to access images in full color, with option to download images. This international effort is creating an extraordinary opportunity for art scholarship, for exhibition curating, and catalog publication that will rival the impact photography has had on the study of art history. Museums wishing both to inform and to interact with the public are already establishing online bulletin boards and calendars like the one presently available from the National Museum of American Art. The future effectiveness of museums to broaden their audience and deepen cultural formation and exchange may depend on the Internet.

Interactive telecommunications force a re-evaluation of what we have learned from television

Some see interactive technological potential, touted as the "extensions of man," as an essential blindness to the infrastructure of technocratic domination and as part of a naive belief in the neutrality of digital control. For critics of technology such as Baudrillard, television "is a paradigm of implosive effects . . . it collapses any distinctions between receiver and sender or between the medium and the real . . . who are locked into an 'uninterrupted interface' with the video screen in a universe of fascination."[40] While Baudrillard enunciates the limits of the "society of the spectacle" and writes of the paralysis and unprecedented social contraction of capitalism's ability to expand, Deleuze and Guattari see it as a new phase of reorganization, a globalization of power interests where geographical borders no longer exist.

> Telecommunications is the new arterial network, analogous in part to what railroads were for capitalism in the nineteenth century. And it is this electronic substitute for geography that corporate and national identities are now carving up. Information, structured by automated data processing becomes a new kind of raw material – one that is not depleted by use. Patterns of accumulation and consumption now shift onto new surfaces.[41]

Figure 6.32. (opposite) *Welcome to a World Without Borders*, 1994, illustration from *Electronic Disturbance* by the collective Critical Art Ensemble, and published by Autonomedia.

The publication announces itself as "anti-copyright 1994 Autonomedia and Critical Art Ensemble. This book may be freely pirated and quoted. However, please inform the authors and publishers at the address below: Autonomedia, POB 568 Williamsburgh Station, Brooklyn, N.Y. 11211-0568, USA, (718-387-6471)."

Jonathan Crary sees self-delusion in those who embrace the technologies as positive and liberatory. He argues against the fictions, mystifications, and bad faith of those who ignore the violence and immensity of the disequilibrium that exist globally between the haves and have-nots:

> The cyberspace mirage of a fiber-optically unified humanity interacting elec-
> tronically became a charged set of images and terms just as events on the
> eighties were disclosing an increasingly striated world – a world in which a
> mosaic of expanding populations and depleted localities has only obsolete or
> fractured routes, if any at all, into the planetary net of telematics . . . The sleek
> cyberdream of a collapsed global surface of instanteneity and dematerialization
> persists only by erasing the waking actuality of a world that is increasingly
> unliveable for most of its inhabitants.[42]

Figure 6.33. Tina LaPorta, *Artport Screen #6*, 2001, image from voyeur_web webcam piece. Commissioned by the Whitney Museum of Art, New York.

While the home represents a private space and the Web a public site, webcams become a window or an invitation to look, to gaze upon everydayness of the inhabitants of these sites. The distance between the watcher and the watched is quite clear, and those who are being watched set the stage for their own exhibitionism – to be seen is to exist. LaPorta samples from real-time flows of media, using webcams as a way to call attention to the interplay between the public and the private sphere that appear to become less and less demarcated as technological ubiquity increases. The floor plan maps the gaze of the voyeur, regardless of whether the cam exists for the gaze of the Web surfer or the husband away at work. Click on a room and a new window opens a stop-frame image hyperlinked from a live cam. Over time, the frame refreshes, and glimpses of a body occupying its own personal space appear on your desktop.

(Tina LaPorta)

Andrew Ross and Constance Penley writing in *Technoculture* argue that technological innovation is so much part of the structure of society that it is coopted into mainstream practice immediately. Carolyn Marvin argues that the history of electronic communication "is less the evolution of technical efficiencies in communication than a series of arenas for negotiating issues crucial to the conduct of social life; among them, who is inside and outside, who may speak, who may not, and who has authority and may be believed." She notes that "the introduction of the telephone did more than enable people to communicate over long distances: it threatened existing class relations by extending the boundary of who may speak to whom; it also altered modes of courtship and possibilities of romance."[43]

From the standpoint of culture and creativity, what *content* does the ubiquity of telematics offer? In *The Cult of Information*, Theodore Roszak reflects the reservations felt by so many in response to the challenge of new technologies: "Thanks to the high success of Information Theory, we live in a time of blinding speed: but what people have to say to one another by way of technology shows no comparable development."[44]

An upgraded expanded national electronic network with broader bandwidth and greater information compression will have unlimited capacity to transmit far more complex material (including television, film, and music) rapidly with interactive service allowing the receivers or viewers to make selections. There is a struggle under way to control this more powerful form of communication, which is upgrading the current, relatively low-cost access to the Internet. Interactive television will mean an even greater invasion of the home by marketing messages than ever before. It will mean profits from the sale of household conduit technologies. Primarily, it is understood as an economic highway for extracting fees from transmissions to viewers of shows, games, films, music, and specialized data such as encyclopedia information, weather, catalogs, and the like. Development of this system is slow because the public, so far, does not want to pay the price.

Questions about cyberspace: issues of concern

A survey by the *New York Times* (August 20, 1995) points out that American public has a starkly negative view of the influence of popular culture. Deeply ambivalent, the public blames television more than any other single factor for teenage sex and violence (over breakdown of family, use of drugs or lack of parental supervision). A direct link is made by most of those surveyed between pop culture and behavior, and language picked up from television, movies, radio, and the Internet. While easy access to the Internet provides rich archives of research materials to students of all ages, it also opens out uncensored sites of all kinds including materials unsuitable for children. Parents may now confine Internet viewing by means of special software. Firewalls in public buildings have been developed to prevent hacking of delicate institutional and personal information. These precautions have a flip side to them and can also be seen as early development of forms of censorship.

Already, the first wave of idealism and the sense of freely sharing information and newly developed software and expertise that characterized the reactions of the first travelers on the Net is being challenged. For example, Netscape software for the Web, developed and originated by paid student help at the University of Illinois at Urbana Champaign, was offered free to anyone who called in requesting it. Use of Netscape software (and now Explorer) makes "browsing" and moving around in the complexity of the Web surprisingly easy to do. The process of creating online bookmarks is a bit like choosing books from a library. Now, because

each development in browser software is such a competitive breakthrough, influencing commercial users particularly, browser software has become highly commercialized.

Will there be cultural dominance and language dominance by those who have greater access to the technology? Will selected access to powerful technologies create an elitism? English, still the lingua franca for banking and science, is the dominant standard mode of telecommunications networking, a situation which is now being challenged by those opposed to its tacit acceptance. However, a universal digital code known as Unicode allows the computer to represent the letters and characters of virtually all the world's languages with fonts for everything from Chinese ideographs and Russian Cyrillic to Sanskrit characters. Yet still, as an Internet provider in Korea commented, there is, side by side with English-language dominance, vast cultural difference. Technology is most often owned and controlled by those in economic power and through government regulatory control. Those who receive training in its development and use tend to have been through a process of higher education. Access to equipment is easier for those attached to universities or top research and entertainment establishments. Access to the Internet for artists is still a problem both in the United States and globally, for many who do not have a computer and modem.

Figure 6.34. Maurice Benayoun, *So-So-So (Somebody, Somewhere, Sometime)*, 2002, Vretina/Internet installation. with Jean-Baptiste Barrier, Laurent Simonini, David Nahon, Stephane Thidet, Karen Benarouche.

This interactive installation tells the story of the moment when parallel spaces meet and transform into a storyline through the way we apprehend them: their fleeting memory is printed on the palimpsest of everybody's looks in this transient instant. The work envisions a universe made of networked scenes that can be explored through a large floor binocular in a full 360-degree omni-directional rotation. Each scene is connected to others through some recurring details within the images, which act like doorways to other images. The spectator thus navigates inside the potential story simply by looking for a while at some key details that then operate as invisible portals.

(Maurice Benayoun)

access+links ── for further information refer to website

How can cultural communications be safeguarded? Can a way be found to preserve the public interest in the decision-making process about the sell-off of public property? During this period when the tangled web of competing interests and technological advances is in place, there is a need to reaffirm the doctrine of public responsibility as a price for private use of public airwaves and to establish criteria of acceptable performance. Otherwise, powerful monopolies such as telephone or cable carriers will determine what ideas and images are fed into the cultural mainstream.

Toward the evolution of a global culture

John Barlow, one of the founders of the Electronic Frontier Foundation (a group formed to protect civil liberties in cyberspace), commented:

> Just because I'm observing that a great social transformation is taking place because of technology doesn't mean that I like every single aspect of it. But I do try to adapt to that which I can't change. I do have my own personal sense of whether or not technology is working for me. And that really takes me back to Nietzsche's statement about sin. If it feels to me that technology separates me, I try to reject it. If it feels like it has within it the opportunity to bring me closer, on some spiritual level, to the rest of humanity, I accept it.

Artists who choose the "future position" are vital to the development of the process of cultural response – probing, exploring, and investigating new directions for evolving technologies to reveal their potential for creating meaningful experiences and heightening awareness of social values. They can challenge the establishment of an all-commercial model of the Internet and preserve a sense of critical aesthetic and democratic use. Because interactive technologies call for the creation of works which require viewers to act as co-creators, participants' choices help to shape and democratize the flow of events, in a work which is incomplete without them. Representation is always strongly influenced by contemporary vision and consciousness and by the nature of the production tools and media which underlie the conditions which create the positions artists can take. In his book *Art and Social Function*, Stephen Willats states:

> The realization that all 'art' is dependent on society – dependent on relation-ships between people and not the sole product of any one person – is becoming increasingly important in the shaping of future culture. This divestment of authorship is seen as more relevant to an emerging culture founded on networks of exchange, fluidity, transience, and mutuality, as it ultimately offers us the prospect of self-organization in personal and interpersonal ways.[45]

Notes

1 All of Walter Benjamin's essays have now been translated into English and have been published in two volumes by Harvard University Press.
2 "The Author as Producer" was first a lecture given at the Paris Institute for the Study of Fascism in 1934. It was copyrighted in 1955 by Suhrkamp Verlag. The English version was copyrighted in 1978. It was published in *Reflections: Essays, Aphorisms, Autobiographical Writings*, edited and with an introduction by Peter Demetz (New York: Schocken Books, 1986), pp. 220–38.

3 See *Harper Magazine* "Forum" "What Are We Doing On-Line", August, 1995.

4 Jon Ippolito e-mail comment submission, 2002.

5 Online *Codedoc* exhibition review by Michael Mirapaul, "ARTS ONLINE: Secrets of Digital Creativity Revealed in Miniatures," *New York Times*, September 16, 2002.

6 Mikhail M. Bakhtin, *The Dialogic Imagination: Four Essays*, ed. Michael Holquist, translated by Caryl Emerson and Michael Holquist (Austin: University of Texas Press, 1981).

7 Internet, the communications "highway," was established with government funds through Arpanet for use by the Defense Department in 1969 to handle defense data. In 1984 the scientific community began data transmission and exchange on it. Now it has become the focus of a major shift in telecommunications and the centerpiece of market economies which are based on information exchange, financial services, software development, and communications markets of all kinds.

8 By dialing an "online" service number, you can be connected to the Net through simple communications software that allows you to pass transparently from computer to computer as you browse, sometimes passing through a more powerful machine (possibly in another country) that enables you to receive a magnitude of informational possibilities if you know what to ask for or if you know the code.

9 The neologism *télématique* was coined by Simon Nora and Alain Minc in *L'Information de la Société* (Paris: La Documentation Française, 1978). It is the branch of information technology which deals with the long-distance transmission of computerized information.

10 Quoted in George P. Landow, *Hypertext: The Convergence of Contemporary Critical Theory and Technology* (Baltimore and London: Johns Hopkins University Press, 1992).

11 G. Deleuze and F. Guattari, *A Thousand Plateaus: Capitalism and Schizophrenia*, translated and with a foreword by Brian Massumi (Minneapolis: University of Minnesota Press, 1987).

12 Ibid.

13 Quoted In Roy Ascott, "Is There Love in the Telematic Embrace," *College Art Association Journal* (Fall, 1990), pp. 241–7 (p. 241).

14 Honolulu; Vancouver; San Francisco; Pittsburgh; Toronto; Alma, Quebec; Bristol; Paris; Amsterdam; Vienna; Sydney.

15 Roy Ascott, "Art and Education in the Telematic Culture," *Leonardo* (supplemental issue, *Electronic Art*) (Elmsford, N.Y.: Pergamon, 1988).

16 Ibid., p. 10.

17 Sherrie Rabinowitz in "Defining the Image as Space: A Conversation with Kit Galloway, Sherrie Rabinowitz and Gene Youngblood," *High Performance Magazine* 37 (1987).

18 Darlene Tong, "New Art Technologies: Tools for a Global Culture," *Art Documentation*, Bulletin of the Art Libraries Society of North America 12(3) (Fall, 1993).

19 More than sixty locations worldwide including Russia, France, Germany, Britain, Canada, Japan, Nicaragua, and South Africa.

20 Nam June Paik, quoted by Laura Foti in Lynette Taylor, "We Made Home Television," *Art Com #23* 6(3) (1984).

21 In 1986, he produced *Bye-Bye Kipling*, jumping live via satellite communications networks in real time from Tokyo and Seoul to New York as a way of challenging Kipling's East and West dictum: "Never the twain shall meet." In 1988, he produced *Wrap around the World*, an Olympics tribute, broadcast live from three continents. Paik worried about how people perceive each other in a world that television is constantly reducing to the long-promised (or threatened) "global village."

22 Douglas Davis produced the first global satellite performance in 1977.

23 Anna Couey, "Art Works as Organic Communications Systems," *Leonardo* 24(2) (1991), p. 127.

24 *Art Com* was structured in collaboration with Nancy Frank, Anna Couey, Donna Hall, Darlene Tong, Lorna Truck, and the Whole Earth 'Lectronic Link (WELL, www.well.com begun in 1985) as well as Matthew McClure and John Coate.

25 *Art Com* was a monthly periodical within the context of contemporary art and new communications technology, with rotating editors. It was available in ACEN's News-stand and in alt.artcom, an internationally distributed USENET news group. It was also electronically mailed free of charge upon request to ACEN readers and to readers on other networks.

26 New forms of electronic art technologies included such activities as artists' online networks, satellite transmissions, telefacsimile projects, addressable and interactive video and computer works, and, most recently, virtual reality. Telecommunications imply electronic transmission of information through computer networks, slow-scan video, telephone, radio, television, and satellites.

27 The electronic edition of *Art Com* magazine attempted "to realize publishing as a creative (art publishing as art work) and communicative medium shaped by the community that reads it." Couey, "Art Works," p. 127.

28 LINUX is the main form of an open-source operating system which is not copyrighted and is accessible to anyone who wants to develop software applications. A key part originated with the Finnish computer engineer Linus Torvalds. It is based on the UNIX-based operating system widely used by ISP servers and is part of the large and vibrant freeware movement which is proving that copyright protection is not a necessary condition of software development.

29 Sherry Turkle, *Life on the Screen: Identity in the Age of the Internet* (New York: Simon and Schuster and Touchstone, 1995 and 1997), p. 10.

30 CU-SEE ME, developed at Cornell University, transmitted live digitized video without audio. Live black-and-white video was received in a small-screen format at twenty-four frames per second on a regular or audiovisual MacIntosh or PC with a standard modem and telephone line. To send a video, one needed only a video camera, and a video card capture. Today this software has largely been replaced with streaming video technology requiring specialized software.

31 Walter Benjamin, "The Work of Art in the Age of Mechanical Reproduction," p. 236.

32 "Future Cinema: The Cinematic Imaginary After Film," ZKM Press release describing this exhibition in Karlsruhe, Germany, November 16, 2002, to March 30, 2003.

33 Roy Ascott, "Issues of Content," *CAA Journal* 49(3) (Fall, 1990), special issue, *Computers and Art*, guest editor, Terry Gips, p. 243.

34 Quoted in Rachel Schreiber. "Net.Art: Shedding the Utopian Moment?," *LINK: A Critical Journal on the Arts in Baltimore and the World* 7: CODE (Baltimore, MD: Linkarts, Inc., 2001. www.baltolink.org).

35 Ibid.

36 Muntadas URL: http://www.thefileroom.org.

37 For comprehensive notes on Joseph Beuys's social sculpture see the website of the Social Sculpture Research Unit of Oxford Brookes University.

38 Quoted in Michael Mirapaul, *New York Times*, August 5, 2002.

39 Roughly one-third of those living in the industrialized world have access to computers.

40 Jonathan Crary, "Eclipse of the Spectacle," in Marcia Tucker, ed., *Art After Modernism: Rethinking Representation* (Boston: The New Museum of Contemporary Art in association with David R. Godine, 1984), p. 286.

41 Ibid.

42 Jonathan Crary, "Critical Reflections," *Artforum*, February, 1994, p. 59.

43 Quoted in Stephen Wilson, "Light and Dark Visions," *Siggraph* catalog 1993.

44 Theodore Roszak, *The Cult of Information* (New York: Pantheon, 1986), p. 16.

45 Stephen Willats, *Art and Social Function* (London: Ellipsis, 1976 and 2000), p. 1.

7

Transaesthetics

History as allegory

In her video performance work *Stories from the Nerve Bible*,[1] Laurie Anderson asks her audience to confront the future and to determine whether there is hope for human progress or whether we will sink only more deeply into the violence and social upheaval we are experiencing globally. She invoked the allegory of the "angel of history" described by Walter Benjamin in the spring of 1940 as he fled German fascism. Having lost hope for the future, Benjamin could see only loss and devastation ahead, the past and present a heap of lost dreams. Simplifying the text, Anderson in the first part of her evening-long performance work, which featured projections, moving props, vocals and texts, intones words based clearly on Benjamin's allegorical statement:

> She said: What is history?
> And he said: History is an angel
> Being blown backwards into the future
> He said: History is a pile of debris,
> And the angel wants to go back and fix things,
> To repair the things that have been broken.
> But there is a storm blowing from paradise
> And the storm keeps blowing the angel
> Backwards into the future.
> And this storm, this storm
> Is called
> Progress.[2]

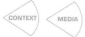

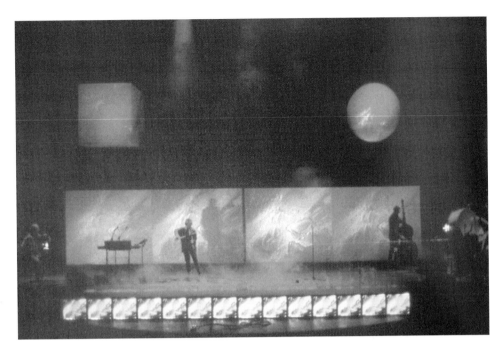

Figure 7.1. Laurie Anderson, *Stories from the Nerve Bible*, 1995, multimedia performance work. Originating at the Neil Simon Theater in New York, this multimedia work traveled to Chicago and Boston and overseas.

Comprising a full-scale mix of songs, video, and slide projections, and fast-changing industrial and postindustrial images, *Nerve Bible* explores the future through Anderson's ruminations about life, death, and pleasure through a chain of stories, songs, and globe-hopping tall tales. *The Nerve Bible* is Anderson's metaphor for the body. She refers often to the impermanence of human life. She sees the human eye as "not being much better than a pre-World War Two field camera – it doesn't even have a zoom lens." While she acknowledges that technology offers the promise of order and control, "One World, One Operating System," Anderson refers often to the bright antiseptic images drawn from coverage of the war in the Persian Gulf: that of a bombing run that looks like a videogame combined with the beautiful light arcs from aerial bombardments. She reminds us that, behind those polished media images, people were dying.

(Photo: Mark Garvin)

Committed to using a variety of technological media tools as a means to amplify powerfully her personal performance with visual elements, Anderson believes that new technological media make possible innovative production for her work, expanding her means of expression. She believes that art has a transformative role to play in postmodern culture. However, like Benjamin, she is keenly aware that the benefits derived from the use of technological media have a negative side to them. There is a tension between the extremes of technology's manifold benefits and its power to control and manipulate public consciousness unduly. Both Benjamin and Anderson understand the paradox technology represents – that it can be the agency both for terrible spiritual and social loss and for enormous social and cultural gain.

see color illustration 10

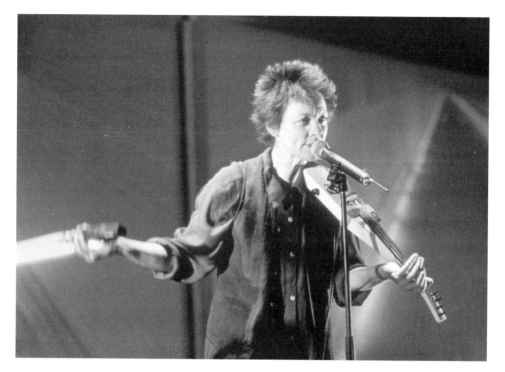

Figure 7.2. Laurie Anderson performing *Stories from the Nerve Bible*, 1995.

(Photo: Mark Garvin)

Artists using technology are caught between tensions of two divergent worldviews

Questions about the use of technology are deeply implicated in questions about the future of art. Contemporary artists attempting to negotiate technologically based media are confronted with two divergent ways of thinking. Many scientists, technologists, and artists who use technology tend to retain a fundamentally positive belief that they are making progress in understanding and mastering their new tools and in the invention of new cultural forms. Those artists who embrace a technological worldview function from an implicitly Aristotelian point of view. Through tools, they gain the access to new forms of knowledge about the world and powerful contemporary means for representation they did not have before. As we have seen in Chapter 1, confidence in the usefulness of observing the real world through enhanced technological seeing is based on the understanding that this is the way to new and potent forms of knowledge. This view is energized by a system of values in which knowledge of the observed material world is fundamental to understanding it.

Cultural analysts tend not to share the same worldview as scientists and technologists. Each group doubts the other. Scientists working in emerging technologies such as virtual reality, artificial intelligence, robotics, simulation, and telecommunications maintain their faith in progress and see their work as unlocking worlds of knowledge, forging new forms of

empowerment and opportunities for human development. They believe in their enterprise and are not usually engaged in the self-questioning typical of the humanities and social sciences. On the other hand, some critical theorists see technologists as having little autonomy in their research, as having constructed behavior and attitudes and as having little concern about the ultimate ramifications of their technologies.

Artists as both makers and theoreticians have spanned both worlds.[3] They see that technology has the power to create significant cultural experiences. At the same time they are critical of the very consciousness-transforming tools they employ to comment on contemporary social implications of its use. Artists who use technology struggle to negotiate the dilemma presented by these conflicting simultaneous directions. The artists who work in these media face particular challenges. For one thing, many cultural critics are averse to even recognizing their work. They so deeply distrust technology and the losses it will bring in the future that they often do not want to look at an art that uses it as a means of representation. For another, they must contend with scientists whose optimism often does not allow for any of the skepticism, criticism, and philosophical complexity so necessary for the creation of contemporary art.

Artists live in a state of tension between these two positions They must understand the dilemma provoked by change. Still there are barriers to understanding the social and cultural implications of powerful new technologies, unless we are ready to learn the lessons of history that can apply to the crisis of the present.

The fantasy of a harmonious and affluent future as promised by the new technologies has been mythologized and used as a form of successful ideology in order to obscure real conditions – that actual technological changes have been accompanied by so much privation, conflict, dislocation, and wrenching transformation brought about by the unbridled appetite of global capitalism. The promise of the future as it resonates in popular dreams and expectations amounts to a faith in a better tomorrow through a "technological fix." It has been tied to a society based on mass consumption where a firm faith prevailed that democracy and technology were symbiotic. "As an ideology, a powerful system of rhetoric and belief, technological futurism . . . faith in technology (or more accurately, in the future as promised by technology) became not only a kind of secular religion but also a substitute for politics"[4] (and social justice). This faith continues to influence policy-making at all levels even though there is significant change toward widespread awareness that the media are being used to manipulate public consciousness. Prototypical of the dangers Walter Benjamin warns us of in the negative applications of technology are politicians who embrace electronic media technologies as an integral strategy in their drive to power. They use television, the Internet, and the fax machine as powerful tools for conveying their rhetoric.

Media theorist Marshall McLuhan, who wrote about the global village in the 1960s,[5] saw electronic media as extensions of the human body. "We put our whole nervous system outside ourselves." He believed that each new technological advance would both shape humanity and traumatize it. "We shape our tools and our tools shape us." His views resonate further with us today. When a television camera is mounted on a tank as part of an invading force, viewers seem to be traveling with it as though they have become part of the rolling military operation. The cameras are rolling with them in real time. There is general confusion as to who is acting and who is watching. Those who conduct the war are also watching it on television. The *New York Times* asks: "When a camera is mounted on a tank, which is the more powerful weapon?"[6] Watching the action, one strangely becomes a performer in it.

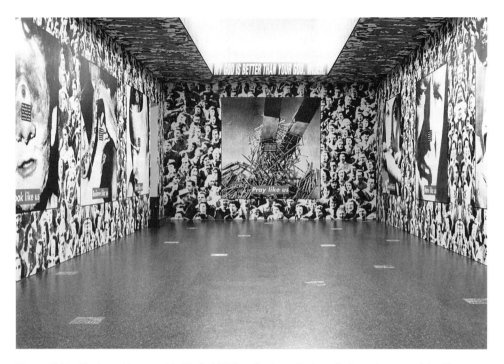

Figure 7.3. Barbara Kruger, *Untitled*, 1994, mixed media installation, photographic silkscreen on paper.

In this gallery-sized installation, Kruger extends her practice of using graphic black-and-white found images with red-and-white text panels. In this one, the texts announce around the top of the constructed room, "My God is Better Than Your God, Wiser . . ." The large image captions "Hate Like Us", "Pray Like Us," "Fear Like Us," "Believe Like Us," "Look Like Us" appear on top of their antithetical images. Imbedded in the floor are text plaques which further arrest the viewer's attention. The totality of the installation is a powerful sense-around experience of media, forcing an examination of this disturbing theme in today's climate of ethnic, racial, and religious wars.

(Mary Boone Gallery)

Representation changes

New imaging technologies have more and more challenged conventional notions of representation. As we have seen in Chapter 1, representation is a complex system which refers to the most significant aspects of art practice. Representation not only refers to realistic productions of reality but encompasses all forms of art production, including symbolic manifestations, aspects of an image's likeness, and imitations or copies of work in some material or tangible form including abstract symbols or forms. Most often, representation refers to a work of art in which emotion and intellect aim to depict things as they actually appear to the eye. Representation is the making visible of products of the imagination. The artist sees and yet may represent something only related to what one sees. The *means* of representation is the tool or the medium by which something is represented. As we have seen in Chapter 1, there is a tension in the way representation and the *means* of representation intersect.

Representation is part of a larger frame of reference. It changes at different moments of history. When a shift occurs in a cultural paradigm, representation changes. All theorization and research is shaped by the guiding assumptions of the new paradigm. Since the Enlightenment the following questions have dominated art discourse: What is the function of art? What is useful and significant to look at? Who has authority? Who should one believe? Who are the most important artists? All of these questions presume the stability of the work of the artist; the position of the observer; the integrity of the subject and of the author. That was all assumed within modernism. All that changed with the shift to postmodernism.

With digital technologies we no longer have a spatial fixed-point perspective; with morphing, we no longer have fixed spatial or temporal relationships; reality can now be paralleled by a completely simulated (virtual) one. Digitization has destroyed the faith in the truthfulness in representation.

Cultural conditions have dramatically changed. Technologically based art does not just change the kind of art that is made and our relationship to it, but it changes the nature of human perception. Technological instrumentation makes it possible to see things that could not have been seen before and to see them in a way in which they could never before have been seen. Just as photography and the cinema opened the world to an expanded consciousness of the close-up, the far distant view, and the psychological, through editing and out-of-context views, so has the use of digital technologies allowed for the complete restructuring of the visual, opening to new territory of completely simulated, or virtual, reality with entirely different space relations. In new forms of technological representation, such as database ones, the technological tool is integral to the form, content, context, and process of the art, not just a way of transmitting it. Interactive digital media are international, inviting participation from individuals globally. Every desktop is now a printing press. Digitized images are set immediately into the electronic page setup for printing in millions of copies. Computer networks can act as broadcasting stations. We are only beginning to realize the implications for education and community relations, using powers at our fingertips. "The world has . . . become too small for an ivory tower mentality."[7]

Images are becoming entirely mediated. Instead of a photograph, an artist may present a disc either for viewing the work on the computer screen or for printing it out on a laser printer or other device in large or small format. Its appearance will depend on the image resolution provided by information formatted in the disc and by the technical characteristics of the viewing medium. Representation opens to include new aspects now that images can be linked directly to the text and to sound. Digital distortion of image structures allows for the small to appear large, or vice versa; for positive and negative or be turned inside out; for objects and people to be inserted seamlessly into any image structure on the computer; and for the easy manipulation and alterations of color and tone to create different effects. Totally new kinds of recombinant forms can be constructed to create images of great strength and beauty. Interactive capabilities can create works that require audiences to act as co-creators. Some works are incomplete without the viewer taking action. On the Internet, we democratically become part of an art work and travel with it, adding to its content in constantly changing contexts. We are closer to the imaging processes of the imagination linked to dream or logic. With virtual reality, we enter a world of complete simulation moved by a new perspective and new kinds of constructed forms. All of this has led to the destabilization of the image, of the art object, and of the function of art in daily life. It has also led to an overloaded image culture.

In each of the media we have been discussing, there is evidence for the future of unprecedented advance and expansion in the possibilities for representation and convergence of media. Forms of technological representation have potentially, a democratizing influence. Technological tools are capable of making endless copies, of transmitting images over long distances, of communicating and exchanging ideas and information far afield. Images can now be reproduced, scanned, digitized, or simulated, reprocessed and manipulated, edited, transmitted internationally via satellite or on the Internet. They may be downloaded and printed digitally using electronic printers of all kinds. They can be inserted seamlessly into other images as either still or moving elements to create a true impression of a false reality. They can be instantly copied, reduced, enlarged, changed from positive to negative, or printed in color.

Whether or not representation has changed, the culture it is operating in has. Traditional ways of looking at the world have become obsolete. Technology is the new language through which experience is understood.[8] Computer terminals and television monitors connect us to language and image sources that we require to reach others and see ourselves.

Predictions about the end of art

As early as 1827, Hegel was predicting the inevitability of art's end. In 1839, when the invention of photography was demonstrated, Delaroche announced the end of painting. Similar predictions arose at the turn of the century, in the 1920s, and in the 1960s. Again, at the beginning of this century, more predictions have emerged. Despite those dire predictions, in each of these strikingly new periods the concept of art did not die. Definitions of art alter with historical and technological change. Art and time are related: art functions as an alternative reality which grows out of the contrasting principles of the dominant worldview by which we live. As we have seen, attitudes toward representation and the art-making that grows out of its assumptions have always been shaped relativistically by powerful social and techno-logical forces, a relationship which is more and more coming into focus through the process of theoretical analysis, revision, and deconstruction. In his important essay "Revising Modernism, Representing Postmodernism: Critical Discourses of the Visual Arts," critic Michael Newman discusses the progressive stages:

> It is possible to isolate two tendencies under modernity which could be taken as answers to the question "What is art?" One answers "Art is art": it is the tendency towards autonomy, "art for art's sake." The other answers "art is not-art": the category of art is supposed to "wither away" into social and political practice and/or theory. If we recognize anything as "postmodernist," it is the impossibility of either answer. Art as supposedly autonomous remains depen-dent upon its Other for its very autonomy, and so is infected by heteronomy. And artists' repeated attempts to defeat art have either been re-incorporated into art, its institutions and ontology, or else have forgone the radical potential that inheres in art's relative autonomy.[9]

Newman's analysis suggests that the need for art as an autonomous force in society does not fade or change, but rather our perspective changes about its role and its form. The latter are subject to wildly fluctuating external influences in the form of political and social forces

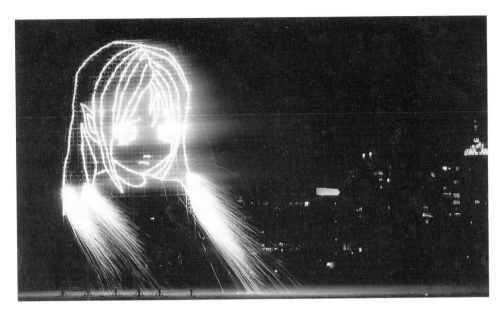

Figure 7.4. Pierre Huyghe with Philippe Parreno, *A Smile Without a Cat (Celebration of Annlee's Vanishing)*, December 4, 2002, fireworks display.

Pierre Huyghe has been interested in the discrepancies between the real and its representation, primarily in modern entertainment industry media, since the early 1990s. Buying the copyright to a magna drawing from a Japanese firm in 1999 was, for Huyghe and Philippe Parreno, an experiment in testing the perils of image rights in the digital age. They named the *anime* character Annlee and created, as a new kind of platform for the artistic community, the Annlee Association, which now held official rights to her image for a limited time. A dozen artist friends were invited to realize works based on Annlee which became the foundation for an international traveling exhibition about naming, signification, representation, copyright. Amongst others, a panel "Creativity and Intellectual Property: What Would Annlee Say?" was convened at San Francisco Museum of Modern Art. Turning on the problematics of appropriation and ownership, the exhibition raised questions such as: What are the issues when Annlee moves from paper to video? From a drawing to an operable digital model? Why could her image be used only for a particular limited time? On December 4, 2002, the mournful image of the *anime* waif Annlee lit up the sky over Miami Beach and vanished into the night.

(Marian Goodman Gallery)

which grow inevitably out of changing technological conditions. These transform awareness, provide new tools from which new art forms develop. Each time the conditions of a new paradigm arise, the question "What is art?" surfaces. We are once more at this juncture. Once again we are examining art's different categories of value, such as use value, exchange value, commodity value, aesthetic value, exhibition value, as well as its different categories of production, whether by hand or by technological means, and what these entail. And we are examining its forms of dissemination; and its effects. The question is not whether art is dead but how the need for it has been transformed by technology. In the contemporary world, the questions need to be about how technology is being used for art and what new forms are evolving from its use.

Technology can be both medium and tool

Each machine places its own imprint on its output. The high-contrast effect of the photocopy is completely different from the dithered look of a projected "virtual" computer image or the dithered effect of a video image with its moving raster lines constantly refreshing and changing with the movement of the image. Most tools such as camcorders and computers can also be thought of as mediums in their own right. When artists use the tool their final production is a complete system integrating production with statement. A photographer with his or her camera or a painter with brush or canvas can say that tool and medium are conjoined. However, some artists, like those in the nineteenth century we have discussed in Chapter 2, wish to use technology only *as a tool or as a means* to reproduce work or imagery which has arisen through other means such as still photography, drawing, painting, or sculpture.

All traditional media have been recontextualized as a result of dramatic developments in electronic technology. Can all the media of the past find their place within the same essential individual relationship to image-making? Earlier in the century, Man Ray said, "I photograph what I do not wish to paint and I paint what I cannot photograph."[10] Today, a growing number of contemporary artists exploit the potential of electronic tools in combination with hand skills and more traditional media for what they can offer in terms of scale, effect, style, expressiveness, economy, and all-important communicating effects. Others seek to use the computer as a medium to create an alternative reality which could be achieved in no other way – such

Figure 7.5. Chris Ware, *Building Spring*, 2002, ink and pencil on board, 20in. × 29in.

In creating his visual narratives, Ware combines a variety of visual languages into a single stream, although its narrative is not a linear story. His work is unlike any comic book you've ever seen because of its levels of complexity. Each page of his work is broken into an extraordinary array of narrative compartments, characterized by wildly diverse scale and expressive color. His compositions are sometimes filmic, at times resembling scientific flow charts, and at times looking like abstract paintings. In his most famous chronicle, that of the Corrigan family – a narrative of repetitious family dysfunctionality over four generations – his drawings turn their story into a surreal Pilgrim's Progress of an American coming of age.

(Chris Ware)

as a projected Internet or 'virtual realty" production – or to work in new forms such as CD and DVD.

Now that commonly available graphic communications tools such as digital video cameras, fax machines, photocopiers, personal computers, and printers have entered into use by a wide public, they are beginning to change the image-cultures in which they exist. Because they are available as imaging devices to a wide population outside of the usual cultural communities, a new populist circulation of images with disregard for "high culture" has arisen through mail and fax-art projects or exhibitions on the Internet, and through new distribution routes. This vernacular phenomenon has been referred to as a form of technological folk art "volks" graphics or "zines" as opposed to more elite forms of representation. As technologies age, and become more accessible and more deeply embedded in cultural usage, a different kind of art-making arises. Already, so-called digital "tekkies" or "cyberpunks" acquire outdated equipment that is being junked and continue to challenge its use. Their fresh aesthetic is based on simple graphic applications and a populist imagination. Like the alternative magazine and music culture of the new generation, "zines" are technological productions which often powerfully touch the public nerve.

Reconfiguring the negotiation of cultural meaning

In a period in which cultural politics dominates, in which revised assumptions and discourses deconstruct and dismantle the Western tradition, and in which new technologies are having a destabilizing effect, the negotiation of cultural meaning has become even more fraught with difficulty. Questions arise about the role of the artist along with questions about audience and the function of art. Now that creative work can be distributed or transmitted widely, art may come to focus on issues of communication and interactivity. Creative work may proceed entirely outside of museums and galleries, traditional institutions of art.

Modernism was predicated on the concept of original vision and genius as connected to the conception of a unique self and private identity. As we have seen, this vision of the artist as a creative genius is still deeply ingrained in the Western tradition. The theoretical basis of that kind of individualism is ideological and political.

Artists using contemporary technological means for their art practice can assume many stances in today's climate. On the one hand they could engage in a modernist art practice that assimilates technologically based art within the same conceptual framework as drawing, painting, and sculpture without using it as a means of cultural critique. It then becomes sublimated as a tool for art-making. On the other hand, they can fully engage electronic media in a practice which critically analyzes contemporary media-dominated cultural conditions using the very tools which power it. Whether they choose technology as a medium or as a tool for their work, contemporary artists have access to concepts, themes, and methodologies for creating art works which reflexively examine the process of representation itself. The intentions of some may be to destabilize and expose the narratives of mass media, which cast doubt on normalized perceptions of everyday life. Stephen Wilson comments that, because technology is associated with the very cultural concepts being examined through theoretically based analysis:

> Artists using electronic media for their work can directly and critically tackle the
> mediated sign and codes that shape contemporary life working from within the

system. Some artists study the media to such an extent they become capable
of knowledgeably imitating, subverting, and redirecting its meaning. Further,
it shows the way to a more general critical practice which, surrounding and
playing off art, might place in broader circulation an important body of issues
and ideas.[11]

This gives to art a critical responsibility and political potential it is often denied.

Another stance in art practice would be for artists, while remaining aware of the dangers
implied by the uses of technology, to enter into the heart of the inventive process itself, making
themselves available at the core of activity to help elaborate, humanize, and develop the new
cultural forms. The Internet offers more possibilities than ever before both to create the
new cultural forms and to disseminate them.

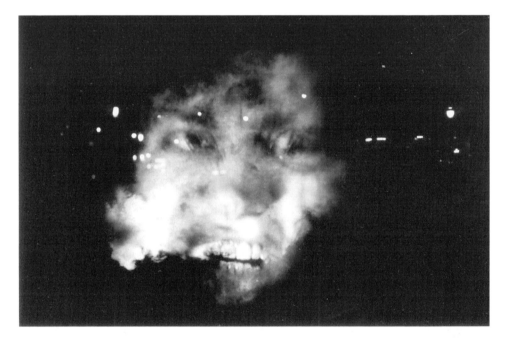

Figure 7.6. Tony Oursler, *Influence Machine*, 2002, outdoor projection with sound in Madison
Square Park, New York, and Soho Square, London.

As a way of dramatically calling attention to the social and psychological impact of media today, Oursler
created a public projection project which comments on how much we have shed our bodies to embrace
the virtual with its promise of interconnectivity. He researched media history to track the long drive toward
the paradox of mind/body separation, and found the evidence of nineteenth-century pre-cinematic
phantasms and superstitions about electricity that gave him the idea for this project. On clouds of
chemically generated smoke surrounding the surfaces of trees and a pond in the park, he projected
disembodied heads. These presences quote historical figures and poetic texts produced for the project.
A street lamp in the park seems to speak as it undulates with the sounds of a human voice. A small
figure with a computer-animated face becomes an interactive public conduit as it gives voice to messages
received via the Internet throughout the installation.

(Metro Pictures)

All art makes a comment on the ideology of everyday life. It is the nature of art to speak of the moment, in one way or another. Art can be expressive of progress or of alienation: thesis–anti-thesis. Steven Durland, writing on the future of art, commented: "We can easily get lost in thinking that art is about theories, deconstructing, reifying and the like. Those are just the tools for understanding. Sometimes they are the right tools. The important thing is that artists are trained to look and they're trained to express what they see and understand."[12]

Technological tools such as video and the computer can blur the lines between the production of fine-art works and commercial and design production. Artists must contend with these high/low boundaries if they wish to stay firmly within traditional fine-art discourse of cultural institutions. If however, they wish to participate in a mass-audience field such as film, television, or the Internet, they can seek to develop hybrid aesthetic strategies to suit their intentions of communicating within a wider field. It will be difficult to keep their ideas intact as they struggle for access to equipment, funding, and collaborative expertise to create meaningful works with such powerful, demanding media.

Now that the image is digitized, residing primarily within the mainframe of the computer or in cyberspace, art becomes more and more defined in symbolic non-visual terms. As we

Figure 7.7. Christian Marclay, *Video Quartet*, 2002, 17-minute four-screen DVD projection.

Marclay was trained as a visual artist, and much of his work in experimental sound has long been concerned with the gap in the relationship between imagery and sound. In *Video. Quartet*, a fast-paced flowing production created with sound and image bites borrowed from hundreds of films, he brings music, sound, and image into a perfect, amusing alignment, bringing together seeing and hearing in an ecstatic synthesis. His fastidiously arranged grouping of sound bites connected to the clips of the original films he collaged can be said to be a rhapsody of sound sampling. According to *New York Times* critic Roberta Smith, the work "makes new sound out of old in a process of split-second editing that has kaleidoscopic visual effects. It is an illustrated score in which the illustrations produce all the sound while also cataloging scores of movies, clichés and narratives."

(Paula Cooper Gallery; Photo: Ben Blackwell)

have seen, the work may be composed as an interactive system designed by the artist to be collaborative with the viewer; it may be programmed with minimal visual resolution for the Internet combined with text-based directories of information; it may be created for viewing via the computer as a CD or DVD, a world of moving image and text designed to be "read" as a composite multimedia experience.

In all of these examples. the ontological status of the image as we have known it becomes destabilized, a further extension of dematerialization (Chapter 3). It is capable of being constantly invaded and changed by other images. These new conditions present the opportunity for audience participation and communication. However, they also represent a terrible loss to artists that will keep them from creating works in the same way that they always have done. Benjamin described the arrival of cinematography as a medium and a tool which shattered existing traditions of representation, the effects of which we are only beginning to understand and fully integrate into the visual arts canon a century later. We are now at a more extreme moment of change in representation with the database as a new cultural form, one which challenges traditional ideas of linearity and narrative, and can be distributed widely on the Internet.

The artist's role

There are real risks in using technology for making art. As we have seen, since the 1970s, there has been the danger of dominance by a powerful new technique which can subvert the experimental character of art with its dedication to raising questions and to exploring meaning. Because access to technology is costly and often difficult, artists may have to make important artistic, stylistic, and political concessions in order to obtain funding for their projects through governmental or corporate institutions. If the project is not a popular one, and does not fit the current funding guidelines, it may never be realized. The technological art work is then sometimes controlled by forces beyond the power of the artist. Through coercion, or cooptation, the art work might be used as a tool to maintain institutional values rather than as a means of questioning them. However , with increasing access to the Internet, artists are able to create "homepages" which allow others to study their work or for themselves to be able to research those of others in a growing community of distribution and exchange which is, in many ways, opening higher levels of communication and perception in the arts.

Historically, there have been many ways of representing the artist's role. Among these many, one is as a prophet, pointing to a possible future society; another is as a dissident reflecting the alienation of the marginalized. Yet another is as a public intellectual representing philosophical or conceptualized issues. Many thinkers believe that the artist's role is as a citizen of the future – and that artists must be more involved in society and community. They see the artist as a cultural worker, sometimes involved with public art projects, with responsibilities to be involved in its transformation. As such, the artist must be engaged in a continual process of evaluation and assessment of present social options, locating and understanding important contemporary issues.

It can be said that historically the self-representations of artists have fallen into categories that have been available to them. Under the pluralism of postmodernism, the artist can encompass many roles. There is not any clearcut definition of the artist's role.

In one way or another art is a reflection of the contemporary moment. The conditions artists face have been brought into focus by, among many others, contemporary writer Celeste

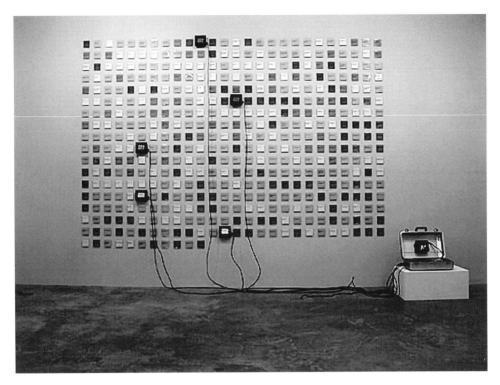

Figure 7.8. Jennifer and Kevin McCoy, *448 Is Enough*, 2001, installation environment.

In this piece, the McCoys have created the kind of archaeology of entertainment narratives they have perfected by dissecting shot by shot single episodes of commercial films and television soap operas in order to focus on the repetitious nature of these formulaic creations and their systems of violence. To make *448 Is Enough*, they broke down one of the episodes of *Eight's Enough*, a family television series, into 448 constituent shots. These are compressed, numbered, gridded onto a single wall and hung with small monitors according to where commercial breaks originally occurred. The installation uses the time scale of the show to map the structure of time onto a wall. A small suitcase on the right is used to watch the show, one shot at a time.

(Postmasters Gallery)

Olalquiaga,[13] a contemporary writer who discusses postmodern conditions. She notes that the formal mechanisms and functions of modernity remain, although its utopian beliefs have been exhausted, leaving disillusionment in the failure of utopian aspirations. This loss of the dream of progress leaves in its place skepticism, a sense of temporal emptiness with a past whose beliefs have been discredited as stale and insufficient. The complex image world in which we live requires informed, trained artists who can bring unique perspectives to the task of interpreting and reshaping culture. Contemporary artists must engage in self-scrutiny and self-revision; must be involved in research, have a capacity for empathy and compassion; have an urge to explore the unfamiliar and be comfortable with uncertainty. Above all, they must realize their power to create works that are needed both as interpretations of the contemporary and as acts of witness.

Figure 7.9. Krzysztof Wodiczko, *The Tihuana Projection*, public projection for the Centro Cultural, Tijuana, Mexico, February 23 and 24, 2001. The closing event of InSite 2000, a seven-month public art festival on both sides of the Mexican–American border.

El Centro Cultural is a huge globe-like structure (designed for an I-MAX theater) which dominates the mall-like center of the border city of Tijuana, Mexico. Because the city is the center of border factories, or *maquiladores*, which exist there to exploit low-paid workers for transnational companies, it has become a symbol of difficult social and psychological crossroads for the large number of primarily female workers who come there from all over Mexico. Seeking to manifest the presence of this silent, faceless mass, Wodiczko fitted six volunteer women from different age groups with specially designed head-mounted camera-microphone and wearable transmission equipment which amplified their voices. The face of each of the women was projected onto the huge Centro Cultural's globe. Their voices could be heard clearly in the square. In this public transmission, the women voiced the difficulties of their personal situations – domestic and sexual abuse, exploitation at the workplace, police violence – trying to find words for the events rarely addressed either in their culture or in the media. For the women, this was a transformative psychological and ethical step forward. For the public in the square, co-actors in the event, it created a dynamic bridge to possible interventions in real life.

(Krzysztof Wodiczko and Galerie Lelong, New York)

Educating artists for a new era

Media domination of our culture has created a malaise which is symptomatic of a crisis in fundamental assumptions about society, culture, and the meaning of art itself. In response to this malaise, the European Community launched an extensive study on the future of European art schools. Writing in reaction to the questions being asked, Don Foresta, a professor at the Ecole Supérieure des Arts Décoratifs in Paris, proposed that "schools must teach the new technologies, debate their role in society, master their use, and renovate visual languages. They must humanize the new technologies by better adapting them to human creativity fulfilling a role that may never be accepted by the marketplace, but which could have a positive impact on it." Art school should provide an important forum for discussion about technological development and artistic endeavor throughout the last century and up to the present. It is not enough for students to master the operation of the machines, they must understand artistic, scientific, philosophic aspects of twentieth-century history.

Foresta recommended that art schools should be linked to promote "further exchange, interactivity, cross-over, shared resources, and a more organic system with enormous numbers of routes through it providing opportunities beyond the possibilities of a single institution. . . . Networking is becoming the organizational framework for many future tasks and activities and it is important that artists are active in what is becoming a future institutional form."

Foresta has been instrumental in setting up network programs to explore their potential for the arts. Art en Réseau is an association made up of thirty French art schools. The schools, with the help of the French Cultural Ministry, have acquired a collection of French, German, and American video art which is managed through the telematic Minitel system. Implicit in this network is the idea of a virtual faculty with student–teacher interaction over long distances.

Artists as necessary innovative partners

According to a report sponsored by the European Union, there is value and urgency in encouraging the development of cultural institutes in which artists collaborate with researchers in developing new technologies. The report states:

> Economic growth will depend on the existence of a new media culture which is innovative, diverse, inclusive, and challenging. Cultural activity in digital media is driving innovation at all levels, with a constant movement of skills, ideas, individuals and infrastructures across different sectors. Innovative market activity can only be upheld insofar as the "nonprofit" creative research it depends on is fostered on a permanent, continuous basis, and sufficient fluidity is encouraged between the commercial and "non-profit" sectors . . . A technical infrastructure for cultural activity needs to be implemented along the same lines as the well-established frameworks of the scientific and academic networks . . . To be effective, culture as much as science requires its domains of primary research, which need to be supported by appropriate environments and resources (e.g., independent research laboratories for media art).[14]

Canada's Centers for Research on Canadian Cultural Industries and Institutions hired Michael Century to analyze how innovation is generated by forms of hybridized cultural

research mediated through artists' involvement in technological development. His paper "Pathways to Innovation in Digital Culture" (1999) analyzes the history of such collaboration and has anxious concerns about the possible cooptation of artists by the commercial realm. Too much exposure to this realm could lead to a loss of criticality in the arts and a growth of acceptance of technologies designed to automate public life, rather than to act as creative partners in re-humanizing the technological conditions we inhabit.

However, he concludes more optimistically by noting that, with the greater access afforded by low-cost technological infrastructure now available to artists, there is less necessity for long-term residencies in commercial labs or the models of ZKM and ATR. This places the artist in the role as a kind of invitee, one regarded as a necessary extension to the field of innovation who can plug into the projects at hand more as a creative partner rather than being sucked into the totality of its research and development. While theory is an important issue for the pioneering artist, new media fosters "learning through using . . . [this] . . . is how artists have always fashioned their poised balance between form and content, technique and idea."[15]

Century wishes to see wider awareness of the potential of an "engaged style of cultural support modeled more on innovation than traditional notions of patronage" as a way of reconnecting (in theory and practice) art, science, and technology as forms of instrumentation and sense-perception.

A new geography of culture

Attempting to assess and capture the complexity and conditions of our time, the curators of Documenta 11 created an exhibition in 2002 which raised searching questions about cultural change in the extreme transition we are experiencing. They asked: Is visual arts practice a method of inquiry, a form of knowledge production? What constitutes the visual? Is it only the world of the retinal? The discursive and non-discursive? Can it be just a mediated spectacle? If culture does not respect boundaries – is it ready to go beyond borders, beyond language? Do our visual forms of culture reflect the times we live in?

The six curators of the exhibition headed by its Nigerian director Okwui Enwezor believed their purpose was not to be mere "taste makers but to produce knowledge – not just of art, but of the world in which it is made." They felt that tracing contextual questions about world conditions through art alone was not possible and structured the exhibition as a series of five platforms which would take place over an eighteen-month period in different parts of the world – Berlin/Vienna; New Delhi; St Lucia; and Lagos, with the final platform being the exhibition in Kassel, Germany, itself. Because Documenta takes place only every five years, it is an event that is respected as one which can define themes that are less superficial than those of all the many biennial exhibitions which now take place on planetary circuits.

The platforms brought together a cross-disciplinary group of historians, social scientists, anthropologists, writers, filmmakers, and artists – to create open debate and exchange during the free-floating platform seminars on topics such as "Democracy Unrealized," "Experiments With Truth," and "Under Siege." This strategy allowed the exploration of contemporary issues of transnational subjects related to migration and displacement of populations worldwide which the curators felt are major indicators of our times. The interdisciplinary attitude of the curators is a reflection on the fact that many of the most significant thinkers now associated with modern and contemporary art come from outside the field. Many of these maintain that we are at the beginning of a crisis where we must follow the trajectory of art as a work of imagination while challenging given notions of art.

Enwezor sees the exhibition "more as a diagnosis than a prognosis" and "an expression of social change," inclusive of culture worldwide. As a result, the exhibition was structured to fill in the gaps ignored by European and American institutions. More than half of the artists come from the developing world (including those coming from outside their diasporas). Some, such as Mona Hatoum (Palestine) and Shirin Neshat (Iran) amongst many others, are well known in the West. Enwezor speaks of art works that wage "a productive resistance" to the culture industry. He questions arguments of art for art's sake: "how can you sequester art from politics and social upheaval?"[16]

The goal of Documenta with its constellation of platforms was to journey beyond the "world of contemporary art to the world of contemporary ideas." Some critics worried that theory and the seminars, coming first, would make the art a theoretical by-product. However, Documenta's vast labyrinth of buildings, spaces, hallways displaying an amazingly rich variety of visual works helped to dispel those fears for many.

The exhibition in many ways bridges a gap between the two poles that currently exist in the art world – one ideological, the other aesthetic. One pole is hedonistically convinced that the future of art is defined by exploring and discovering new forms of beauty. The other maintains that beauty is a "bourgeois ruse" and that separation between art institutions and the outside world needs to be radically engaged. The themes of Documenta – ethnic and social conflict, forced migration, political instability, urban unrest – are revealed and explored in countless ways, through photographs, video, films, and DVD installations, written texts, and a few Internet installations. But the distance between the two poles seem transcended in these works. The curators have walked the dividing line by choosing art "in which both protest and visual pleasure are often deeply interwoven."[17] Most of the artists are as fully involved in creating the formal structure of their works as they are in getting across their messages.

Critic Peter Schjeldahl, in his *New Yorker* review[18] of the exhibition *The Global Salon: European Extravaganza*, reacted to the expanded field of transnational, transgenerational global players from forty-five countries in the show including those from several African nations, Indonesia, Iran, Lebanon, Singapore, Vietnam. He points out that the global spread of multi-culturalism has been taken to a new level in this exhibition, which brings with it many new conditions and points of view. He writes: "in today's convulsive world, everyone must learn new things. I was obliged to include myself: a New York art critic who left Kassel uncomfortably marginalized."[19] In speaking about the examination of art works and ideas at Documenta that have been left outside the mainstream art world for so long, Thelma Golden, Deputy Director of the Studio Museum in Harlem, New York, commented: "The outside is the new inside."[20]

In Documenta, careful exercise of the curator's craft is clearly evident through the effective placement of photographs, installations, and some objects so that they illuminate each other. Their choices make viable connections between the different buildings, rooms, hallways, and turrets in their different sizes and complexities in a non-linear, multiple-choice style. Some critics took issue with some of the choices as discrepancies in the balance of represented works: e.g., not enough paintings, too few Internet works.

David Small's sophisticated digital book which allows the viewer to explore the United Nations' Declaration of Human Rights by touching its paragraphs is a new experience of the Charter's significance. (See p. 188.) Chantal Akerman's three-part installation *From the Other Side* explores the tension on the frontier between Mexico and the United States via an Internet webcam connecting the virtual reality of live border scenes to the concrete gallery space in a flow of continuous images. (See p. 147.) She brought these images night and day

Figure 7.10. Shirin Neshat, *Tooba*, 2002, production still of video installation.

Neshat allows us to draw larger truths from what we actually see when we view the two different projection sets in the installation environment of Tooba. Neshat's realms are always ones which both perpetuate and challenge our myriad assumptions and associations. We first see a tree on a hill surrounded by a circular wall. On the opposing screen, we glimpse a delineated path winding across empty dry hillocks. Moving closer to the tree, we see that it encompasses the body and features of a woman who seems to be part of its structure. Gradually a long line of men begins to appear over the horizon and makes its way toward the tree enclosed within its defined wall of stones. The men stand at the edge of the wall, but do not penetrate it. We are captured in the midst of Neshat's cinematic poem of tradition and epiphany embedded in these two opposing representations.

(Barbara Gladstone Gallery; Photo: Larry Barns)

to Kassel, combined with film and video, to call attention to the perils of immigration between two very different worlds. In her poetic multiscreen installation space, Shirin Neshat uses images of a tree morphing with that of a woman. The tree/woman stands alone in a space surrounded by a wall. In the distance, a long parade of chanting figures approaches to pay tribute at the wall's edge. The work gives a deep sense of the poetry of grief and renewal.

Anwar Kanwar's *A Season Outside* is an exploration of the Indian–Pakistani military frontier in Kashmir. His documentary's skillful shooting and structure, while portraying the local, imparts a universal sense of today's dislocation and displacement of populations. A very public website, Distributed Justice, created by Croatian artist Andreja Kuluncic and her many

collaborators (see p. 259), deals with difficult issues of distribution of goods in society in relation to one's own social and ethical sense of justice. The work successfully encompasses both the virtual tools of the website and the real processes of connection to the reality of open discussions, talk, lectures which question and engage what is "just" and "unjust."

⦿ ⦿ ⦿ ⦿ ⦿ see color illustration 8

Digitally expanded: the future of cinema and narrative

The proliferation at Documenta of video and film installations in darkened rooms gives rise again to the issue discussed earlier about the transition from the "white box" environment of the gallery to the "black box" of the cinema now taking place in gallery and museum environments (p. 142). *Future Cinema* is an exhibition which encompasses current art practices which both embody and anticipate new modes of expression while growing out of cinematic tendencies evolved through the domains of video, film, digital, and Internet-based installations. It sees the cinema as an unfinished project which now must deal with non-linear approaches to storytelling. While linear narrative is still the all-time cultural favorite (see Chapter 4), curators Jeffrey Shaw and Peter Weibel focus the exhibition on the emergent expressive possibilities which derive from the multiplicity of inventions and techniques which affect modalities of representation and intercommunication. They are interested in the social dynamics of the new forms of experience now evolving because they tend toward major forms of cultural renewal.

⦿ ⦿ ⦿ ⦿ ⦿ see color illustration 12

Both curators see the exhibition as "an appreciation of the radical impact that the increasing shift to digital techniques is having on the nature of the cinematic experience . . . the digital is offering . . . differences that are not just other ways of achieving analagous artistic objectives, but with another set of technical constraints and therefore another set of formal strategies."[21] Apart from types of immersive environments (discussed in Chapters 4 and 5), other directions come into focus. *Remapping* encompasses the reuse, referencing, reframing, and recycling of image appropriations from our cinematic heritage so as to propose a new modality of perception and apprehension. Updated forms of collage and montage developed a century ago (Chapters 1 and 2) now become multimedia database structures.

Transcriptive experiments with traditional notions of cinematic narrative are in conjunction with a work's installation spatial environments. This kind of experimentation allows for multiple layerings of interactive narrative that can create branching loops and the reassembly of narrative paths.

Recombinary strategies of development make use of a work's underlying algorithms as controllers of seemingly chaotic narrative systems. These combinatory permutations of defined narrative systems are controlled by the algorithm which defines the artistic definition of each articulated work. A common example here is of well-known video games such as *Myst* or *Quake* or a more sophisticated form, *Proxy*, which use software-generated formations rather than real "captured" images (although these works may deal with artificial representations that mimic and synthesize image structures).

The *distributed* forms and modalities of Internet telecommunication technologies (Chapter 6) have had an enormous impact on cinematic imaginary and will dominate its future

Figure 7.11. Jeffrey Shaw, *Place Ruhr: Room With a View*, 2002, cinematic installation. With Mathias, Kiel, Nelissan, Waliczy.

In this installation, a rotating platform allows the viewer to interactively rotate a projected image within a large circular projection screen to explore a three-dimensional virtual environment made up of various panoramic locations in the Ruhr area mixed with cinematic events. The complex mechanism of the project involves use of an underwater video camera located in a column at the center of the piece. This acts as the user interface. Its buttons and handling allow the viewer to control movement through the virtual scene as well as to cause the rotation of the platform and of the projected image around the circular screen. A microphone on top of the central interface camera picks up any sound the viewer makes, releasing words and sentences within the projected space for a limited amount of time. The physical arrangement of the sound and texts is determined by the path of the viewer's movements while they are being generated. The surface of the overall landscape is inscribed with a Tree of Life diagram representing eleven Ruhr site cylinders and mining tunnels in the Dortmund area.

(Jeffrey Shaw and ZKM)

development accordingly. 'The distributed technologies of virtual environments, whether they are worn, on mobile phones, or on multi-user devices, are "social spaces so that the persons present become protagonists in a set of narrative dis-locations."[22] The major proliferation of distributed networked communications have laid the ground for the cinematic imaginary to arrive not only in everyone's home but also in limited ways to the nomadic mobile phone, and possibly even to what one is wearing.

Figure 7.12. Lev Manovich and Andreas Kratky, *Soft Cinema*, 2002, screenshot from the Internet software projection installation.

Soft Cinema is a dynamic computer-driven media installation. The viewers are presented with a series of narrative films constructed randomly by the custom software. Using the systems of rules defined by the author beforehand, the software decides what appears on the screen, where, and in which sequence; it also chooses music tracks. Because editing is performed in real time by the software, the movies run infinitely. To highlight the fact that in digital cinema all constants of traditional cinema become variables, the layout of the screen changes every few minutes. The generation of the layout is controlled by an algorithm; the same algorithm was also used to design the installation architecture. All elements are chosen from a media database which contains four hours of video and animation, three hours of voice-over narration, and five hours of music. Each element in the database is described by a number of keywords. For instance, in the case of a video clip, the keywords specify where it was shot, its subject matter, its average brightness, contrast, the degree of motion, and so on.

[Lev Manovich]

The Internet is the "driving force" in creating dynamic experimentation with new kinds of narrative development. Early efforts mimicked television's soap-opera tendencies, but soon evolved to the more interactive strategy of a pass-along narrative such as a travel or journey. A filmmaker starts a story and places it online. Viewers from around the world add to it (Chapter 6). The characters evolve as the story does and may rely on props or costumes being sent to each locale to provide story continuity .

Sonic bridges

Acceptance of sound work as an element of visual culture (Chapter 5) have taken place not only because of new tools, media, and attitudes but also because technological conditions arise out of independent experimental film, video, and digital media art works in which sound tracks are integral to the work. As a result of the great interest in electronic means of creation and production that now exists, sound culture has gained momentum as a vibratory, immaterial, shimmering element.

Exhibitions related more specifically to the realm of sound bring into focus the rapid growth of a culture more and more based in electronic music and sound as a result of the accessible creative potential of the electronic sphere. Christine Van Aasche, one of the curators of the international exhibition *Sonic Process: A New Geography of Sound* refers to *sonic* as a term which attempts to bridge the borders of the realms of "sound" and "musical" to grasp the "creative flux" which now exists. The latest generation of computers and software has made music and sound easy to record, create, produce, and edit alone, without other musicians, in

Figure 7.13. Janet Cardiff, *Playhouse*, 1997, multimedia installation, with mixed video and binaural audio.

In this work, there are many levels of play involved, such as the intricate ones between perception and belief; truth and fiction. *Playhouse* uses sculptural elements, audio, and video projection to create a theatrical yet intimate experience. The curtained structure that one encounters in the gallery is reminiscent of a traveling playhouse. The viewer/participant enters this enclosure wearing a headset to experience an imaginary world where the visual and aural play upon expectations of the theatrical experience. The listener sits in what seems to be the second balcony in an old opera house. A video projection of an opera singer onto the miniature stage set below is in sync with the 3-D aural environment of the headset. The environment of the opera house plays with the experience of a possible, but ultimately missed, romantic encounter.

(Luhring Augustine Gallery)

a home studio. It is now possible for anyone to eqip themselves with the necessary tools and software for sound creation. The work can be listened to immediately without the necessity of initial instrumental performance and can be easily distributed (e.g., online) without the test of first transcribing it, thus eluding the traditional circuits of music publishing companies. The sound art work now moves to an era of digital hyper-reproducibility There is no longer an original since everything takes place through sampling and duplication. "This scrambling, in the division of roles between production and consumption, creation and reception, at the same time renders fragile two modes of traditional totalization in the artistic field: in intention, the author, synonym of the closure of the work's meaning; in extension, the work itself, which loses its physical and temporal limits – fantasy rendered to the flux of a universal sound material."[23]

Share, an open forum founded in 2001 by Geoff Matters, is a vibrant example of live interactive performance for audio and video artists "jamming" by using laptop tools and software. Matter declares that the forum is "a new way of enacting ritual." Because of his interest in novel and useful interfaces for live music performance, including repurposed game controllers and scientific equipment, Matters has created a community of eager participants in "jams" that take place weekly in New York's Lower East Side. In collaboration with Matters, Eric Redlinger is developing software for manipulating audio and video in real time. Although their club meeting space is small, it is amply equipped with visual screens and audio amplifiers and switchers for plugging into everyone's laptop and allows for sound experiments based in looping, sampling, change, and randomness. Essentially the laptops become the sound instruments for the jam. Owing to the excitement generated by this open, fluid performance attitude, Share has attracted participants interested in the development of new ideas for creating both sound and image software.

The exhibition *Sonic Process* featured eight visual, sculptural installations as veritable sound studios especially created for the exhibition (at the Pompidou Center, Paris, 2002, then on to Berlin and Barcelona) by a variety of artists – Doug Aitken, Mathieu Briand, Marti Guixe, Flow Motion; Mike Kelley and Scanner; Richard Dorfmeister, Rupert Huber and Gabriel Orozco amongst several others. One could create sounds in these works as well as being involved in enjoying the spatial aspects of the installation with its time-based visual media. This exhibition is quite different in scope from the single dark-room space allotted to the 2002 Whitney Biennial sound installation with its immersive surround sound works by Meredith Monk, Steven Vitiello, and Mary Ann Amacher, amongst others. These artists based their work on thresholds of perception, field recordings, or works that use sound in a sculptural way.

Art/science and the "big picture"

The curators of Documenta suggested that art is a form of knowledge in itself, a concept which implies research in the arts. They also pose contextual questions about global culture as reflected in the questions about the human condition and living in an interconnected universe. These issues are ones which are very much related to science as a form of knowledge. As we have seen, Aristotle proposed research through observation of reality as leading to potent ways of knowing and visualizing.

Scientist Stephen J. Gould argues that the truest path to understanding comes sometimes from the empiricism of the arts, by norms of its discourse, categories that science cannot address within its "straitjacket of objectivity" but which "art engages as a primary interest and

responsibility." Art's versions of nature can fracture the strict boundaries between scientific disciplines in an open way by asking different questions, thus creatively expanding fields of inquiry.

We have seen models of relatedness between science, technology, and art in the work of Leonardo da Vinci (Chapter 1); references to artist's stances toward technological development and science amongst artists at the turn of the twentieth century (Chapter 2); experiments in art and technology (EAT, Chapter 3) in the 1960s; and references to residencies for innovative artists at Banff; at the Institutes for the Arts at ASU, and at ZKM, Center for Media and Art (Chapter 5).

Scientific concepts before World War II had still been within the comprehension of well-informed lay intellectuals who often attended public talks by prominent scientists of the day delivered as a way of popularizing science. Linda Dalyrymple Henderson, in her 1998 book *Duchamp in Context: Science and Technology in the Large Glass and Related Works*, writes:

> In contrast to the highly mathematical and abstract nature of the relativity theory and quantum physics to come, science in the years before World War II was still within reach of the lay person. The general public could keep abreast of the latest developments in physics and chemistry in a wide range of popular periodicals – from *Harper's Monthly* to *La Nature* . . . Most important, even when dealing with invisible phenomena (such as x-rays), physics could still be visualized: scientists talked in terms of models, and interested artists, like Duchamp, could attempt to give form to the new discoveries that were redefining reality and transforming contemporary life.[24]

However, science was expanding into other areas far less comprehensible to the public. Also, especially after World War II, there were changes in scientific practice which now began to depend on the collaboration of large numbers of scientists as teams. This practice had begun notably in the Manhattan Project, and later technological military projects, but it extended even into more purely scientific projects, especially in high-energy physics, to the point where important papers were sometimes authored by literally hundreds of physicists. With the development of biology, especially molecular genetics, the team approach became important in that science too. Finally the development of computer and information sciences and technology created a similar pattern of large-scale scientific research backed by governments but followed up by corporate development of the related technologies. One example of these developments is the Human Genome project, which was developed through a decentralized amalgam of university, federal, and commercial sources. This need for large-scale financial support and the resulting need to again popularize science in order to attract public support has aroused the imagination of a wide range of artists.

Science as a discipline also endured the traumas of postmodern probes which pointed to the often conflicting but possibly correct answers to the research questions, depending on how the question was framed. "Kuhn's [*The Structure of Scientific Revolutions*] seemed to show that rather than progressing inevitably toward a better representation of reality, scientists moved from one theoretical framework to another, based on social and psychological factors as well as experimental ones."[25]

This model of thinking seemed to suggest a parallel with art – that science can be thought of as progressing in a non-linear fashion, mirroring Barthes's notion that there are no longer any linear hierarchies (Chapters 3 and 5). The realization of the possibility that "science was

not beyond question, and that there is no singular scientific truth, piqued the interests of artists, freeing them to rewrite science as they saw fit."[26] They realized they were able to discuss, pose questions, and argue about research which impinged on cultural questions they were raising that were different from those asked by science.

We have also explored the ways in which artists have always been interested in pushing the boundaries in the use of new technological tools for art-making to the point where some of them took on the artist/researcher role and became hybrid artist technologists (Mohr, Paik, Shuye, Vasulka, Sandin, and Etra, amongst many others) or collaborated in science labs to create new tools and forms. By exploring artistic experience with new tools and media, we have seen that artists through their experience and research have expanded on conventional notions of what constitutes art and have developed the unconventional combinations of skills and values that most often offer stimulation and provocation to the research community. Artists' focus on the value of creativity and innovation, and on different response criteria in terms of critical perspectives, makes them now in demand by the high-density trans-disciplinary new media culture that is evolving.

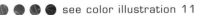 see color illustration 11

We can learn much from works of art that have successfully bridged the realms of art and science in some ways – by moving from technique to memorable works that invite public participation. Eduardo Kac's *Genesis* deals with coding a cultural production like the Bible's Genesis story of creation to bring it parallel with the codes of DNA. His work examines, via the Internet installation in a gallery setting, the relationship between belief systems, ethics, and biotechnology and information technology. Visitors to the Genesis website are able to remotely turn on an ultra-violet light over a petri dish affecting the DNA plasmid of bacteria by disrupting the DNA sequence and thus accelerating the mutation rate. The translation of different forms of information between these realm results in a creation form that was originally based on language and "code."

Kac has also brought public attention to the realm of genetics through the hybridized creation of a "Green Rabbit" –a cloned live cross-over between a phosphorescent jellyfish and a white rabbit. When the newspapers headlined the birth of the "glow-in-the-dark" rabbit, Kac was delighted. He was able, all the more publicly, to state his point that, if we are to use scientific knowledge to create new creatures, we must be ready to take responsibility for what we do.

Working in Japan with scientists exploring biotechnology, Christa Sommerer and Laurent Mignonneau are pioneers experimenting with systems of natural and artificial life, studying their possible behavior and ability to survive. In *A-Volve*, visitors actually create a virtual creature by designing it on a touch screen. It then takes on dimensionality and life as it is transferred to the nearby water-filled pool. Participants in the project can touch and give direction to the swimming creatures they have created as they move in the pool in relation to those created by other participants. The life of the creatures is dependent on their form and the way they react to others' hand movements. *A-Volve* reminds us of the fragility and complexity of any life form and of our role and responsibility in shaping artificial life.

Developing her work in the field of robotics and artificial intelligence, Adrianna Wortzel created "Kiru," a telerobot who inhabited the Whitney Museum ground-floor environment as a cultural ambassador during *Data Streams*, a 2002 digital exhibition. As an autonomous entity, Kiru was able to communicate with its own gestures, independent navigation, and

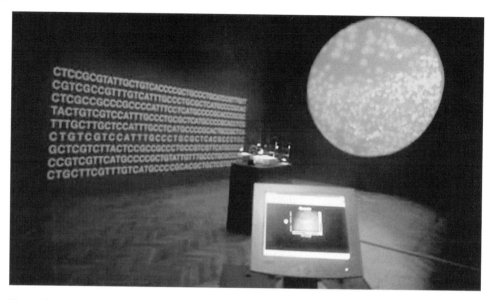

Figure 7.14. Eduardo Kac, *Genesis*, 1999, transgenic Internet installation.

Genesis is a transgenic work that explores the intricate relationship between biology, belief systems, information technology, dialogical interaction, ethics, and the Internet. With knowledge gleaned from the release of genetic code information, Kac created an artificial "artist's" gene by translating a sentence from the biblical book of Genesis into Morse code and converting the Morse code into base pairs. The synthetic gene was then cloned into plasmids, which are then transformed into bacteria. On entering the gallery installation, visitors find a petri dish on a pedestal with an ultra-violet light over it. The DNA sequence in the plasmid can be disrupted by visitors who turn on and off the light which then accelerates the mutation rate, influencing the process. Visitors to the Genesis website online can also participate by remotely turning the light on. The Genesis project has become an examination of the relationship between information technology and biotechnology, resulting in the creation of a life form which was originally based on language and "code."

(Julia Friedman Gallery, Chicago)

Figure 7.15. (opposite) Eduardo Kac, *GFP Bunny, Alba, the Fluorescent Rabbit News*, 2000

Kac's transgenic work *GFP Bunny* (Alba, celebrated as the "Green Bunny") was realized through genetic engineering to transfer natural or synthetic genes to an organism to create unique living beings. The birth of the fluorescent rabbit, a collaboration between French scientists and Kac, was presented to the news media at a press conference in Avignon, France, in 2000. The work created a media sensation internationally. In this exhibition of the poster and photographs about the project which he collected over time, Kac reflects on the productive tension that is generated when contemporary art enters the realm of daily news. Just as Kac wished, the evolution of Alba has sparked lively debate and has become part of an ongoing dialogue not only with the general public but also between the scientific disciplines and the humanities. Genetic engineering is here to stay. The questions surrounding the issue of cloning need to be debated and resolved. Above all, Kac claims that there must be commitment to respect, nurture, and love the life that is created.

(Julia Friedman Gallery, Chicago)

speeches. However, the behaviors of Kiru (Fig. 7.19) could be influenced at any time through actions of those participants connected to the World Wide Web. The remote visitor could control the tilt and zoom of Kiru's camera and, while viewing parts of the exhibition, establish contact with visitors to the museum via real-time video and speech. Both video and audio were streamed to the Web for all to see. In this way, physical visitors could "talk" to virtual museum visitors, playing out human willingness to interact with a digital machine character as if it were more than a mechanical, electronic manifestation.

These projects reflect a range of interests of contemporary artists fascinated with the implications of new transgenic forms – clones, cyborgs, hybrids, chimeras, bio-robots – and their impact on philosophical and ethical questions. Other artists work in fields related to artificial intelligence and areas dealing with the brain including aspects of consciousness and cognition. Some are investigating narratives associated with nanotechnology and social engineering. Given widespread growth of collaborative relationships between engineers, scientists, and artists, a plenitude of work now in process will seek to clarify and critique the seriousness and implications of research which explore the basic systems that underlie our human condition and our relation to the world.

Figure 7.16. Christa Sommerer and Laurent Mignonneau, *A-Volve*, 1994, interactive installation.

In the interactive environment of *A-Volve*, viewers drawing on a monitor screen with a sensor pencil can create 3-D forms or organisms which when submitted to the computer program are then endowed with the ability to live, mate, and evolve. These immediately become "alive" and will seem to swim in a water-filled pool nearby. Reacting to the slightest movement of the hand in the pool, the moving virtual creatures will modify their behavior. Participants can catch a creature, protect it, or help it to mate. Fitness to survive is an aspect of the creature's form, as to how it will adapt to its environment. The fittest will survive predator attacks and be able to mate and reproduce. The artists' goal in creating the *A-Volve* project is to minimize the borders between "real" and "unreal" for the public by creating a step in the search for "natural interfaces" and "real-time interaction" with biological issues.

(Christa Sommerer and Laurent Mignonneau)

Figure 7.17. Christa Sommerer and Laurent Mignonneau, *A-Volve*, 1994, interactive installation.

Figure 7.18. Christa Sommerer and Laurent Mignonneau, *Phototropy*, 1994, interactive installation.

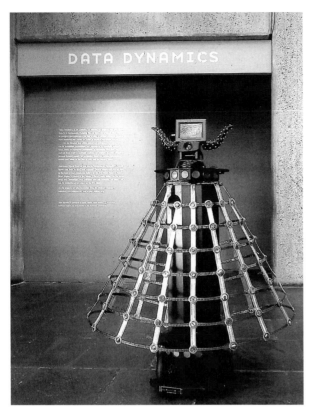

Figure 7.19. Adrianne Wortzel, *Camouflage Town*, 2001, www.camouflagetown.tv, telerobotocs, interactive installation. Commissioned by the Whitney Museum of American Art for *Data Dynamics* exhibition, March 2–June 10, 2001. Support and development grants through NSF.

Camouflage Town creates a theatrical scenario for a robot that lives in a museum space and interacts with visitors. The robot, named Kiru, comments on its environment and transmits video images to monitors. It can be remotely controlled by visitors through the computer and plays the role of cultural curmudgeon. Mapping physical and virtual space as well as physical and virtual identity, Kiru's personality reflects its ability to be each visitor's avatar or alter ego, and its comments play on our willingness and capabilities to interact with a digital machine or character. The artist comments that "Kiru offers fine-tuned philosophy and juxtapositions to everyone it meets: hot/cold, benign/lethal, inside/outside. What it sees, the world sees."

(Adrianne Wortzel)

Figure 7.18. (opposite) Christa Sommerer and Laurent Mignonneau, *Phototropy*, 1994, interactive installation.

This project exploits light as a natural force that affects organisms which must follow its rhythms in order to find the food they need to survive. Upon entering the installation space, the visitor picks up a flashlight from a low podium and shines it onto the organic forms located on the projection screen. The light beam will awaken the virtual insects, causing them to emerge from their cocoons and fly towards it in their search for energy and food. If they reach enough light, they live longer and reproduce, for otherwise they cannot survive. Since all insects are affected by the same needs, they swarm and follow all the moves of the visitor's light. Careful control of the light is important not to "burn" the insects so they will mate more frequently. The genetic code of each insect is transferred to their offspring, continuing the fight-for-light survival instinct. Participants in the project thus become partners in supporting, developing, and enhancing the life of the artificial life insect population in the installation.

(Christa Sommerer and Laurent Mignonneau)

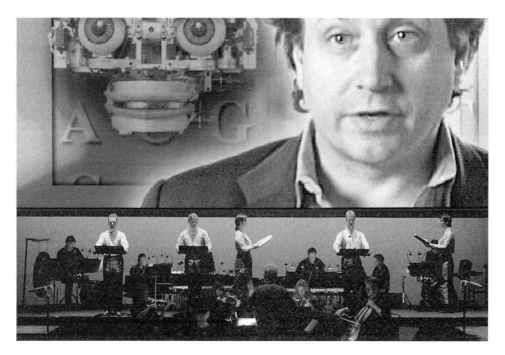

Figure 7.20. Beryl Korot (video) and Steve Reich (music), *Three Tales*, 2002, 32ft wide, projected image with live musicians and singers.

Through image and sound, this work in three acts reflects on our relationship to technology in relation to three events from the beginning, the middle, and the late twentieth century. Act One recalls the destruction of the so-called "invincible" airship the *Hindenberg*. Act Two recalls the expulsion of the native population of Bikini atoll and its destruction in a nuclear test. Act Three poses questions about the cloning of the sheep Dolly. The work combines images of archival footage, photos, drawings, and text all within a single frame. Its music incorporates prerecorded sounds and uses slow-motion sound techniques in conjunction with the live music onstage.

(Beryl Korot and Steve Reich)

Referring to ecological art, Lynne Hill remarked: "I would like to suggest that ecological art will often differ from ecological restoration science in its process rather than its intent . . . The scientist has to go through this scientific method, which can narrow perspective, and there-fore he or she can lose track of the larger picture. The artist, on the other hand, is encouraged to be wide-ranging and open to all possibilities. Artist Mierle Laderman Ukeles suggests that once an artist gets involved in science (or in a related technological process), . . . the artist can question and re-define anything at any step, and the scientist won't do that."[27]

The larger culture at the end of the twentieth century began to be aware of the profound personal, physical, and ethical issues now being explored by biologists who are researching animal cloning, stem cell research, and applications of DNA.

These profound issues of the day, touching directly on personal and cultural concerns, provide fertile narrative ground to bridge the divide between art and science. Collaborations are now growing between scientists, humanists, and technologists to tackle significant questions about who we are and what we are.

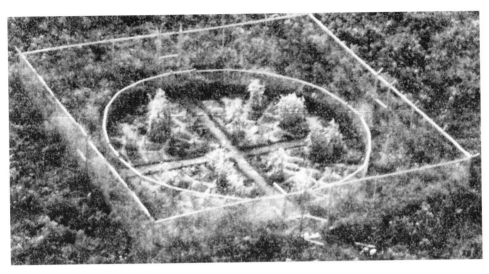

Figure 7.21. Mel Chin, with Dr Rufus Cheney, *Revival Field*, 1990–2003, environmental installation. Originally funded by the National Endowment for the Arts.

When Mel Chin came upon an article about the use of plants as remediation tools, he immediately thought of such a process as a sculptural tool capable of bringing into reality the return to life of devastated landscapes. After a long struggle to complete his research on this issue, and to seek funding for a related project, Chin found a collaborator – Dr Rufus Cheney, a senior research scientist who had proposed phytoremediation (using plants as remediation agents) as early as 1983 but hadn't yet conducted a field test. Their combined enthusiasm for such an experiment inspired *Revival Field* as one of the first in the United States to use plants to absorb toxic metals from the soil. Chin has compared the plants' absorbtion of toxins as a form of carving in the landscape – for the revitalized soil puts out new growth that has an aesthetic level to it. Chin continued the project and successfully negotiated the transfer and growth of "super" accumulating plants, working with German scientist Volker Romheld on public lands in Germany. The direct effect of the project's success was not only a cultural one but launched the new phytoremediation industry.

(Mel Chin)

Blade Runner: science fiction and the politics of the future

The celebrated science fiction film *Blade Runner*[28] took up the theme of how our real selves' biological futures are deeply implicated in the postmodern climate of genetic engineering, simulation, and the hyperreal. It explores the threat posed to society when the body can be reproduced technologically and explores the assumptions underlying this threat, earlier presented in films such as *Metropolis* and *Frankenstein*. What does it mean when the reproduced becomes a danger to the reproducers? The film connects the fully realized android reproductions with an earlier technology of photography, as a form of reproduction which could offer proof of their history.

The mise-en-scène for *Blade Runner*[29] is not the ultramodern of *Metropolis* but the postmodern. It gives off the aesthetic of postindustrial decay, exposing the dark side of technology, the process of disintegration. The narrative of the film participates in the logic of imitations, reproductions, simulations, and of the hyperreal. Several "replicants" hijack a

spaceship, murdering the passengers, and illegally land on Earth. Deckard, a hard-boiled antihero, a "blade runner," comes back from retirement to track down and destroy the renegade androids. These replicants, as they are called, have been created to serve mankind in dirty, out-of-the-way places and jobs. To keep them from using their superhuman strength and intelligence against their masters, they have been designed with a built-in safety mechanism – they self-destruct four years after their "inception" date. Wishing to survive longer, they seek out their creator, Tyrell, who has denied them status as "real" human beings but endows some of them with feelings and even artificial memories. Rachel, the latest model android, is so perfect that she doesn't know at first that she is anything less than human. With Rachel, we understand that the distinction between real and artificial, between android and human has become meaningless.

Replicants (androids) are the perfect simulacra, technologically replicated to such a degree that they now become dangerous to their human makers. "The unreal is no longer that of dream or fantasy or a beyond or a within, it is that of hallucinatory resemblance to the

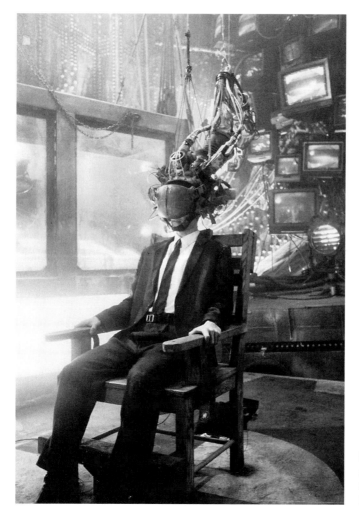

Figure 7.22. *Johnny Mnemonic*, 1995, film directed by Robert Longo. Publicity film still.

real itself."[30] Created as slaves, the replicants look like a he or a she. Like all simulacra they undermine the notion of an original by refusing any difference between themselves and their masters. They have neither past nor memory. They are denied a personal identity since they cannot name their identity over time. The viewer is constantly engaged with Deckard in the attempt to discover and separate the artificial from the real. In this tension, the figure of the mother becomes a breaking point. Rachel goes to Deckard to convince him she is not a replicant. Her argument is a photograph of a mother and daughter. That photograph represents the trace of an origin and thus a personal identity, the proof of having existed and therefore of having the right to exist in 2019. Deckard falls in love with Rachel and she is allowed to live when Deckard is saved by one of the dying replicants. The film thus poses the question: If the replicants are not human, then neither are we; conversely, if we are human, can they be any less?

Narrative science fiction films question the control and Influence of machines. We can learn from the visions of the future constructed in science fiction films with their references to technology and their use of digital special effects (Chapter 5) because they bring up issues which reflect our current fearful attitudes as to what the future might be like if technological conditions get out of control. These stories often provide not only cautionary attitudes to the expansion of technology in the future, but show a deep and pervasive fear in the direction we might choose.[31]

New diversity in creating film options: artists begin to make narrative films

see color illustration 9

A significant number of visual artists have become interested in creating traditional narrative films on various themes which they believe will reach mainstream audiences. Performance artist and designer Julie Taymor's *Frida* (2002) and *Titus Andronicus* (1999); painter Julian Schnabel's *Before Night Falls* (2002) and *Basquiat* (1996); visual artist Peter Greenaway's *The Draughtsman's Contract* (1982) and *Prospero's Books* (1991) are examples of this trend toward locating mainstream audiences. In an *Art Forum* interview, conceptual artist Kathryn Bigelow commented about her move from visual arts to film:

> Film was this incredible social tool that required nothing of you besides twenty minutes to two hours of your time. I felt that film was more politically correct, and I challenged myself to make something accessible using film but with a conscience . . . As our environment becomes increasingly mediated, so are all our experiences . . . The desire to watch, to experience vicariously – there's a tremendous gluttony for images right now, that hunger to experience someone else's life instead of your own is so palpable. It's pure escapism, but it seems fundamental. What else is the appetite for cinema?[32]

However, even in a global environment still dominated by Hollywood productions, alternatives continue to exist and are gaining momentum. Just before digital video and editing systems first became available, a Danish group calling itself Dogme 95 was founded by four filmmakers: Lars Von Trier, Thomas Vinterberg, Soren Kragh-Jacobsen, and Kristin Levring.

They created a manifesto which defined their movement and restricted them to simple, readily available materials, stating that all shooting must be done on location, using hand-held cameras with available sound and lighting. The name of the director must not be credited.[33] In their official website (www.dogme95.com) they declared: "Today a technological storm is raging, the result of which will be the ultimate democratisation of the cinema. For the first time, anyone can make movies. But the more accessible the media becomes, the more important the avant-garde." Like video artists (Chapter 4) Dogme was affected by new digital processes which can be used to make films in a more spontaneous, intimate, and less mannered way using small cameras and less standard equipment.

New narrative forms and practice

While many visual artists such as Lynn Hershman, Julian Schnabel, Katherine Bigelow, and Robert Longo have started to make their own films with traditional story formats, other artists are moving from different directions and contexts to create new kinds of works which challenge the narrative. An example of this tendency is Matthew Barney's multimedia work *Cremaster*, which involves films and sculpture installed in a many-faceted architectural installation.

Barney's art practice has reached a new level in the complex use of so many media in an installation. Although he has become best known as a filmmaker for his five-part *Cremaster Cycle*,[34] he regards himself as a sculptor, with the films being the vehicles for the sculptural works he produces.

The work embraces elements of new kinds of narrative and performance, installation, video, and sound. Some have compared Barney's ambitious, wide-ranging, well-focused, intense work with Wagner's. He is thought of as a new kind of "auteur," creating new worlds using autobiographical quotations with biological, architectural, and landscape elements. What has drawn crowds to his huge installations which take up the whole interior space of museums such as the Guggenheim is the powerful intensity of his vision of a fantasy world which includes elements of classical myths, elaborate costumes, prosthetic devices, and transforming make-up. The primary idea behind the work is the fateful moment of sexual definition – "the cremaster" as the fetus is growing in the womb.

● ● ● ● ● see color illustration 7

Choosing another genre as her starting point, Eija Liisa Ahtila has chosen a semi-documentary form, telling stories with real characters but bringing surreal twists into the narrative content. Through this shift her works touch a place where time and space are confounded in many ways that speak to her viewers. Her multiscreen works use sound in important ways. In *The House* (see Fig. 4.38, p. 143), a woman speaks about the difficulty she is having in maintaining boundaries between her interior life and objective reality. At one point, she covers the windows but cannot keep out the sound from the outside world. In her monologue, she intones, "Things that occur no longer shed light on the past."

Labyrinth is a projected interactive memoir, a many-layered DVD project which challenges the borders between autobiography, memory, history, and fiction. It mines the outrageous fictions which formed the notorious lifestyle of its protagonist John Rechy. By combining original art work, video, and archival documents with recorded interviews and commentaries, the work explores the collective histories of Chicano culture and the gay world.

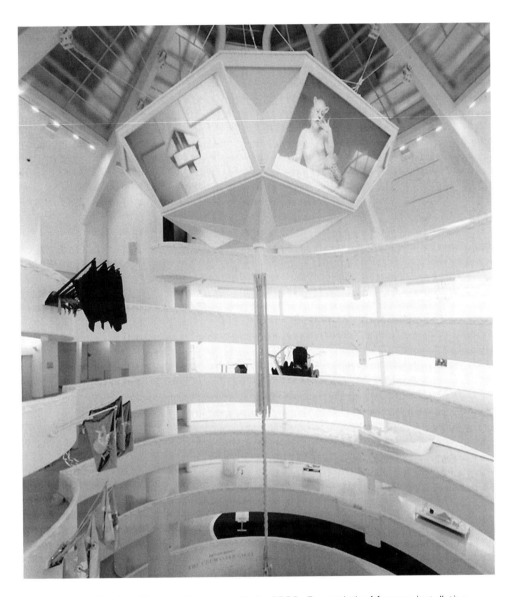

Figure 7.23. Matthew Barney, *Cremaster Cycle*, 2003, Guggenheim Museum installation.

The *Cremaster Cycle* is an epic (1994–2003) self-enclosed aesthetic system consisting of five feature films that explore processes of creation. At the narrative core of each of the films are the photographs, drawings, and sculptures that are distillations of each film installment. The exhibition mirrored the structure of the architecture of the Guggenheim Museum as a site-specific installation designed by the artist to encapsulate the five-part cycle combining all its varied components into one cohesive whole. The centerpiece of the installation is a five-channel video piece suspended in the middle of the Rotunda. Each screen shows different footage from "The Order," a sequence from number three of the film cycle which was filmed in the museum itself. "The Order" deploys five levels of the Guggenheim's spiraling ramps in an allegory representing the five chapters of the cycle.

(The Guggenheim Museum)

Figure 7.24. Marsha Kinder, Kristi H. A. Kang, and the Labyrinth Project in collaboration with John Rechy and Jim Tobias, *Mysteries and Desire: Searching the Worlds of John Rechy*, 2000, CD-ROM. Winner of the New Media Invision 2000 gold award for overall design.

By challenging the borders between autobiography, memory, history and fiction, this interactive memoir presents a diverse array of personal materials by and about John Rechy and sets them against larger collective histories of Chicano culture and the gay world. To mine the notoriety and fantasy that circulate around this celebrated literary figure, the work combines original art work, video, archival documents, recorded interviews, and commentaries. Viewers move between three interrelated themes – Memories, Bodies, and Cruising – each with its own repertoire of gestural interfaces.

(Jo Ann Hanley)

In *These Are Not My Images (Neither There Nor Here*, Irit Batsry articulates a deep sense of displacement, dispossession, and ambivalence. Her imagery, defined through her rich experience of another culture, is a reflection on the dislocation of place – a metaphor for a physical location and the remoteness of one who does not belong but who seeks the meaning of place. Her genre shifts between documentary, experimental narrative, and personal essay. Her extraordinary use of digital editing techniques brings her work into the realm of abstract poetry.

New directions: a seismic shift

Major exhibitions in the past decade demonstrate increasingly significant acceptance of media technologies as a component of cultural life in a powerful range of ways. Many curators planning for the future are taking into account the way museums are changing. They claim they are not waiting for many of the critics to catch up with the interests of their public. Exhibitions now inhabit both real and virtual architectures reflecting how audiences, too, are influenced and changed by the increasing presence of digital media in the everyday conditions of their lives. Artists are finding new ways to bring their work to wider audiences. Lawrence Rinder, curator of Contemporary Art at the Whitney Museum, comments:

> Nothing since the invention of photography has had a greater impact on visual art practice than digital media . . . Computers, digital cameras, video recorders, projectors, sound mixers and the software programs that run them, and the Internet, have dramatically and irrevocably widened the dimensions of artistic expression, adding new methods of production, dissemination, interaction, and response.[35]

Figure 7.25. Isaac Julien, *Paradise Omeros*, 2002, production still of triple DVD projection.

In this multichannel installation work, Julien develops a post-cinematic practice of the moving image. He explores the emblematic search for the "new life" promised by the West through an allegorical reworking of a wide range of cultural differences. Through its intense engagement with visual pleasure, it is at the same time concerned to expose, deflect, and reconstruct the conventions of cinematic narrative, and, in so doing, opens the audience to other concerns: complex subjective moves explore a wide range of psychic differences where questions of gender, race, or sexual difference become a matter of indirect reference rather than embodiment.

(Isaac Julien and the Bohen Foundation)

As we have seen in Chapters 4, 5, and 6, previously distinct categories of media such as photography, film, and video are merging through digital practices which extend them, and in some cases, allow for direct participation in the art work itself (Chapters 5 and 6) by allowing the user unprecedented control of data, imagery, and sensation. Rinder sees digitally based art experiences as "a constellation of physical, emotional, and cognitive phenomena which have transformed aspects of human experience."[36] The field of possibilities opened to artists, architects, designers by digitial tools has allowed some to extend the traditional forms as they continue to work in photography, film, video, printmaking, artists' books, painting, and sculpture while others are deeply engaged in plumbing the potential of digital means to create new forms of expression.

see color illustration 4

In 2001, both the San Francisco Museum of Modern Art and the Whitney Museum featured exhibitions heralding and exploring this shift. In their exhibition *010101: Art in Technological Times* a group of SF MOMA curators commissioned several Internet projects and featured sound works and interactive installations.[37] The Whitney Museum, which had included Web works in its 2000 and 2002 Biennials, also mounted an exhibition *Bit Streams: Exploring the Importance of Technology in American Art*, which also included sound works. Its ancillary Net art exhibition *Data Dynamics*, curated by Christiane Paul, focused on Web works as visual models which allow users to "navigate visual and textual information and experience the flux of data . . . which constitutes a form of 'dynamic mapping' where the map constantly adapts to changes in the data stream and is continually reconfigured in front of the viewer's eyes at any given moment."[38] The contexts of some of the works in the exhibition reflect the dynamics of stories, memories, mapping, or movement in both real and virtual space. This exhibition was created in the context of an ongoing online presentation of the archived as well as the current work of major Web artists who have made contributions to the field at the museum's ARTPORT portal.

In *CODeDOC*, a 2002 Whitney exhibition (see p. 226), Christiane Paul focused on the "back end" of a software art work's " front end" by exhibiting the actual "code" or "language" composed (or written) to create the work. She assigned several artists to write code in the language of their choice which could connect and move three points in space. Each artist could interpret this request in any way they chose – whether literal, abstract, or philosophic. Visitors to the exhibition would first see the code (an element normally hidden from view) and then be able to bring up the "front end" or visual aspect of the work. Paul claimed that the code exhibits were

> expressions of distinct artistic signatures: the conceptual approach to the project, the way the code has been written, and the results produced by it reveal a lot about the respective artist – one explicity treats the language of code as a narrative connecting three "characters"; another creates a meta-layer for profiling the code itself, collapsing the boundaries between front and back ends; yet another project focuses on "language abuse" and illegal instructions.
> **(whitney.org.artport/commissions/codedoc/index. shtml)**[39]

An earlier exhibition, *Art and Global Media*, was a mutimedia, multilocal networked event (1999–2002) in four cities – Barcelona, Graz, Karlsruhe, and Tokyo – in various shifting media.

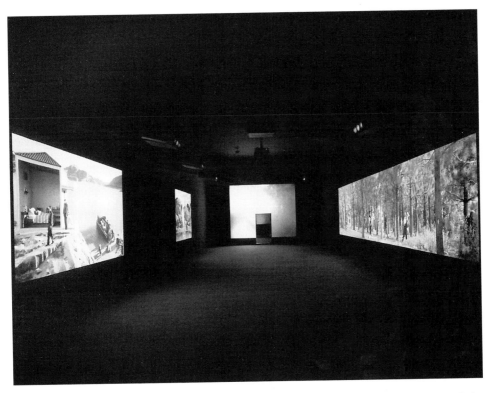

Figure 7.26. Bill Viola, *Going Forth By Day*, 2002, video/sound installation in five parts. Installation at the Guggenheim Museum, New York, September 21, 2002–January 12, 2003. Originally commissioned for the Deutsche Guggenheim in Berlin.

This major work in five parts – Fire Birth; The Path; The Deluge; The Voyage; and First Light – reflects Viola's ongoing personal spiritual journey and his engagement with art history, spirituality, and conceptual as well as perceptual issues (see Chapter 4). The five-part image cycle explores themes of human existence: individuality, society. birth, death, and rebirth. The work is experienced architecturally with all five image sequences playing simultaneously in one large gallery. Since 1989 Viola has been drawn deeply into the study of early painting to explore timeless issues of composition, landscape gesture, and emotion. In this work, time unfolds slowly like the single moment of a painting that has been brought to life and transformed into a temporally and spatially unfolding video installation that captures and engages a response from the senses.

(Bill Viola Studio)

The final focus of the exhibit was about the way artists look at the way technological conditions interact with society producing new constructions of knowledge, memory, politics and economics globally. It seeks to deal with how media have both formed and taken over the construction of reality. In its final manifestation at ZKM, the exhibit had become one titled *Net Condition: Art in the Online Universe*. From the point of view of the exhibition, social interaction is particularly changing with the advent of the Internet. Artists are reflecting on the cultural changes in the way people play music, tell stories, receive news, correspond, connect, demonstrate, research. The exhibition is about how events distributed in the virtual "space" of the Net trigger and collide with each other. In the shared virtual multi-user environment of

the Web, an open system is unlocking new possibilities for global cultural development. Peter Weibel, curator of this portion of the exhibit, comments: "Net art is the driving force, which is the most radical in transforming the closed system of the aesthetic object of modern art into the open system of post-modern fields of action."[40]

Banquet: Metabolism and Communication is a further exhibition created in a collaboration between curators at ZKM and the Madrid and Barcelona MediaLabs which tests threads of media culture which interact with the individual living in the real space of society. The overall concept of the exhibition is to gauge communication from ancient tribal forums for exchange and reflection to the long-range methods of interactive communication via the architecture of virtual communities. The exhibition takes human metabolism as the starting point for an "investigation of our social and ecological system."

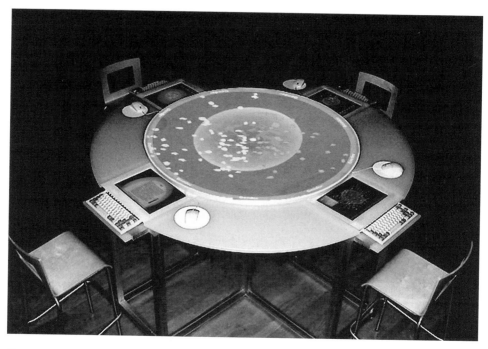

Figure 7.27. Margot Lovejoy, *TURNS*, 2000 ongoing, generative website project with Hal Eagar, Jon Legere, and Marek Walczk.

The Internet becomes a form of collective social consciousness. The *TURNS* Installation table for four participants Web project collects and shares personal stories of life turning points. These are represented on the site as pebble-like shapes that can be opened and returned to the narrative pool. Visitors to the site can browse stories according to twelve categories such as family, health, immigration, or can reorganize the archive of submitted stories by filtering them in different ways such as gender, ethnicity, time in which the turning point was experienced. Participants may also contribute by drawing a "lifemap," visually representing the course of their lives. Seen through relational filters, lenses, and links, one's story is understood as part of social memory.

(Margot Lovejoy)

Translocal, transcultural, transnational

We are now living in an increasingly polycentered world. The concept of *polycentered*, originally suggested by writers such as Baudrillard and Barthes, seems an apt one in relation to postmodern webs, nets, and communication modules.

It's a question not of quotas or simple political correctness but of methodology, on the part of curators who choose artists from different contexts and place them together in international exhibits. One must think about and deal with the meanings of cultural confrontations. The dynamics between center and periphery, between north and south, have been changing. As we have seen, contemporary art is no longer just about Western Europe and New York City. But can the larger context of a global culture enrich us by reducing the gaps between cultures and societies? Black cultural critic Michelle Wallace remarked:

> I don't think the response of people in the Third World who are confronted by American or European mass culture is to say: "Oh well, what's the use. Let's not make any more music, let's not write any more poetry". I think instead that the impact of mass culture is to generate even greater cultural production. Cultural differences always exist and are important to the perpetuation of mass culture. And I think you'll find that mass culture can stimulate and tolerate much more difference than anyone would ever imagine.[41]

Wallace is right in her feeling that human creativity, identity, and culture is strong and resilient. However, if we are making judgments based on our commercially based culture, with its airwaves almost totally controlled by the market economy, we will miss seeing this point. There is, at the present, little chance for its reform although its power as a medium could be usurped through the public access potential of new interactive channels for positive ends.

However, it is the Internet, with its global interactive potential, that has already shown that there is room for responses worldwide that can form levels of unprecedented connection, response, and resistance (Chapter 6).

This chapter has meant to reflect the seriousness and complexity of our future practice of the arts. Out of this very concern, out of the knowledge of and resistance to the excesses of technology, we may forge important directions and strategies for the future. The structure of this kind of crisis is very familiar. There is a recurrence of the loss, displacement, and change in consciousness similar to the effects on society and culture of the machine and of the photographic representation technologies we have been following. The electronic era, because of the greater complexity of its power to disrupt, is causing even more fundamental change and loss than did the machine era. We are again at the beginning of a century where technological developments have deeply affected conditions of life and the construction of culture.

The social structure of the networked age we are now inhabiting asserts itself in powerful ways. Our evolution from the centralized hierarchical cultural systems of modernism to the reconstruction of culture and society which has taken place since the 1950s in ways we have traced throughout this text has brought us to the realization that our culture has shifted dramatically to a more open decentralized "distributed" one. By the 1990s social, political, and economic infrastuctures became reorganized around electronic networks. Institutions today, including museums and galleries, are located everywhere – anywhere there's an online terminal. The IP address is beginning to be more important than the street address.

Figure 7.28. William Kentridge, *Ubu Tells the Truth*, 1997, still from the film.

Kentridge's evocative, expressionistic drawings on paper are created as animations through a simultaneous process of erasing or adding segments to these, thereby sequencing the images as parts of a narrative so they become alive, moving drawings in the projection space. For Kentridge, his works are not illustrations, but exist as a mode of knowledge production designed on the Brechtian model – as a reflection on the fundamental responsibility to critically evaluate stories and histories that we have as a form of self-knowledge. Drawing on his rich experience as actor, director, stage designer, and filmmaker, he creates works which forcefully bring into synthesis his passionate response to contemporary issues, particularly to conditions in his native South Africa. In *Ubu*, he mixes film clips with drawings and performance elements. In fusing together contrary visual languages, he heightens their shock value. The abrasive contrasts he uses counter the tendency so often found in conventional media to depict forms and modes of violence as banal and commonplace.

(Marian Goodman Gallery)

The postmodern period deconstructed old ways of thinking and paved the way for a different order of social organization which promoted major advances in knowledge and culture. The past decade has produced major reconstruction of institutions to more productive ones, a factor largely due to networks ideally constructed for the exchange of information and ideas. Widespread connectivity between individuals in the networks is promoting dynamic "grassroots" organizing and influence never before imagined. Some analysts speak about a decentralization of political power and money as a positive good allowing citizen groups far more autonomy to speak out than ever before. Artists online, too, have constructed a new kind of community.

This postmoden development has been both a historical and a cultural category full of paradox, contradiction, and divergent interpretation. But to writers such as Lyotard, Fiedler,

Figure 7.29. Lorna Simpson, *Easy to Remember*, 2001, DVD projection with sound, Whitney Biennial.

"Separate but together" is the theme of Lorna Simpson's DVD projection piece. Fifteen sets of lips move together as a chorus symbolically hums the Rodgers and Hart pop song – bit it seems more as a cultural question than as an affirmation. Simpson's works encourage a wide range of conclusions and celebrate the social potential inherent in poetic presentation. She has always been interested in revealing in her work that the self one presents to the public is a mere fiction based on misconceptions of the other and a failure to recognize the value of one's true self.

(Sean Kelly Gallery)

and Hassan, the "post" signifies not decline or fatigue but the freedom and self-assertion of those who have awakened from the past. Donna Haraway, feminist author of *Simians, Cyborgs, and Women: The Reinvention of Nature*, thinks of major cultural challenges and breakdowns as an opportunity for the possibility of a positive good. Commenting that the disruption of hierarchies and traditional boundaries between things has possible beneficial social uses, she points to the potential to create new social and cultural practices. Haraway sees that subversion and intervention could be effective in creating change. She proposes a hybrid body in the form of a cyborg as a metaphor for the new that could expand boundaries beyond their present margins to include a more diverse discourse.

For Vietnamese filmmaker Trinh-Minh-Ha, the postmodern condition implies "a new threshold, a suspension of closure and of walking forward into a new space. I prefer to talk about threshold, frontier, limit, exhaustion, and suspension; about void as the very space for an infinite number of possibilities . . . about making possible the undoing, re-doing and modifying of this very limit."

Notes

1 Laurie Anderson, *Stories from the Nerve Bible* (1995), a multimedia performance work which began at the Neil Simon Theater in New York and traveled to other cities including Boston and Chicago.

2 Laurie Anderson, *Stories from the Nerve Bible Retrospective 1972–1992* (New York: Harper Perennial, 1994), p. 282.

3 For this argument I am indebted to Stephen Wilson, "Light and Dark Visions: The Relationship of Cultural Theory to Art that Uses Emerging Technologies," *Siggraph 1993* catalog (a document released uncopyrighted on the Internet), pp. 175–84.

4 Dick Higgins, quoted in Brian McHale, *Constructing Postmodernism* (London and New York: Routledge, 1992).

5 Marshall McLuhan, *Understanding Media: The Extension of Man* (New York: McGraw Hill, 1964).

6 "McLuhan's Messages, Echoing from Iraq," *New York Times*, April 3, 2003.

7 Steven Durland, "Artist of the Future," *High Performance Magazine*, (Winter, 1989).

8 Celeste Olalquiaga, *Megalopolis: Contemporary Cultural Sensibilities* (Minneapolis: University of Minnesota Press, 1992).

9 Michael Newman, "Revising Modernism, Representing Postmodernism: Critical Discourses of the Visual Arts," in *ICA Documents 4, Postmodernism* (London: Institute of Contemporary Arts, 1986), p. 50.

10 Susan Sontag, *On Photography* (New York: Delta, 1973), p. 186.

11 Wilson, "Light and Dark Visions."

12 Steven Durland, "Art 21: The Future of Art?", *High Performance Magazine* (Summer, 1994).

13 Olalquiaga, *Megalopolis*.

14 1999 European Union Report quoted in Michael Century's Web document prepared for Canada's Centers for Research on Canadian Cultural Industries and Institutions.

15 p. 37 Michael Century web paper

16 "A Global Vision for a Global Show," *New York Times*, June, 2002.

17 "Enwezor's Big Show", *New York Times* Magazine, June 2, 2002.

18 *New Yorker* magazine, July 1, 2002, p. 95.

19 Ibid.

20 Quoted in *New York Times* Magazine, "His Really Big Show."

21 Jeffrey Shaw, Introduction to *Future Cinema: The Cinematic Imaginary after Film*, exhibition November 16, 2002, to March 30, 2003, curated by Jeffrey Shaw and Peter Weibel, ZKM, Karlsruhe, Germany, p. 3.

22 Ibid.

23 Elie During, "Appropriations: Deaths of the Author in Electronic Music," in exhibition catalog *Sonic Process: A New Geography of Sounds*, Barcelona, Paris, Berlin, 2002–3, p. 40.

24 Linda Dalyrymple Henderson, *Duchamp in Context: Science and Technology in the Large Glass and Related Works* (Princeton: Princeton University Press, 1998).

25 Laura Heon, in *Unnatural Science*, exhibition catalog, MASS MoCA, North Adams, 2000–1, p. 12.

26 Ibid., p. 13.

27 Lynne Hull, "The Natural Order," talk at the *Environmental Arts and Collaboration* symposium, 2000, reported in exhibition catalog *Ecoventions: Current Art to Transform Ecologies*, Texas, 2002, curated by Amy Lipton and Sue Spaid, copublished by greenmuseum.org, The Contemporary Arts Center, and ecoartspace.

28 *Blade Runner* (1982), adapted from Philip K. Dick's novel *Do Androids Dream of Electric Sheep?* directed by Ridley Scott (*Alien*), starring Harrison Ford as Deckard.

29 For this discussion, I am indebted to Giuliana Bruno's essay "Ramble City: Postmodernism and Blade Runner," in Annette Kuhn (ed.) *Alien Zone: Cultural Theory and Contemporary Science Fiction Cinema* (London: Verso, 1990).

30 Ibid.

31 In *Gattaca* (1997), genetic tinkering allows parents to tweak their offsprings' DNA before birth. This results in a "caste system" of "perfect" humans which exist alongside those who have not had such an advantage.

In Steven Spielberg's *AI* very few parents are allowed to have children. Their natural parental "instincts" are dealt with by allowing them to choose a "bot" which seems and performs just like a human although bots cannot tolerate human food or have deep emotions such as love. We see a society which is designed around throwing out its discarded bots in frenzies of destruction akin to gladiatorial excess. The focus is on the inequality between bots and humans (although they can look and behave like humans) and on their longing to be human as in the story of Pinocchio.

In *The Matrix*, a complex film about illusion and reality, the hero Nero guesses that the world around him is nothing but a computer-generated illusion. He learns that this façade has been created by machines who use human beings as an electrical energy source.

In *Minority Report*, the real feeling and thinking processes of humans can be interpreted by machines which scan their eyes, and are thus able to anticipate their very actions. No one is safe from this form of surveillance and control.

In *2001* (1968) a computer, HAL 9000, attempts to take over during a space probe to Jupiter. The film is a grim vision of human reliance on technology which becomes so intelligent that it can try to take over.

Several other 1990s movies such as *Johnny Mnemonic* (based on the novel by William Gibson), *The Net*, and *Virtuosity* exploit irrational technophobic fears, fears that somehow computers will take over our lives, that they will make our brains go haywire.

Taking advantage of a world obsessed with sex and violence, *Strange Days* relentlessly explores the virtual reality playback machine and the accompanying sale of clips. These tempt customers with offers of illicit sensation, of seeming involvement in virtual sex or violent crime as easy as loading the playback machine. The film is meant to shock people out of their complacency about a misused technology which has gone "over the edge."

32 "Reality Bytes: Andrew Huktrans Talks with Kathryn Bigelow," *Art Forum* 24(3) (November, 1995): 78–81.

33 See www.international-film.org/dogme.htm.

34 The cremaster is a muscle that raises or lowers the testicles in response to changes in the outside temperature or involuntary reflexes.

35 Lawrence Rinder in *Bit Streams* press release.

36 Ibid.

37 010101.sfmoma.org.

38 Press release for *Data Dynamics*.

39 www.CODEDOC.org.

40 Press statement of *Net_Condition* exhibition.

41 *Art in America*, special issue devoted to global issues, 1989.

Glossary

Algorithm A standardized mathematical procedure for obtaining a desired result. Rules taught at school in arithmetic, for example, long division, are a simple example of an algorithm.

Analog and digital There are, broadly speaking, two ways of encoding information. Analog encoding has a varying frequency and amplitude, whereas in digital encoding the signal is composed of a stream of binary units (on and off, one and zero), referred to as *bits*. See **bits and bytes**. In the past, media used by artists were entirely analog, e.g., still and movie film cameras, audio and video magnetic tape. The Internet did not yet exist. Most of these media are now being replaced by digital devices – digital video and still cameras, music CDs, CD-ROMs, and DVDs. Access to the Internet is completely digital. Still cameras with a thumbnail-size silicon chip (Charge-Coupled Device, CCD) as sensor (or three CCDs, corresponding to the three primary colors, in professional level cameras) are now rivaling film cameras in image quality. The television industry is converting, and mobile phones (but not yet wired phones) are digital. One of the last holdouts, the movie industry, now seems set for conversion. A complete three-hour movie can be recorded on one DVD. Copies can then be made and mailed out to exhibitors, who can then show them on digital video projectors with substantial cost savings once the initial changeover costs have been met.

Avatar In Hindu mythology the gods could each appear in different forms, or avatars. Similarly in computer games and "chat rooms" a participant can protect his or her identity by assuming a different form or personality. This is taken furthest in animated moving pictures where complete actors are created from scratch using 3-D modeling software (for example, Shrek in the movie of the same name). There is now available a new MPEG-4 (see **streaming video** and **data compression**) animation standard, which defines sixty-eight facial and body animation features that can be moved to simulate normal facial gestures including speaking. The data streams can be made small enough that automated

avatars can be downloaded from the Internet with lip-synched speech in real time with facial animation elements (called visemes) to match the speech phonemes.

Bits and bytes Digital signals are transmitted in binary code or **bits**. For example, eight bits of binary code, referred to as a **byte**, can be used to represent up to 256 characters, which may be familiar alphanumerics (letters and numbers) on a keyboard, or may represent shades of an image color. Signal transmission rates are given as bps (bits per second), data storage as bytes. Note also the prefixes *kilo* (k) for one thousand times – as in kbps; *mega* (M) for one million times – as in MB or megabytes; *giga* (G) for one billion. Closely related is frequency or bandwidth in cycles per second or Hertz (Hz).

Bluetooth A type of short-range (up to about 10m) wireless connection between computers and peripherals (including mobile phones and, through them, the Internet). It is intended to replace cable connections such as USB. Although Bluetooth, at around 1 Mbps, is ten times slower than USB cable, it makes up for this by its greater versatility. Like **WI-FI** (wireless fidelity – see **wireless networking**) it uses the 2.4 GHz radio band, but avoids frequencies used by WI-FI in order to reduce possible interference.

Broadband The speed with which information is transmitted electronically is determined by bandwidth. For example, a standard "dial-up" telephone modem has a bandwidth of up to 56 kbps (kilobits per second), which limits the speed at which images can be downloaded from the Internet. It is now possible to achieve much higher rates of 1 Mbps and above (referred to as broadband) using cable modems, Digital Subscriber Line (DSL), or satellites. However, with some of these technologies, uploading to the Internet is about ten times slower than downloading from it, hence these ones are referred to as asymmetric. Cable broadband can be accessed in 80 percent or so of US homes, whereas DSL, which uses "copper" wire, requires proximity (up to 10 km) to a telephone sub-station, and satellite Internet service (as distinct from satellite television) is currently limited.

CD and DVD Compact discs, which tend to music and data applications, and Digital Versatile Discs, which tend to video applications, have largely overtaken the field of recording music, data, and video from earlier analog tape media. They both rely (typically) on a powerful laser "burning" a sequence of "pits," corresponding to the data being recorded, on to a plastic surface. The pits then reflect a lower power laser beam that "reads" the data. Whereas the CD can store about 700 MB, the more advanced DVD (having the same dimensions as the CD) can store 4800 MB (and up to three times this in future): 4000 MB is sufficient for storing a complete feature film.

Community antenna television (CATV) and cable CATV was developed in the 1940s to provide clear reception to communities where normal broadcast reception was poor as a result of distance from the main transmitter or intervening topographic features such as hills. The broadcast signal was received by an antenna mounted on a high tower and retransmitted by cable to the homes of subscribers. It was soon realized that cable, because of its large bandwidth, had the possibility of offering many more channels (up to eighty as opposed to the seven or so "over-the-air") and so the modern cable television industry was born.

In the United States, in 1966, the Federal Communication Commission assumed regulatory powers over cable and, in 1972, specified that the industry should allocate a certain amount of free access programming to local groups – a decision that the industry has continued to fight through the courts and in Congress. In addition to local access

programming the cable companies make available a variety of programs paid for by a mix of subscriber fees, advertising, pay-per-channel, and pay-per-view.

For homes outside of the high-density urban areas reached by cable, essentially the same services (but not local access programming) are provided by satellite. Older systems use a 3 m dish antenna aimed at one or other of twenty-four different satellites. These are being replaced by a more sophisticated Digital Satellite System (DSS) with a smaller 0.5 m dish receiving up to 150 channels with superior picture reception, from only one or two satellites. This offers direct competition to cable in many urban areas, although there may be siting or orientation problems in congested areas.

Data compression The success of digital devices including CDs, DVDs, digital cameras, websites with images and animation, digital television, and much else depends on the ability to reduce file sizes by data compression algorithms. Still images, for example, usually include swaths of similar color, which can be specified by a relatively few bits of information. Similarly, moving images usually show relatively few areas of change from one frame to the next; music has silent moments. The basic information does not have to be repeated, only the changes. Data compression standards for still images (the Joint Photographic Expert Group, JPEG); for moving images and sound (the Motion Picture Expert Group, MPEG); and for music (MP3, which is a sub-set of MPEG) are prepared by industry-supported technical committees established to ensure some degree of interchangeability and adopted by the International Organization for Standardization. MPEG-2 is the earlier version developed for video, DVD, and movies. MPEG-4 was developed more recently for the Internet (see **streaming video**). There are also proprietary codecs (code/decode devices) for compression of data outside of the standard systems.

Digital television DTV (also known as High Definition television, HDTV) is expected to replace existing analog television systems, especially since the US Federal Communication Commission (FCC) has mandated the changeover from the existing NTSC in the USA by 2006, mostly as a result of pressure from the electronics industry, and despite a lack of enthusiasm from the public. Whereas the NTSC has 480 lines on the screen with 640 pixels per line, HDTV has 720 lines with 1280 pixels per line (there are also other differences including a change in aspect ratio from 4:3 to 16:9). This will permit much higher image resolution. It will also open the way to other onscreen and interactive services, which may have greater commercial appeal. This development has been largely made possible by the development of sophisticated **data compression** software that is inherently digital.

Digital video projectors DVPs combine with DVD and like technologies, to provide a major tool for artists, as well as for business presentations, and, in future, replacing analog film projectors in cinema. Intense light sources (2000 lumens and above) have been developed for DVPs. There are two competing modulation technologies. In one, light from the source passes through a digitally modulated LCD (one centimetre or so square with one LCD for each primary color), and in the other, known as Digital Light Processing (DLP), the light is modulated by millions of microscopic mirrors deposited on a silicon chip. There is also an LCD variant – Liquid Crystal on Silicon (LCOS).

DSL See **broadband**.

Electronic music In the early 1960s, the first electronic synthesizers became commercially available to traditional musicians. Shortly afterwards Robert Moog's Mini-Moog synthesizer

was widely adopted by rock musicians. Moogs were used mostly to simulate pianos and traditional instruments. In 1982, Roland, a manufacturer of synthesizers, introduced two sequencing instruments. One, the TB303 (transistor bass), emulated the bass guitar, while the other, the TR606 (transistor rhythm), emulated a drummer. Rock musicians, the original target users, found little use for these machines, which did not sound much like a real drummer or real bass player. However, in the late 1980s and early 1990s they were picked up by hip-hop musicians (mostly in the US) and by techno music (mostly in Britain and Europe where techno was associated with "raves"). By the mid-1990s, personal computers were becoming widely available together with software powerful enough to make complex audio synthesis and production possible. It was no longer necessary to own a synthesizer, sampler, or sequencer in order to produce electronic music, and sounds could be processed and manipulated in ways that were once impossible or simply tedious and time-consuming. This led at first to intelligent dance music (IDM). However, this did not lend itself to performance and was too cerebral for most musicians and publics. By the late 1990s there evolved a combination of IDM with uniquely American influences from the more visceral hip-hop and hard-core punk. This new music (sometimes referred to as "electronica") combines experimentation and complexity but, at the same time, has energy and fun, and is danceable.

Ethernet See **local area network**.

Fiber-optics fine fibers of plastic, glass, or silica, less than one milimetre in diameter, can be fabricated to very high purity limits to provide extraordinarily wide bandwidth connections. They have now replaced conventional cable, not only in virtually all long-distance transmission of voice, video, and data but increasingly in short-distance local applications.

Flat panel displays Until recently, television screens and computer monitors were bulky and heavy cathode ray tubes (CRTs). They were limited in size to around 40 in. (diagonal) and the only way of enlarging the image was by back-projection, usually involving three CRTs, one for each of the primary colors, red, green, and blue. More recently, liquid crystal displays (LCDs) have become available. In the active matrix form with thin film transistors on glass (and with backlighting), they are replacing CRTs in many applications. However, very high precision is required in manufacture so that it is thought unlikely that LCDs will be produced in sizes above 40 in. or so. The most promising contender for the big screen is currently thought to be the plasma panel, but other technologies, such as electroluminescent panels and organic LCDs (OLEDs), are being explored. An important new, related, development is the low-temperature polysilicon thin film transistor LCD, which (unlike current LCDs) can incorporate circuitry in the thin film on specially prepared glass, making possible new devices such as LCD copiers.

Fractals A class of mathematical expressions that yield similar patterns at different scales (or magnifications). They can be used to describe many natural features including landscapes, and vegetation. Fractals have found important application in animations and simulations of natural features.

Global positioning system GPSs can establish the position of a person or site on the surface of the Earth to within as little as one meter. This is achieved by comparing arrival times of signals from each of three Earth satellites (there are twenty-four in orbit to ensure there will always be three overhead at any one time). The GPS receiver can now be made small

enough and cheap enough to be carried by say a hiker walking in the woods, or to track a single animal in wild-life studies. GPS has been used in some arts projects.

Infrared The use of a modulated infrared (IR) light beam to transmit data from one computer or peripheral (such as a PDA or a printer) to another. It is the same technology found in the familiar television "zapper," and like that has to be in "line-of-sight" and is only short-range.

Intelligent agent Most Web programs are based on HyperText Markup Language (HTML) programming code. This is now being superseded by Extensible Markup Language (XML), which is making possible the development of programs called Intelligent Agents that can more efficiently search the Web to obtain information. This is, up to now, being undertaken by relatively crude search engines, such as Google, as well as specialist search engines such as Lexus-Nexus. However, Berners-Lee, the inventor of the Web, is now pushing this further with the creation of the Semantic Web, which, it is hoped, will make possible a more human-like and comprehensive approach involving images as well as text, and incorporating a wide range of input information.

Internet This was originally developed as ARPANET by the US government as a distributed form of data transmission that could resist degradation in wartime. This became accessible to universities and other civilian users in the 1980s. However, it did not really "take off" until Tim Berners-Lee, then at the European Nuclear Research Centre (CERN) at Geneva, invented the World Wide Web as a way of finding and accessing individual sites. He assigned addresses such as www.university.edu (known as Universal Resource Locators (URLs) and, more familiarly, as websites or homepages). To additionally simplify access he developed the first "Browser" (MOSAIC – forerunner of Netscape and Explorer). It should be emphasized that the Web is only one subset of the Internet. Another is electronic mail (e-mail).

Internet Service Provider The IPS is the "portal" or entry point to the Internet for most users. There are currently some six thousand small ISPs in the USA and a few bigger ones, such as AOL and Hotmail. The ISP is found in e-mail addresses such as jane@ISP.com.

Laserdiscs Analog forerunners of CDs and DVDs. Like the latter, they permit random access to different segments of the contents, and they have been widely used by media artists.

Light emitting diodes LEDs are small (pea-size) semiconductor lamps that have been developed to a high luminous efficiency (better than 50 percent) and service life (100,000 hours). Originally available only in red, they are now available in most colors and, since they are easily incorporated into electronic circuitry, they are becoming prominent in large billboard displays that are interesting to many artists. They are somewhat distantly related to laser diodes widely used for swiping barcodes at checkout desks.

Local area network (LAN) A number of computers joined in the same office, organization, or even household. One computer, the server, or master, can provide a common link to the Internet. The network computers are linked by optic fibers; high-speed cable connection, such as T1 lines provided by telephone companies; ethernet cables, available on most personal computers; or by wireless connection, WI-FI (of which Mackintosh's Airport is an example).

MIDI Musical Instrument Digital Interface, a standardized computer language permitting information exchange between different devices that are used to create music, such as computer, sampler, sequencer, synthesizer.

Mobile phones Also known as cell phones. A covered area of land is divided into cellular areas each having a wireless tower to hand on a mobile phone transmission from one tower to another or to a landline. Mobile phones are mostly digital, which simplifies access to the Internet and this is being provided on some mobiles, although limited by slow transmission rates (10 kbps). Mobile transmissions are coded in one of four different (and incompatible) ways. One of these, General Services for Mobiles (GSM), has been standardized in Europe, but not yet in North and South America. Mobiles can also provide simple text messaging services. Pagers and walkie-talkies have been largely replaced by mobiles except for niche markets. The need for faster download times is leading to the development of a number of new (for the Internet) technologies, such as multiplexing, packet switching, spread spectrum, ultra-wide-band (UWB), and phased-array antennas.

Modems and codecs Modems (modulate/demodulate) convert analog signals to digital signals and vice versa, e.g., telephone modems (having transmission rates of up to 56 kbps) and cable modems (with rates of 1 Mb/s or more). Somewhat similarly, codecs are used to compress and decompress data.

MP3 A subset of the MPEG data compression standard for audio, MP3 permits downloads of music CDs from the Internet in up to ten times less time than it takes to play the music. This has created widespread copying of music files over the Internet as well as much litigation around copyright issues.

NTSC National Television Standards Committee. Has established the technical standards used in television and video in the United States, the Western hemisphere generally, and Japan (see **pixel**). Other countries have adopted incompatible formats – PAL in Britain, Germany and some other countries, and SECAM in France and Russia.

Personal digital assistants (PDAs) Pocket-sized small computers, which can be linked to larger computers by cables, or by short-range infrared or wireless technology.

Pixel Pixels, or picture elements, consist of primary color triads (red, green, blue subpixels) that determine by their size and number the resolution of a television screen, computer monitor, digital camera, etc. For example, the NTSC television standard has 525 lines that set the vertical resolution (at 480 lines taking account of the scanner's flyback time), and 700 horizontal pixels (or 350 sets of alternate black-and-white squares) to give the standard 4:3 aspect ratio (640 by 480 pixels). For the standard thirty frames per second, a bandwidth of 525 by 350 by 30 Hz = 5.5 MHz is required. Television channels are 6 MHz in practice (US). For **DTV**, much larger channels, approaching 100 MHz, would have been required but for the development of data compression. For analog systems, the light intensity of each pixel element is determined by the amplitude modulation of the scanning electron beam. For digital systems, intensity is determined by a binary coding with one byte for each pixel element, giving two to the eighth power or 256 intensity values to each of the three elements in the triad (millions of colors).

Robot (also Bot) Uses electronic digital (mostly) sensors and feedback to control mechanical devices that mimic some human functions. The Mars Lander telerobot with its

fascinating images of the surface of Mars is by now well known. Robots have been used by artists. They are likely to have increasing importance in the future.

Sampler A device used by musicians to store digitally recorded sounds (or samples). These sounds – from traditional acoustical instruments, natural sounds, noises, short musical excerpts – can be linked through the sampler and a **MIDI** interface to a keyboard where the originals can be combined and replayed with variations.

Satellite communications Near Earth orbiting satellites at an altitude of around 500 km and period of 90 minutes are used by the **global positioning system** and by the IRIDIUM system that has given a global reach to mobile phones. Geostationary satellites at an altitude of 36,000 km have a 24-hour period and in equatorial orbit appear stationary in the sky. They are extensively used for telecommunications, including digital satellite system television service.

Semantic web See **Intelligent agent**.

Simulation, virtual reality, and interactivity Digital electronics lends itself to the creation of a virtual reality by simulation and by its interactive possibilities. First developed as a way of training airplane pilots and military personnel, it became the source of the huge video game industry. Interactive and virtual reality websites, CD-ROMs, and DVDs are now an important medium for artists.

Streaming video The MPEG **data compression** standard comes in different "flavors." MPEG-2 was largely designed to meet the needs of high-resolution **DTV** and DVDs. However, Internet downloading makes even stronger demands, and MPEG-4 was intended for this purpose. Image resolution is reduced, as is frame rate (this latter often to 12 fps or less). Moreover, the advanced streaming video codecs have anticipation functions that permit changing frame rates and other parameters to optimize download speed and image quality.

Unicode The international standard that permits computers to exchange e-mail and other technical messages. The 2003 version, Unicode 4, comprises the binary code for each of 96,000 letters and symbols (70,000 of them Chinese characters) from 55 of the 148 known writing systems. It has been largely the work of one man – the American Irish Michael Everson.

URL Universal resource locator. See **Internet**.

Webcam An inexpensive digital video camera with which moving images can be uploaded to the Internet in real time along with instant voice messaging. It is the modern successor to the earlier, unsuccessful, videophone.

Wireless networking The 802.11 wireless networking standard, also known as WI-FI (see also **local area network**) comes in three flavors – a, b, and g. The earlier 802.11a version is not compatible with 802.11b and 802.11g but all have high transfer rates (around 20 Mbps for 802.11g). They are to be found in home and office networking, and in coffee shops, and campuses set up for laptop users. Typically they have a range of up to 100 m or more. This may, however, be reduced by electromagnetic interference.

Select bibliography

Books

Ades, D. (1976) *Photomontage*. London: Thames and Hudson.
Alpers, S. (1983) *The Art of Describing: Dutch Art in the 17th Century*. Chicago: University of Chicago Press.
Anders, P. (1999), *Envisioning Cyberspace: Designing 3D Electronic Spaces*. New York: McGraw-Hill.
Anderson, L. (1994) *Stories from the Nerve Bible Retrospective 1972–92*. New York: Harper Perennial.
Arnheim, R. (1969) *Visual Thinking*. Berkeley and Los Angeles: University of California Press.
Ascott, R. and Shanken, E. (2003) *Telematic Embrace: Visionary Theories of Art, Technology and Consciousness*. Berkeley: University of California Press.
Barthes, R. (1972) *Mythologies*. New York: Hill and Wang.
—— (1974) *S/Z*. Paris: Editions du Seuil, 1970. Translated by Richard Miller. New York: Hill and Wang.
—— (1977) *Image-Music-Text*. Translated by Stephen Heath. New York: Hill and Wang.
—— (1982) *Elements of Semiology*. New York: Hill and Wang.
Battcock, G. (1978) *New Artists Video*. New York: E. P. Dutton.
Baudrillard, J. (1983) *In the Shadow of the Silent Majorities: Or the End of the Social, and Other Essays*. New York: Semiotext(e).
—— (1988) *Selected Writings*, ed. Mark Poster. Stanford: Stanford University Press.
—— (1988) *The Ecstasy of Communication*. New York: Autonomedia.
—— (1993) *The Transparency of Evil: Essays on Extreme Phenomena*. London: Verso.
Bazin, A. (1968) *What Is Cinema?* Berkeley and Los Angeles: University of California Press.
Bender, G. and Druckrey, T., eds (1994) *Culture on the Brink: Ideologies of Technology*. Seattle: Bay Press.
Benedetti, P. and DeHart, N., eds (1996) *McLuhan: Forward through the Rearview Mirror*. Cambridge, MA: MIT Press.
Benedict, M., ed. (1991) *Cyberspace: First Steps*. Cambridge, MA: MIT Press.
Benjamin, W. (1978) *Illuminations*. New York: Schocken Books.
—— (1986) *Reflections: Essays, Aphorisms, Autobiographical Writings*, ed. Peter Demetz. New York: Schocken Books.

—— (1988) *Understanding Brecht*. New York: Verso.

—— (1988) *On Walter Benjamin: Critical Essays and Recollections*, ed. Gary Smith. Cambridge, MA: MIT Press.

Berger, J. (1980) *About Looking*, New York: Pantheon Books.

—— (1981) *Ways of Seeing*, London: BBC and Penguin Books.

Bishton, D., Cameron, A. and Druckrey, T., eds (1991) *Ten 8: Digital Dialogues* (Autumn, 1991). Birmingham: Ten 8 Ltd.

Burnham, J. (1968) *Beyond Modern Sculpture*. London: Braziller.

—— (1971) *The Structure of Art*. New York: Braziller.

Coke, V. D. (1974) *The Painter and the Photograph*. Albuquerque: University of New Mexico Press.

Connor, S. (1989) *Postmodern Culture: An Introduction to Theories of the Contemporary*. London: Basil Blackwell Ltd.

Corn, J. J., ed. (1986) *Imagining Tomorrow: History, Technology and the American Future*. Cambridge, MA: MIT Press.

Corn, J. J. and Harrigan, B. (1984) *Yesterday's Tomorrows*. New York: Summit.

Crary, J. (1990) *Techniques of the Observer: On Vision and Modernity in the Nineteenth Century*. Cambridge, MA: MIT Press.

Crimp, D. (1993) *On the Museum's Ruins*. Cambridge, MA: MIT Press.

Critical Art Ensemble (1994) *The Electronic Disturbance*. Brooklyn, NY: Autonomedia.

—— (1996) *Electronic Civil Disobedience and Other Unpopular Ideas*. New York: Autonomedia.

Cubitt, Sean (1993) *Videography: Video Media as Art and Culture*. New York: St Martin's Press.

D'Agostino, P. (1985) *Transmission: Theory and Practice for a New Television Aesthetics*. New York: Tanam Press.

Davis, D. (1974) *Art and the Future*. New York: Praeger Publishers.

—— (1977) *Artculture*. New York: Harper & Row.

Davis, D. and Simmons, A., eds (1977) *The New Television: A Public/Private Art*. Cambridge, MA: MIT Press.

De Bord, G. (1994) *The Society of the Spectacle*. New York: Zone Books.

De Lauretis, T., Hayssen, A. and Woodward, K., eds (1980) *The Technological Imagination*. Madison, WI: Coda Press.

Deleuze, G. and Guattari, F. (1987) *A Thousand Plateaus: Capitalism and Schizophrenia*. Translated by B. Massumi. Minneapolis: University of Minnesota Press.

D'Harnoncourt, A. and McShine, K., eds (1973) *Marcel Duchamp*. New York: Museum of Modern Art.

Druckrey, T., ed (2001) *Ars Electronica, Facing the Future, A Survey of Two Decades*. Cambridge, MA: MIT Press.

Duberman, M. (1972) *Black Mountain: An Exploration in Community*. New York: E. P. Dutton.

Dupuy. J. (1980) *Collective Consciousness: Art Performance in the Seventies*. New York: Performing Arts Journal Publications.

Eagleton, T. (1983) *Literary Theory: An Introduction*. Minneapolis: University of Minnesota Press.

—— (1992) *Walter Benjamin: Or Towards a Revolutionary Criticism*. London: Verso.

Ellul, J. (1967) *The Technological Society*. New York: Alfred Knopf.

Felshin, N., ed. (1995) *But Is It Art? The Spirit of Art as Activism*. Seattle: Bay Press.

Ferguson, R., Olander, W., Tucker, M. and Fiss, K., eds (1992) *Discourses: Conversations in Postmodern Art and Culture*. Cambridge, MA: MIT Press.

Flanagan, M. and Booth, A., eds (2002) *Reload: Rethinking Women and Cyberculture*. Cambridge, MA: MIT Press.

Foster, H., ed. (1983) *The Anti-Aesthetic: Essays on Postmodern Culture*. Port Townsend, WA: Bay Press.

Foucault, M. (1970) *The Order of Things*. New York: Pantheon Books.

—— (1972) *The Archaeology of Knowledge: And the Discourse on Language*. New York: Pantheon Books.

Frampton, H. (1983) *Circles of Confusion*. Rochester, NY: Visual Studies Workshop.

Francke, H. W. (1971) *Computer Graphics/Computer Art*. London: Phaidon.

Frank, P. and McKenzie, M. (1987) *New, Used and Improved: Art for the 80s*. New York: Abbeville Press.

Frascina, F. and Harrison, C., eds (1982) *Modern Art and Modernism*. New York: Harper and Row.

Fuller, B. (1969) *Operating Manual for Spaceship Earth*. Carbondale: Southern Illinois University Press.

Fuller, P. (1980) *Beyond the Crisis in Art*. London: Writers and Readers Publishing Cooperative.

—— (1981) *Seeing Berger: A Revaluation*, 2nd edn. London: Writers and Readers Publishing Cooperative.

—— (1980) *Progress in Art*. New York: Rizzoli.

Gablik, S. (1991) *The Re-enchantment of Art*. New York: Thames and Hudson.

Gaggi, S. (1989) *Modern/Postmodern: A Study in Twentieth Century Arts and Ideas*. Philadelphia: University of Pennsylvania Press.

Gendron, B. (1977) *Technology and the Human Condition*. New York: St Martin's Press.

Gernsheim, H. and Gernsheim, A. (1969) *The History of Photography*. New York: McGraw-Hill.

Giedion, S. (1948) *Mechanization Takes Command*. New York: Oxford University Press.

Gill, J. (1976) *Video: State of the Art*. New York: Rockefeller Foundation.

Gillette, F. (1973) *Between Paradigms*. New York: Gordon and Breach.

Goldberg, K. (2000) *The Robot in the Garden: Telerobotics and Telepistemology in the Age of the Internet*. Cambridge, MA: MIT Press.

Goldberg, R. L. (1988) *Performance Art: From Futurism to the Present*. New York: Harry N. Abrams.

—— (2000) *Laurie Anderson*. New York: Abrams.

Gombrich, E. H. (1950) *The Story of Art*. London: Phaidon Press.

Goodman, C. (1987) *Digital Visions: Computers and Art*. New York: Harry N. Abrams.

Graham, D. (1979) *Video-Architecture-Television*. New York: Press of Nova Scotia College of Art and Design and New York University Press.

Grau, O. (2003) *Virtual Art: From Illusion to Immersion*. Cambridge, MA: MIT Press.

Grundberg, A. G. and McCarthy, K. (1987) *Photography and Art: Interaction since 1946*. New York: Abbeville Press.

Hall, D. and Fifer, S., eds (1990) *Illuminating Video: An Essential Guide to Video Art*. New York: Aperture Foundation Inc.

Hamilton, E. and Cairns, H., eds (1965) *The Collected Dialogues of Plato*. Princeton: Princeton University Press.

Haraway, D. J. (1991) *Simians, Cyborgs and Women: The Reinvention of Nature*. New York: Routledge.

Hayles, N. K. (1999) *How We Became PostHuman: Virtual Bodies In Cybernetics, Literature, and Informatics*. Chicago: University of Chicago Press.

Haynes, D. (1996) *The Vocation of the Artist*. Cambridge: Cambridge University Press.

Heartney, E. (1997) *Critical Condition: American Culture at the Crossroads*. Cambridge: Cambridge University Press.

Heidegger, M. (1977) *The Question Concerning Technology and Other Essays*. New York: Harper and Row.

Hockney, D, (2001) *Secret Knowledge: Rediscovering the Lost Techniques of the Old Masters*. New York: Viking Press.

Ivins, W. M. (1969) *Prints and Visual Communication*. New York: Da Capo Press.

Jameson, F. (1991) *Postmodernism: The Cultural Logic of Late Capitalism*. Durham, NC: Duke University Press.

Jammes, A. (1973) *William H. Fox Talbot*. New York: Collier Books.

Kahn, D. (1985) *John Heartfield: Art and Mass Media*. New York: Tanam Press.

Kemp, M. (1990) *The Science of Art: Optical Themes in Western Art from Brunelleschi to Seurat*. New Haven: Yale University Press.

Kepes, G. (1951) *Language of Vision*. Chicago: Paul Theobald.

—— (1956) *The New Landscape in Art and Science*. Chicago: Paul Theobald.

Kern, S. (1983) *The Culture of Time & Space 1880–1918*. Cambridge, MA: Harvard University Press.

Klüver, B., Martin, J. and Rose, B., eds (1972) *Pavilion – Experiments in Art and Technology*. New York: E. P. Dutton and Co.

Knowlton, K. (1972) *Collaborations with Artists – A Programmer's Reflections*. Amsterdam: North Holland Publishing.

Kostelanetz, R., ed. (1977) *Moholy-Nagy*. New York: Praeger Publishers.

Krueger, Myron (1983) *Artificial Reality*. Reading, MA: Addison-Wesley.

Kuhn, T. (1970) *The Structure of Scientific Revolutions*, 2nd edn. Chicago: University of Chicago Press.

Landow, G. (1992) *Hypertext: The Convergence of Contemporary Critical Theory and Technology*. Baltimore and London: Johns Hopkins University Press.

Lanham, R. A. (1983) *The Electronic Word: Democracy, Technology and the Arts*. Chicago: University of Chicago Press.

Lunenfeld, P., ed. (1999) *The Digital Dialectic: New Essays on New Media*. Cambridge, MA: MIT Press.

Lyotard, J.-F. (1984) *The Postmodern Condition: A Report on Knowledge*. Minneapolis: University of Minnesota Press.

MacCabe, C. (1980) *Godard: Images, Sounds, Politics*. Bloomington: Indiana University Press.

—— ed. (1986) *High Theory/Low Culture*. New York: St Martin's Press.

McEvilley, T. (1991) *Art and Discontent: Theory at the Millennium*. Kingston, NY: McPherson & Co.

McHale, B. (1992) *Constructing Postmodernism*. London and New York: Routledge.

McLuhan, M. (1951) *The Mechanical Bride: Folklore of the Industrial Man*. New York: Vanguard Press.

—— (1962) *The Gutenberg Galaxy*. Toronto: University of Toronto Press.

—— (1964) *Understanding Media: The Extensions of Man*. New York: McGraw-Hill.

Malina, F. J., ed. (1974) *Kinetic Art: Theory and Practice*. New York: Dover Publications.

Manovich, L. (2001) *The Language of New Media*. Cambridge, MA: MIT Press.

Moholy-Nagy, S. (1969) *Laszlo Moholy-Nagy: Experiment in Totality*. Cambridge, MA: MIT Press.

Moles, A. (1966) *Information Theory and Esthetic Perception*. Urbana: University of Illinois Press.

Monaco, J. (1981) *How to Read a Film*. New York: Oxford University Press.

Monk, P. (1988) *Struggles with the Image: Essays in Art Criticism*. Toronto: YYZ Books.

Moser, M. A. and MacLeod, D., eds (1996) *Immersed in Technology: Art and Virtual Environments*. Cambridge, MA: MIT Press.

Mumford, L. (1952) *Art and Technics*. New York and London: Columbia University Press, 6th printing 1966.

—— (1967) *The Myth of the Machine*. New York: Harcourt, Brace and World.

Myerson, G. (2001) *Heidegger and the Mobile Phone*. Postmodern Encounters Series. Cambridge: Icon Books.

Negroponte, N. (1970) *The Architecture Machine: Toward a More Human Environment*. Cambridge, MA: MIT Press.

—— (1996) *Being Digital*. New York: Vintage Books (Random House).

Nelson, T. (1974) *Dream Machines: Computer Lib*. Chicago: Hugo's Book Service.

Newman, C. (1985) *The Post-Modern Aura*. Evanston, IL: Northwestern University Press.

Nichols, B. (1994) *Blurred Boundaries: Questions of Meaning in Contemporary Culture*. Bloomington and Indianapolis: Indiana University Press.

Olalquiaga, C. (1992) *Megalopolis: Contemporary Cultural Sensibilities*. Minneapolis: University of Minnesota Press.

Packer, R. and Jordan, K., eds (2001) *Multimedia: From Wagner to Virtual Reality*. New York and London: W. W. Norton.

Paik, N. J. (1984) *Art and Satellite*. Berlin: Daardgalerie.

Parenti, M. (1986) *Inventing Reality: Politics of the Mass Media*. New York: St Martin's Press.

Parker, W. E., ed. (1985) *Art and Photography – Forerunners and Influences*. Rochester, NY: Peregrine Smith Books with Visual Studies Workshop Press.

Penley, C. and Ross, A., eds (1991) *Technoculture*. Minneapolis: University of Minnesota Press.

Penny, S., ed. (1995) *Critical Issues in Electronic Media*. Albany, NY: SUNY Press.

Popper, F. (1968) *Origins and Development of Kinetic Art*. London: Studio Vista.

—— (1975) *Art, Action, and Participation*. London and New York: Studio Vista and New York University Press.

—— (1993) *Art in the Electronic Age*. New York: Abrams.

Postman, N. (1985) *Amusing Ourselves to Death: Public Discourse in the Age of Show Business*. New York: Viking.

Reichardt, J. (1971) *The Computer in Art*. London and New York: Studio Vista and Van Nostrand Reinhold.

—— (1971) *Cybernetics, Art and Ideas*. Greenwich: New York Graphic Society.

Rheingold, H. (1993) *The Virtual Community: Homesteading on the Electronic Frontier*. Reading, MA: Addison-Wesley.

—— (2003) *Smart Mobs: The Next Social Revolution*. Cambridge, MA: Perseus.

Richards, C. and Tenhaaf, N., eds (1991) *Virtual Seminar on the Bioapparatus*. Banff, Alberta: Banff Centre for the Arts.

Richter, H. (1978) *Dada: Art and Anti-Art*. New York and Toronto: Oxford University Press.

Rieser, M. and Zapp, A., eds (2002) *New Screen Media: Cinema/Art/Narrative*. London: British Film Institute and ZKM.

Rochlitz, R. (1996) *The Disenchantment of Art: The Philosophy of Walter Benjamin*. New York: Guilford Press.

Rosenberg, M. J. (1983) *The Cybernetics of Art – Reason and the Rainbow*. New York: Gordon and Breach.

Roszak, T. (1986) *The Cult of Information*. New York: Pantheon.

Scharf, A. (1968) *Art and Photography*. London: Allen Lane, The Penguin Press.

Schlossberg, E. (1998), *Interactive Excellence: Defining and Developing New Standards for the Twenty-First Century*. New York: Ballantine Publishing Group.

Schneider, I. and Korot, B., eds (1976) *Video Art – An Anthology*. New York and London: Harcourt Brace Jovanovich.

Scholder, A. and Crandall, J., eds (2001) *Interaction: Artistic Practice in the Network*. New York: Eyebeam Atelier and Distributed Art Publishers.

Schwarz, H. P. (1997) *Are Our Eyes Targets? Media Art History: Media Museum*. Karlsruhe: ZKM, and Munich and New York: Prestel.

Sekula, A. (1984) *Photography against the Grain*. Halifax: Press of Nova Scotia College of Art and Design.

Shurkin, J. (1984) *Engines of the Mind*. New York: Washington Square Press.

Siepmann, E. (1977) *Montage: John Heartfield*. Berlin: Elefanten Press.

Sitney, P. A. (1974) *Visionary Film: The American Avant-Garde*. New York: Oxford University Press.

Smith, G., ed. (1989) *Benjamin: Philosophy, Aesthetics, History*. Chicago: Chicago University Press.

Sommerer, C. and Mignonneau, L., eds (1998) *Art@Science*. Vienna and New York: Springer-Verlag.

Sontag, S. (1978) *On Photography*. New York: Delta.

Toffler, A. (1970) *Future Shock*. New York: Random House.

—— (1984) *Previews and Premises*. Boston: South End Press.

Tomkins, C. et al. (1977) *The World of Marcel Duchamp 1887–1968*. Alexandria, VA: Time-Life Books.

—— (1983) *Off the Wall*. New York: Penguin Books.

Trifonas, P. P. (2001) *Barthes and the Empire of Signs*. Postmodern Encounters Series. Cambridge: Icon Books.

Tucker, M., ed. (1986) *Art and Representation: Rethinking Modernism*. New York: New Museum of Contemporary Art.

Turkle, S. (1995), *Life on the Screen: Identity in the Age of the Internet*. New York: Simon and Schuster.

Valéry, P. (1964) *Aesthetics, the Conquest of Ubiquity*. New York: Pantheon.

Varnedoe, K. and Gopnik, A. (1990) *Modern Art and Popular Culture: Readings in High and Low*. New York: Harry N. Abrams.

Venturi, R., Scott-Brown, D. and Izenour, S., eds (1977) *Learning from Las Vegas: The Forgotten Symbolism of Architectural Form*. Cambridge, MA: MIT Press.

Victorues, P. B. (1968) *Computer Art and Human Response*. Charlottesville, VA: Lloyd Sumner.

Viola, B. (1995) *Reasons for Knocking at an Empty House: Writings 1973–1994*. Cambridge, MA: MIT Press.

Virilio, P. (1997) *Open Sky*. Translated by Julie Rose. London: Verso.

—— (2000) *The Information Bomb*. Translated by Chris Turner. London: Verso.

Virilio, P. and Lotringer, S. (1983) *Pure War*. New York: Semniotext(e).

Vitz, P. C. and Glimcher, A. B. (1984) *Modern Art and Modern Science: The Parallel Analysis of Vision*. New York: Praeger.

Wallis, B., ed. (1984) *Art after Modernism: Rethinking Representation*. New York: The New Museum of Contemporary Art, and Boston: David R. Godine.

Warhol, A. and Hackett, P. (1980) *POPism: The Warhol '60s*. New York: Harper and Row.

Weibel, P. and Druckrey, T., eds (1999), *net. condition: art and global media*. Cambridge, MA: MIT Press.

Wheeler, D. (1991) *Art Since Mid-century: 1945 to the Present*. Englewood Cliffs, NJ: Prentice Hall/Vendome Press.

Willats, S. (2000) *Art and Social Function*. London: Ellipsis.

Williams, R. (1961) *The Long Revolution*. London and New York: Chatto and Windus and Columbia University Press.

—— (1975) *Television: Technology and Cultural Form*. New York: Schocken Books.

Wilson, S. (2002) *Information Arts*. Cambridge, MA: MIT Press.

Wodiczko, K. (1999) *Critical Vehicles: Writings, Projects, Interviews*. Cambridge, MA: MIT Press.

Woodward, K., ed. (1980) *The Myths of Information*. Madison, WI: Coda Press.

Wooley, B. (1993) *Virtual Worlds: A Journey in Hype and Hyperreality*. London: Penguin Books.

Youngblood, G. (1970) *Expanded Cinema*. New York: E. P. Dutton.

Zizek, S. (2002) *Welcome to the Desert of the Real*. London: Verso.

Catalogs

01010101: Art in Technological Times (2001) San Francisco: San Francisco Museum of Modern Art.

Attitudes/Concepts/Images (1980) Amsterdam: Stedelijk Museum.

Aurora Borealis (1985) Montreal: Centre International d'Art Contemporain.

Before Photography (1981) New York: Museum of Modern Art.

Biennale d'Art Contemperain de Lyons (1995) Lyons.

Biennial Exhibition (1993) New York: Whitney Museum of American Art.

Biennial Exhibition (1995) New York: Whitney Museum of American Art.

Biennial Exhibition (2002) New York: Whitney Museum of American Art.

Bill Viola (1987–88) Essays by Barbara London, J. Huberman, Donald Kuspit, and Bill Viola. New York: Museum of Modern Art.

Blam! The Explosion of Pop, Minimalism, and Performance 1958–1964 (1984) New York: Whitney Museum of American Art.

The Challenge of the Chip (1980) London: Science Museum.

Comic Iconoclasm (1987–88) London: ICA (traveling exhibition).

Computer Graphics: Visual Proceeding (1993) New York: ACM Siggraph.

Cybernetic Serendipity (1968) London: ICA.

Cyborg Aesthetics (1993) Essays by Alice Yang for *The Final Frontier*. New York: New Museum of Contemporary Art.

Disinformation: The Manufacture of Consent (1985) Text by Noam Chomsky and Geno Rodriguez. New York: Alternative Museum.

Documenta 11 Platform 5: Exhibition, Kassel. June 8 to September 15, 2000.

Ecovention: Current Art to Transform Ecologies (2002) Text by Sue Spaid. greenmuseum.org; The Contemporary Arts Center; ecoartspace, Cincinnati.

Energized Artscience (1978) Chicago: The Museum of Science and Industry.

Film as Film: Formal Experiments in Film 1910–1975 (1979) Text by Phillip Drummond. London: Hayward Gallery.

Frank Gillette Video: Process and Metaprocess (1973) Essay by Frank Gillette. Interview by Willoughby Sharp. Syracuse, New York: Everson Museum of Art.

Future Cinema: The Cinematic Imaginary after Film (2002–3) Curated by J. Shaw and P. Weibel. ZKM, Karlsruhe.

Game Show: An Exhibition (Spring, 2001 to Spring, 2002) Mass MoCA. North Adams, MA: Massachusetts Museum of Contemporary Art.

Gary Hill (1994) Seattle: Henry Art Gallery, University of Washington.

German Video and Performance (1981) Text by Wulf Herzogenrath. Toronto: Goethe Institut.

Image World: Art and Media Culture (1989) New York: Whitney Museum of Art.

Les Immatériaux: Album et Inventaire Epreuves d'Ecritude (1985) Paris: Centre Georges Pompidou.

Influencing Machines: The Relationship between Art and Technology (1984) Toronto: YYZ.

Information (1970) New York: Museum of Modern Art.

Into the Light: The Projected Image in American Art 1964–1977, Chrissie Iles (2001–2) Whitney Museum of American Art.

Iterations: The New Image (1993) Text edited by Timothy Druckrey. New York: International Center of Photography/MIT Press.

Laterna Magika: New Technologies in Czech Art of the 20th Century (2002–3) Paris: Espace EDF Electra.

Lumières: Perception – Projection (1986) Montreal: Centre International d'Art Contemporain.

The Luminous Image (1984) Essays by Dorine Mignot *et al*. Amsterdam: Stedelijk Museum.

The Media Arts in Transition (1983) Edited by Bill Horrigan. Walker Art Center, NAMAC, Minneapolis College of Art and Design, University Community Video and Film in the Cities.

Media Post Media (1988) New York: Scott Hanson Gallery.

MultiMediale 4 (1995) Karlsruhe: Medienkunstfestival des ZKM.

The Museum as Seen at the End of the Mechanical Age (1968) New York: Museum of Modern Art.

Nam June Paik (1982) Essays by Dieter Renke, Michael Nyman, David Ross, and John Hanhardt. New York: Whitney Museum of American Art.

National Video Festival (1983) Los Angeles: American Film Institute.

Nine Evenings: Theatre and Engineering, (1966) Text by Billy Klüver. Statements by John Cage *et al*. New York: New York Foundation for the Performing Arts.

On Art and Artists (1985) Chicago: School of the Art Institute of Chicago.

Photography and Art: Interactions since 1946 (1987) New York: Abbeville Press.

Photography After Photography (1996) Munich: Aktionsforum Praterinsel.

Report on Art and Technology (1971) Text by Maurice Tuchman. Los Angeles: Los Angeles County Museum of Art.

Robert Wilson: From a Theater of Images (1980) Cincinnati, OH: Contemporary Arts Center.

The Second Link: Viewpoints on Video in the Eighties (1983) Calgary, Alberta: Banff Center School of Fine Arts.

Software (1970) Essays by Jack Burham and Theodore Nelson. Introduction by Karl Katz. New York: Jewish Museum.

Some More Beginnings (1968) New York: EAT in collaboration with the Brooklyn Museum and the Museum of Modern Art.

Sonic Process: A New Geography of Sounds (2001) Barcelona: Museu d'Art Contemporani.

Symptomatic: Recent Works by Perry Hoberman (2001) Bradford: National Museum of Photography, Film and Television.

United States/Laurie Anderson (1984) New York: Harper and Row.

Unnatural Science (2000) North Adams, MA: Massachusetts Museum of Contemporary Art.

Vectors: Digital Art of Our Time (2003) Tenth Anniversary New York Digital Salon catalog, *Leonardo*, 35 (5). Cambridge, MA: MIT Press.

Video: A Retrospective 1974–1984 (1984) Long Beach, CA: Long Beach Museum of Art.

Video Acts: Single Channel Works from the Collections of Pamela and Richard Kramlich and New Art Trust (2002–3) New York: PS# 1 Contemporary Art Center.

Video Spaces: Eight Installations (1995) New York: Museum of Modern Art.

Vision and Television (1970) Waltham, MA: Rose Art Museum, Brandeis University.

Articles

Alloway, L. (1974) "Talking with William Rubin: The Museum Concept Is Not Infinitely Expandable." *Artforum*, October.

Art Journal (1985) Video Issue, Fall.

ArtsCanada (1973) Video Issue, October.

Ashton, D. (1968) "End and Beginning of an Age." *Arts Magazine*, December.

Bangert, C. and Bangert, C. (1974) "Experiences in Making Drawings by Computer and by Hand." *Leonardo 7.*

Bohlen, C. (2002) "A Global Vision for a Global Show." *New York Times*, February 17.

Boxer, S. (2003) "McLuhan's Messages, Echoing on Iraq." *New York Times*, April 3.

Buchlock, B. H. D. (1981) "Figures of Authority, Ciphers of Regression." *October* 16, Spring.

Burnham, J. (1971) *Systems Aesthetics*, Artforum 7 (1), September.

—— (1971) "Problems in Criticism IX: Art and Technology." *Artforum*, January.

Bush, V. (1945) "As We May Think." *Atlantic Monthly*, July.

Cornock, S. and Edmonds, E. (1973) "The Creative Process Where the Artist Is Amplified or Superseded by the Computer." *Leonardo 6.*

Couchot, E. "Between the Real and the Virtual." *Annual Inter Communication*. Tokyo: ICC.

Couey, A. (1984) "Participating in an Electronic Public: TV Art Effects Culture." *Art Com* 25 (7).

Crary, J. (1994) "Critical Reflections." *Artforum*, February.

Crimp, D. (1973) "Function of the Museum." *Artforum*, September.

—— (1980) "On the Museum's Ruins." *October* 13, Summer.

—— (1980) "The Photographic Activity of Postmodernism." *October* 15, Winter.

Danto, A. (1995) C. "Art Goes Video." *The Nation*, September 11.

Davis, D. (1968) "Art and Technology: The New Combine." *Art in America*, January/February.

—— (1972) "Video Obscura." *Artforum*, April.

—— (1995) "The Work of Art in the Age of Digital Reproduction." *Leonardo* 28 (5).

Dieckman, K. (1985) "Electra Myths: Video, Modernism, Postmodernism." *Art Journal*, Fall.

Dietrich, F. (1985) "Visual Intelligence: The First Decade of Computer Art (1965–1975)." *Computer Graphics and Applications*, IEEE Computer Society Journal, July.

Durland, S. (1989) "Artist of the Future." *High Performance Magazine*, Winter.

EAT News 1 *nos* (1) and (2) (1967) "New York: Experiments in Art and Technology, Inc."

Fink, D. A. (1971) "Vermeer's Use of the Camera Obscura." *Art Bulletin* 3.

Franke, H. W. (1971) "Computers and Visual Art." *Leonardo* 4.

Fried, M. (1967) "Art and Objecthood." *Artforum*, Summer.

Furlong, L. (1983) "Artists and Technologists: The Computer as An Imaging Tool." *Siggraph*, catalog.

—— (1983) "An Interview with Gary Hill." *Afterimage*, March.

—— (1983) "Notes Toward a History of Image-Processed Video." *Afterimage*, Summer.

Glueck, G. (1983) "Portrait of the Artist as a Young Computer." *New York Times*, February 20.

—— (1983) "Video Comes into Its Own at the Whitney Biennial." *New York Times*, April 24.

Graham, D. (1983) "Theatre, Cinema, Power." *Parachute Magazine* 31, June, July, August.

Henderson, L. D. (1971) "A New Facet of Cubism: 'The Fourth Dimension' and 'Non-Euclidean Geometry' Reinterpreted." *Art Quarterly*, Winter.

Hess, T. B. (1970) "Gerbil Ex Machina." *Art News*, December.

Huktrans, A. (1995), "Reality Bytes: Andrew Huktrans Talks with Kathryn Bigelow." *Art Forum* 24 (3), November.

Huyssen, A. (1984) "Mapping the Postmodern (Modernity and Postmodernity)." *New German Critique*, Fall.

Kaprow, A. (1972 and 1974) "The Education of the Un-Artist, Parts I, and II and III." *Art in America*, February, 1971; May, 1972; and January/February, 1974.

Kirkpatrick, D. (1978) "Between Mind and Machine." *Afterimage*, February.

Legrady, G. (1991), "Image, Language, and Belief in Synthesis." *CAA Art Journal* 49 (3).

Lippard, L. and Chandler, J. (1968) "The Dematerialization of Art." *Arts International* 12.

Magdoff, S. H. ed. (2002), "What Documenta Meant to Them." *New York Times*, June 2.

Mallary, R. (1969) "Computer Sculpture: Six Levels of Cybernetics." *Artforum*, May.

Mayor, A. H. (1946) "The Photographic Eye." *Bulletin of the Metropolitan Museum of Art*, July.

Mirapaul, M. (2002) "New Public Art Uses the Internet for a Personal Touch." *New York Times*, August 5.

—— (2002) ARTS ONLINE. "Secrets of Digital Creativity Revealed in Miniatures." *New York Times*, September 16.

Noll, M. (1967) "The Digital Computer as a Creative Medium." *IEEE Spectrum*, October.

Owens, C. (1982) "Phantasmagoria of the Media." *Art in America*, May.

—— (1982) "Representation, Appropriation and Power." *Art in America*, May.

Reidy, R. (1984) "Video Effects Art/Art Affects Video." *Art Com* 24 (6).

Rice, S. (1984) "The Luminous Image: Video Installations at the Stedelijk Museum." *Afterimage*, December.

Richmond, S. (1984) "The Interaction of Art and Science." *Leonardo* 17.

Root-Bernstein, R. S. and Robert S. (1984) "On Paradigms and Revolutions in Science and Art: The Challenge of Interpretation." *Art Journal, College Art Association of America*, Summer.

Schjeldahl, P. (2002) "The Global Salon." *The New Yorker Magazine*, July 1.

Schreiber, R. (2001) "Net.Art: Shedding the Utopian Moment?)." *LINK: A Critical Journal on the Arts in Baltimore and the World* 7: CODE. Baltimore, MD: Linkarts, Inc.

Seymour, C. (1964) "Dark Chamber and Light-Filled Room: Vermeer and the Camera Obscura." *Art Bulletin* 46, September.

Shatz, A. (2002) "His Really Big Show." *New York Times*, magazine, June 2.

Sheridan, S. (1972) "Generative Systems." *Afterimage*, April.

—— (1975) "Generative Systems – Six Years Later." *Afterimage*, March.

Strauss, D. L. (1976) "When Is a Copy an Original?" *Afterimage*, May/June.

Sturken, M. (1983) "The Whitney Museum and the Shaping of Video Art: An Interview with John Hanhardt." *Afterimage*, May.

—— (1984) "TV as a Creative Medium: Howard Wise and Video Art." *Afterimage*, May.

—— (1985) "Feminist Video: Reiterating the Difference." *Afterimage*, April.

Turner, F. (1984) "Escape from Modernism: Technology and the Future of the Imagination." *Harper's Magazine*, November.

Vasulka, W. and Nygren, S. (1975) "Didactic Video: Organizational Models of the Electronic Image." *Afterimage*, October.

West, S. (1984) "The New Realism." *Science '84*, July/August.

Wilson. S. (1994) "The Aesthetics and Practice of Designing Interface Computer Events." Uncopyrighted essay on the Internet.

Wohlfarth, I. (1979) "Walter Benjamin's Image of Interpretation." *New German Critique*, Spring.

ZKM Press release (2002–3) "Future Cinema: The Cinematic Imaginary After Film." Karlsruhe, ZKM.

Index